Franklin & His Friends

"I now take the Freedom of thy usual
Benevolence and favour of thy wife to inclose
this letter in hers hopeing this way we may
keep the chain of friendship bright while
thee art diverting thy self with the generous
conversation of our worthy friends in Europe
and adding dayly new acquisitions to thy
former extensive stock of knoledge by thair
free comunication of thair experimental
improvements. . ."

JOHN BARTRAM TO BENJAMIN FRANKLIN,
July 29, 1757

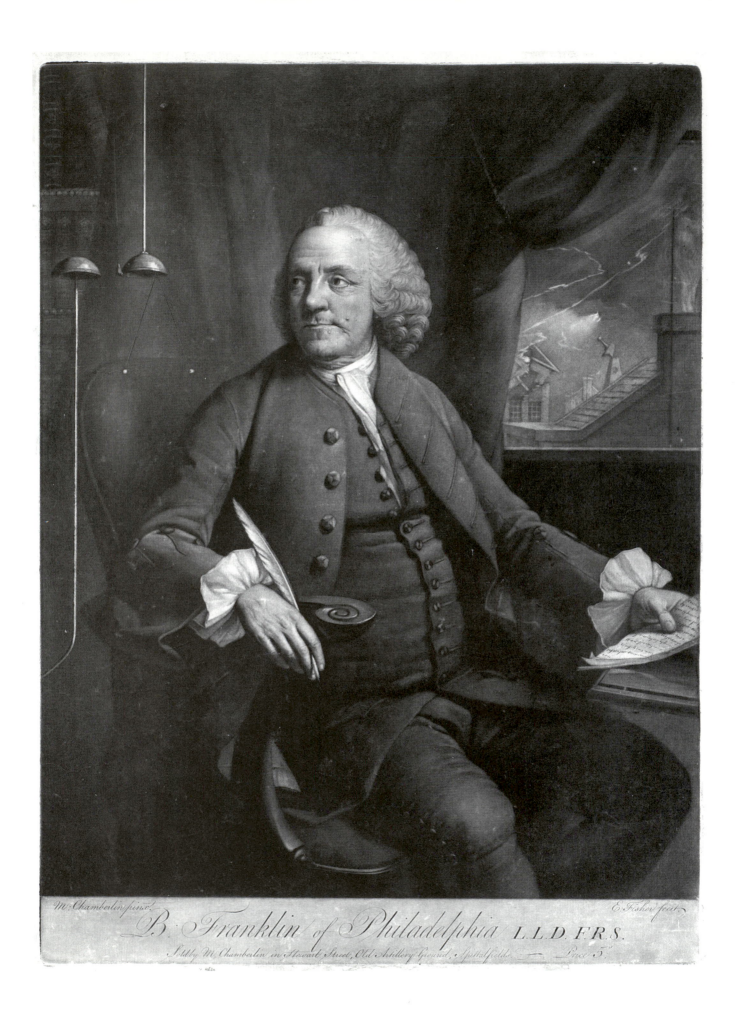

B. Franklin of Philadelphia L.L.D. F.R.S.

Sold by M. Chamberlin in Stewart Street, Old Artillery Ground, Spitalfields. ——— Price 5.

Franklin & His Friends

Portraying the Man of Science in Eighteenth-Century America

Brandon Brame Fortune
with Deborah J. Warner

SMITHSONIAN
NATIONAL PORTRAIT GALLERY
WASHINGTON, D.C.

In association with the
UNIVERSITY OF PENNSYLVANIA PRESS
PHILADELPHIA

An exhibition at the
NATIONAL PORTRAIT GALLERY, SMITHSONIAN INSTITUTION
Washington, D.C.

April 16–September 6, 1999

Partial support for the exhibition was
provided by the Smithsonian Institution
Special Exhibition Fund and the Smithsonian
Institution Scholarly Studies Fund.

LIBRARY OF CONGRESS CATALOGING-IN-PUBLICATION DATA

Fortune, Brandon Brame.
 Franklin and his friends : portraying the man of science in
eighteenth-century America / Brandon Brame Fortune with Deborah J. Warner.
 p. cm.
 Includes bibliographical references and index.
 ISBN 0-8122-1701-2 (alk. paper)
 1. Franklin, Benjamin, 1706–1790—Exhibitions. 2. Scientists—
United States—History—18th century. I. Warner, Deborah Jean.
II. Title.
Q143.F8F67 1999
509'.2'273—dc21 98-55086
 CIP

Manufactured in Canada

COVER:
Benjamin Franklin (detail) by David Martin (1737–1797), oil on canvas, 1767.
Pennsylvania Academy of the Fine Arts, Philadelphia; gift of the heirs of
Thomas and Elizabeth McKean, 1943; on loan to the U.S. Department of State,
Diplomatic Reception Rooms. Illustrated in full on page 28.

FRONTISPIECE:
Benjamin Franklin by Edward Fisher (1722–1785), after Mason Chamberlin,
mezzotint, 1763. National Portrait Gallery, Smithsonian Institution, Washington,
D.C. Also illustrated on page 121.

Contents

Foreword

Scientific investigation is one of the intellectual pursuits most esteemed by Americans today. New discoveries in the biological sciences and medicine, new explorations in astrophysics, new insights into the global environment, all are given prominence in the news media. Even though many are insufficiently equipped with the scientific and mathematical skills to comprehend the details of new discoveries, the subject retains its fascination for the public, and scientists are regarded with an esteem bordering on worship.

Exhibitions and publications in the past at the National Portrait Gallery have explored many aspects of life and thought in the early United States, but until now the sciences have been put aside as a subject. Now, through the collaboration of Brandon Brame Fortune, assistant curator of painting and sculpture at the Gallery, and Deborah Warner, curator of the physical sciences collections at the Smithsonian's National Museum of American History, the role of Benjamin Franklin and his contemporaries in the sciences is given center stage.

During the eighteenth century, the sciences (then termed "natural philosophy") enjoyed a degree of popular interest resembling that of the present time, but the profession of science was very different from what it is today. Instead of being the exclusive precinct of highly trained specialists, natural philosophy was thought to be one of the appropriate pursuits of the educated gentleman, along with the fine and musical arts, philosophy, theology, and political theory. Perhaps the most remarkable example of this intellectual range and versatility can be found in Benjamin Franklin, who was successful in business, participated in the framing of the political structure of a new nation, represented his country as a diplomat, wrote essays of moral instruction, composed music, invented several useful devices, and was a tireless investigator into the behavior of electricity. Thomas Jefferson was deeply concerned with natural philosophy throughout his life, and maintained a lively correspondence with naturalists and investigators in Europe as well as America even while he was President. He specifically charged explorers Lewis and Clark to record and collect animal and plant specimens on their expedition west, experimented with plant hybridization and controlled animal breeding on his property at Monticello, and kept a telescope in his study for astronomical observation. Many other examples of people known for their accomplishments in other fields who made substantial contributions to scientific knowledge can be found, and they are among the subjects of this study.

Another difference between the practice of science in the eighteenth century and the present day is in the tools of the trade. Today we marvel at the power of the linear accelerator to force the atom to reveal its smallest components, or the Hubbell space telescope and the earthbound multiple-array instruments to capture waves emitted from galaxies more distant than any detected before. Two hundred years ago—as will be seen by the instruments depicted in these portraits (many of which have been loaned for exhibition along with the paintings in which they appear)—the tools of the investigator were far less

elaborate. Electricity was generated by static machines. A telescope with two lenses was regarded as sophisticated. Yet, striking observations were made, owing to the care with which early scientists made their studies, documented their findings, and shared the results with their colleagues in lectures and published papers. One of the special pleasures of this study is to observe the care with which many of these instruments were made, and the craftsmanship with which they were finished and decorated. Clearly, there was pride in the devising and ownership of these instruments, and it is striking to sense these qualities across time.

George Sarton, one of the founders of the history of science as an academic discipline, observed in 1938 that the greatest portraits of scientists can give you "the whole man at once,—that intelligent yet crossgrained and cantankerous man, almost alive," to quote his description of Franz Hals's portrait of Rene Descartes in the Louvre. "You are given immediately some fundamental knowledge of him, which even the longest descriptions and discussions would fail to evoke." Of course, portraits vary in their quality, and thus in their power to communicate, and our collaborators have managed the delicate task of finding the better ones while also suggesting the main currents of scientific exploration in the time of Franklin.

It is especially fortunate that we were able to enlist the help of a distinguished colleague in the Museum of American History, and we are deeply appreciative of the cooperation extended by the many other museums and libraries that have shared their knowledge with Dr. Fortune and Ms. Warner, and agreed to make precious objects available from their collections. Without their help, this exhibition would have been impossible.

Bringing together the images of so many learned people and the tools they used in their quest for understanding the world, our writers have been able to evoke the world of science in the early years of our nation with remarkable clarity and provide more than a little "fundamental knowledge" of the people who contributed to it.

ALAN FERN
Director, National Portrait Gallery

Acknowledgments

In October 1765, John Morgan wrote to Benjamin Franklin, thanking him for a recommendation to the medical faculty at the University of Edinburgh. Morgan's effusions of gratitude serve as an example for our own, but his phrases are prettier than ours could ever be:

> I am under so many Obligations to You that I fear I shall never have it in my power to make you any due acknowledgement. If a Mind filled with esteem and regard for You could be a proper Apology for the want of a better return, I should have no difficulty to make one. Very many Instances of your readiness to oblige those of whom you have ever been pleased to entertain a good opinion, and the actual favours you have conferred upon them offer themselves to my Memory with the strongest evidence of your friendly disposition; Be assured Sir, that the many kindnesses you have shewn not only to myself but to my relations and friends have operated powerfully with me to create a lively remembrance of your Goodness which I shall carefully cherish.

In seeking to understand portraits of early American men of science, we have similarly accrued many debts and made many friends. First, we want to express our gratitude to the Smithsonian's Scholarly Studies Fund and Research Opportunities Fund, which enabled us to travel to see objects, and obtain the photography for this book.

At the National Portrait Gallery, we would like to thank everyone, for in a small museum, no project comes to fruition without great effort on the part of the entire staff. Still, special thanks are due to several individuals. First, we are grateful to Ellen Miles for careful reading of this manuscript, crucial references, shrewd advice, kind counsel, and well-timed encouragement. The late Lillian B. Miller supported our research and generously provided help with grant proposals and in locating paintings by Charles Willson Peale. Philippe W. Newton, a tireless volunteer in the Department of Painting and Sculpture, researched whatever was necessary, from Scottish portrait painters to the transits of Venus, and provided much-needed assistance in fundraising for the exhibition. National Portrait Gallery Director Alan Fern and Deputy Director Carolyn K. Carr supported this project from its inception. Linda Thrift, Susan Foster Garton, and Deborah Sisum of the Catalog of American Portraits made their files available and offered advice on electronic imaging. Deborah Sisum created the exhibition's Web site. Cecilia Chin and her staff in the National Portrait Gallery/National Museum of American Art Library, including Pat Lynagh, Jill Lundin Dowdy, and her successor Katrina Brown, moved mountains to obtain interlibrary loan materials for our use. Beverly Cox and her staff, Claire Kelly and Liza Karvellas, quite literally made the exhibition happen. Their attention to detail is extraordinary. Our exhibition design team, headed by Nello Marconi and Al Elkins, created a beautiful showcase for the portraits, and took special care in designing settings for the instruments. Suzanne Jenkins and Molly Grimsley of the Office of the Registrar handled the enormous task of bringing together a variety of

fragile objects. Through their careful editing, Frances Stevenson and Dru Dowdy transmuted the dross that was our manuscript into a book. Other staff members who deserve our thanks include Leni Buff, Greg Canik, Margaret C. S. Christman, Heather Egan, Pie Friendly, Kevin Greene, Marianne Gurley, Barbara Hart, Sidney Hart, Ruth Hill, Carole Kurfehs, Leslie London, John McMahon, Dorothy Moss, Cindy Lou Ockershausen, Mary Panzer, Leila Putzel, Brennan Rash, Wendy Wick Reaves, Jewell Robinson, Kellie Shevlin, Ann Shumard, Frederick Voss, Ann Wagner, LuLen Walker, David Ward, and Rolland White. Thanks are due, too, to NPG intern and University of Maryland Fellow Michelle Kloss, and to four former Smithsonian Institution pre-doctoral fellows who worked at NPG: Konstantin Dierks, David Steinberg, Anne Verplanck, and Lee Vedder.

Other colleagues within the Smithsonian responded quickly and graciously to our pleas for assistance with research and in locating appropriate objects for the exhibition: Silvio Bedini, Judy Chelnick, Claudia Kidwell, Nathan Reingold, Roger Sherman, Carlene Stephens, Margaret Vining, Helena Wright, and Marko Zlatich at the National Museum of American History; Tom Crouch, Paul McCutcheon, and Tom Soapes at the National Air and Space Museum; Paul Theerman at the Smithsonian Archives; William Baxter, Leslie Overstreet, Bonnie Sousa, and Marca Woodhams at the Smithsonian Institution Libraries; Dan Nicolson at the National Museum of Natural History; and Owen Gingerich at the Harvard-Smithsonian Center for Astrophysics.

We would also like to acknowledge the assistance we received from scholars, curators, and staff at institutions across the United States and Canada: Carol Spawn, Academy of Natural Sciences, Philadelphia; Tammis Groft and Scott McCloud, Albany Institute of History and Art; Georgia Barnhill, American Antiquarian Society; Whitfield J. Bell Jr., Beth Carroll-Horrocks, Emily Croll, Scott DeHaven, and Roy Goodman, American Philosophical Society; Katharine J. Watson, Bowdoin College Museum of Art; Teresa A. Carbone, Brooklyn Museum of Art; Fred Burchsted and Karen Bailey, Burndy Library, Dibner Institute, Massachusetts Institute of Technology; Patricia Junker, M. H. de Young Memorial Museum; Dorinda Evans, Emory University; John V. Alviti, Franklin Institute; Marjorie B. Cohn and Sandra Grindlay, Harvard University Art Museums; William J. H. Andrewes, Collection of Historical Scientific Instruments, Harvard University; Lucretia McClure, Countway Library of Medicine, Harvard University; Roger Stoddard and Susan Halpert, Houghton Library, Harvard University; Joel T. Fry, Historic Bartram's Garden; Amy R. W. Meyers, Huntington Library; Karie Diethorn, Independence National Historical Park; Michiko Okaya, Williams Center for the Arts, Lafayette College; Wendy Woloson, Library Company of Philadelphia; Joan F. Higbee, Library of Congress; Nancy Davis, David DeLorenzo, and Anne Verplanck, Maryland Historical Society; Carrie Rebora Barratt, Metropolitan Museum of Art; Joseph Ewan, Missouri Botanical Garden; Ann C. Madonia, Muscarelle Museum of Art, Williamsburg, Virginia; Sylvie Toupin, Musée de la Civilization, Québec, Canada; John D. Hamilton and Maureen Harper, Museum of Our National Heritage; Carolyn Kirdahy, Museum of Science, Boston; Ruth Philbrick, National Gallery of Art; Alan Hawk, National Museum of Health and Medicine, Armed Forces Institute of Pathology, Washington, D.C.; Donna-Belle Garvin and Hilary Anderson, New Hampshire Historical Society; Margaret Tamulonis and Megan Hahn, New-York Historical Society; Miriam Mandelbaum, Rare Books and Manuscripts, New York Public Library; Barbara B. Oberg and Ellen R. Cohn, the Papers of Benjamin Franklin; Dan Finamore and Dean Lahikainen, Peabody Essex Museum; Sylvia Yount, Pennslvania Academy of the Fine Arts; Gail Pietrzyk, University of Pennsylvania Archives; Jacqueline Jacovini and Jennifer Muck, University Art Collection, University of Pennsylvania; John Pollock, Rare Books Department, University of Pennsylvania Library; Janet Evans, Pennsylvania

Horticultural Society; Darrel L. Sewell and Joseph J. Rishel, Philadelphia Museum of Art; Elizabeth E. Fuller, Rosenbach Museum and Library; Sara Gronim, Rutgers, the State University of New Jersey; Eva Laird Smith, Tacoma Art Museum; Leni Preston, Tudor Place Foundation, Inc.; Gail Serfaty and Thomas G. Sudbrink, U. S. Department of State, Diplomatic Reception Rooms; Laura E. Beardsley, Jonathan P. Cox, and Kristen Froehlich, Historical Society of Pennsylvania; Elizabeth Mankin Kornhauser and Linda Roth, Wadsworth Atheneum; Thomas V. Litzenburg Jr., the Reeves Center, Washington and Lee University; E. McSherry Fowble, Winterthur Museum, Garden and Library; Patrick Noon and Inger Schoelkopf, Yale Center for British Art; Robin Frank, Yale University Art Gallery; Barbara Trelstad, Jane Voorhees Zimmerli Art Museum, Rutgers, the State University of New Jersey.

In the United Kingdom we received valuable assistance from Patricia Fara, Darwin College, Cambridge; Gina L. Douglas, the Linnean Society of London; J. A. Bennett, Museum of the History of Science, Oxford; Richard Ormond, Andrew Picknell, Nick Booth, and Paul Cook, National Maritime Museum; Malcolm Beasley, the Natural History Museum; Jacob Simon, Tim Moreton, and Tina Fiske, National Portrait Gallery; Natasha Held, the Paul Mellon Centre for Studies in British Art; Helen Valentine, Royal Academy of Arts; Geoffrey Davenport, the Royal College of Physicians; Stella Mason, the Royal College of Surgeons of England; Sandra Cumming, the Royal Society; Wendy Sheridan and Ailsa Jenkins, Science Museum; and William Schupbach, Wellcome Institute for the History of Medicine, all in London. In Edinburgh, we would like to thank James Holloway, Nicola Kalinsky, and Helen Grant of the Scottish National Portrait Gallery; and Duncan MacMillan and Valerie Fiddes of the University of Edinburgh.

Whitfield J. Bell Jr. spent hours sharing information on the early members of the American Philosophical Society, many of whom are represented in this book. Dr. Bell's depth of knowledge of the early years of American scientific and medical endeavor, particularly in Philadelphia, is unmatched, and we are most thankful for his interest and assistance. Dr. Bell and several other colleagues served as reviewers for the Scholarly Studies grant so crucial to our work; their help was invaluable, and their comments were taken to heart: David Bjelajac, George Washington University; Sandra Grindlay, Harvard University Art Museums; R.W. B. Lewis, Bethany, Connecticut; Carrie Rebora Barratt, Metropolitan Museum of Art; Richard Saunders, Johnson Gallery, Middlebury College; and Maxine F. Singer, Carnegie Institution, Washington, D.C.

Several private lenders to the exhibition, some of whom prefer anonymity, were generous with their time, as well as with their portraits. We would like to acknowledge the kindness of Dean Emerson and Mrs. Josiah Macy.

We would also like to thank Gerard A. Valerio for his beautiful design of this book.

In addition, Brandon Fortune would like to acknowledge delightfully helpful conversations with Ruth Kassinger, Arthur Marks, and Frederick Voss. My greatest thanks are reserved for my husband, Terry Fortune, who made it all possible.

Deborah Warner would like to thank Brandon for bringing her into this project.

Lenders to the Exhibition

ALBANY INSTITUTE OF HISTORY AND ART, New York

AMERICAN ACADEMY OF ARTS AND SCIENCES, Cambridge, Massachusetts

AMERICAN ANTIQUARIAN SOCIETY, Worcester, Massachusetts

AMERICAN PHILOSOPHICAL SOCIETY, Philadelphia, Pennsylvania

BOWDOIN COLLEGE MUSEUM OF ART, Brunswick, Maine

BROOKLYN MUSEUM OF ART, New York

DIBNER INSTITUTE FOR THE HISTORY OF SCIENCE AND TECHNOLOGY, Cambridge, Massachusetts

DEAN EMERSON

THE FRANKLIN INSTITUTE, Philadelphia, Pennsylvania

PRESIDENT AND FELLOWS OF HARVARD COLLEGE, Cambridge, Massachusetts

COLLECTION OF HISTORICAL SCIENTIFIC INSTRUMENTS, HARVARD UNIVERSITY, Cambridge, Massachusetts

HISTORICAL SOCIETY OF PENNSYLVANIA, Philadelphia

INDEPENDENCE NATIONAL HISTORICAL PARK COLLECTIONS, Philadelphia, Pennsylvania

LIBRARY OF CONGRESS, Washington, D.C.

THE LODGE OF ST. ANDREW, A.F & A.M., Boston, Massachusetts

MARYLAND HISTORICAL SOCIETY, Baltimore

METROPOLITAN MUSEUM OF ART, New York City

MUSÉE DE LA CIVILISATION, Québec, Canada

NATIONAL AIR AND SPACE MUSEUM, SMITHSONIAN INSTITUTION, Washington, D.C.

THE NATIONAL LIBRARY OF MEDICINE, NATIONAL INSTITUTES OF HEALTH, Bethesda, Maryland

NATIONAL MUSEUM OF AMERICAN HISTORY, SMITHSONIAN INSTITUTION, Washington, D.C.

NATIONAL MUSEUM OF HEALTH AND MEDICINE, ARMED FORCES INSTITUTE OF PATHOLOGY, Washington, D.C.

NATIONAL PORTRAIT GALLERY, SMITHSONIAN INSTITUTION, Washington, D.C.

TRUSTEES OF THE NATURAL HISTORY MUSEUM, London, England

NEW HAMPSHIRE HISTORICAL SOCIETY, Concord

THE NEW-YORK HISTORICAL SOCIETY, New York City

PEABODY ESSEX MUSEUM, Salem, Massachusetts

PENNSYLVANIA ACADEMY OF THE FINE ARTS, Philadelphia

PHILADELPHIA MUSEUM OF ART, Pennsylvania

PRIVATE COLLECTION

SMITHSONIAN INSTITUTION LIBRARIES, Washington, D.C.

TUDOR PLACE FOUNDATION, INC., Washington, D.C.

WINTERTHUR MUSEUM, Delaware

YALE CENTER FOR BRITISH ART, New Haven, Connecticut

YALE UNIVERSITY ART GALLERY, New Haven, Connecticut

JANE VOORHEES ZIMMERLI ART MUSEUM, RUTGERS, THE STATE UNIVERSITY OF NEW JERSEY, New Brunswick

Franklin
& His Friends

"I flatter'd myself that, by the sufficient tho'
 moderate Fortune I had acquir'd, I had
 secur'd Leisure during the rest of my Life,
 for Philosophical Studies and Amusements."

BENJAMIN FRANKLIN, *Autobiography*

"Ye pamphlet & espetially ye picture of my
 dear Peter [Collinson] was very acceptable &
 now I am furnished with four of our worthies
 Linneus, Franklin, Edwards & Collinson
 (but I want Dr. Fothergill) to adorn my new
 stove & lodging room . . . alltho I am no
 picture Enthusiast, yet I love to looke at ye
 representation of men of inocency integrity
 ingenuity & Humanity."

JOHN BARTRAM TO BENJAMIN FRANKLIN,
November 24, 1770

Introduction

Portraits, like the printed texts and manuscript documents more conventionally used by historians, can serve as historical evidence. They are central to our understanding of the social construction of personal identity, of how people presented themselves in a social context. This book is a study of portraits of men from varying ranks of eighteenth-century American society. The subjects are linked in that they were all investigating the natural world—their passion, regardless of their actual vocation, was for science. The portraits document their pride in their scientific accomplishments, in the pursuit of which they invested money, time, and energy.

Historians have only recently begun to study visual images as evidence rather than as illustration. And like art historians before them, they have found that portraiture is both factual and fictive.[1] Some degree of likeness was always expected of a portraitist, although artists could temper verisimilitude with culturally acceptable norms for male and female appearance. But portraitists could also draw on a stock of available images—traditional representational constructs, as well as contemporary objects and costumes—in order to present sitters as they would wish to be seen. Portraiture can reveal not only a likeness, but the ambitions, desires, ideals, and even the foibles of its subjects.

We focus on portraits that clearly reveal the sitter's scientific interests. Our goal is twofold. First, we attempt to provide a full documentation of the portrait's creation and imagery. And second, we argue that such portraits construct a scientific identity through visual means. We also examine the original context and reception of these portraits, in order to strengthen our argument that they situate each sitter not only within his local community, but across cultural, economic, and geographical boundaries to fix him within the international community of science. The identity presented in each portrait is both individual and collective; that is, such men aligned themselves with others who were investigating the natural world, and wished to express this collective identity through portraiture.

The practice of science was relatively unstructured in the eighteenth century; science meant different things to different people, and persons engaged in science at different levels. As Margaret Jacob has noted, early men of science were not professionals—the term scientist was not coined until 1833—but neither were they amateurs, in our sense of that term.[2] The physical, mathematical, and natural sciences had developed into well-defined bodies of knowledge, and such knowledge became desirable within the polite world as well as being the purview of more serious practitioners. In Britain, instruments of science and science books were produced in quantities never before seen—part of the enormous growth of consumer culture and the commercialization of leisure. Many

books and public lectures were directed to popular audiences, while more serious investigators aligned themselves with colleagues in "philosophical societies" and through correspondence to form an elite corps of like-minded men. Wealthy consumers purchased telescopes along with their fine silver or furniture. George III amassed a collection of gorgeously crafted instruments.[3] And practicing astronomers, botanists, or professors of natural philosophy sought the finest and most up-to-date instruments available. As Roy Porter has summarized, "The market for such wares steadily spread out from the small elite genuinely involved in 'research' to a much larger public, hungry to own such objects for pleasure, amusement, instruction, as status symbols, as things of beauty, or in pursuit of hobbies."[4]

In America, as in Britain, the continuum of scientific interest ranged from polite curiosity on the part of wealthy consumers or popular participation in the dissemination of scientific knowledge to those who were active investigators of nature. Those whose portraits are studied here were for the most part busy "investigators." A 1767 letter from Thomas Collinson to Benjamin Franklin goes far to explain some of the positions on this continuum. Collinson was organizing a friendly gathering in London, including himself (nephew of the well-known Quaker merchant, plant collector, and patron of botanists, Peter Collinson), Franklin, James Ferguson (a notable scientific lecturer of the day), and Edward Nairne (a leading instrument maker). Collinson wrote, "Do not conclude I imagine myself a man of Science—and as such invite you to spend any of your Hours with me. No I rise no higher than being a Lover of Knowledge—which is in Philosophy, as in Gallantry, quite a different State from that of Possession."[5]

These serious men of science were, however, a diverse group—in background, wealth, and vocation. They were educators, physicians, planters, wealthy men with time for scientific observation and experiment, scientific lecturers, those who used science for their business—mariners, instrument makers, surveyors, and mapmakers—and those, like Franklin, who made science the focus of a public reputation. In identifying themselves, they employed terms unfamiliar to us today. The word "philosopher" was often used. In closing a 1755 letter to his future wife, Elizabeth Hubbard—a lengthy discourse on eclipses and the moon's influence on tides—Yale College tutor Ezra Stiles styled himself as "Your affectionate Philosopher." Or, as Benjamin Franklin mentioned in a 1757 letter to Stiles, he was enclosing a copy of a letter "lately sent to a philosophical Friend in Carolina."[6] Other contemporary terms that defined a scientific identity included the adjectives "ingenious" and "curious," used to define a man's propensity for scientific endeavors. As John Bartram wrote in 1744 to Cadwallader Colden, who shared his botanical interests, concerning Dr. John Mitchell, who was studying the flora of Virginia, "ye Ingenious Doctor Mitchel has discribed curiously many of ye plants in virginia."[7] A convenient, and contemporary, term for members of this loosely defined group with its varied interests is "man of science."

Our book is anchored by portraits of Benjamin Franklin (1706–1790), whose scientific reputation was universal within the Western republic of letters. It is clear from the information assembled by scholars that Franklin manipulated his public image through portraits in various media.[8] Many of these portraits emphasize his inventiveness and scientific accomplishments. Franklin also provides a link between many of the subjects considered here. He knew, or was known to, almost all of them, and many were his friends.

Correspondence and conversation were the foundation of the exchange of scientific knowledge during the eighteenth century, and Franklin was a particularly devoted correspondent. He wrote to James Bowdoin when both were old men:

Our ancient Correspondence used to have something Philosophical in it. As you are now more free from public Cares, and I expect to be so in a few Months, why may we not resume that kind of Correspondence? Our much regretted Friend Winthrop once made me the Compliment, that I was good at starting Game for Philosophers; let me try if I can start a little for you.[9]

Americans were well aware of their isolation from European centers of learning. Imported books and instruments were rare and expensive. Correspondence, often painstakingly cultivated and carefully delivered through friends traveling to distant towns or abroad, "kept bright the chain of friendship" that helped scientific ideals to flourish.[10] As Cadwallader Colden wrote in 1745 from his New York estate, Coldengham, to Dr. John Mitchell in Virginia:

> You see in what manner I amuse my self in a Solitary part of the world where I am allmost deprived of the benefite of all conversation. . . . Sorry I am that your state of Health should so much disable you. . . . I am much concern'd that it endangers the loss of a Correspondence of which I have but just tasted the pleasure. . . . I hope however that if your health require you to go to Brittain that even amidst the Crowds of the engaging Conversation you will there meet with in the Company of Philosophers of the first rank you may sometimes find a void hour to remember [me].[11]

This growing sense of collective identity was reinforced through portraiture that presented sitters as men of science, and was further established through engravings, most of which were derived from painted portraits. Engravings were sometimes included in letters exchanged between men of science, and were often framed and displayed in their houses. While on his first voyage to London in 1811, Samuel F. B. Morse recalled an engraved portrait belonging to his father, minister and geographer Jedidiah Morse. On meeting Dr. John Coakley Lettsom, a famed London physician, the young artist wrote to his father, "Dr. Lettsom is a very singular man. He looks considerably like the print you have of him."[12] Other prints were published as frontispieces to scholarly treatises, or gathered in biographical volumes devoted to great men. Still other engravings were produced in response to public demand for images of men of science with broader appeal—Isaac Newton, Carl Linnaeus, or Benjamin Franklin.

Colden's plural notion of the "Company of Philosophers" is a guiding one for this book. Eighteenth-century portraits of men represented persons who moved in the almost exclusively masculine spaces of official, business, or professional life. The portraits we discuss make up a subset of these, with a particular, and in some ways more private, focus. Their imagery does not necessarily define masculinity; rather, the pictorial emphasis is on an endeavor. Regardless of where they were displayed, or whether or not they were engraved, they address through their imagery the international "republic of science" and the relationships forged therein.[13] For these people, science provided access to networks of intellectual and social exchange that crossed boundaries of rank and class, as well as national or colonial borders. We explore, through a close examination of a small group of portraits, what it meant to be portrayed as a "philosopher"—a man of science—and discuss the imagery used for such portrayals within a sociocultural and art historical context.

The artist and the patron shared in the creation of a portrait. This relationship is addressed whenever possible, for artists often shared the interests of the men of science who sat to them. Some were directly involved in scientific observation and study or in the recording of natural phenomena and naturalists' specimens, and cartography. Other artists were intrigued by optics, the chemistry of paints, color and its effects, the use of

mechanical drawing devices such as the camera obscura or physiognotrace, and the craft involved in making scientific instruments. Charles Willson Peale was a naturalist and museum keeper, as well as an artist. Portrait painter Samuel King came from a family of mathematical instrument makers, and also made and sold such instruments. Such mutual fascination often created opportunities for compelling portraits.

Most of the portraits discussed here were made from 1750 to 1810. Our analysis dissects their component parts to recover their contemporary resonance. Eighteenth-century portraitists and their subjects would not have separated the constellations of meaning attached to certain images, poses, or costumes. In order to interpret these portraits, however, we must first examine contemporary conventions and prescriptions for portraiture, especially in images of men. Then, the variety of attitudes and attributes found in portraits that privilege scientific interests are analyzed. In many cases, these portraits emphasize the contemplative life and draw much of their imagery from portrait conventions used for intellectuals. Most portraits that reveal a scientific identity, however, include highly specific attributes or tools (books and instruments) or products of the sitter's scientific work. As the book is organized as a study of portraiture, biographical and scientific information is included only as it is necessary for an understanding of the messages conveyed by the portraits. The last section of the book highlights images of men of science created after the American Revolution, and explores the connections expressed in portraiture between science and the developing culture of the United States.

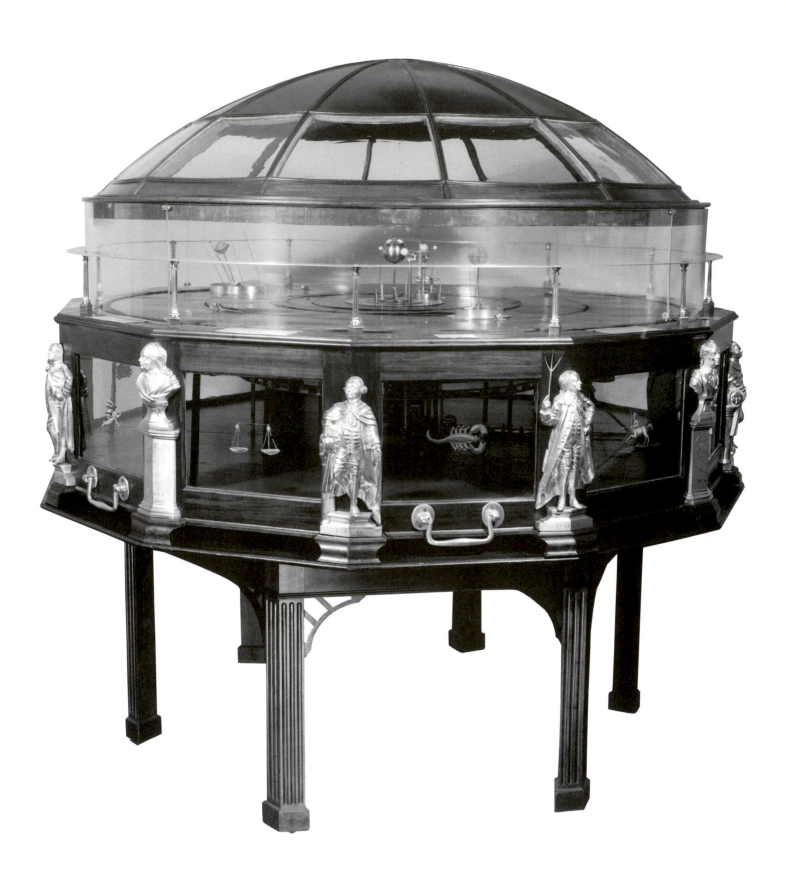

Chapter 1

The Man of Science in America

During the course of the eighteenth century, science entered public culture and polite society. American science was closely linked to that of Western Europe, and particularly of Great Britain. Most of the scientific books and instruments in America were published or made in England. Some persons acquired a smattering of scientific knowledge through such books or at demonstrations using philosophical instruments. Knowledge gained in the realms of natural philosophy (the physical sciences), natural history (the biological sciences), medicine, chemistry, and mathematics (both "pure" and practical) was disseminated through schools and scientific societies, popular books and encyclopedias, public lectures, and private correspondence. South Carolinian Eliza Lucas Pinckney, who was educated in London—a rarity for an American woman—knew enough about astronomy to comment on the appearance of a comet in the spring of 1742: "The light of the Comitt to my unphilosophical Eyes seems to be natural and all its own. How much it may really borrow from the sun I am not astronomer enough to tell."[1]

But most of the portraits discussed here portray men who spent more time in scientific pursuits than was deemed merely genteel. Science was difficult, rational—an emblem of the Enlightenment—and its practitioners valued the important but still rather quirky reputation that an identification with the sciences gave them. Some, such as Benjamin Franklin or Charles Willson Peale, are still viewed as important figures; others, such as James Greenway or Nehemiah Strong, are almost forgotten. These men occupied a variety of places within the social hierarchy, for scientific knowledge was available to a broad spectrum of society. That was part of its appeal. Many American scientific enthusiasts had inherited or acquired sufficient wealth to afford the leisure needed for "Philosophical Studies." A few might have been considered "gentlemen," such as Virginia planter and plant enthusiast John Custis, but most were from the middling classes. These men squeezed the observation and study of nature into already busy lives. The Charleston physician and botanist Alexander Garden lamented in 1755: "I have not had an hour to spend in the woods this 2 months which makes me turn rusty in Botany."[2] Some were clergymen or physicians, some held positions within American colleges, and a few—such as plantsmen, makers of mathematical instruments, or lecturers who traveled from town to town, offering series of demonstrations of scientific phenomena to the public—made science their business.

Relationships were forged through a shared interest in science, and maintained through networks of correspondence. Naturalists exchanged seeds and plant specimens with eager transatlantic correspondents, and British contacts, such as Peter Collinson

and John Fothergill, served as conduits for letters to other Europeans and arranged for books and apparatus to be sent to Americans. After midcentury, American men of science increasingly corresponded with each other and began to form societies for the exchange of scientific information of all sorts. These networks provided opportunities for valued contacts within international communities that served as channels for scientific exchange. The American Philosophical Society, founded in 1743 in Philadelphia, for example, was to serve all the American colonies by promoting "philosophical Experiments that let Light into the Nature of Things, tend to increase the Power of Man over Matter, and multiply the Conveniences or Pleasure of Life."[3] By 1769, when the nearly dormant society was reorganized with Benjamin Franklin as its president and a vastly expanded membership, its interests were still varied and inclusive. Not only did the society elect foreign members to increase its status within the larger republic of letters, but like the Royal Society of London, it invited correspondence on both highly specific and practical topics, as well as more rarefied speculations, ranging from reports of ethnographic discoveries, canal design, and variations in compass readings to the astronomical observations of the 1769 transit of Venus, experiments in evaporation, or treatises on optics.

For most people in the eighteenth century, there was no conflict between science and religion. Science was seen as revealing the workings of God's creation. It was ideally viewed as a proper adjunct to religion. Rarely did men of science discuss their observations without making some link to a moral or religious purpose. Timothy Matlack observed in an oration before the American Philosophical Society in 1780 "that fair Science, while her right Hand guides and supports Man through the World, her left always points toward Heaven."[4] Some considered that men of science were aided by religion. As Joseph Priestley, who immigrated to America in 1794, proposed in the introduction to his *History and Present State of Electricity*:

> A PHILOSOPHER ought to be something greater, and better than another man. The contemplation of the works of God should give a sublimity to his virtue, should expand his benevolence, extinguish every thing mean, base, and selfish in his nature, give a dignity to all his sentiments, and teach him to aspire to the moral perfections of the great author of all things. . . . A life spent in the contemplation of the productions of divine power, wisdom, and goodness, would be a life of devotion. . . . The tranquility, and chearfulness of mind, which results from devotion forms an excellent temper for conducting philosophical inquiries; tending to make them both more pleasant, and more successful.[5]

Priestley, like many American men of science, was an ordained minister. Others, like Franklin, believed in a deity, the "Divine Architect" of the universe, but avoided organized religion. As Franklin wrote in 1753, "The Worship of God is a Duty; the hearing and reading of Sermons [is not, but] may be useful."[6]

Individuals pursued scientific interests for a number of reasons, often intertwined. When John Winthrop wished to make an arduous voyage from Massachusetts to Newfoundland in order to observe the transit of Venus across the sun in June 1761, the project was described as an astronomical problem "in itself most noble," for, by finding the parallax of the sun, Winthrop proposed to determine "a just idea of the vast dimensions of the solar system, and of the mighty globes which compose it." However, in persuading the representatives of Massachusetts to finance Winthrop's voyage, Governor Francis Bernard pointed out that the astronomical observations "would be very serviceable to Navigation."[7] Philosophical pursuits were not necessarily useful—but they might be. Observations of the transit of Venus were both philosophical and practical.

For the most part, however, science was viewed as being less important than public concerns. As Benjamin Franklin wrote to a friend in 1750, on the eve of the French and Indian War,

> let not your Love of Philosophical Amusements have more than its due Weight with you. Had [Isaac] Newton been Pilot but of a single common Ship, the finest of his Discoveries would scarce have excus'd, or atton'd for his abandoning the Helm one Hour in Time of Danger; how much less if she had carried the Fate of the Commonwealth.[8]

Its practitioners and proponents viewed science as a primarily masculine avocation.[9] Science was linked to the scholarly life as well as the practical worlds of medicine, navigation, and exploration. Women in polite society were not expected to participate in professional, business, or university life. But an *interest* in science within polite society was less restricted to gender. Some educated women, beginning in the seventeenth century, were involved in scientific inquiry and maintained extensive correspondence with men.[10] Others attended more popular scientific lectures and demonstrations. As Mary Norris of Philadelphia wrote to arborist Humphry Marshall on February 23, 1785:

> The town is at this time greatly entertained with a course of lectures on the Philosophy of Chemistry and Natural History, by Doctor MOYES. He is a most extraordinary man. . . . People of every description, men and women, flock to the lectures. They are held at the University, three evenings in a week. . . . My son and daughter Logan are in town. They are come, like the rest of the world, to the lectures.[11]

Women also read popular books that explained scientific principles. Some, like Benjamin Martin's *The Young Gentleman and Lady's Philosophy* (1759), were structured as a dialogue between a knowledgeable man and a receptive young woman. In Martin's case, they are brother and sister. Such formulas were sometimes expressed in actual correspondence, such as the letters exchanged around 1760–1762 between Benjamin Franklin and Mary Stevenson (his London landlady's daughter). But for an eighteenth-century woman to participate in scientific experiments with men, or to have her work published, was exceptional. No portraits exist of the few American women who attempted such serious work, such as Charleston plantswoman and botanist Martha Logan (1704–1779), whom her correspondent John Bartram denigrated as his "fascinated widow," or Jane Colden (1724–1760), whose father, Cadwallader Colden, taught her the binomial nomenclature for plants devised by Carl Linnaeus, translating the Latin into English.[12] Jane's manuscript volume of descriptions and drawings of plants found in New York, following the Linnean system, is now in the collections of the Natural History Museum in London [Figures 1–2a and b].[13] By 1758 her father reported to a friend:

> She now fills up a good deal of idle time agreably to her self & as she is more curious & accurate than I could have been her descriptions are more perfect & I believe few or none exceed them. As her fondness for this study grew upon her She attempted likewise drawings of the plants & considering that she had no instructor the proficiency she has made & the justness of her figures surprise those who have seen them.[14]

Jane Colden was recognized for the depth of her knowledge. Her father's English correspondent Peter Collinson called her "the Only Lady that I have yett heard off that is a proffesor [of] the Linnaean System of which He [Linnaeus] is not a Little proud."[15] Another of Colden's correspondents, Alexander Garden of Charleston, had a "botanical description" written by Jane Colden in 1754 published in an Edinburgh journal in 1756.[16] Garden had obtained permission from Cadwallader Colden to offer for publica-

FIGURES 1–2A and B.
Pages from Jane Colden's bound botanical manuscript with drawings, circa 1755. Trustees of the Natural History Museum, London

tion Jane's description of a plant—Hypericum virginicum—which she had named "Gardenia" after Garden when they both thought (incorrectly) that it might be a new discovery.[17] Collinson sent Cadwallader Colden a copy of the "Edinburgh Essays for the Sake of the Curious Botanic Desertation of your Ingenious Daughter" in the spring of 1757.[18] Although a few colonial women were published authors, Jane Colden's work remained essentially unknown until this century. When she was nearly thirty-five, she married a local physician, William Farquhar, but after only a year, in 1760, she fell ill and died.[19]

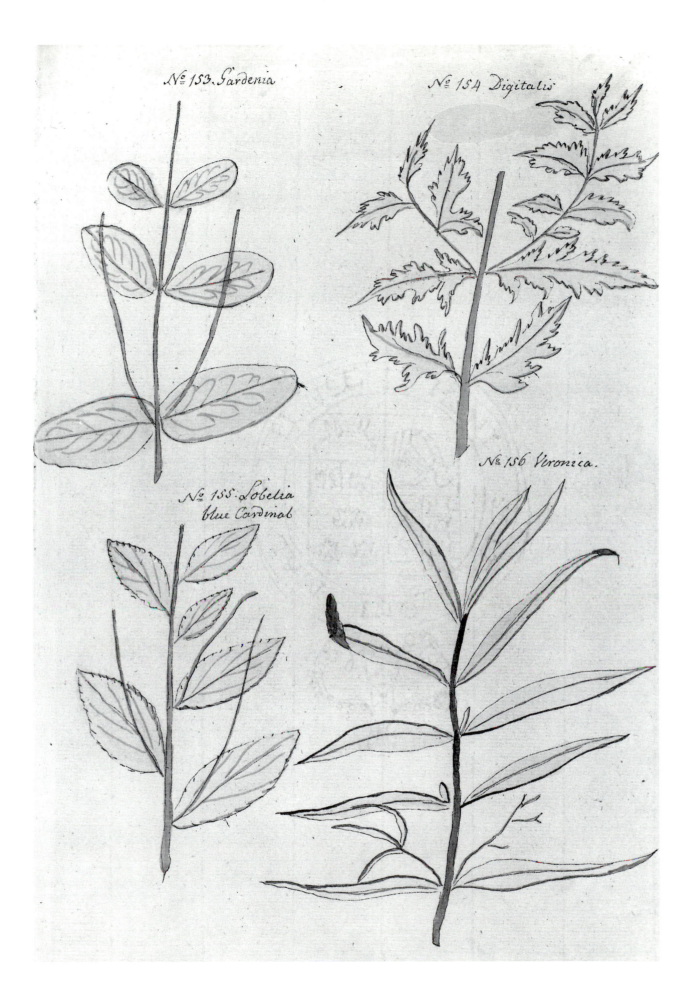

Nº 153. Gardenia

Nº 154 Digitalis

Nº 155. Lobelia
blue Cardinal

Nº 156 Veronica.

11

Chapter 2

Portrait Conventions, Gentility, and Gender

Portraits of both men and women painted in America increased noticeably after about 1750, coinciding with growth in consumerism and a burgeoning interest, on the part of the wealthy and the middling classes, in polite behavior in society. Commissioned most often to mark a marriage or other change in status, portraits were expensive objects, usually intended for private or semiprivate use. They varied in size and price, and were made for only a tiny percentage of the population. Many of those considered here are large enough to include most of the sitter's body and a variety of accoutrements. Rarely was more than one portrait painted of a particular subject; such persons were often men with an important public reputation. Thus, a painting that revealed a sitter's status as a man of science emphasized that role in his life above all others. Portraits could be displayed in the more public rooms in a private home, or presented to friends. They were sometimes displayed in institutional or civic settings, or later in public exhibition spaces such as Charles Willson Peale's Philadelphia museum. Engravings disseminated likenesses to a much wider audience.[1]

Portraits were intended to convey likeness, but also to present their subjects as they wished to be viewed in polite society.[2] At least some sitters, artists, and recipients of portraits appreciated the finest nuances of pose, costume, attributes, and expression. We, who are daily bombarded with images by the media, at work, and on the Internet, may have lost the sensitivity that a person living in the eighteenth century had toward such imagery.

Most portraits followed certain accepted conventions of pose and attitude. These formulas were informed by contemporary etiquette and standards of behavior, and otherwise governed by traditions established in earlier portraits. Lord Chesterfield, whose *Letters* was a popular guide to polite behavior, admonished his heir to "attend to what every body says in the company where you are, but attend still more to their looks and countenance. The tongue may say what it pleases, and consequently may deceive, but the looks, the air, and the countenance cannot easily deceive a discerning observer."[3] In portraits, however, the air (facial features, expression, and position of the head), attitude (the position of the body), and costume were to be delineated so that the subject was presented accurately as an individual, but in the best possible light. Formulas employed for portrayal and characterization varied somewhat from sitter to sitter and from artist to artist.

Because most eighteenth-century American artists rarely wrote about the process through which they conceptualized a portrait, we must turn to European texts that they would have known and studied for evidence of how portraits were meant to be created and viewed. Two European writers whose treatises on art contained long sections on

portraiture, and whose works were well known throughout the eighteenth century, were Roger de Piles and Jonathan Richardson. De Piles's *Principles of Painting*, translated from French into English in 1743, was such a favorite that excerpts from it made up the article on painting in early editions of the *Encyclopedia Britannica*. His ideas on portraiture were practical and precise. Acknowledging the importance of an accurate portrayal of individual features, he also noted that a painter "should never forget good air nor grace, and that there are, in the natural, advantageous moments for hitting them off." De Piles also called for careful attention to the distinguishing features of costume, but gave priority to a decorous choice of pose. He noted that the subject's actions should be portrayed with ease and naturalness, and should speak to the spectator of his accomplishments:

> In short, the portraits, in this sort of attitudes, must speak to us of themselves, and, as it were, to say to us—*Stop, take notice of me: I am that invincible King, surrounded with majesty*—. . . *I am that great minister, who knew all the springs of politicks—I am that magistrate of consummate wisdom and probity—I am that man of letters who is absorbed in the sciences.*[4]

The British painter and writer Jonathan Richardson was even more specific concerning the purpose of portraiture:

> Upon the sight of a Portrait, the Character, and Master-strokes of the History of the Person it represents are apt to flow in upon the Mind, and to be the Subject of Conversation: So that to sit for one's Picture is to have an Abstract of one's Life written, and published, and ourselves thus consign'd over to Honour, or Infamy.[5]

For Richardson, the portraitist must improve his subject's appearance without losing the individual likeness:

> The figures must not only do what is proper, and in the most commodious manner, but as people of the best sense, and breeding (their character being considered) would, or should perform such actions. The painter's people must be good actors; they must have learned to use a human body well; they must sit, walk, lie, salute, do everything with grace.[6]

Thus, portraits created in eighteenth-century Europe and America were far more than copies of faces and bodies. Portraitists presented their subjects in social roles and in guises suitable to the purpose or location of the portrait. They often used complicated poses, costumes, and attributes to express the portraits' messages. To quote Richardson once more, each "character must have an attitude, and dress; the ornaments and background proper to it: every part of the portrait, and all about it must be expressive of the man, and have a resemblance as well as the features of the face."[7]

Richardson also made it clear that the role of the portraitist could be far more sophisticated than that of a mere recorder of separate features:

> In portraits the invention of the painter is exercised in the choice of the air and attitude, the action, drapery and ornaments, with respect to the character of the person. He ought not to go in a road, or paint other people as he would chuse to be drawn himself. The dress, the ornaments, the colours, must be varied in almost every picture.[8]

A portrait painter should ideally be able to converse with his sitters and understand their social positions. The painter should "enter into their characters, and express their minds as well as their faces."[9]

Portraits of men express these ideas through a variety of means. Certain conventions of pose were considered markers of elegance and style. One example is the cross-legged pose, complete with walking stick, that British painter Joshua Reynolds gave to John

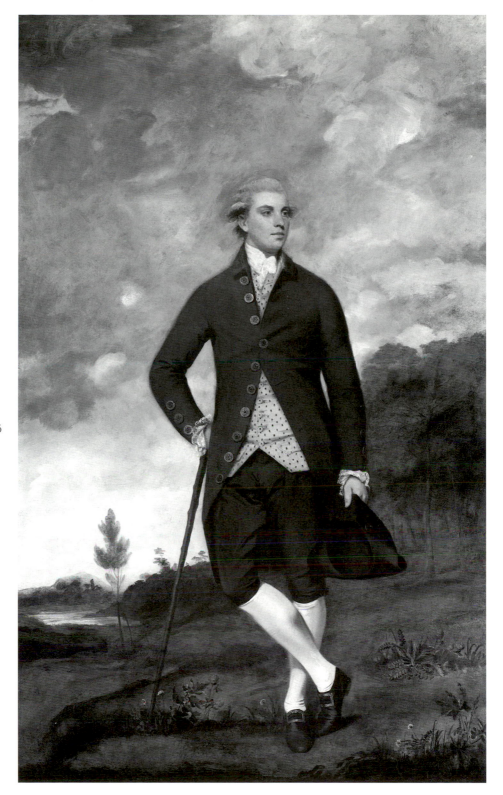

Musters (1753–1827) in his fashionable full-length portrait commissioned in 1777 [Figure 2–2].[10] Charles Willson Peale's 1772 portrait of John Philip de Haas (circa 1735–1786), with its easy, graceful pose, carefully delineated sword, and framed battle scene positioned behind the subject, refers to the sitter's military career [Figure 2–3].[11] Many other poses denoted the sitter's nobility or fashionable status, in combination with appropriate expressions, costumes, and attributes. Sometimes artists made use of these conventions to characterize men of science as active participants in public life. Ezra

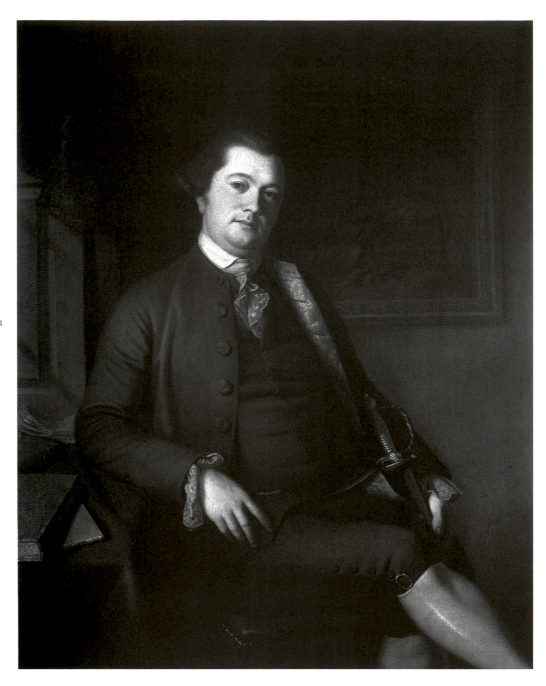

FIGURE 2–3.
John Philip de Haas by Charles
Willson Peale (1741–1827), oil on
canvas, 127 x 101.5 cm (50 x 40
in.), 1772. National Gallery of
Art, Washington, D.C.; Andrew
W. Mellon Collection

Ames's painting of surveyor and cartographer Simeon De Witt is a good example [see Figure 6–1]. Ames used the conventions of the "state portrait"—a figure standing beside a table with a background column and drapery—to give visual form to De Witt's role as a public official—surveyor general of New York.

Artists employed other formulas as references to retirement from business or public service. The term "retirement" did not necessarily mean that a man left business or professional life at the end of his career. Instead, it denoted a temporary retreat, to refresh oneself through solitude or family activities, and by reading and contemplation. Such portraits often included references to gardens or to rural life (as opposed to the bustle of the city), or visual references to quiet contemplation, reading, and study. This sort of imagery was also used for subjects who were intellectuals—clergymen, academics, and men of science. They are most often posed in interior spaces, with books, papers, and pens, and are placed in traditional poses for scholars. All of these portraits give the sitter

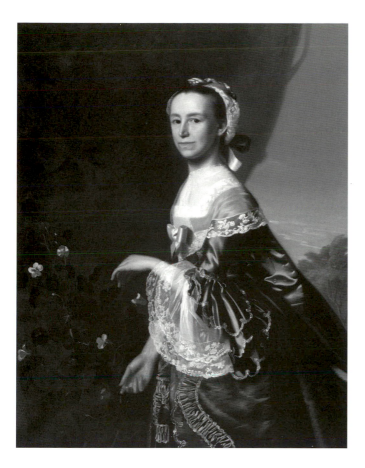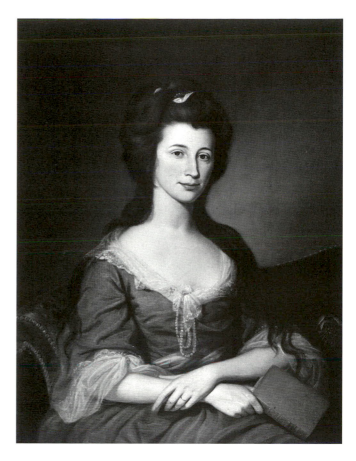

an air of easy grace, solemn contemplation, or noble fortitude that confirmed or elevated his standing in the eyes of his peers. Portraits of men of science similarly represent the sitter's projected identity and ambition. Artists created images of "gentlemen" of science in order to give legitimacy to ambitious men of the middling classes—those whose scientific work laid the foundations for the professionalization of the field in the nineteenth century.

Women, in spite of their intellectual or professional accomplishments, were most often portrayed with attributes that referred to their virtues or fecundity. If a portrait of Jane Colden had been painted in the 1750s, it would probably have been commissioned at the time of her marriage, and it is most unlikely that it would have included any reference to her botanical studies. One of America's first historians and authors, Mercy Otis Warren (1728–1814), a woman of formidable intelligence, was painted around 1763 by John Singleton Copley. He portrayed her as a fashionable young matron, clothed in an elegant *sacque* dress of blue satin and fingering a flowering nasturtium vine. This plant has been interpreted as a metaphor for her prescribed role as a mother entrusted with the training of children—symbolically tending her flowers [Figure 2–4]. Copley, true to the conventions of female portraiture that he was mastering and testing, made no reference to the conflicts Warren experienced between what her husband called her "Masculine Genius" and the "Weakness which is the Consequence of the Exquisite delicacy and softness of her Sex."[12]

The small volumes found in women's portraits are not always identified, but those that are inscribed are usually prayer books, Bibles, or collections of poetry, such as James Thomson's *The Seasons*, a perennial eighteenth-century favorite pictured, for example, in Charles Willson Peale's 1788 portrait of Elizabeth Maxwell Swan (1762–1825) [Figure 2–5]. While the presence of these painted books certainly indicates their importance to

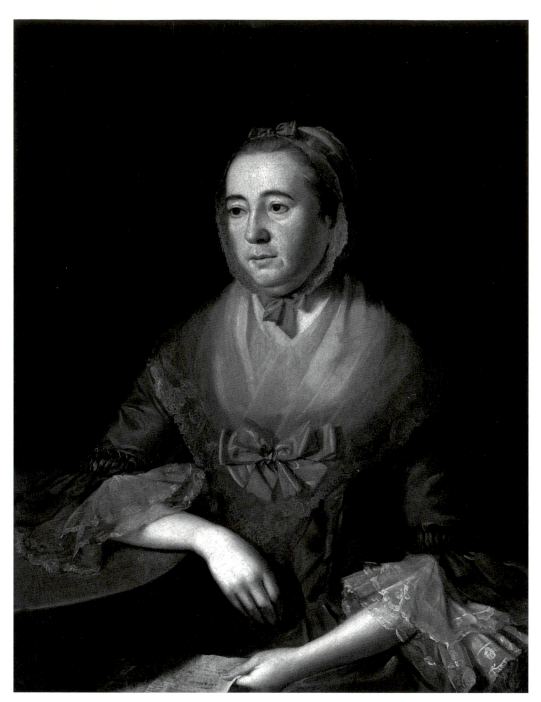

FIGURE 2–6.
Anne Catharine Hoof Green by Charles Willson Peale (1741–1827), oil on canvas, 92.1 x 71.1 cm (36 1/2 x 28 in.), 1769. National Portrait Gallery, Smithsonian Institution, Washington, D.C.; Gallery purchase, with funding from the Smithsonian Collections Acquisition Program and gift from the Governor's Mansion Foundation of Maryland, Mrs. Hilda Mae Snoops, Executive Director, the Honorable William Donald Schaefer, Governor

the sitters, only a few exceptional examples survive of portraits in which women are pictured as intellectuals, or with any reference to work that they may have done in the world outside the home. Peale's 1769 portrait of Anne Catharine Hoof Green (circa 1720–1775) is one such painting. Green published the *Maryland Gazette*, that colony's only newspaper, after the death of her husband, Jonas Green, in 1767. Green was the colony's official printer, an appointment that was also granted to his widow, who in the portrait holds a paper inscribed "ANNAPOLIS Printer to," a reference to her official position [Figure 2–6]. Another example is an engraved portrait of African American poet Phillis Wheatley (circa 1753–1784), which served as the frontispiece for her *Poems on Various Subjects, Religious and Moral*, published in London in 1773. Wheatley's image was based on a painted portrait (unlocated) by Scipio Moorhead, a fellow slave in Boston, and depicts her in a studious pose, with pen in hand and a book at her side [Figure 2–7].

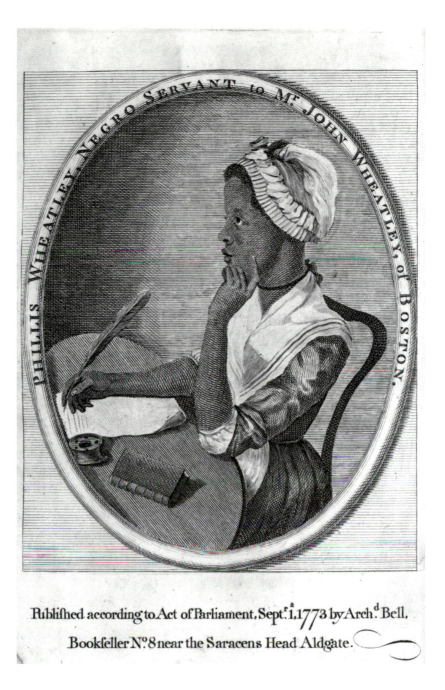

PHILLIS WHEATLEY. NEGRO SERVANT to Mr. JOHN WHEATLEY, of BOSTON.

Publifhed according to Act of Parliament, Sept.ʳ 1, 1773 by Arch.ᵈ Bell, Bookfeller Nº 8 near the Saracens Head Aldgate.

FIGURE 2–7.
Phillis Wheatley by an unidentified artist, after Scipio Moorhead, engraving, 12.8 x 10.1 cm (5 1/16 x 4 in.), 1773. National Portrait Gallery, Smithsonian Institution, Washington, D.C.

Ralph Earl's painting of his wife, Ann Whiteside Earl (1762–1826) [see Figure 2–1], was done in England in 1784, around the time of their marriage. Earl's Loyalist sympathies led him to leave America during the Revolution. The portrait is a rare instance of a woman portrayed with a globe and a nautical chart, objects usually found in portraits of mariners. Ann Whiteside, however, was not a mariner. It has been suggested that the pictured globe and chart refer to the couple's upcoming return voyage to New England.[13] If so, the painting's imagery plays on the singularity of these instruments in a woman's portrait to create a sense of wry humor and intimacy, for her curiosity about the future voyage to her new home would be understandable only to her family and friends; others would puzzle at the meaning of objects with such masculine associations.

While women moved rather freely within polite society in the eighteenth century, it was still rare in portraiture to find imagery that denoted the scientific work of women or their interaction with the larger communities of scientific exchange. That imagery was reserved for men.

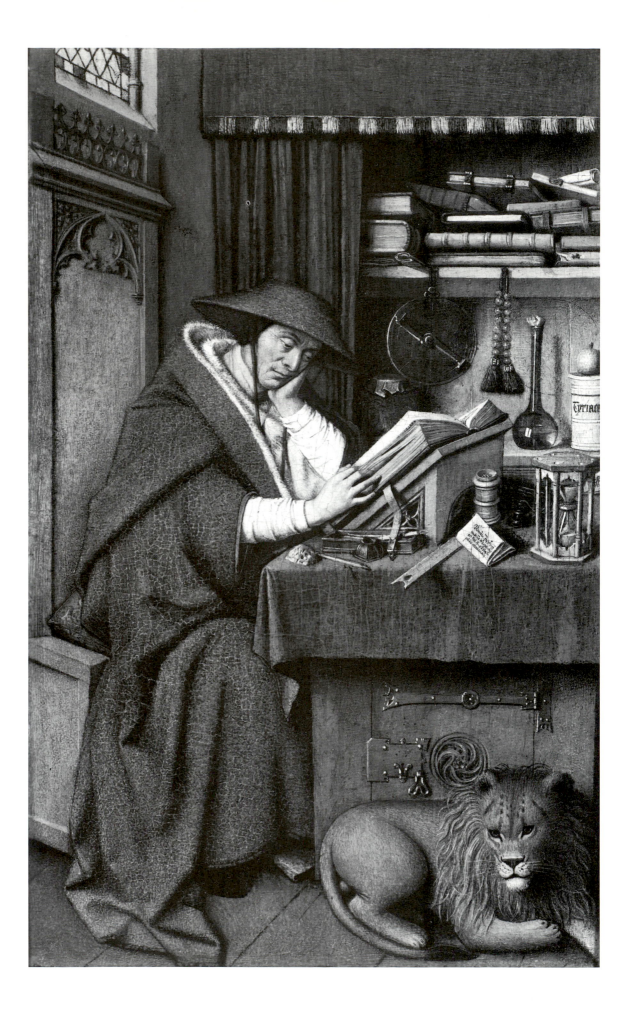

Chapter 3
Constructing the Studious Man of Science

Within seventeenth- and eighteenth-century Anglo-American visual culture, imagery existed that could serve as a resource for portraits of men who enjoyed the life of the mind. Such imagery, often European, could be found not only in portraits—including the rich iconography of engravings—but in pictures of scholarly saints [Figure 3–1], philosophers, and even alchemists. However, it had not always been considered polite or genteel for a man to be portrayed as an intellectual. Since the Renaissance, time and space for reading and study were the privilege of the elite, but before the seventeenth century, few were painted as scholars.[1] Anthony Van Dyck's 1633 portrait of Henry Percy, ninth Earl of Northumberland (1564–1632), the "Wizard Earl," is a notable example of a seventeenth-century portrait that illustrates the subject's intellectual *and* scientific endeavors [Figure 3–2].[2] Other early portraits emphasize the quiet life of retirement and books, but the subjects of these paintings or prints are rarely linked directly to scientific study.

In the early seventeenth century, however, few gentlemen in England would have chosen to be identified as scholars, or as natural philosophers, for such men were thought to be unfit for polite society. John Aubrey wrote, for instance, that until "about 1649, when Experimental Philosophy was first cultivated by a Club at Oxford, 'twas held a strange presumption for a Man to attempt an Innovation in Learnings; and not to be good Manners to be more knowing than his Neighbours and Forefathers."[3] Or, as John Evelyn noted in 1667: "our learned book-worms come forth of their Cells with so ill a grace into *Company*."[4] By the early eighteenth century, however, some Englishmen were pleased to count learning and scholarship as accomplishments befitting a man of substance. Joseph Addison expounded his liberal views on gentility and education in the *Spectator*: "as men grow wise, they naturally love to communicate their discoveries; and others seeing the happiness of such a learned life, and improving by their conversation, emulate, imitate, and surpass one another, till a nation is filled with races of wise and understanding persons."[5] That the study of nature required, and might even produce, a man of outstanding moral character was a notion that might inform the creation and reception of a portrait of a man of science—it could certainly inform a public reputation.[6]

By midcentury, science was viewed as an appropriate interest for refined persons; those wishing to be viewed as "polite" might also choose an interest in science as the means for social advancement. Lovers of science were free to indicate their passion in their portraits. More important, those for whom science was a vocation, such as college professor and astronomer John Winthrop or surveyor Simeon De Witt, could have portraits that celebrated their work and yet portrayed them within the conventions of gentility. By the last decades of the eighteenth century, to be portrayed as a pensive, bookish

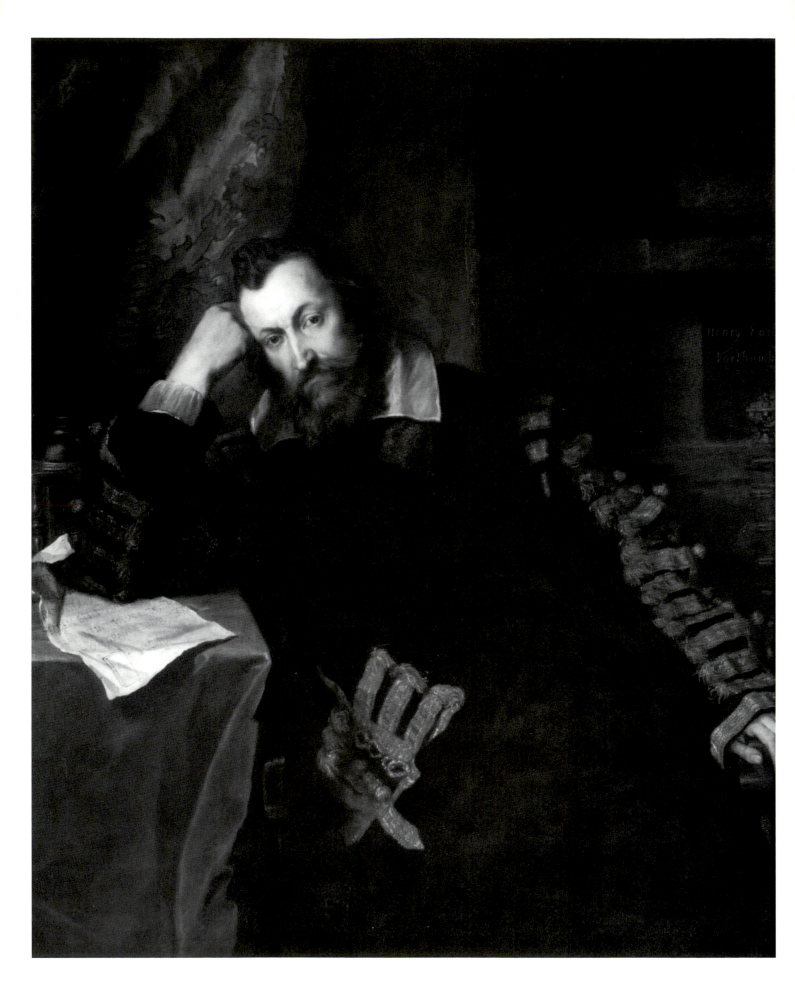

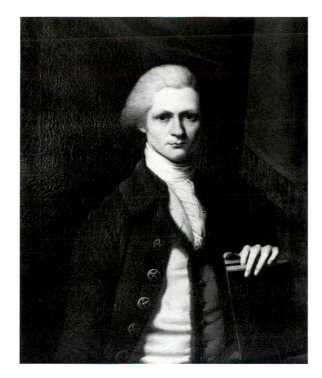

FIGURE 3–3.
Bushrod Washington by Henry
Benbridge (1743–1812), oil on
canvas, 76.2 x 63.5 cm (30 x 25
in.), 1783. The Mount Vernon
Ladies' Association, Mount
Vernon, Virginia

FIGURE 3–2. *(opposite)*
*Henry Percy, ninth Earl of
Northumberland* by Anthony van
Dyck (1599–1641), oil on canvas,
137.2 x 119.4 cm (54 x 47 in.),
1633. The National Trust
Photographic Library, London

sort, even as a man of science, was evidently quite acceptable, even fashionable. A great
change had occurred over less than a century. Bushrod Washington's (1762–1829) letter
to his mother, concerning a portrait he had commissioned in Philadelphia from artist
Henry Benbridge [Figure 3–3], makes it clear that to be painted as an intellectual in
1783 was pleasing:

> He has thrown me into a thoughtful posture which in my opinion rather borders on austerity
> than intense meditation. . . . Some say, that having a Book in my hand which I appear to have
> been Just reading, that the Countenance is very properly expressed—Some Join with me in
> thinking that their [*sic*] is a degree of ill nature in it—But the opinion of my friend Mr. and
> Mrs Powel has so much weight as almost to have made me a Convert—They say, that the
> Countenance is not an ill natured one, nor entirely thoughtful, but rather a mixture of
> thought with Pensiveness, and that they have sometimes seen me in that situation.[7]

How might we interpret portraits of men portrayed with attributes of their interest
in science, often combined with references to the contemplative life? Many of these por-
traits include objects from the scholar's study—books, papers, and pens—or scientific
apparatus. Often the subjects are men of middle age or older, and the poses chosen were
traditionally linked with images of scholars and melancholics, often posed with head in
hand, as in Dürer's engraving [Figure 3–4]. The melancholy temperament, one of the
four humors associated with human beings from antiquity through the Renaissance, was
often connected with old men, whose bodies had lost their youthful heat and were now
cold and dry. Melancholia was also traditionally associated with the scholarly, intellectual
life, and with genius.[8] Other portraits emphasize the scholarly life through the use of cos-
tume—the banyan, a loose robe worn for comfort and for study. A portrait of the aging
Isaac Newton (1642–1727) attributed to John Vanderbank includes much of this
imagery. Newton is seated at a table, wearing a loose but elegant banyan, and is sur-
rounded by a globe, shelves of books, and an open copy of the third edition of the
Principia, the famous book in which he introduced the notion of gravitation and laid the
groundwork for modern physics and astronomy [Figure 3–5].[9]

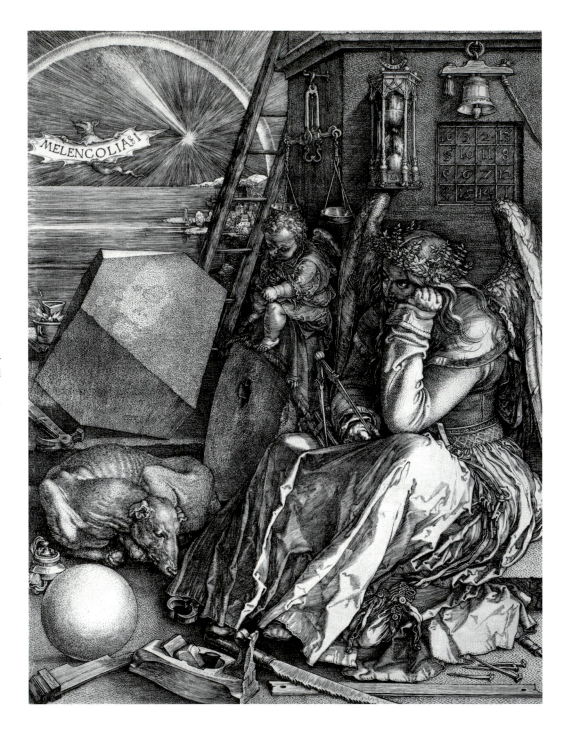

FIGURE 3–4.
Melencholia I by Albrecht Dürer
(1471–1528), engraving on laid
paper, 24.2 x 18.8 cm (9 1/2 x
7 3/8 in.) sheet, 1514. National
Gallery of Art, Washington,
D.C.; Rosenwald Collection

In the portraits to be discussed here, artists have given primacy to the subject's scientific pursuits by linking them visually to traditional and contemporary images of scholars. At times, this reference is made simply, through just one attribute, but in most cases, the artist has used a complex combination of costume, pose, setting, and objects to create an image that defines the sitter as a man of thought and study. Contemporary British and French portraits make use of similar imagery, including Joshua Reynolds's 1773 portrait of botanist and explorer Sir Joseph Banks (1743–1820) at his desk [Figure 3–6] or Jacques-Louis David's 1783 likeness of chemist and physician Alphonse Leroy (1741–1816) [Figure 3–7].

Paradoxically, although men of science are often portrayed as solitary figures in dark interiors, the overwhelming message of their portraits is that of connection and belonging—to the loosely constructed "republic of science," defined by correspondence and

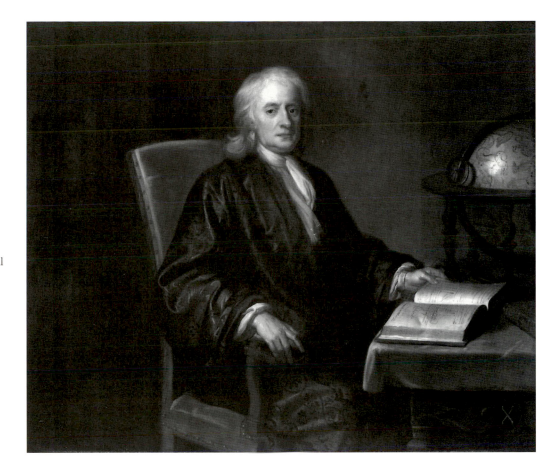

FIGURE 3–5.
Isaac Newton attributed to John
Vanderbank (1694?–1739), oil
on canvas, 127 x 148 cm (50 x
58 1/4 in.), circa 1726. National
Portrait Gallery, London

FIGURE 3–6.
Joseph Banks by Joshua Reynolds
(1723–1792), oil on canvas,
127 x 101.5 cm (50 x 40 in.),
1773. National Portrait Gallery,
London

institutionalized through the formation of philosophical societies. Often the subject's accomplishments go far beyond that of science, either in the acquisition of wealth or in government service. But it was the link to the larger world of science that informed his portrait, and by extension, formed the identity by which the sitter chose to be recorded for posterity.

In 1766, Benjamin Franklin was in London as the representative of the American colonies, testifying eloquently before the House of Commons for the repeal of the Stamp Act. His public reputation, however, rested on his scientific achievements. His *Experiments and Observations on Electricity* had been published in 1751, and was now in its third English and second French editions. He had been awarded honorary degrees in America, England, and Scotland, and in 1753 had received the Royal Society's highest honor, the Copley Medal.

While in London, Franklin had his portrait painted by David Martin. It had been commissioned by Franklin's friend, Edinburgh wine merchant Robert Alexander.[10] Martin was a Scottish artist working in London who counted a number of Scotsmen, including Alexander, among his patrons, and who would go on to paint such eminent physicians and professors at the University of Edinburgh as William Cullen (1710–1790) and Joseph Black (1728–1799) [Figures 3–8 and 3–9].[11] Franklin had Martin paint a slightly modified replica, which he shipped home to Philadelphia [Figure 3–10].[12] The original portrait was shown at the Society of Arts exhibition in Spring Gardens in April 1767. It was entitled *Portrait of Dr. Franklin*, at a time when only the names of well-known public figures were given in exhibition catalogues; Horace Walpole, who attended the exhibition, called it a "great likeness."

Martin portrayed Franklin as a studious man of science. He is seated, holding papers in his left hand, which he peruses intently with the aid of his spectacles, using his right hand to support his head. Other papers and books, none with legible titles, are scat-

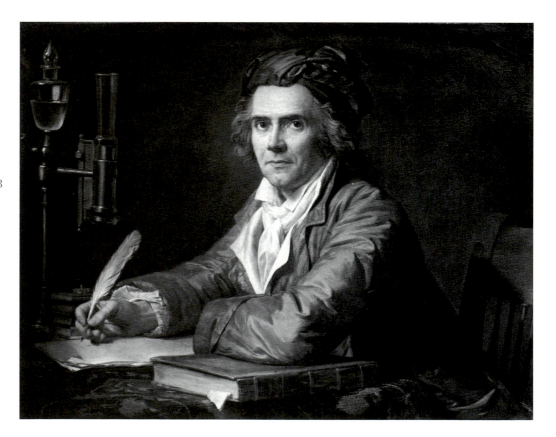

FIGURE 3–7.
Alphonse Leroy by Jacques-Louis David (1748–1825), oil on canvas, 72 x 91 cm (28 3/8 x 35 7/8 in.), 1783. Musée Fabre, Montpellier, France

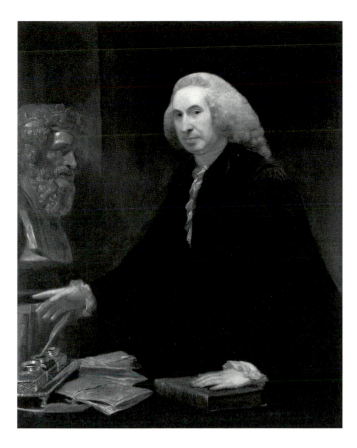

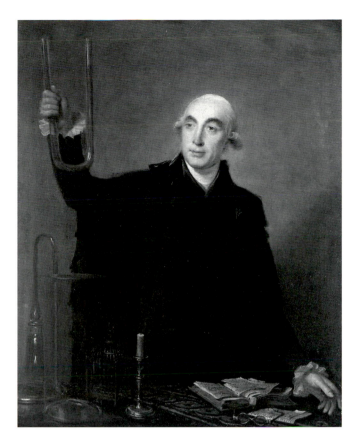

tered across his red-velvet-draped table. Franklin is dressed in an expensive, up-to-date blue suit of what may be velvet or fine wool, with elaborate gold braid and buttons, a far cry from the simple dress he affected at the French court in later years. He wears a wig of the type called "physical," usually worn by men of learning, including physicians. Franklin is not portrayed as an ancient philosopher or a "slovenly" scholar. He is a dignified member of the professional and commercial class—associated through his portrait with others of his station, in London, Edinburgh, and scattered through the English Midlands, who shared his interest in science. The position of Franklin's hand, supporting his head, is traditionally associated with deep thought, as well as with the time-honored image of the melancholy scholar. Poses such as this occur not only in portraiture but also in contemporary emblem books, in which pictures are matched with words. In an eighteenth-century English version of a very well known Renaissance emblem book, Cesare Ripa's *Iconology*, the emblem for "Study" represents a man in a darkened room, leaning, with head in hand, on a table strewn with pen and inkwell, books, papers, and a lamp. His pose is described as "a studious attitude" [Figure 3–11].[13]

Martin, however, has placed Franklin's hand in an active position. Only the thumb, turned up and out, supports his head, in a gesture that gives far more alertness to the pose than that of a weary scholar. An early nineteenth-century observer noted that Franklin's portrait represented "the philosopher. . . . Its highest praise was, that 'It seemed to think.'"[14] Emphasis is placed on Franklin's intense concentration, contained within an appropriately poised and dignified body. The individuality of the pose was noted by one of Franklin's visitors in 1781, who found him "in the exact posture in which he is represented by an admirable engraving from his portrait; his left arm resting upon the table, his chin supported by the thumb of his right hand."[15] This may actually have been a characteristic pose—or an instance whereby portraiture shaped the manner in which a person was perceived.

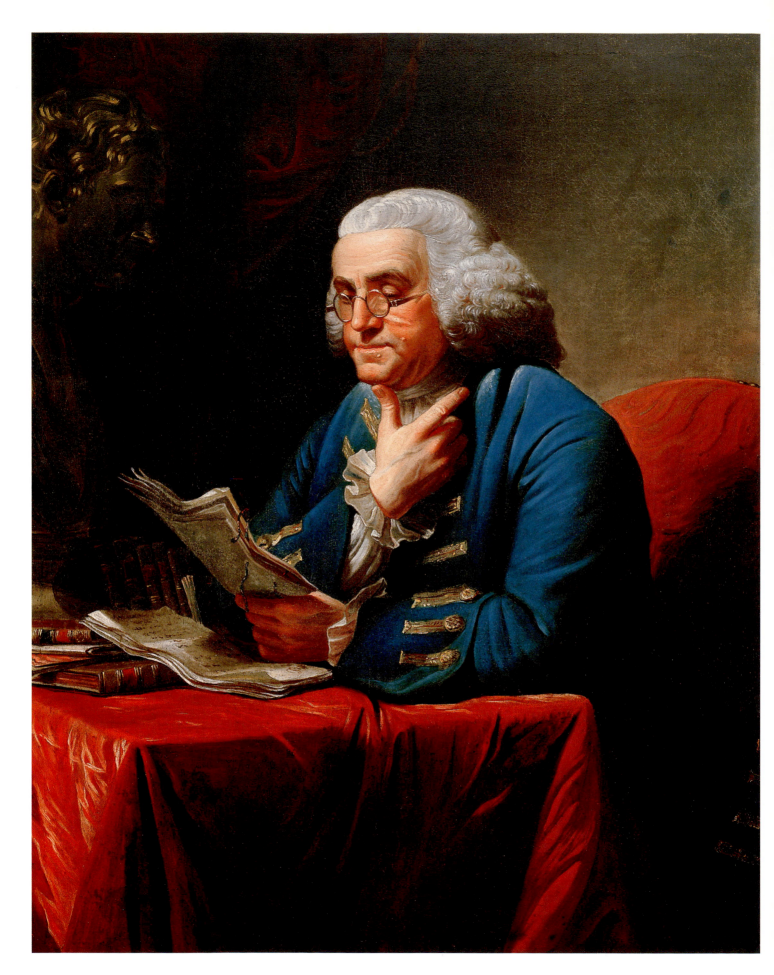

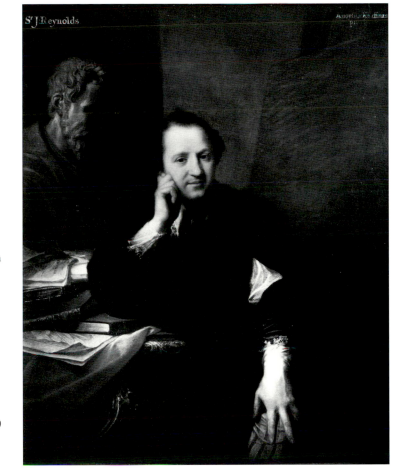

FIGURE 3–10. *(opposite)*
Benjamin Franklin by David
Martin (1737–1797), oil on
canvas, 125.7 x 100.3 cm
(49 1/2 x 39 1/2 in.), 1767.
Pennsylvania Academy of the
Fine Arts, Philadelphia; gift of
Maria McKean Allen and
Phebe Warren Downes, through
the bequest of their mother,
Elizabeth Wharton McKean

Figure 3–12.
Joshua Reynolds by Angelica
Kauffman (1741–1807), oil on
canvas, 127 x 101.6 cm (50 x 40
in.), 1767. The National Trust,
Photographic Library, London

FIGURE 3–11.
"Study," in George Richardson,
*Iconology; or, a Collection of
Emblematical Figures,* 2 vols.
(London, 1779), vol. 1.
Rosenwald Collection, Rare
Books and Special Collections
Division, Library of Congress,
Washington, D.C.

Franklin's concentration in this portrait is witnessed by a bust of Isaac Newton, copied from the sculpture created by Louis-François Roubiliac. Portraits of contemplative men pictured with classical busts have a long history. Since men of wealth and learning sometimes displayed antique busts in their libraries, the visual conceit of a man seated with his books, next to a bust, was a logical derivative of cultural practice. In such portraits, a particular bond between the subject and the bust is assumed.[16] A similar example, painted in London in 1767, is Angelica Kauffman's sympathetic portrayal of her friend and fellow artist Joshua Reynolds (1723–1792), seated with his books and gazing at the viewer in a pose of quiet contemplation, overlooked by a bust of the artist he most admired, Michelangelo [Figure 3–12]. In Franklin's case, the bust also represents a modern, as opposed to ancient, subject, but Newton was far closer to Franklin in time— he was still alive when Franklin made his first trip to London in 1724. Franklin admired Newton, deeming him "the prince of astronomers and philosophers."[17] That he would wish to be linked with Newton is natural; but Franklin, ever the master of witty self-deprecation, would not be equated with him. As he noted in 1749,

> But what is all our little boasted knowledge, compar'd with that of the angels? If they see our actions, and are acquainted with our affairs, our whole body of science must appear to them as little better than ignorance. . . . Now and then . . . a Newton, may, perhaps, by his most refined speculations, afford them a little entertainment.[18]

Another portrait of an American man of science ensconced in his study, surrounded by books, papers, busts, and instruments, is a panel painting of Franklin's friend and correspondent James Bowdoin II (1726–1790), which is attributed to Christian Gullager.

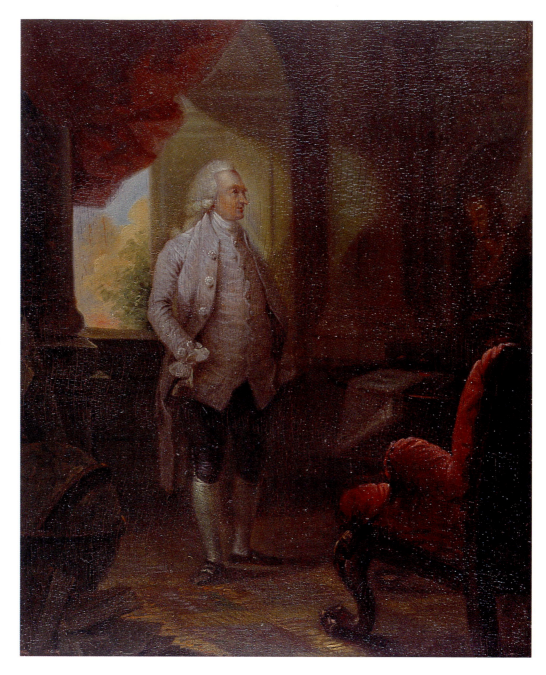

FIGURE 3–13.
James Bowdoin II attributed to
Christian Gullager (1759–1826),
oil on panel, 27.3 x 21.9 cm
(10 3/4 x 8 5/8 in.) (version B),
circa 1791. Bowdoin College
Museum of Art, Brunswick,
Maine; bequest of Mrs. Sarah
Bowdoin Dearborn

Like Franklin, Bowdoin was one of the few Americans who were depicted in more than one portrait. He was also among the few American men of science with sufficient wealth and social position to merit the term "gentleman." Bowdoin was painted as a child by John Smibert, and again at the time of his inheritance and marriage by Robert Feke. In 1791, a year after his death, the Danish-born Gullager made his small portrait, based on a miniature [Figure 3–13]. There are two versions, both owned at the time by members of Bowdoin's family.[19] This one shows Bowdoin in an elegant interior setting, complete with a large globe, several books, and a bust befitting a gentleman's library. The little painting situates him in what appears to be the "great Upper Chamber" of his Boston home, where he kept his vast book collection, his paintings and portraits, and his valuable "scientific apparatus." An inventory of 1774 listed five telescopes, a microscope, two "Electrical Machines," and a pair of globes; some of these items survive today in the collections of Bowdoin College.[20]

Bowdoin is portrayed as a scholar. That the portrait privileges that role is clear from an account of it published in 1791:

> Mr. Gulliger, of this town, has lately executed a fine portrait of the late Hon. Mr. Bowdoin, which, we are told, is the only one ever taken of that distinguished, learned and virtuous character—and which from this circumstance alone, must be highly valuable. The industry, genius, and attention of Mr. G. point him out as worthy the highest encouragement of every class of citizens—on this effort of his, in creating, if we may be allowed the expression—a likeness of Mr. B. must to the friends of Philosophy, Science, and the liberal Arts.[21]

Bowdoin's interest in science was piqued early in life, when he attended lectures on electricity, and by 1750 he was corresponding with Benjamin Franklin. An excited student of electrical phenomena, Bowdoin later studied astronomy and scientific agriculture. He was elected to the Royal Society after the American Revolution, and in 1780 founded Boston's American Academy of Arts and Sciences, New England's answer to the American Philosophical Society. Bowdoin gave scientific apparatus to Harvard, including an exquisite orrery ordered from London instrument maker Benjamin Martin in May 1764, just after the fire that destroyed Harvard's apparatus [Figure 3–14].

FIGURE 3–14.
Orrery made by Benjamin Martin (1704–1782), London, brass and ivory, 57.2 cm (22 1/2 in.) diameter, overall height 78.7 cm (31 in.), 1764. Collection of Historical Scientific Instruments, Harvard University, Cambridge, Massachusetts

This type of astronomical model, which shows the way the planets move around the sun, is known as an orrery. The name comes from Charles Boyle, the fourth Earl of Orrery, who purchased the first of these instruments around 1713. Within a few years, orreries had become popular for recreational as well as educational purposes. One could buy an inexpensive orrery with a hand crank to move the planets, or more costly examples with clockwork mechanisms. Harvard College ordered this orrery in 1764 with the £50 that James Bowdoin had donated for this purpose. The instrument was delivered in 1767, and the final cost was more than £90.

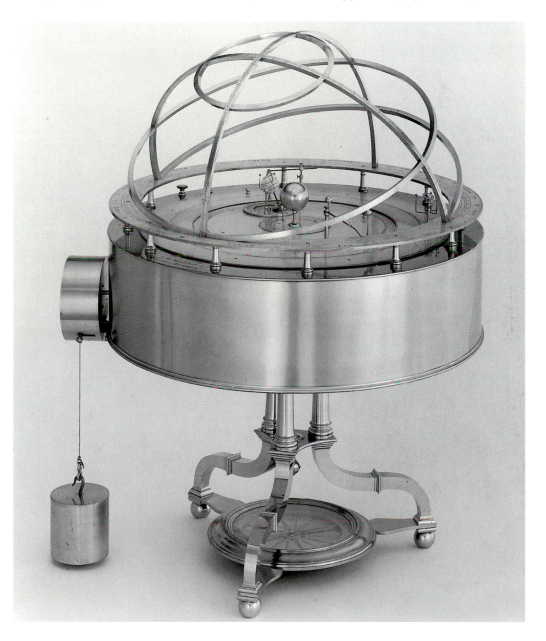

FIGURE 3–15.
Ezra Stiles by Samuel King
(1748–1819), oil on canvas, 85.1
x 69.9 cm (33 1/2 x 27 1/2 in.),
1771. Yale University Art
Gallery, New Haven,
Connecticut; bequest of Dr.
Charles Jenkins Foote, B.A. 1881,
M.A. 1890

Samuel King's painting of Newport clergyman and Yale professor Ezra Stiles (1727–1795) is probably the best-documented portrait of an American scholar of this period [Figure 3–15]. Stiles was extraordinarily learned; his interests were as far ranging as any eighteenth-century American. He was fascinated by Eastern languages and religions, by Hebraic culture and the Cabala, and by all areas of science. Stiles knew Samuel King through his father Benjamin, from whom Samuel learned to make mathematical instruments, and who had collaborated with Stiles in observing the 1769 transit of Venus.[22]

Stiles began to correspond with Franklin about science around 1749, when Franklin sent an electrical apparatus to Yale. Franklin sent Stiles books, and kept him apprised of scientific developments in London and Philadelphia. During the 1760s, Stiles projected a philosophical society for America, writing about it to John Winthrop and making copious notes concerning its form, name, and the wide range of subjects to be investigated. Although the society never became a reality, Stiles became a member of the American

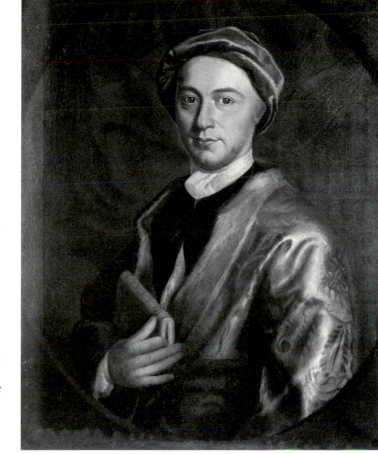

Philosophical Society in Philadelphia and, in 1780, of the American Academy of Arts and Sciences in Boston.[23] As president of Yale, Stiles purchased a fine selection of philosophical apparatus for the college, and gave occasional lectures on natural philosophy there. In July 1787, he was so fascinated with the botanical specimens and microscope of a visitor, Manasseh Cutler, that Cutler despaired of making a decorous escape:

> I had to explain technical terms, and construe crabbed Linnaen Latin for an hour on a stretch. At length a call to dinner put an end to my fatigue. But the [topic] was introduced at table. . . . After dinner I was determined to set out immediately, but there was no such thing as getting away. We returned to the microscope and plants.[24]

Stiles was interested in portraits. At least twice during the 1760s, he requested that Franklin send him his engraved portrait. Several artists made likenesses of Stiles and other members of his family, and he oversaw the collecting of a number of historical and contemporary portraits by Yale College. In 1790, Stiles asked Franklin for "a Present of his Picture or Pourtrait to be deposited in the College Library" as part of this collection.[25] Stiles's own portraits all emphasize his scholarly interests. In a 1756 painting by Nathaniel Smibert [Figure 3–16], Stiles is posed in a banyan and cap, holding a book, as would befit a man of his scholarly inclinations and polite upbringing. Stiles was drawn in similar fashion several times during the 1780s by one of his favorite students, St. John Honeywood [Figure 3–17]. In his 1771 portrait by Samuel King, however, he wears a black suit and clerical bands and holds his Bible out to the viewer. At this time, both artist and subject were in Newport, where Stiles was minister to the Second Congregational Church. He wrote at length about this painting [see Figure 3–15]:

The Effigies sitting in a Green elbow Chair, in a Teaching Attitude, with the right hand on the Breast, and the Left holding a preaching Bible. Behind & on his left side is a part of a Library—two Shelves of Books—[all the titles are named and described]. At my Right hand stands a Pillar. On the Shaft is one Circle and one Trajectory around a solar point, as an emblem of the Newtonian or Pythagorean System of the Sun & Planets & Comets. It is pythag. so far as respects the Sun & revolvg Planets: it is newtonian so far as it respects the Comets moving in parabolic Trajectories, or long Ellipses whose Vertexes are nigh a parab. Curve. At the Top of the visible part of the Pillar & on the side of the Wall, is an Emblem of the Universe or intellectual World. . . . These emblems are more descriptive of my Mind, than the Effigies of my Face.[26]

Stiles must have worked carefully with the artist to design the pose, attributes, and diagrams in the painting. His gesture, with the right hand resting on his breast, "a Teaching Attitude," also occurs in a contemporary British portrait by David Martin of Hugh Blair, the Regius professor of rhetoric and belles-lettres at the University of Edinburgh. King copied the emblem of the universe from that which Stiles had record-ed in his diary for 1771. Stiles drew it again, with some changes, in 1792—proof of its importance.

Stiles had read all of the books depicted in his portrait and had strong opinions about them. Authors and subjects ranged from philosophy (Plato), mythology, and reli-gious tracts to science. About the volume labeled "Newton/Prin.," Stiles wrote: "I posess & have read all Newtons Works & his Principia often; and am highly delighted with his Optics & Astronomy." Stiles's portrait depicts him as a teacher and learned man; science is an important aspect of his knowledge and focus of his curiosity, but only a part.

A Philadelphia physician, Dr. John Morgan (1735–1789), participated fully in the design of his 1764 portrait by Angelica Kauffman, a Swiss-born artist working in Rome when Morgan visited there. His trip to Italy was part of a five-year sojourn to Britain and the Continent designed to further his medical education (in London and Edinburgh). He sought honors and memberships in organizations such as the Royal Society of London and the Royal Academy of Surgery in Paris in order to launch what he hoped would be a lucrative and advantageous career as a physician. The professional problems and jealousies that would plague his efforts to lead the Philadelphia medical community and to be the prime founder of the medical school associated with the College of Philadelphia were unthinkable for the supremely confident young man who set sail for London in 1760.[27] Morgan carried letters of introduction with him, including one to his father's old friend Benjamin Franklin. He immediately introduced Morgan to Dr. John Fothergill, who helped him establish his program of study in London. Franklin wrote other letters to friends in Edinburgh on Morgan's behalf, and followed his mete-oric progress with interest. Morgan studied with some of Britain's most accomplished physicians and teachers, and perfected a method for injecting anatomical specimens, which brought him much notice on the Continent. At the conclusion of his formal course of study in 1763, his friend and fellow Philadelphian Samuel Powel wrote that "Dr. Morgan has graduated at Edinburgh with such Reputation as few, if any, have ever obtained."[28]

Morgan was consumed with ideas about the nobility of the medical profession, and hoped to consult only as a physician in Philadelphia, eschewing the related work of the surgeon and apothecary as being beneath the dignity of his European training—an extreme position. As he wrote to his mentor William Smith, provost of the College of Philadelphia, he considered his professionally oriented version of the Grand Tour to have been a success:

FIGURE 3–18. *(opposite)*
John Morgan by Angelica Kauffman (1741–1807), oil on canvas, 134.9 x 99 cm (53 x 39 in.), 1764–1765. National Portrait Gallery, Smithsonian Institution, Washington, D.C.; gift of the James Smithson Society and Gallery purchase

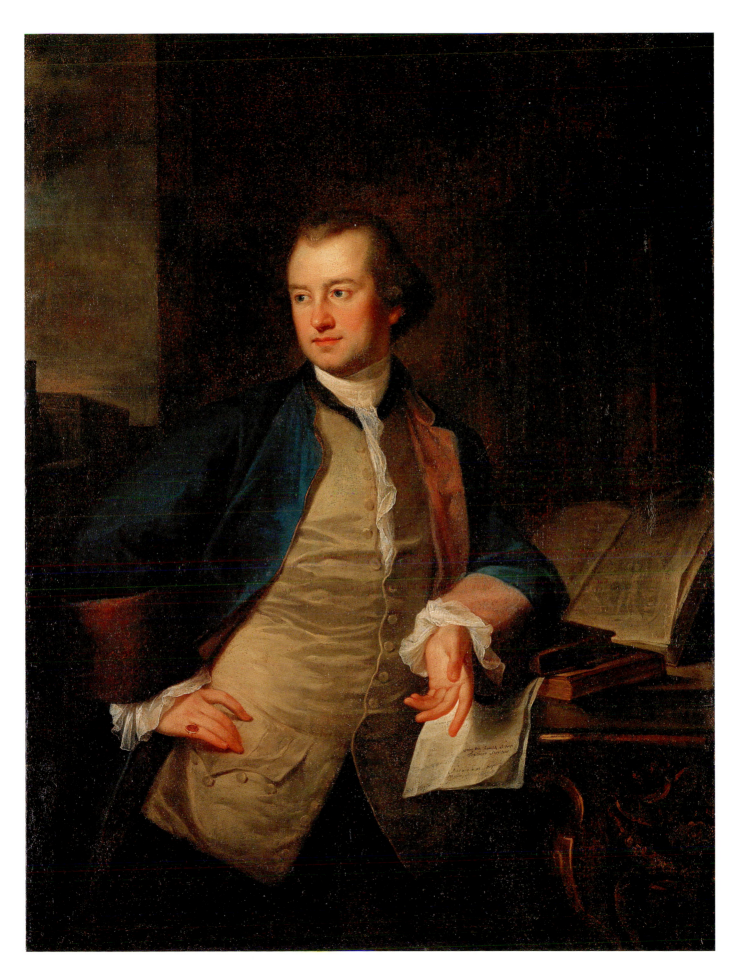

35

FIGURE 3–19.
Giambattista Morgagni,
Adversaria Anatomica Omnia
(Lugduni Batavorum, 1723).
History of Medicine Division,
National Library of Medicine,
National Institutes of Health,
Bethesda, Maryland

whether considered in regard to the amusement or the Improvement & advantage, if I may be allowed to speak what I think, it has fully answered the trouble, time & Expense . . . to have been presented to Crowned Heads & had an Introduction to the first Nobility of Italy as well as some of the most learned Men in Europe is an Object on which a young Man may well congratulate himself.[29]

Morgan had self-presentation on his mind when he sat for Kauffman, at a time when he was exceedingly pleased with himself and his accomplishments.[30] His portrait is similar to likenesses of many other young British gentlemen who, as part of their Grand Tour experience, were painted in Italy by artists such as Pompeo Batoni or expatriate British artists living there [Figure 3–18]. Morgan's portrait, however, does not include the conventional references to antiquarian interests often found in such paintings. Rather, it contains painted allusions to his profession and visual links to prominent med-

ical personages and organizations. As Arthur Marks has pointed out, the portrait is an attempt to create a "professional ancestry" for Morgan.[31]

Morgan sat for Kauffman in Rome sometime during the late spring or early summer of 1764. He left the city in early July before the painting was complete; it appears to have been forwarded to London the following spring. Morgan is posed with graceful ease and wearing an elegant costume: a buff-colored waistcoat and a blue banyan lined in pink silk, a robe often worn when at home. Instead of Roman ruins or antiquities, the view through the open window reveals a public edifice. This may be a reference to Morgan's plans for a medical school in Philadelphia, for he had completed a draft of his *Discourse upon the Institution of Medical Schools in America* earlier that year while in Paris. The interior is dark and gives the subtle impression of a library, with bookshelves in the background and books and papers displayed on an ornate table. The large open volume has been identified as Giambattista Morgagni's *Adversaria Anatomica Omnia*, first published in 1719, an important text for the study of pathology [Figure 3–19]. Morgagni (1682–1771), then eighty-two years old, was still living in Padua, where Morgan would call on him in July 1764. The venerable physician received Morgan cordially, and showed him his museum of anatomy and pathology, where the walls were hung with portraits of his predecessors in the study of anatomy, including Vesalius and Fallopius. According to Morgan's journal, they discussed the portraits and the variations in costume displayed in them. When Morgagni inscribed for Morgan a copy of his more recent book, the influential *De Sedibus et Causis Morburum* (1761), he was said to have made a witty comment on the similarity of their names.[32]

The paper under Morgan's hand is inscribed, but parts of the inscription are illegible. It has been suggested that it is an invitation to a meeting Morgan attended at the Royal Academy of Surgery in Paris on October 4, 1764, months after he sat for the portrait, and at which he was granted a corresponding membership in the academy—not the full foreign associate membership he had coveted, but certainly another feather in his cap.[33] This inscription, as well as the addition of Morgagni's text, is puzzling. They were surely added after Morgan left Rome, and may indicate that the artist and sitter corresponded before the portrait was finished, or that another painter added these elements at a later date.

Kauffman painted Morgan as he wished to be seen. He is depicted as a polite and learned physician—a dignified member of the European community of medical scholars, displaying references to learned men and associations that none of his contemporaries in Philadelphia could match. Kauffman was well versed in the conventions of such portraits; she was aware of work done in Rome by some of the leading artists resident there. Her portraits of J. J. Winckelmann (1764) and of Joshua Reynolds (1767) [see Figure 3–12] indicate her knowledge of the iconography of the thoughtful man posed among his books and papers.

Two portraits of Cadwallader Colden (1688–1776), a faithful friend of Franklin, also emphasize the scholarly life of science. Colden was raised in Scotland and trained as a physician there. After practicing for some years in Philadelphia, he moved to New York in 1718. He was appointed surveyor general of the colony in 1720, and lieutenant governor in 1761. He held this position until 1775, when he was ousted for his royalist sympathies.

Throughout his life, Colden remained fascinated with botany, anthropology, mathematics, and natural philosophy. He was one of the earliest members of the American Philosophical Society, elected in 1744. His correspondence was varied, and recipients of his letters on scientific matters included Americans such as Franklin, John Bartram, and

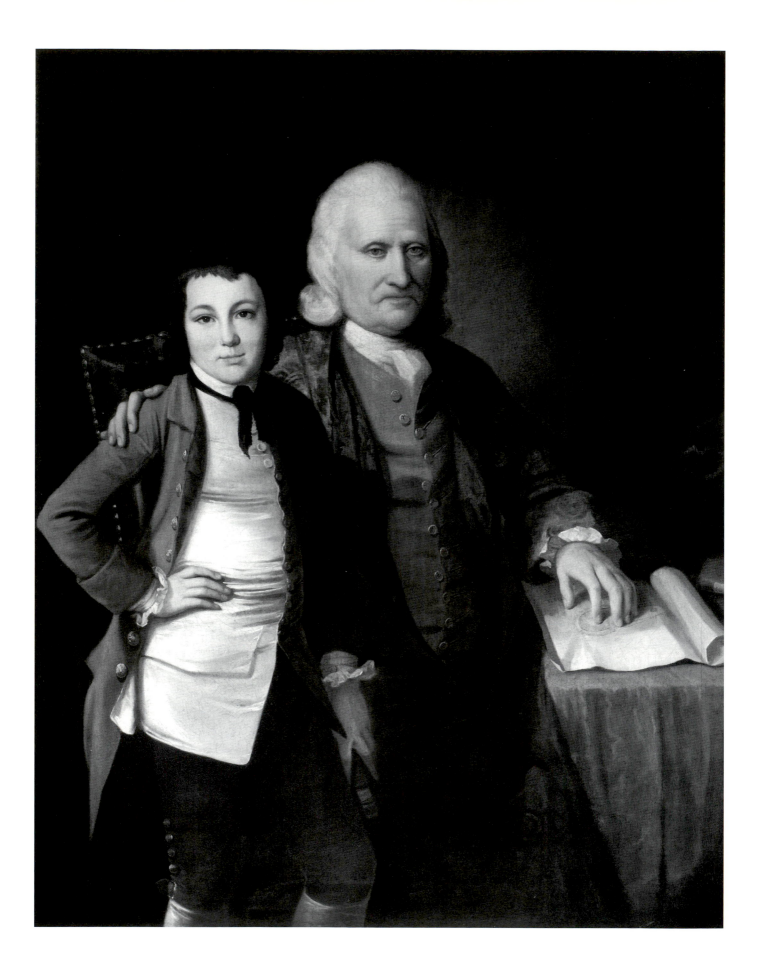

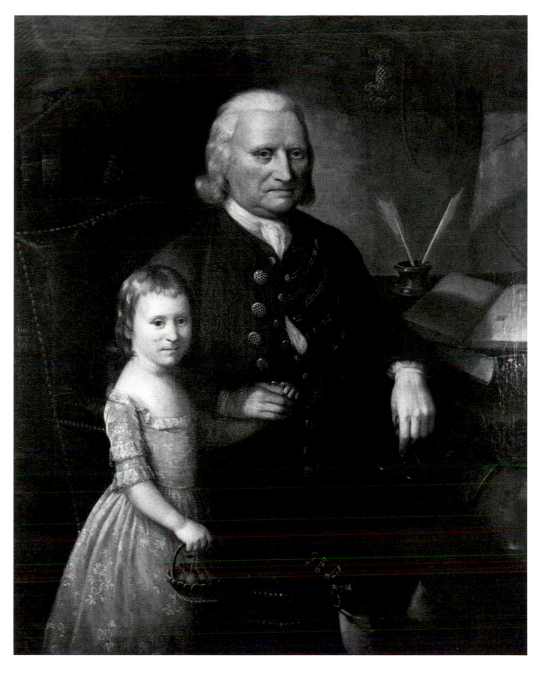

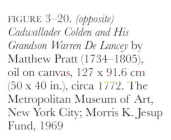

FIGURE 3–20. *(opposite)*
*Cadwallader Colden and His
Grandson Warren De Lancey* by
Matthew Pratt (1734–1805),
oil on canvas, 127 x 91.6 cm
(50 x 40 in.), circa 1772. The
Metropolitan Museum of Art,
New York City; Morris K. Jesup
Fund, 1969

FIGURE 3–21.
Cadwallader Colden attributed to
Matthew Pratt (1734–1805), oil
on canvas, 122.2 x 99.5 cm
(48 1/8 x 39 1/8 in.), not dated.
Mrs. John W. Titcomb, daughter
of Mrs. David L. Stone; on loan
to the Tacoma Art Museum

Alexander Garden, and Europeans, including Peter Collinson, Dr. John Fothergill, Carl Linnaeus, and the Dutch botanist Johann F. Gronovius.

Several portraits of Colden, by or attributed to Matthew Pratt, express the sitter's pride in his scientific interests. They are unique, however, in that through the inclusion of likenesses of a grandchild, these paintings also express his determination to transmit scientific ideals to his progeny. Pratt's portrait of Colden with his grandson Warren De Lancey [Figure 3–20] was probably painted in New York around 1772. Pratt, who had studied painting in London with Benjamin West during the mid-1760s, had returned to America, where he worked as an itinerant artist before settling in Philadelphia. He was in New York at some point during the period from mid-June through December 1771, when John Singleton Copley was painting there, for Pratt is known to have commented on Copley's work.[34] Pratt was commissioned to paint a full-length portrait of Cadwallader Colden for New York's Chamber of Commerce in May 1771. His bill was

An Introduction to the Study of
Philosophy wrote in America for the use
of a young Gentleman

Sect. I

You are now, my ——, going to the college, in order to
learn those principles, which may be of use to you in all your
future inquiries; & to acquire that knowlege, by which you
may be enabled to distinguish your self in every part
of your life, either in publick imployments, or in private
life, or that you may become an usefull member of the society
common wealth and of a private family. But the common
methods of teaching, hitherto generally in use in the publick
Schools, is so far from answering these good purposes,
that it serves only to fill young peoples heads with useless
notions & prejudices, which unfit them for the acquiring of
real & usefull knowlege. The design of my present writing
is to guard you against these common errors, & to instruct
you how to avoid them: In doing this I have supposed
that you have a general notion of the sciences, which are usually
taught. I could not do otherwise, within the limits I have set to
my self, & therefor be not discouraged, if at present you do not
comprehend the full scope & view of what I write. When
you come to read on any of the sciences I hope you will then find
it of use to you.

History informs us, that the Egyptian priests, the chaldeans
& Persian magi had acquired great knowlege in physicks
before the christian æra, such as exceeds the knowlege of the
most learned of the moderns. It is certain that they had carried
Geometry Astronomy & Mechanicks, to a great perfection. The
Greeks were only meer Scholars of the Egyptians. It may be ques-
tioned whether they made any discovery absolutely their own:
& it is not improbable, that, like meer Scholars, they did not
perfectly understand the principles of the Egyptian philosophy;
& yet it is from them only that we have any knowlege of the
learning of these ancients. Pythagoras was the best instruc-
ted of any of the Greeks in the Egyptian learning. It appears
from the little which remains of his doctrine, that the Egyptians
knew what of late times has been called the Copernican System,
& that he knew the general apparent attraction between bodies,
which has been rediscovered in the last century by Sr Isaac
Newtone. But as we have nothing remaining of the Py-
thagorean philosophy, except what is found in a few abstracts
in much later writers, we know very little of what were
the true principles of that philosophy. It may be that we
are now regaining the Principles of Physics, which were
known many ages before the beginning of the christian æra

Was

presented on October 6, 1772. Since Pratt was in Williamsburg, Virginia, by March of 1773, and is not known to have returned to New York, it is probable that Colden commissioned the portraits with his grandchildren at this time.[35]

In 1772, Colden would have been in his early eighties—an extremely advanced age for that time. Pratt's full-length likeness emphasizes Colden's public character as a venerable state official. In his portrait with Warren De Lancey, however, he sits in a private space, clad in a red waistcoat and mauve morning gown made of figured damask and lined in blue silk, with his arm gently encircling the standing figure of his young grandson. On the table beside him are a globe (it is indistinctly marked), a book, and an unusual astronomical diagram.[36] The diagram may relate to Colden's publications on an explanation for the force of gravity. The first treatise, *An Explication of the First Causes of Action in Matter, and, of the Cause of Gravitation*, was published in New York in 1745 and reprinted in London the next year. In the preface Colden noted the practical uses of his theories "for determining the orbits of the planets, and even of the moon" and referred to himself as an old man (he was then fifty-eight) who hoped to be useful in the "last stage of my life."[37]

Colden's theories were attacked as anti-Newtonian, but he revised his work and published *The Principles of Action in Matter . . .* in 1751. Franklin had tried, in 1746, to alert Colden gently to the obtuseness of his ideas:

> I am sorry I have so little to tell you relating to your Treatise, that may afford you any Satisfaction. Seven or eight of our Gentlemen, have, within my Knowledge, read more or less of it. . . . And all I can learn of their Sentiments concerning it is, that they say they cannot understand it, it is above their Comprehension. . . . Thus, tho' you should get no Praise among us, you are like to escape Censure, since our People do not seem to suppose that you write unintelligibly, but charge all to the Abstruseness of the Subject, and their own Want of Capacity.[38]

Another portrait of Colden with a grandchild exists, similar in composition, that is attributed to Pratt [Figure 3–21]. While the grandchild is unidentified, Colden is unmistakable. He sits at a table in a book-lined study, holding the little hand of a girl clad in a pink frock worked with floral designs, who holds a small basket of cherries. On the table are an inkstand with quills and books; behind Colden is a celestial globe. The open book is inscribed "The/Principals/of/Action & Matt[er]." Other books on the table and shelves are labeled to indicate authors including Newton, Cicero, and Lazare Rivière, a seventeenth-century physician.

Colden was actively concerned with the education and upbringing of his children and grandchildren, and was particularly attentive to their scientific interests. He spent many years teaching botany to his daughter Jane, and passed his knowledge of mathematics and natural philosophy to his son David. By the early 1770s he was truly in the "last stage of his life" and perhaps concerned that his accomplishments be remembered by his descendants. Just a decade earlier, he had composed a manuscript treatise for one grandchild, Peter De Lancey, Warren's brother, and sent another copy to his son Alexander Colden for the use of his children. Entitled "An Introduction to the Study of Phylosophy wrote in America for the use of a young gentleman" [Figure 3–22], it summed up Colden's views on the kind of broad scientific knowledge he thought appropriate for his offspring. He warned his grandchildren to beware of the pedantry of the "mere Scholar," for the "gentleman, who proposes to be generally useful in society, ought not to fix his thoughts singly on any one branch of science, but to have a competent knowlege [*sic*] of the principles of every branch," knowledge that was to be derived

FIGURE 3–22.
"An Introduction to the Study of Phylosophy, . . ." circa 1760. Cadwallader Colden Papers, Scientific Letters, Papers, and Notes, New-York Historical Society, New York City

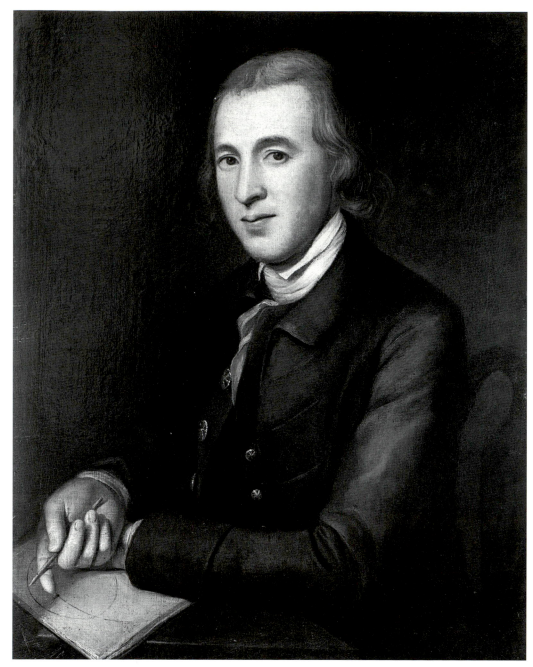

FIGURE 3–23.
David Rittenhouse by Charles
Willson Peale (1741–1827),
oil on canvas, 74.7 x 62.4 cm
(30 x 25 in.), 1772. University
of Pennsylvania Art Collection,
Philadelphia

not only from books but refined "by general conversation" with one's peers.[39] There is
great irony here, for much of Colden's published writings in the field of natural philoso-
phy were so specialized as to be almost incomprehensible. This document, combined
with the visual evidence of the double portraits, reveals his overwhelming concern with
the world of science, not only beyond the reaches of his estate, but through time as well.
As he wrote in the accompanying letter to his son, "I send [these papers] to you, as I
wrote them, that you may preserve them for your children; & that they may be some
memorial to them of their grandfather."[40]

Most of the portraits discussed above make use of an elaborate setting and/or care-
fully chosen objects—even additional persons—to define the subject's relationship to sci-
entific study. Two of Charles Willson Peale's portraits of his friend David Rittenhouse,
however, convey their characterization of the subject through dramatically simplified
images. Rittenhouse (1732–1796) was the best-known astronomer in America, but was

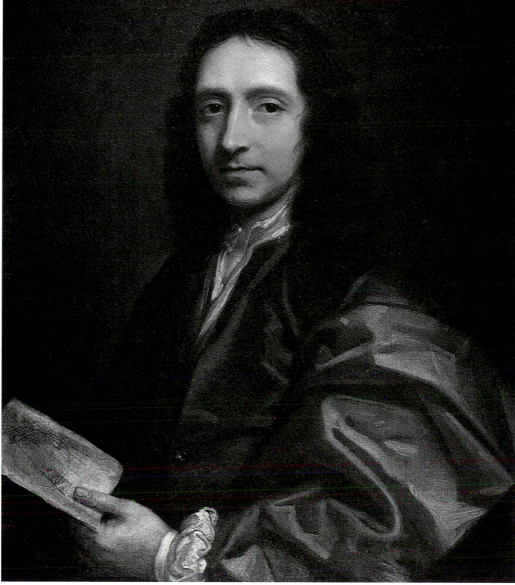

FIGURE 3–25.
Edmond Halley attributed to
Thomas Murray (1663–1735),
oil on canvas, 76.2 x 63.5 cm (30
x 25 in.), circa 1687. The Royal
Society of London

FIGURE 3–24.
Mather Byles, *The Comet: A Poem*
(Boston, 1744). Rare Books
Division, the New York Public
Library, New York City, Astor,
Lenox and Tilden Foundation

neither college-educated nor well-to-do. Rather, he was an artisan—a clock- and mathe-
matical-instrument maker, who was encouraged by his contemporaries to follow his
inclination for astronomy. John Adams described him in 1775 as "a Mechannic, a
Mathematician, a Philsosopher [*sic*], and an Astronomer." Thomas Jefferson made
much of Rittenhouse's seemingly natural genius for mathematics, ranking him "second
to no astronomer living: . . . in genius he must be the first, because he is self-taught."[41]
Rittenhouse was famed for his telescopes, the elaborate orreries that he made for the
College of New Jersey (Princeton) and the College of Philadelphia, and for his careful
observations of the 1769 transit of Venus from his observatory in Norriton, outside
Philadelphia. His appointment as director of the United States Mint was viewed by his
friends and admirers as a wonderful coincidence, since Isaac Newton had served as mas-
ter of the Mint in England. After Franklin's death in 1790, Rittenhouse succeeded him
as the president of the American Philosophical Society.

Peale first "made myself acquainted with the great Mr. Rittenhouse" in 1771, when he made a portrait drawing. By 1772, he exhibited a new portrait of Rittenhouse, "which I sent him for some favour done me," a portrait that Peale had intended to use as the basis for an engraving [Figure 3–23].[42] Peale created a half-length picture on a size of canvas that many other artists would have used for head-and-shoulders portraits, thus giving a greater intimacy to the image. Rittenhouse is posed in a plain but good suit, without a wig, against a dark background. He stares directly at the viewer, but the viewer's eyes are quickly drawn, through lighting and gesture, to a diagram under his hands. He holds a stylus between his thumb and fourth finger (the stylus is aligned with a circle on the diagram which represents the earth's orbit), and points with his index finger to an image of a comet on another line, which indicates the comet's trajectory through the earth's orbit. The paper is pushed to the edge of the painted table and beyond, producing a trompe l'oeil effect.

The diagram represents the comet Rittenhouse observed in June 1770, known today as Lexell's comet.[43] Rittenhouse published a report on the comet, explaining his attempts to map its path. He and his contemporaries, including John Winthrop, were fascinated with comets—awe-inspiring, seemingly haphazard heavenly visitors that had provoked alarm in earlier generations, but were a bit more readily subsumed into the orderly Newtonian universe by the mid-eighteenth century.[44] Mather Byles (1706/7–1788), a Boston minister and nephew of Cotton Mather, composed an illustrated poem on comets in 1744 that contains this sense of rational awe [Figure 3–24]. Comets did not bring earthquakes or pestilence, but were still emblems of chaos, and perhaps of Judgment Day:

> Midnight blazes with the glare of noon
> Big, and more big, it arches all the air,
> A vault of fluid Brass the skies appear: . . .
> Now at the sun it glows, now steers its flight
> Thro' the cold desarts of eternal night,
> Warns every creature thro' its trackless road,
> The fate of sinners, and the wrath of GOD.[45]

It was the "trackless road" that Rittenhouse and his generation sought to define through astronomical observation and mathematical calculation. In 1775, Rittenhouse spoke to the American Philosophical Society on the history of astronomy, noting that despite the incredible advances in man's knowledge of the solar system,

> The Astronomy of comets is still in its infancy [for want of the ability to predict their return]. . . . Whether their business be to repair or to destroy, whether they are worlds yet in formation or once habitable worlds in ruins; . . . or whether they are the vast links that connect the distant parts of creation by surrounding more suns than one, we know not.[46]

Peale's portrait of Rittenhouse emphasizes his subject's own vision and its role in his careful observation of Lexell's comet. The precision and specificity of the diagram, made by Rittenhouse and pictured by Peale, are literally highlighted. The painting is quietly dramatic in its use of light and dark, and derives its power from the plainness of the background, the subject's costume and lack of wig, and his direct gaze. Peale seems to have adapted to visual form a type of rhetoric described by his contemporaries as the "plain style." In the seventeenth century, such a simple, unornamented verbal style was described as being well suited for scientific writing. It is particularly appropriate for this portrait, with its emphasis on the quiet intensity of Rittenhouse's intellectual work and the scientific drawing, created to communicate precise information.[47]

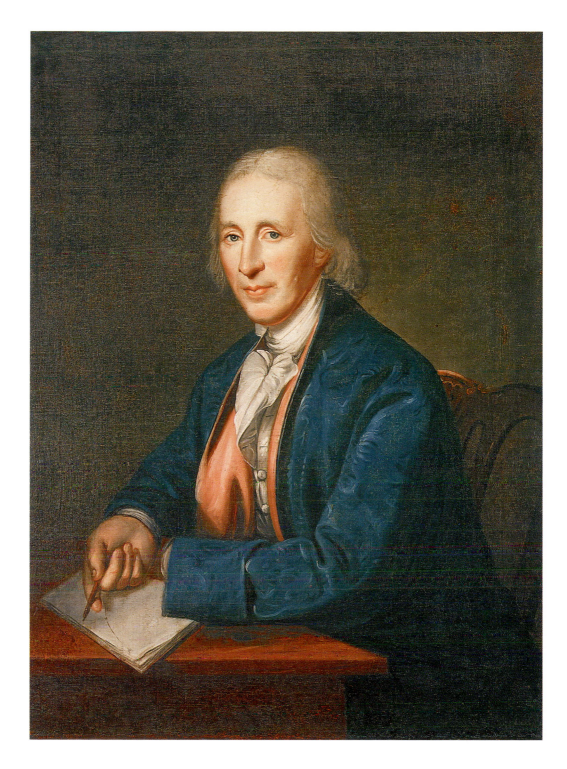

FIGURE 3–26.
David Rittenhouse by Charles
Willson Peale (1741–1827), oil
on canvas, 94 x 68.6 cm
(37 x 27 in.), 1791. American
Philosophical Society,
Philadelphia, Pennsylvania

In size, scale, and visual effect, Peale's portrait is very similar to a late seventeenth-century portrait of England's great astronomer, Edmond Halley (1656–1742), which was already in the collection of the Royal Society of London when Peale was there in 1767–1769 [Figure 3–25]. Although the position of the hands differs in each portrait, Halley's likeness, attributed to Thomas Murray, also includes a specific diagram. It replicates a diagram, published in the Royal Society's *Philosophical Transactions* for July/August 1687, that depicts the intersection of an ellipse and parabola and relates to Halley's work on cubic and quartic equations. However, as late as 1984, the diagram in the portrait had been associated with the parabolic orbit of a comet and the circular orbit of a planet.[48] Although no copies are known of Halley's portrait, nor is it known to have been

engraved, Peale might have seen it at the Royal Society's meeting place at Crane Court while he was in London. He is not, however, listed as a visitor to any of the society's meetings.[49] The portrait would have been an appropriate model for Peale to recall when designing Rittenhouse's portrait, for Rittenhouse, like Halley in England, was certainly viewed as Philadelphia's leading astronomer. The inscription on Halley's portrait (probably added after 1696) also indicates his position as secretary to the Royal Society. Rittenhouse was secretary to the American Philosophical Society at the time Peale painted him. For Peale, relating Rittenhouse to Halley through reference to a portrait of Halley holding a similar diagram, and portrayed with the same directness and intensity, would have been a worthy tribute to both Rittenhouse and his own creative abilities.

Rittenhouse observed and recorded comets again in 1784 and 1793. In the portrait commissioned from Peale by the American Philosophical Society in 1791, just after Rittenhouse had assumed the presidency, another diagram of a comet rests on the table-top [Figure 3–26]. While the general pose of the portrait is similar to the earlier painting by Peale, subtle differences in the diagram and Rittenhouse's clothing alter the effect of this one. This diagram includes only a reference to a comet and its orbit, and the paper is oddly elevated so that the comet is visible. Rittenhouse is obviously older, and still wigless, but is now clothed in a banyan. Peale associated Rittenhouse with Benjamin Franklin by portraying him in this costume, for it is identical to the blue damask banyan lined with pink that Peale painted in the portrait of Franklin that he had created for the society two years earlier [see Figure 8–1]. There is no evidence that members of the Philosophical Society attended meetings attired in their banyans; rather, Rittenhouse and Franklin were associated visually through this costume with the ideal of the studious intellectual, attired in an informal robe for work in his study. Peale also highlights Rittenhouse's head and features more than his gesturing hand in this image. It may be that Peale's record of Rittenhouse's features is meant not simply to demonstrate likeness, but to highlight specific features associated with Rittenhouse's reputation, or character, as a genius and intellectual. His nephew William Barton described him at length, noting the oval face, high forehead, expressive eyes, aquiline nose, and prominent mouth and chin. "In short, his whole countenance was indicative of intelligence, complacency and goodness, even after its characteristic marks had been in some degree impaired by sickness and years."[50] Benjamin Rush also commented on Rittenhouse's appearance in his eulogy, pronounced before the Philosophical Society in 1796: "The countenance of Mr. Rittenhouse was too remarkable to be unnoticed upon this occasion. It displayed such a mixture of contemplation, benignity, and innocence, that it was easy to distinguish his person in the largest company, by a previous knowledge of his character."[51] Rush was known to be interested in physiognomy, the science of reading character in the facial features. In 1795, the year before his eulogy, he was appointed "Professor of the Theory and Practice of Pictorial Physiognomy" to the Columbianum, a group of Philadelphia artists attempting to found an art academy there.[52]

Peale's 1791 portrait of Rittenhouse presents him in a semi-public role—as the president of the American Philosophical Society—in which his intellect and refined posture set him apart from ordinary Americans. Another American inventor and man of science, Benjamin Thompson (1753–1814), took great care to control his portraits, and his public image. Thompson left Massachusetts at the time of the Revolution and prospered in Europe. He was devoted to the idea of making science serve practical purposes. Although best known for experiments concerning the nature of heat, he also experimented with gunpowder; investigated the properties of light; invented stoves, roasters, lamps, and coffeemakers; and studied nutrition. He genuinely wished (as he wrote to

FIGURE 3–27.
The Comforts of a Rumford Stove by James Gillray (1757–1815), hand-colored engraving, 24.4 x 19.2 cm (9 5/8 x 7 9/16 in.), 1800. Prints and Photographs Division, Library of Congress, Washington, D.C.

Joseph Banks in 1797) "to increase the enjoyment and comforts of life, especially in the lower and more numerous classes of society," but he was an unrepentant elitist. For his scientific research on the force of gunpowder, he was elected to the Royal Society of London in 1779. He later served the Elector of Bavaria for thirteen years as a military officer, social reformer, and confidant, and was made a count of the Holy Roman Empire in 1792. He took as his title Count Rumford, using the original name of Concord, New Hampshire, where he had first settled and married. By 1795, he had returned to England, wealthy, titled, and full of energy for scientific and practical projects. By 1799, he was fully absorbed by a pet plan to found "a Public Institution for Diffusing the Knowledge and Facilitating the General Introduction of Useful Mechanical Inventions and Improvements, and for Teaching, by Courses of Philosophical Lectures and Experiments, the Application of Science to the Common Purposes of Life." This plan resulted in the Royal Institution of Great Britain, which promoted the diffusion of scientific knowledge, mainly to an elite audience, and eventually evolved into one of Britain's premier institutions for scientific study.[53]

Thompson was handsome and persuasive, but also cranky, vain, and difficult. Both his marriages, the second to Antoine Lavoisier's widow, failed, and he had few close friends. He was a tireless self-promoter and sent portrait prints to colleagues in order to spread his fame as an author, philanthropist, and man of science.[54] In February 1802, just before he left England for a permanent haven in France, he sat for a portrait by a Mlle. Rath, which was to be engraved and published with a biographical account of his

FIGURE 3–28.
Scientific Researches!—New Discoveries in PNEUMATICKS! . . . by James Gillray (1757–1815), hand-colored engraving, 25.4 x 35.5 cm (10 x 14 in.), 1802. Prints and Photographs Division, Library of Congress, Washington, D.C.

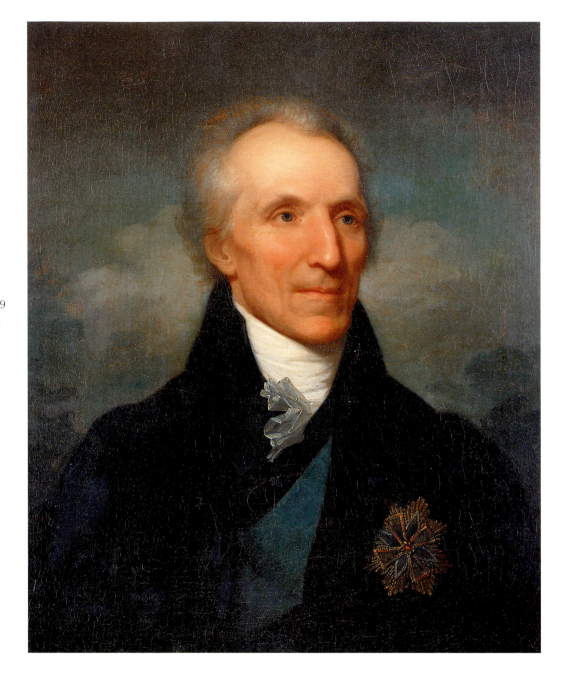

life. A young naturalist who was involved in this episode recounted it later, revealing Thompson's careful self-promotion:

> Knowing nothing about his early life, I asked Rumford for some information about it which he promised to give to me and arranged an appointment for an interview. When I arrived, much to my astonishment, he presented to me an article all completed and written in the most flattering style. That was not all. He required me to copy it then and there, not wanting to leave in my hand the manuscript in his own handwriting.[55]

It is not surprising that a man of such ego and energy would be the subject of caricatures by James Gillray, who created two. The first, published in June 1800, poked fun at his popular improvements to fireplaces and stoves [Figure 3–27]. The second, from May 1802, depicts Thompson at the far right, observing an experiment on the ingestion of gases that has gone awry, an attack on the Royal Institution [Figure 3–28]. This print was particularly galling to Thompson, who complained to Joseph Banks, "those who render

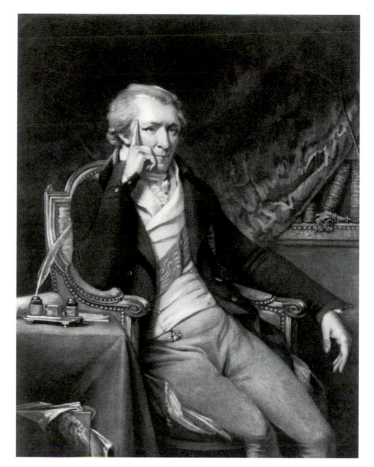

themselves conspicuous by their superior genius, their talents, and, above all, their useful-
ness to society, must necessarily be exposed to the shafts of envy and to the hatred of all
bad men."[56]

A number of more formal portraits exist of Thompson, one painted by
Gainsborough in 1783, others, from which prints were made, by Kellerhoven, and yet
another by Rembrandt Peale, made when he was sent to Paris in 1808 by his father to
collect portraits of noted European men of science [Figure 3–29]. Most of the portraits
show only Thompson's head and shoulders, and occasionally include one of his many
medals and decorations. A small full-length portrait attributed to William Lane was
exhibited, copied, and published in mezzotint in London during the years surrounding
the opening of the Royal Institution, when Thompson was decidedly in the public eye.
This portrait included imagery that was clearly meant to promote Thompson as a man
of "superior genius." Lane's portrait was exhibited at the Royal Academy in the spring
of 1799. Thompson's daughter Sarah called it "the best likeness, to my fancy, that was
ever taken of him."[57] The mezzotint, published in April 1801 [Figure 3–30], was made
by the noted London engraver John Raphael Smith after his own painting, which was
exhibited at the Royal Academy in the spring of 1800. This image, in all of its manifes-
tations, was chosen to represent Thompson to the public at a crucial time in his career.
He is depicted as though in a deep reverie, surrounded by his books and writing materi-
als. His attitude is relaxed, but his costume is carefully put together, with no hint of
dishabille. The hand supporting the head is, as we have seen, a configuration used in
portraiture to indicate the action of the mind. For Thompson, born to a respectable but
far from aristocratic or wealthy family, his intellect and scientific achievements were the
source of all his riches and reputation.[58]

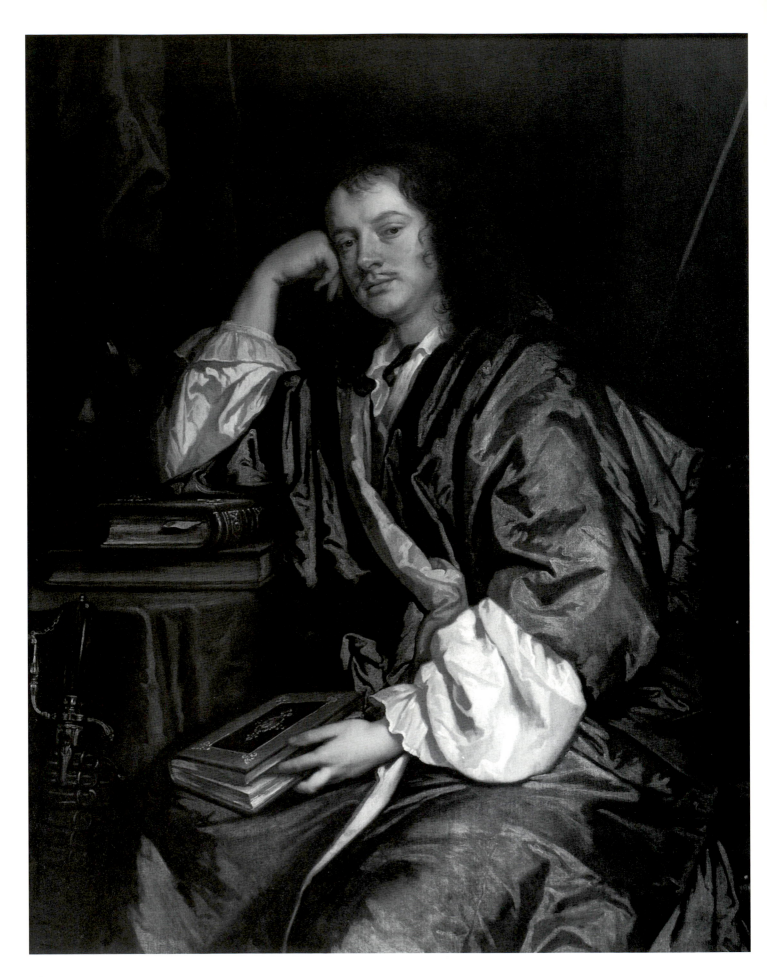

Chapter 4

Banyans and the Scholarly Image

Studious men are always painted in gowns

—Dr. Benjamin Rush, *Medical Lectures*, 1799

FIGURE 4–1.
Thomas Clifford, first Baron Clifford by Peter Lely (1618–1680), oil on canvas, 125.7 x 99.1 cm (49 1/2 x 39 in.), late 1660s, Private collection

Many portraits of men of science include an important and unusual piece of clothing—a long, flowing robe, often of heavy damask or a striped fabric. The sitter sometimes wears a cap or turban as well. These were nightcaps of velvet or linen that covered and warmed a close-cropped head when a wig was not worn. Henry Raeburn's circa 1798 portrait of John Robison (1739–1805), professor of natural philosophy at the University of Edinburgh, is a good example [see Figure 4–3]. These robes were known by several names, including nightgown, morning gown, "Indian" gown, and quite often, "banyan."[1] According to the *Oxford English Dictionary*, the term "banyan" originally described an Indian trader or merchant, but by 1755, Dr. Johnson's dictionary defined a "Bannian" as a man's morning gown, a loose gown worn before one was formally dressed. From the mid-seventeenth century, these flowing robes were worn by persons working, reading, or musing in a private space, at any time of day or night, but removed from the necessity for public action or duty. The fashion may have its roots in robes brought back by Englishmen from India or by Dutch merchants returning from the Orient. Made from unshaped lengths of fabric with kimono-like sleeves, the banyan was loose fitting. Unlike the gentleman's suit, which was cut to fit the posture and gestures a man was expected to maintain in public, the banyan permitted the wearer's upper body to move more freely while he concentrated on the mind-engaging task at hand.[2] For comfort, a man of means might wear a banyan over his shirt, breeches, and usually, his waistcoat. In 1734, Jonathan Belcher, merchant and colonial governor of Massachusetts and New Hampshire, requested of a Captain Franklyn, just sailing for the Mediterranean, that he purchase enough black velvet for a "compleat suit," and a "night gown of the best Genoa damask that is made for men's wear. . . . The colour of the outside & lining must be a deep crimson."[3] Such robes could be very expensive, given the amount of fine fabric required for a full-length garment. Joseph Willard, while a Harvard student, listed his possessions that were destroyed when Harvard Hall burned in 1764. Among them was "A Banyand," valued at £1, far more than any other item on his list.[4] Banyans were quite distinct from academic, judicial, or other official gowns.

Banyans were normally worn indoors, at home. Gentlemen wearing these loose-fitting robes could, however, receive visitors. As William Byrd commented in 1723, "I arriv'd at Col'o Martin's who rec'd me with Gravity and saluted me with a glass of Good Canary. I found him in his Night Cap and Banian, which is his ordinary dress."[5] In England, the practice of "nobility receiving company in their morning gowns" was noted in 1762 by Oliver Goldsmith, and by 1785, London's *Town and Country Magazine*

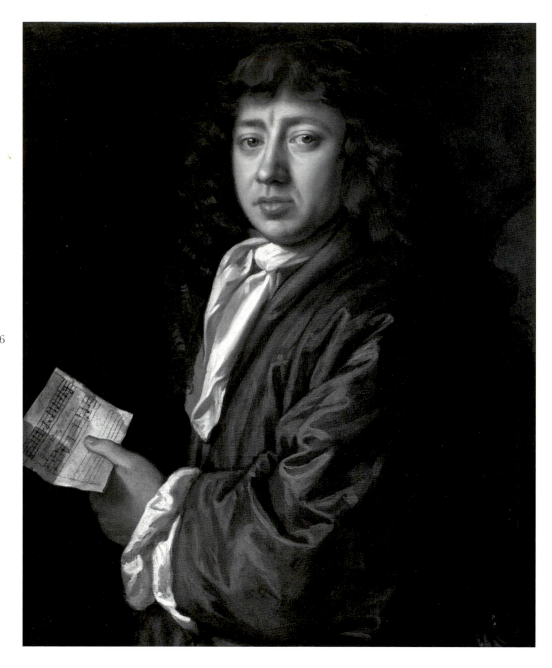

FIGURE 4–2.
Samuel Pepys by John Hayls
(?1600–1679), oil on canvas, 75.6
x 62.9 cm (29 3/4 x 24 3/4 in.),
1666. National Portrait Gallery,
London

reported that "banyans are worn in every part of the town from Wapping to Westminster, and if a sword is occasionally put on it sticks out of the middle of the slit behind. This however is the fashion, the ton, and what can a man do? He must wear a banyan."[6] We do not know to what extent banyans actually were worn in company or out of doors in America, or if one would ever allow oneself to be seen by a social superior when wearing a banyan and cap.

The conventions for the wearing of actual banyans may well have differed from the connotations of banyans depicted in portraiture. In 1666, British artist John Hayls painted Samuel Pepys (1633–1703) in a brown silk robe [Figure 4–2]. Pepys noted in his *Diary* on March 30: "Thence home, and eat one mouthful, and so to Hale's and sat till almost quite darke upon working my gowne, which I hired to be drawn in; an Indian gowne, and I do see all the reason to expect a most excellent picture of it."[7] In portraiture, a banyan made of expensive materials might be employed to display the sitter's wealth, or as a form of costume more timeless and picturesque than a formal suit. Writers on portraiture pointed out the desirable visual effect of flowing robes. Peter Lely's painting of

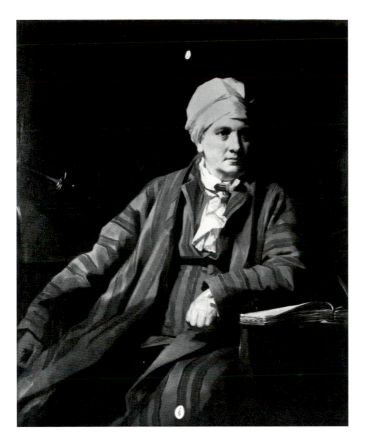 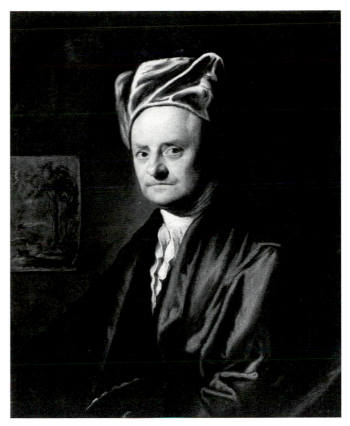

Thomas Clifford, first Baron Clifford (1630–1673), from the later 1660s, is a fine early example of the studied informality of such robes [see Figure 4–1].

Britons and Americans of various vocations were portrayed in banyans, including a few merchants, numerous men of letters and men of science, some clergymen, and artists, including painters and composers. In general, the use of a banyan in eighteenth-century portraiture seems to indicate a body at ease, giving free rein to the mind's work. In some cases, a painted banyan of shimmering silk damask gives an aura of ostentatious display to a portrait, and may indicate the wearer's status (real or desired) as a man of leisure. More compelling, however, given the banyan's occurrence in so many portraits of authors, artists, and other intellectuals, is its association with the studious and creative life, as in American artist William Williams Sr.'s (1727–1791) self-portrait of circa 1788–1790 [Figure 4–4].

Clearly, the connotations of such portraits are multiple and inclusive. Older scholars wearing robes are often pictured in sixteenth- and seventeenth-century paintings and portraits. Zirka Filipczak has pointed out the contemporary connections between old age, the melancholy temperament or humor, and scholarly pursuits: "[It was thought that] Men's greater heat made them intellectually superior to women. Long scholarly hours spent over books, however, drained heat from the body. If a scholar also lost heat through aging, his humoral state would soon become cold and dry." Aged scholars would naturally be depicted in warm robes; such robes also carried connotations of dignity and learning.[8] The association of robes with scholarly activity and melancholy genius were strong in the eighteenth century as well. George Willison's 1765 portrait of Dr. Johnson's companion, James Boswell (1740–1795), elegantly posed in a fur-trimmed banyan, makes this connection clear through the inclusion of a brooding, fierce owl, perched above and behind the subject [Figure 4–5]. The owl is a traditional symbol of melancholy, and appears in emblem books within engraved illustrations representing that

humor.[9] Boswell had originally wanted a bust-length portrait, but Willison talked him into the half-length so that he might include "emblems" indicative of both "adventure and meditation." Boswell sat to Willison for about a week in early May. On May 4, 1765, he noted in his diary, "Yesterday morning Sat to Mr. Willison. Owl, etc., good idea." On the same day, he added, "This day at nine, Willison's, and sit, a plain, bold, serious attitude." Three days later, on a day when he again sat to Willison, Boswell revealed his gloomy state of mind to his friend, Wilkes: "If you would think justly of me, you must ever remember that I have a melancholy mind."[10]

Long robes very like banyans also occur in seventeenth- and eighteenth-century images, both painted and engraved, of alchemists and mystics, as well as more general portrayals of philosophers and men of science. Joseph Wright of Derby's great science paintings, particularly *A Philosopher Shewing an Experiment on the Air Pump*, engraved in 1769, include figures of lecturers dressed in long, flowing robes. Other figures of natural philosophers lecturing to students or to interested adults occur in almanacs or as book illustrations [Figures 4–6, 4–7, and 4–8]. One American example of such a studious, robed figure is the small, full-length drawing made by Christopher Witt around 1705 of the German mystic Johannes Kelpius (1673–1708). Kelpius is seated, next to a table on which rests a small book, in the time-honored pose of intellectual contemplation, with his finger raised to his head [Figure 4–9]. Kelpius, who led a group of Rosicrucians to

FIGURE 4–5. *(opposite)*
James Boswell by George Willison (1741–1797), oil on canvas, 132.7 x 94 cm (52 1/4 x 37 in.), 1765. Scottish National Portrait Gallery, Edinburgh

FIGURE 4–6.
A Philosopher Shewing an Experiment on the Air Pump by Valentine Green (1739–1813), after Joseph Wright of Derby, mezzotint, 44.5 x 58.5 cm (17 9/16 x 23 1/16 in.) image, 1769. Paul Mellon Collection, Yale Center for British Art, New Haven, Connecticut

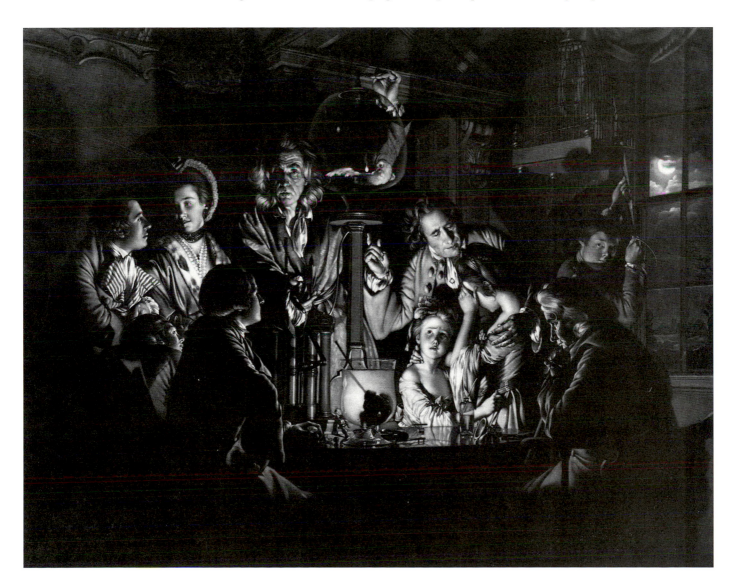

settle on the Wissahickon Creek near Philadelphia in 1694, was deeply involved with hermeticism and the occult, interests shared by his portraitist. Witt was also a physician and botanist. His friend, John Bartram, commented to Peter Collinson on Witt's library, filled with books "containing diferent kinds of learning as Phylosophy natural Magic, Divinity, nay even Mystick divinity all of which was the subjects of our discourse within doors which allternately gave way to botany every time we walked in the garden."[11] The drawing of Kelpius is a reminder that the visual conventions chosen by Enlightenment men of science derived from imagery also associated with older cultural practices of magic and the occult—astrology, alchemy, and hermeticism.

To have been painted in a banyan does not necessarily mean that one actually owned or wore one—some banyans may have been studio props. We do know, however,

FIGURE 4–9.
Johannes Kelpius by Christopher
Witt (1675–1765), watercolor on
paper mounted on wood, 23.2 x
16.5 cm (9 1/8 x 6 1/2 in.), circa
1705. Historical Society of
Pennsylvania, Philadelphia

that the painter John Trumbull's father, Governor Jonathan Trumbull (1710–1785), did own a banyan almost exactly like that in which he was painted by his son in 1778. The portrait, a double likeness of Governor Trumbull and his wife, Faith Robinson Trumbull (1718–1780) [Figure 4–10], was described in later years by the artist as "the size of life— my father dressed in a blue damask nightgown." A banyan (or "nightgown") owned by Governor Trumbull survives in the collections of the Wadsworth Atheneum in Hartford, Connecticut. It is also made of blue damask; only the pattern appears to be different.[12]

Painted portraits discussed earlier in this essay have included a banyan as an important element of the construction of the sitter's identity as a scholar, and a man of science. Matthew Pratt's portraits of Cadwallader Colden, Peale's 1791 likeness of David

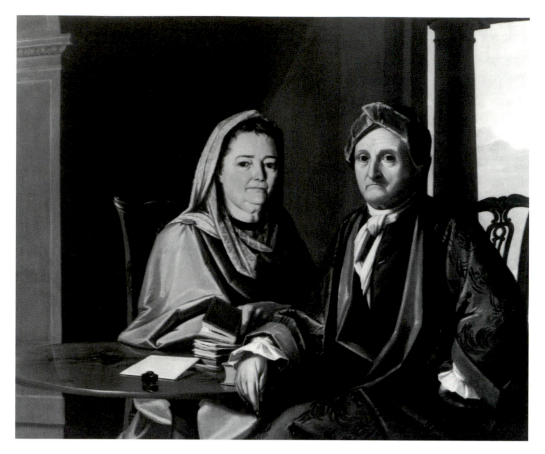

FIGURE 4–10.
Governor Jonathan Trumbull and Faith Robinson Trumbull by John Trumbull (1756–1843), oil on canvas, 101.6 x 127 cm (40 x 50 in.), 1778. Connecticut Historical Society, Hartford

Rittenhouse, Nathaniel Smibert's portrait of Ezra Stiles, and Angelica Kauffman's painting of John Morgan are examples. Pratt, Peale, and Kauffman had, through European study, acquired sufficient familiarity with portraiture to recognize the subtle connotations of clothing their sitters in banyans. Smibert learned the same from his London-trained father, John Smibert. It is probable that their subjects also knew that such garments would create an aura not only of leisured gentility, but also of intellectual and creative endeavor. Other examples further clarify the relationship of banyans with images of men of science.

John Greenwood's portrait of Edward Bromfield (1723/24–1746) [Figure 4–11] is a telling example of this pictorial convention. Since Bromfield died at age twenty-three in 1746 and no work by Greenwood is documented prior to 1747, his portrait may have been posthumous. However, the directness and vivacity of his gaze would indicate otherwise. The two young men could easily have known each other in Boston, for they shared an interest in the visual arts. Also, Greenwood's uncle, Isaac Greenwood, had been the Hollis professor of mathematics and natural philosophy at Harvard, where Bromfield graduated in 1742.[13] According to the Reverend Thomas Prince, Bromfield's "Genius first appeared, in the accurate Use of his *Pen*; drawing natural Landscapes and Images of Men and other Animals, &c." This talent may have drawn him to Greenwood. As for his scientific accomplishments:

> he appeared very ingenious, observant, curious, penetrating; especially in the Works of Nature, in mechanical Contrivances and manual Operations, which increased upon his studying the Mathematical Sciences. . . . But what I would chiefly write of is—His clear Knowledge of the Properties of Light, his vast Improvement in making Microscopes, most accurately grinding the finest *Glasses*; and thereby attaining to such wonderous Views of the inside Frames and Works of Nature, as I am apt to think that some of them at least have never appeared to mortal Eye before. He carried his Art and Instruments to such a Degree;

FIGURE 4–11.
Edward Bromfield attributed to
John Greenwood (1727–1792),
oil on canvas, 91.4 x 71.1 cm
(36 x 28 in.), circa 1746. Harvard
University Portrait Collection,
Cambridge, Massachusetts; loan
from the Bromfield School to the
Harvard Corporation, 1932

FIGURE 4–12.
Culpeper-type microscope,
wood, brass, and shagreen with
an octagonal wooden base, 41 x
17.5 x 17.5 cm (16 3/16 x 6 7/8
x 6 7/8 in.), eighteenth century.
Division of Science, Medicine,
and Society, National Museum of
American History, Smithsonian
Institution, Washington, D.C.

This form of microscope, with
the stable three-legged stand, was
introduced around 1720 by
Edmund Culpeper, a successful
instrument maker in London.
Culpeper's design proved popu-
lar and remained in production
for about one hundred years.
The Culpeper is a compound
instrument, which means it has
two lenses, an objective, and an
eyepiece.

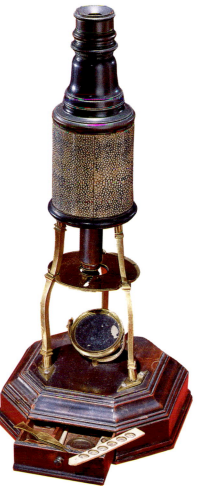

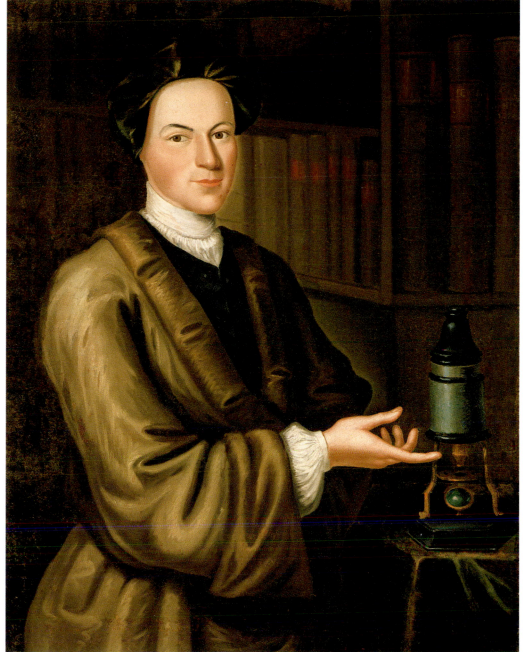

as to make a great Number of surprizing Discoveries of the various Shapes and Clusters
contained in a Variety of exceedingly minute Particles.[14]

Bromfield stands in front of shelves lined with books, including Newton's *Optics*, and
gestures toward a Culpeper-type tripod microscope, which may have been, to some
extent, of his own making [Figure 4–12]. A microscope described by Thomas Clap in
1747 as "A Microscope with the Apparatus. *Excellent*" may be the Culpeper-type micro-
scope now at Yale, demonstrating that instruments of this type were available in New
England.[15] A manuscript treatise on light, and at least two actual microscopes associated
with Bromfield (but not of the type pictured in the portrait) are still owned by Harvard.

Bromfield also wears a banyan and cap in his portrait. We know that banyans were
sold in Boston; "Banjans made of Worsted, Damask and Brocaded Stuffs, Scotch Plods
and Calliminco" were advertised in the *Boston Weekly Gazette* in 1738.[16] Portraits of men

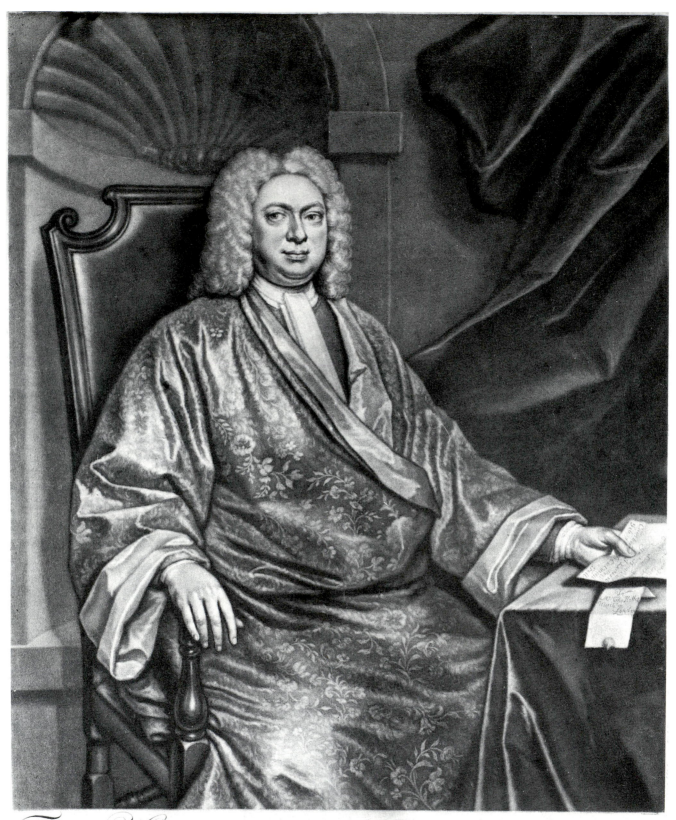

Thomas Hollis late of London Merch.ᵗ a most generous Benefactor to Harvard College, in N.E. having founded two Professorships and ten Scholarships in the said College, given a fine Apparatus for Experimental Philosophy, & increased the Library with a large Number of valuable Books &c.

Jas. Highmore pinx. 1722. Ob. 1731. Æt. 71. P. Pelham ab Origin: fecit et excud.ᵗ 1751.

60

in banyans were rare, but not unknown there. In fact, the finest portrait in Cambridge, British artist Joseph Highmore's painting of Thomas Hollis III (1660–1731), depicted him in a florid damask gown. Harvard had commissioned the portrait of its English benefactor in 1722; this hung in Harvard Hall until it was consumed in the fire that destroyed the building in 1764. All that survives is a 1751 mezzotint by Peter Pelham, the last engraving he made before his death [Figure 4–13]. Hollis is depicted as a man of leisure, seated beside a table bearing his papers; his gown was probably employed to denote his status as an aged man of learning, wealth, and benevolence. The print's inscription mentions not only Hollis's endowed professorships and scholarships, but that he had "given a fine Apparatus for Experimental/Philosophy, & increased the Library with a large Number of valuable Books &c."[17]

FIGURE 4–13.
Thomas Hollis III by Peter
Pelham (1697–1751), after
Joseph Highmore, mezzotint,
29.8 x 24.5 cm (11 3/4 x 9 5/8
in.), 1751. American Antiquarian
Society, Worcester, Massachusetts

John Smibert, who certainly was known to John Greenwood, also included banyans in a number of his English and Scottish portraits. After moving to Boston, however, he painted only two men in banyans and caps, although his son Nathaniel painted Ezra Stiles in this attire in 1756.[18] Banyans appear in several portraits by John Singleton Copley from the later 1760s and early 1770s. These include a self-portrait, a portrait of his friend the goldsmith and engraver Nathaniel Hurd (1730–1777) [Figure 4–14], and portraits of several wealthy merchants with the leisure for public service, philanthropy, or science, including Ebenezer Storer.[19] Storer had "a large apartment in the second story [of his Boston mansion] devoted to a valuable library, a philosophical apparatus, a collection of engravings, a solar microscope, a camera, etc."[20] In like fashion, Edward Bromfield's portrait aligned him with the larger world of science and learning not only through his books and the fine microscope, but through the clothing in which he is portrayed. We know that the Reverend Thomas Prince considered Bromfield to be a scientific genius—his 1746 essay on Bromfield's character concludes with a telling passage that constructs genius in his countenance and gaze:

> Besides the *moral Qualities* of Serenity, Kindness, Prudence, Gentleness and Modesty, displaying in his very *Countenance*, there appeared especially in the Air and Look of his Eyes the strongest Signatures of a *curious and accurate Genius*, that I remember ever to have seen: From this and other Remarks in others, I am apt to think, that even *every Quality* of the Humane Mind, and even in their various Measures, may by the Operation of GOD at least, become even *visible* in the Human *Countenance* and Eye to near Spectators.[21]

Prince's comments are contained within the rhetorical structure of the eulogy, but even so, his assumption that the features and gaze could reveal character—a hallmark of physiognomic practice—is clear. Within the confines of the intellectual world of Boston art and science, it is quite possible that Greenwood's portrait was also constructed to present Bromfield—in banyan and cap, and through his very countenance—as a remarkably gifted and ingenious man.

One of Charles Willson Peale's most complex portraits of a man of science is that of Dr. Benjamin Rush of Philadelphia (1746–1813) [Figure 4–15], a portrait that is inscribed with two dates, 1783 and 1786. It makes use of a banyan to characterize the sitter as a scholar. Rush was, like many of his contemporaries, a man with little leisure time for philosophical pursuits. He was a practicing physician, an energetic and practical man of affairs, reformer and essayist, and professor of medicine and chemistry. John Adams characterized him in 1775 as "an elegant, ingenious Body. Sprightly, pretty fellow. He is a Republican. . . . [He] is too much of a Talker to be a deep Thinker."[22]

Did Peale and Rush discuss the costume, pose, and attributes portrayed in the painting? We would assume so, but there is no documentation. Peale, who shared Rush's sci-

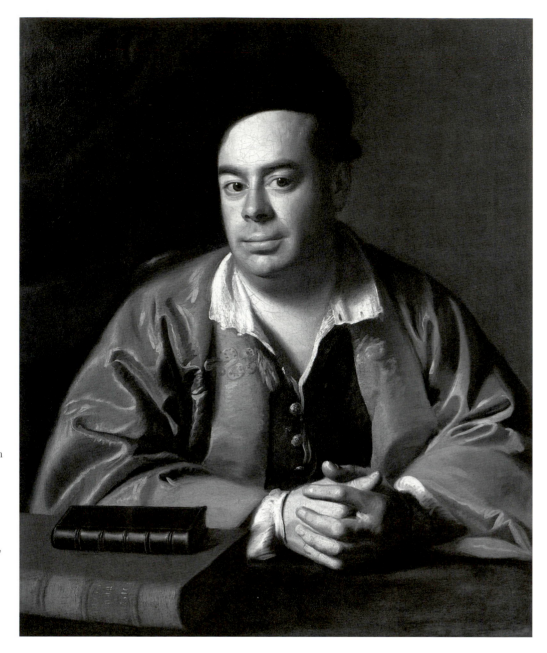

FIGURE 4–14.
Nathaniel Hurd by John Singleton
Copley (1738–1815), oil on
canvas, 76.2 x 64.8 cm (30 x
25 1/2 in.), circa 1765. The
Cleveland Museum of Art,
Ohio; gift of the John Huntington
Art and Polytechnic Trust,
1915.534

FIGURE 4–15. *(opposite)*
Benjamin Rush by Charles Willson
Peale (1741–1827), oil on canvas,
127.6 x 101.6 cm (50 1/4 x 40
in.), 1783 and 1786. Winterthur
Museum, Winterthur, Delaware;
gift of Mrs. Julia B. Henry

entific interests, depicted him in an interior, dressed in a banyan, surrounded by carefully labeled volumes. We know that Rush understood this iconography, for he discussed it in medical lectures:

> Loose dresses contribute to the easy and vigorous exercise of the faculties of the mind. This remark is so obvious, and so generally known, that we find studious men are always painted in gowns, when they are seated in their libraries. Sometimes an open collar, and loose shoes and stockings, form a part of their picture. It is from the habits of mental ease and vigour which this careless form of dress creates, that learned men have often become contemptible for their slovenly appearance, when they mix with the world.[23]

Rush's painted books, most of which he owned, are also part of the portrait's message. These include labeled volumes by noted physicians, as well as books on chemistry, electricity, psychology, political theory, moral philosophy, and the origin of languages.[24]

In the portrait Rush is writing on a paper inscribed "Sec. 29 / We come now, gentlemen, to in/vestigate the cause of earthquakes." Earthquakes were the subject of intense

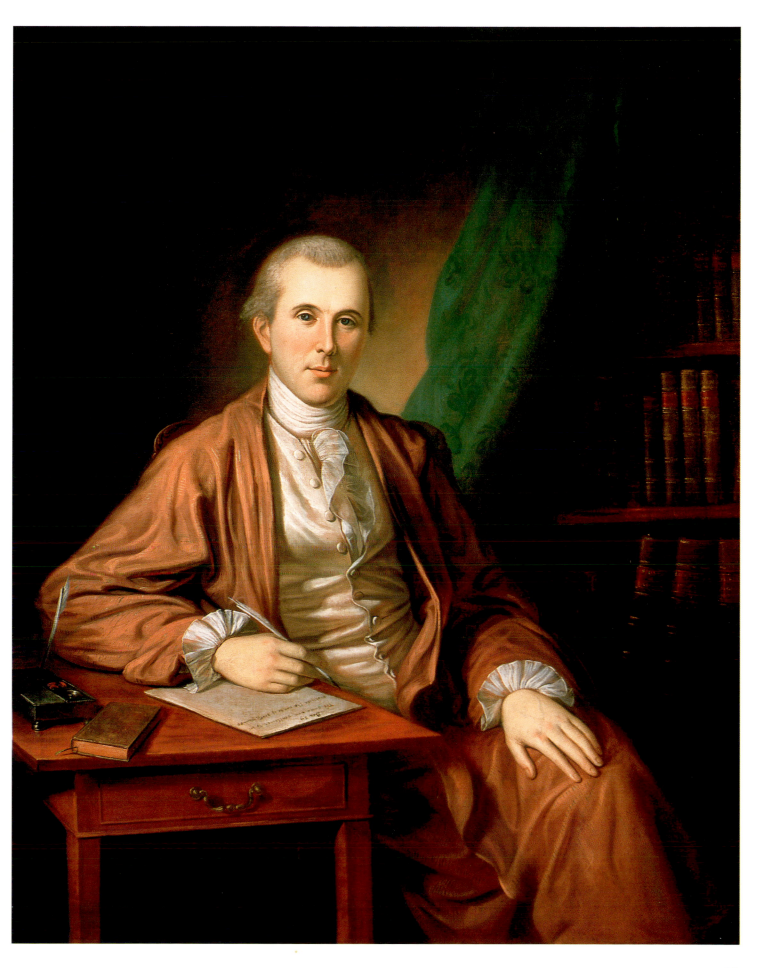

75

study and speculation throughout the century. Peale was often literal in the transcriptions he included in portraits, however, so we might look for something specific. Since Rush never published any essays on earth science, this forceful verbal image may be a reference to unpublished notes for lectures delivered to medical students at the College of Philadelphia. In some surviving notes from around 1790, Rush indicated clearly his familiarity with Sir William Hamilton's report on a major series of earthquakes in Calabria, Italy, in the early spring of 1783.[25] His curiosity about earthquakes is also seen by the inclusion in his later lectures of sections on earthquakes as a cause of disease, and on "the effects of thunder, lightning, and earthquakes, upon health and life."[26] Or he may have had his interest piqued by a Scottish professor of natural philosophy, Dr. Henry Moyes (1750–1807), who gave lectures in Philadelphia in 1785 and 1786 [Figure

4–16]. In February 1786, Moyes proposed that earthquakes were caused by electricity, and that giant steel conductors, or lightning rods, strategically placed into the earth around cities, might protect them.[27]

Rush delivered an oration before the American Philosophical Society in February 1786, entitled "An Enquiry into the Influence of Physical Causes upon the Moral Faculty," in which he noted that solitude often produced virtue: "Where the benefit of reflection, and instruction from books, can be added to solitude and confinement, their good effects are still more certain. To this philosophers and poets in every age have assented, by describing the life of a hermit as a life of passive virtue."[28] On July 21, 1786, Peale was elected to the Philosophical Society, an action that must have pleased him greatly. Ten days later, he wrote to Rush to send him a drawing of an ingenious "Fan Chair," which he hoped would prove "useful to the studious," and described Rush as "you who by Profession and inclinations are lead to studdy, and relieve the distress's of humane Nature."[29] Peale's letter may indicate that he and Rush did discuss Rush's "inclinations" and made a decision to highlight them in the portrait.

Peale presented Benjamin Rush as a man of science, retired (however temporarily) from public life. Rush described himself in these terms in a 1779 letter, in which he distanced himself from the turmoil of the American Revolution:

> These detached thoughts are the speculations of a closet, for I now converse with nobody but my patients, my books, an amiable wife, and a healthy boy and girl. I have shook hands (I hope) forever with public life. In my beloved retirement I have recovered the enjoyment of peace, independence, and happiness, none of which in the present distracted and corrupted state of this country are to be found in power or office.[30]

The posture of retirement adopted by Rush, like many of his American contemporaries, was chosen as a rhetorical device to define his relationship to public life, and his position as a man who might choose to remove himself from the fray of politics or business. Rush is aligned in his portrait with the community of science, a network that moved far beyond national boundaries. As Rush wrote to his teacher in Edinburgh, William Cullen, in 1783: "The members of the republic of science all belong to the same family."[31]

For men who upheld scientific ideals, the character of the retired, contemplative scholar was often adapted as a persona to indicate their devotion to virtue and truth, and their distance from self-serving activities. As William Nicholson wrote in the preface to his *Introduction to Natural Philosophy* of 1787, those "who cultivate the sciences know that they naturally produce a sincere and disinterested love of truth."[32]

A number of poems expressing a devotion to "retirement" were published during the course of the eighteenth century. An American example, William Livingston's "Philosophic solitude, or The choice of a rural life: a poem," praised the retired, rural life, where reading and contemplation of nature would enrich a man's soul. He would also "With level'd tube, and astronomic eye / Pursue the planets whirling thro' the sky." His reading included ancient and modern authors, including Sir Isaac Newton, "Who bound the silver planets to their spheres, / And trac'd th' elliptic curve of blazing Stars."[33]

Rush, Bromfield, and other men of science portrayed in their studies, clad in banyans, represented the studious, contemplative life of the mind, and a devotion to science. Such study required leisure and distance from the urban world of business and politics. Privacy and retirement are obvious connotations of such visual imagery. The retired life was an ideal, perhaps achieved only in men's imaginations, or in their portraits, but it was a powerful image throughout the eighteenth century.[34]

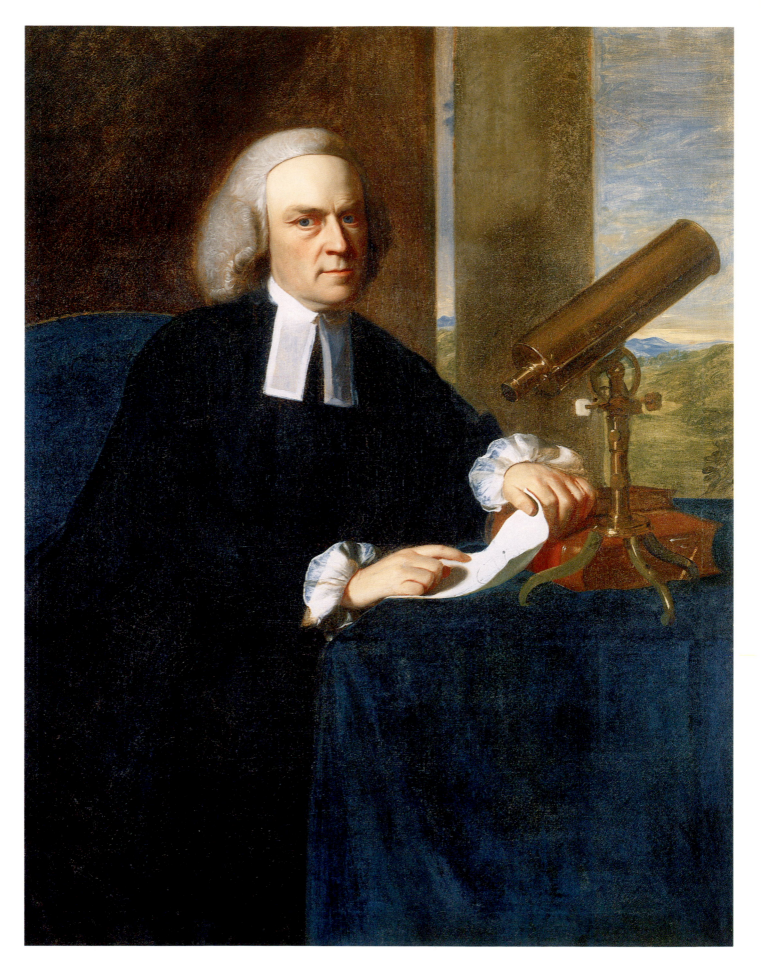

Chapter 5

Painted Tools of Science
Mathematical, Optical, and Philosophical Instruments in Portraits

Artists used pose, setting, and costume to represent certain subjects as proponents of the contemplative, studious life. Most portraits of men of science also include highly specific references to their scientific pursuits. Benjamin Rush's portrait, for instance, included carefully delineated book titles, as well as the text he was writing. A portrait that includes specific instruments and tools serves as particularly compelling evidence of the subject's desire to construct a scientific identity. Although this imagery occurs more frequently in eighteenth-century painted portraits, it was evident much earlier in portrait engravings.

Since the Renaissance, finely crafted instruments of science had been collected by the wealthy. They were valued as precious objects and were rarely used. By the 1740s, the possession of instruments and apparatus of science was a marker of polite gentility in England. This development had been effected, to some extent, through the aggressive marketing of science and instruments and through lectures using instruments to demonstrate scientific principles. The occurrence of such instruments in English and Scottish "conversation pieces"—paintings containing portraits of several members of a family or group in a domestic setting—is telling evidence of the desirability of these objects.[1] William Robertson's painting of the family of Sir Archibald Grant of Monymusk, which dates from the early 1740s, is a notable example [Figure 5–2].[2] Sir Archibald's wife and children pose before bookshelves loaded with books and instruments, including a reflecting telescope, a long reverse-taper refracting telescope, a microscope, a ringdial (a form of sundial made from two brass rings and a crosspiece), and other various mathematical instruments. A parallel ruler lies on the central table, while a globe is in the background. This is not, however, a portrait of Sir Archibald. The instruments arranged within the same pictorial space as children and women are commodities. They refer to a polite interest in science, to the desirability of these objects for displaying status, and to the education of Sir Archibald's children (although only the boys are active), but they do not mark their owner as a serious "man of science" in the same way that an individual portrait would have done.

Instruments *had* been included in European portraits and other painted figures of men of science, albeit rarely, since the Renaissance. The book, celestial globe, and instruments pictured in Jan Vermeer's *Astronomer* of 1668, for example, have been identified precisely.[3] Terrestrial and celestial globes, which were usually sold in pairs, are found in portraits of men of science, but they also occur in portraits of persons with more general and varied interests. Many portraits of sea captains or merchants include spyglasses, and some, such as Charles Willson Peale's enormous painting of William Stone

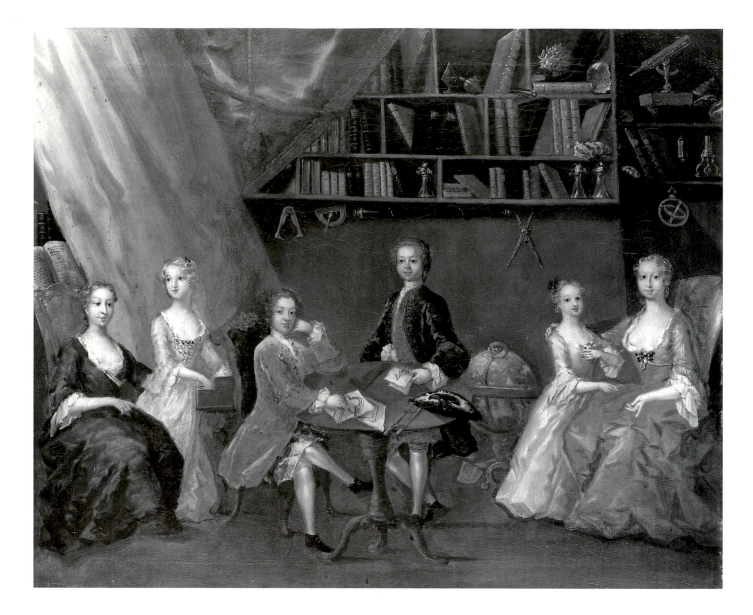

FIGURE 5–2.
The Family of Sir Archibald Grant of Monymusk by William Robertson (active 1727–1783), oil on canvas, 66 x 76.8 cm (26 x 30 1/4 in.), early 1740s. Private collection, Scotland

(1739–1821) [Figure 5–3], included mathematical instruments used for navigation. In Stone's 1774–1775 portrait, Peale has augmented an imposing full-length figure, fashionably dressed and posed beside a classical urn, with a fine spyglass and a background view that includes his sloop, the *Hornet*. At his feet lies an expensive octant, an instrument designed to determine latitude by measuring the altitude of celestial bodies.

Images of men with mathematical instruments or telescopes were not confined to paintings and portraits. Almanacs, with their carefully calculated celestial observations and predictions, also included crude woodcuts. Some of these depicted men with instruments. A woodcut figure with an enormous telescope decorated *Father Abraham's Almanack* (published in Philadelphia and New York) for a number of years [Figure 5–4], while a figure of a navigator with his instruments filled the cover of the *Neu-Eingerichteter Americanischer Geschichts und Haus-Calender*, a Philadelphia almanac published in 1763 [Figure 5–5].

Mathematical instruments also played a part in the visual culture of Freemasonry. During the eighteenth century, speculative Freemasonry became, in Europe and America, a new arena of sociability, not for working masons, but for a higher echelon of polite society. Masonic societies centered around ideals of love and fraternity, embracing a nonsectarian deity as the Grand Architect. Along with their sometimes arcane rituals

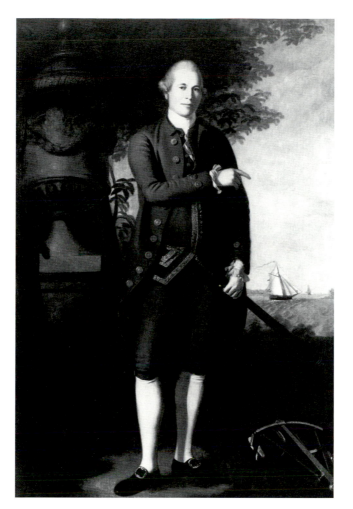

FIGURE 5–3.
William Stone by Charles Willson
Peale (1741–1827), oil on canvas,
254 x 154.9 cm (100 x 61 in.),
1774–1775. Maryland Historical
Society, Baltimore

FIGURE 5–4.
Page from Abraham
Weatherwise [pseudonym], *Father
Abraham's Almanack (on an entirely
new plan). For the Year of our Lord,
1764* (Philadelphia, 1763).
American Antiquarian Society,
Worcester, Massachusetts

based on the ancient hermetic traditions, Freemasons embraced the new science. Freemasonry offered a microcosmic society based on republican principles and a model of harmony paralleled by the order of the Newtonian universe.[4] Benjamin Franklin joined St. John's Lodge in Philadelphia in February 1730/31. His Masonic connections in England are obscure, but in Paris he visited and was affiliated with the radical Lodge of the Nine Sisters.[5]

The symbolism of Freemasonry was a pervasive part of American culture, recognizable and yet mysterious. Elements of this symbolism are found, of course, on Masonic paraphernalia, certificates, and medals, but also in other examples of eighteenth-century visual culture, including our one-dollar bill.[6] Thus, it is not surprising to find that in 1763, Samuel King (who later painted Ezra Stiles) made a watercolor drawing (a copy from an English engraving) entitled *A Free Mason Form'd out of the Materials of his Lodge* [Figure 5–6]. A human figure is created out of elements such as a compass, square, plumb line, Masonic apron, radiant sun, the checked floor that symbolized good and evil, and the pillars of Solomon's temple. A verse is inscribed within a cartouche below the figure:

Behold a Master Mason rare,
Whose mistic Portrait does declare,
The secrets of *Free Masonry*,
Fair for all to read and see,
But few there are to whom they're known,
'Tho they so plainly here are shown.[7]

But of course, for those with serious, practical scientific interests, instruments were much more than decorative objects, symbols of conspicuous consumption, or Masonic symbols. They were the tools that made scientific observation and investigation possible, and as such, were very important additions to portraits of men of science.

In the middle years of the eighteenth century, London was the hub of the scientific instrument trade, sending instruments to customers around the world. Many factors contributed to London's leadership in the field. One was a large and growing demand for instruments, stimulated by military activities, imperial expansion, and popular interest in natural history and natural philosophy. The industrial revolution played a part as well, as did the growing commercial culture.

In the eighteenth century, before the term "scientific instrument" had been coined, instruments were referred to as mathematical, optical, or philosophical. Mathematical instruments were designed to measure something—such as distance, angle, or weight—

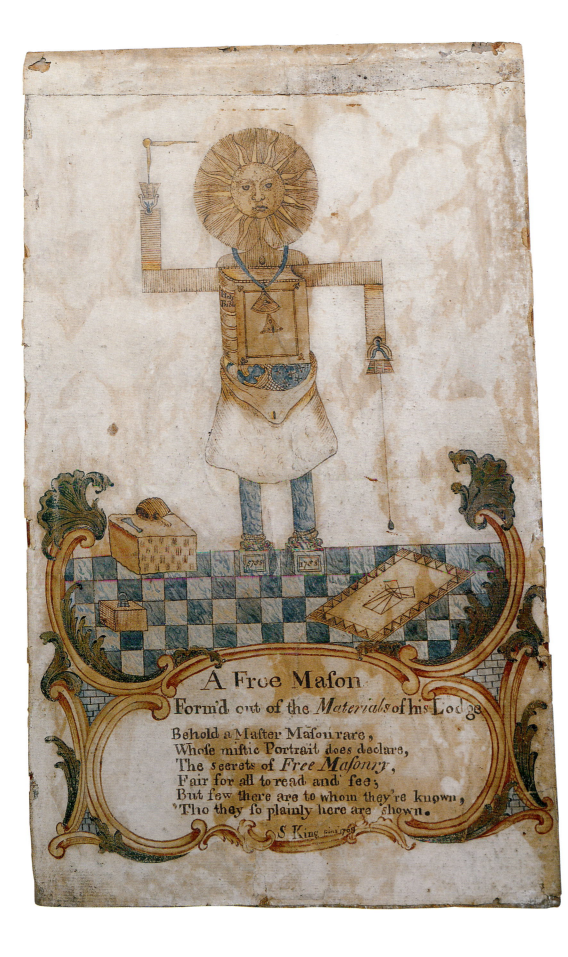

A Free Mason

Form'd out of the *Materials of his Lodge*

Behold a Master Mason rare,
Whose mistic Portrait does declare,
The secrets of *Free Masonry*,
Fair for all to read and see;
But few there are to whom they're known,
Tho they so plainly here are shown.

S King *sinx 1769*

and they tended to be used for practical purposes. Some Americans used mathematical instruments made in England. But because of the great demand for these instruments, particularly for surveying and navigation, and because of the high cost of importing instruments from abroad, several American craftsmen began making mathematical instruments for the American market.

Optical instruments—the term encompassed telescopes and microscopes—might be used for practical or scientific purposes. There was no optical industry in America in the eighteenth century. The few optical instruments said to have been made here were undoubtedly equipped with imported lenses.

Philosophical instruments were designed for teaching of, or research in, the new natural philosophy. The primary instruments here were air pumps and electrical machines, globes and orreries, and they tended to be expensive. The market for philosophical instruments was limited to a few colleges, itinerant lecturers, and wealthy individuals. While there was no philosophical instrument industry in America in the eighteenth century, some philosophical instruments were made here. Notable examples include the electrical apparatus made for Benjamin Franklin and his friends, and the two great orreries made by David Rittenhouse.

Franklin was quite knowledgeable about the London instrument scene, and he often acted as an agent for Americans who wished to purchase English instruments. He aided Harvard in the acquisition of instruments for more than a decade, and procured a number of items to replace those that burned in Harvard Hall in 1764. In April 1769, the president and fellows of Harvard College voted "that the thanks of this Board be given to Dr. Franklin . . . for his care in procuring several valuable Instruments for the Apparatus, and that he be desired to continue his kind regards to the College."[8]

On a livelier note, Franklin's Philadelphia friend and scientific enthusiast, Francis Hopkinson, wrote to him in 1779:

> I would just hint that you cannot oblige me more than by communicating any new philosophical Discoveries, or Systems, new Improvements in Mathematical or philosophical Machinery—new Phenomena—new Doctrines Gim-Cracks &ca for all which I have an insatiable Avidity—When I was in London I never ventured into Nairne's or Adams's Shops, 'till I was just ready to sail for America & had spent all my Money not caring to expose myself to irrisistible Temptation.[9]

Despite a great deal of research into the history of the instrument enterprise, there is much about the production of instruments that remains a mystery. We do not know, for instance, how many hands were employed in most shops, or how many elements of an instrument were made by anonymous subcontractors. At best, we can say that a signature on an invoice or an instrument indicates the shop where that instrument was bought and sold, but that signature is not necessarily that of the actual instrument maker.

In most cases, portraitists depicted instruments actually owned by their subjects. Specific ships could be pictured in portraits of merchants, and landowners might insist on portraits of their estates or houses in the background of theirs. A book or two might be labeled in a clergyman's portrait. But in portraits of men of science, pictured instruments had specific uses, and are still readily identifiable. They could be even more valuable than the portraits in which they were depicted, and were thus tokens of personal wealth as well as markers of scientific ability. While in London, Franklin was given a reflecting telescope made by James Short, noted for his fine instruments. He later made a specific bequest of this instrument to his friend, astronomer David Rittenhouse. The telescope was one of the most highly valued objects in the inventory of Franklin's posses-

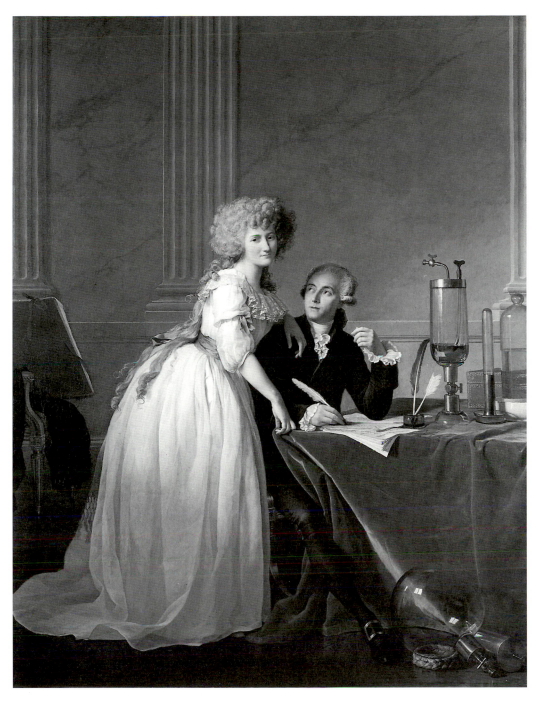

FIGURE 5–7.
*Antoine Lavoisier and Marie Anne
Pierrette Paulze Lavoisier* by
Jacques-Louis David
(1748–1825), oil on canvas,
286 x 224 cm (112 1/2 x 88 1/8
in.), 1788. The Metropolitan
Museum of Art, New York City;
purchase, Mr. and Mrs. Charles
Wrightsman gift, in honor of
Everett Fahy, 1977

sions made after his death.[10] Such instruments were also important indicators of the sitter's connections to the larger European world of science. They, more than any other form of imagery, defined the sitter as a man of science.

We must assume that in most cases, the sitter requested the inclusion of such instruments. However, documentation for the collaboration between subject or patron, and artist in designing portrait imagery is rare. William Gardiner, who in 1774 sought to have his portrait painted by the British artist Joshua Reynolds, was quite specific:

> Having been so fortunate as to make Two Astronomical Discoveries, which will probably incline Posterity to wish for a lively Resemblance of me, I would willingly avail myself of your masterly Pencil to gratify them therein. . . . I will communicate to you the Way and Means I would recommend to make the Portrait acceptable, by the Introduction of Machinery, of which I can furnish you with great Choice.[11]

Mr. Gardiner was not painted by Reynolds, nor remembered for these discoveries, but his letter serves as evidence of the emphasis placed in the conception of a portrait on its potential audience and, in the case of a man of science, the importance of "Machinery" or instruments for a fully realized portrait.

We find a variety of instruments in portraits of Americans. Telescopes were often used to define astronomical interests, while microscopes are found in portraits of botanists, who were often physicians. One academic lecturer, David Wiley, was portrayed with an electrostatic generator, used for demonstrating the properties of electricity to his students. Instruments used in electrical demonstrations appear in one portrait of Franklin, while another depicts a lightning rod of his invention. Dividers or compasses occur in portraits of architects and builders, but also in portraits of surveyors. There are parallels in portraits of British and French men of science, including Jacques-Louis David's full-length double portrait of Antoine Lavoisier (1743–1794) and his wife, Marie Anne Pierrette Paulze (1758–1836), with apparatus for his experiments on gases [Figure 5–7].

Instruments connected with his experiments concerning electricity are prominent in Benjamin Franklin's 1762 portrait, painted while he was in London by a British artist, Mason Chamberlin [Figure 5–8].[12] Little is known of Chamberlin's life. He was a portraitist and a founding member of the Royal Academy, but early sources indicate that he did not live in the West End neighborhoods inhabited by other artists. Rather, he lived in Stuart Street, Spitalfields, in the City, where he found most of his clients. Spitalfields was also the home to a number of Huguenots, many of whom worked as silk-weavers. Among them was John Dollond, a silk-weaver interested in optics, who in 1758 received a patent for an achromatic lens—the most important optical discovery of the century, for it almost eliminated the color distortion present when using a single-element lens. Chamberlin painted Franklin seated, quill pen in hand, in a capacious armchair, turned slightly away from his papers and writing table and listening intently to the ringing of two small bells beside his chair. An iron lightning rod is pictured on a chimney outside the window. The bells and the lightning rod were invented by Franklin. As he wrote in his *Experiments and Observations on Electricity* (one edition of which was published in 1762), "In September 1752, I erected an Iron Rod to draw the Lightning down into my House, in order to make some Experiments on it, with two Bells to give Notice when the Rod should be electrified." The painting also shows two small cork balls, electrified and thus repelled. This experiment was recounted by Franklin's colleague Ebenezer Kinnersley (1711–1778), who traveled throughout the American colonies during the early 1750s, lecturing on "electrical fire" and giving demonstrations of its power [Figure 5–9].[13] The third experiment illustrated in the painting is the so-called "thunder house"—that is, a small, wooden model of a house or church, demonstrating the efficacy of lightning rods, particularly the pointed version promoted by Franklin. The view painted into the window in Franklin's portrait is probably not meant to be an actual cityscape. Or, it is meant to carry more than one interpretation. The exploding house and toppling steeple are likely to be references to the small models used in lectures and demonstrations. These "powder houses," or "thunder houses," were touched with an electrical charge; if uninterrupted, it passed through the house and left it intact, but if blocked, as in a house without a protective lightning rod, the house would explode quite violently [Figure 5–10].[14]

By 1762, Franklin was famous as a man of science, an "electrician." His portrait had already been painted in 1759 in London by Benjamin Wilson, who shared Franklin's interests in electricity, and had developed a rival design for a lightning rod topped with a round ball. Although a mezzotint by James MacArdell was published soon thereafter

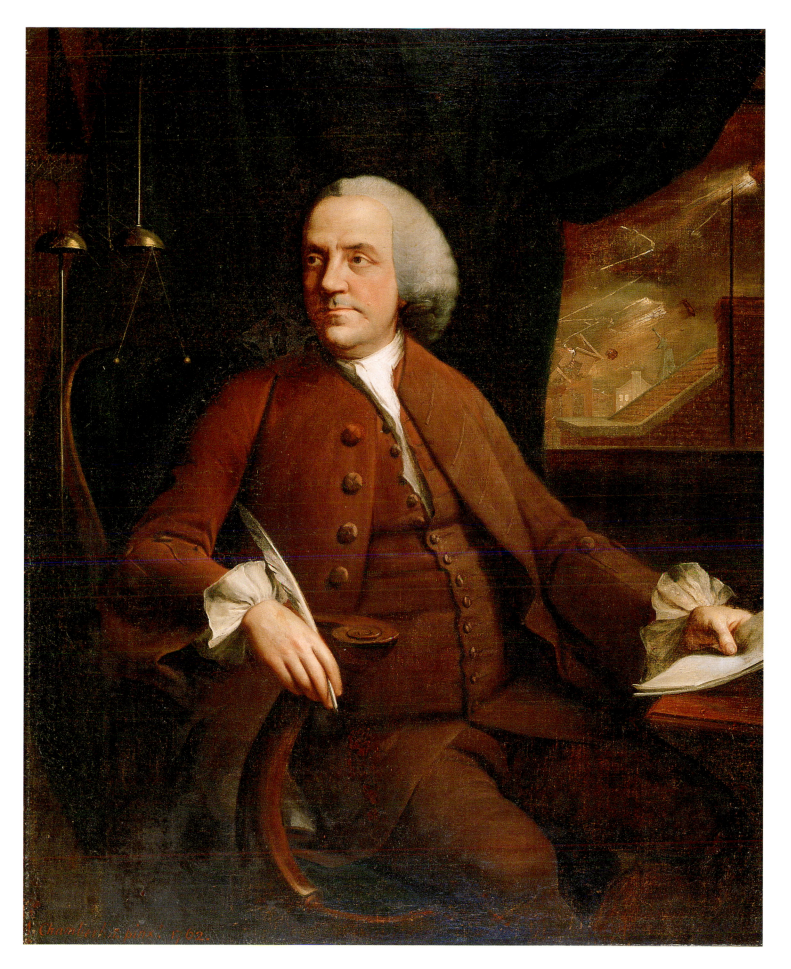

Newport, March 16. 1752.

Notice is hereby given to the Curious,

That at the COURT-HOUSE, in the Council-Chamber, is now to be exhibited, and continued from Day to Day, for a Week or two;

A COURSE of EXPERIMENTS, on the newly-discovered

Electrical FIRE:

Containing, not only the most curious of those that have been made and published in *Europe,* but a considerable Number of new Ones lately made in *Philadelphia*; to be accompanied with methodical LECTURES on the Nature and Properties of that wonderful Element.

By *Ebenezer Kinnersley.*

LECTURE I.

I. OF Electricity in General, giving some Account of the Discovery of it.

II. That the Electric Fire is a real Element, and different from those heretofore known and named, and *collected* out of other Matter (not created) by the Friction of Glass, &c.

III. That it is an extreamly subtile Fluid.

IV. That it doth not take up any perceptible Time in passing thro' large Portions of Space.

V. That it is intimately mixed with the Substance of all the other Fluids and Solids of our Globe.

VI. That our Bodies at all Times contain enough of it to set a House on Fire.

VII. That tho' it will fire inflammable Matters, itself has no sensible Heat.

VIII. That it differs from common Matter, in this; its Parts do not mutually attract, but mutually repel each other.

IX. That it is strongly attracted by all other Matter.

X. An artificial Spider, animated by the Electric Fire, so as to act like a live One.

XI. A Shower of Sand, which rises again as fast as it falls.

XII. That common Matter in the Form of Points attracts this Fire more strongly than in any other Form.

XIII. A Leaf of the most weighty of Metals suspended in the Air, as is said of *Mahomet's* Tomb.

XIV. An Appearance like Fishes swimming in the Air.

XV. That this Fire will live in Water, a River not being sufficient to quench the smallest Spark of it.

XVI. A Representation of the Sensitive Plant.

XVII. A Representation of the seven Planets, shewing a probable Cause of their keeping their due Distances from each other, and from the Sun in the Center.

XVIII. The Salute repulsed by the Ladies Fire; or Fire darting from a Ladies Lips, so that she may defy any Person to salute her.

XIX. Eight musical Bells rung by an electrified Phial of Water.

XX. A Battery of eleven Guns discharged by Fire issuing out of a Person's Finger.

LECTURE II.

I. A Description and Explanation of Mr. *Muschenbrock's* wonderful Bottle.

II. The amazing Force of the Electric Fire in passing thro' a Number of Bodies at the same Instant.

III. An Electric Mine sprung.

IV. Electrified Money, which scarce any Body will take when offer'd to them.

V. A Piece of Money drawn out of a Person's Mouth in spite of his Teeth; yet without touching it, or offering him the least Violence.

VI. Spirits kindled by Fire darting from a **Lady's** Eyes (without a Metaphor.)

VII. Various Representations of Lightning, the Cause and Effects of which will be explained by a more probable Hypothesis than has hitherto appeared, and some useful Instructions given, how to avoid the Danger of it: How to secure Houses, Ships, &c. from being hurt by its destructive Violence.

VIII. The Force of the Electric Spark, making a fair Hole thro' a Quire of Paper.

IX. Metal melted by it (tho' without any Heat) in less than a thousandth Part of a Minute.

X. Animals killed by it instantaniously.

XI. Air issuing out of a Bladder set on Fire by a Spark from a Person's Finger, and burning like a Volcano.

XII. A few Drops of electrified cold Water let fall on a Person's Hand, supplying him with Fire sufficient to kindle a burning Flame with one of the Fingers of his other Hand.

XIII. A Sulphurous Vapour kindled into Flame by Fire issuing out of a cold Apple.

XIV. A curious Machine acting by means of the Electric Fire, and playing Variety of Tunes on eight musical Bells.

XV. A Battery of eleven Guns discharged by a Spark, after it has passed through ten Foot of Water.

As the Knowledge of Nature tends to enlarge the human Mind, and give us more noble, more grand, and exalted Ideas of the AUTHOR of Nature, and if well pursu'd, seldom fails producing something useful to Man, 'tis hoped these Lectures may be tho't worthy of Regard & Encouragement.

Tickets to be had at the House of the Widow Allen, in Thames *Street, next Door to Mr.* John Tweedy's. Price Thirty Shillings *each Lecture. The Lectures to begin each Day precisely at* Three o'Clock in the Afternoon

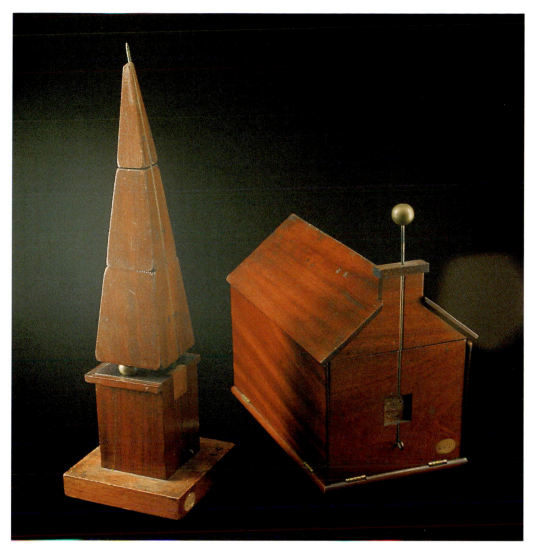

FIGURE 5–10.
Obelisk, mahogany model, 42 cm (16 1/2 in.) high, on a 12 cm (4 3/4 in.) square base, circa 1765, and powder house—mahogany model of a house with a lightning rod, 27 x 16 x 26 cm (10 5/8 x 6 1/4 x 10 1/2 in.), circa 1765. Collection of Historical Scientific Instruments, Harvard University, Cambridge, Massachusetts

This powder house, which could contain a bit of gunpowder, offers a dramatic demonstration of the efficacy of lightning rods. The house is safe when electricity can travel from a cloud to a lightning rod to the ground, but when the circuit is broken, the roof flies off and the walls collapse. Simpler versions of the powder house were known from the 1750s. Harvard College purchased this device in 1789; it was probably made in London. The obelisk works the same way.

FIGURE 5–9. *(opposite)*
Ebenezer Kinnersley, "Notice is hereby given to the Curious . . . A Course of Experiments, on . . . Electrical Fire," broadside, 32.8 x 22.2 cm (12 15/16 x 8 11/16 in.), Newport, Rhode Island, 1752. The Rosenbach Museum and Library, Philadelphia, Pennsylvania

[Figure 5–11], Franklin does not appear to have made much use of it, as he would with the Chamberlin image. Chamberlin's portrait was commissioned by Colonel Philip Ludwell III, a Virginian living in London, and was probably painted during the summer, just before Franklin departed for Philadelphia. As Franklin recounted about two years later: "a Gentleman requested I would sit for a Picture to be drawn of me for him by a Painter of his choosing. I did so, and the Pourtrait was reckon'd a very fine one."[15] Franklin must have approved of it, for he ordered a replica from Chamberlin for his son William, and together they purchased more than one hundred copies of Edward Fisher's engraving after the painted portrait [see Figure 7–13]. Franklin sent them to his friends and colleagues for years thereafter. As he wrote to Thomas François Dalibard on September 22, 1769: "As I cannot soon again enjoy the Happiness of being personally in your Company, permit my Shadow to pay my Respects to you. 'Tis from a Plate my Son caus'd to be engrav'd some years since."[16]

Franklin cultivated his image as a man of science and knew the power of a portrait to secure a public reputation. He also appreciated the subtleties of visual portrayal. When a new French edition (1773) of his *Experiments and Observations* was published with another engraving based on the Chamberlin image, Franklin commented with humor on the slight changes that the engraver had made: "To the French Edition they have prefixed a Print of me, which tho' a Copy of that by Chamberlin, has got so French a countenance, that you would take me for one of that lively Nation."[17]

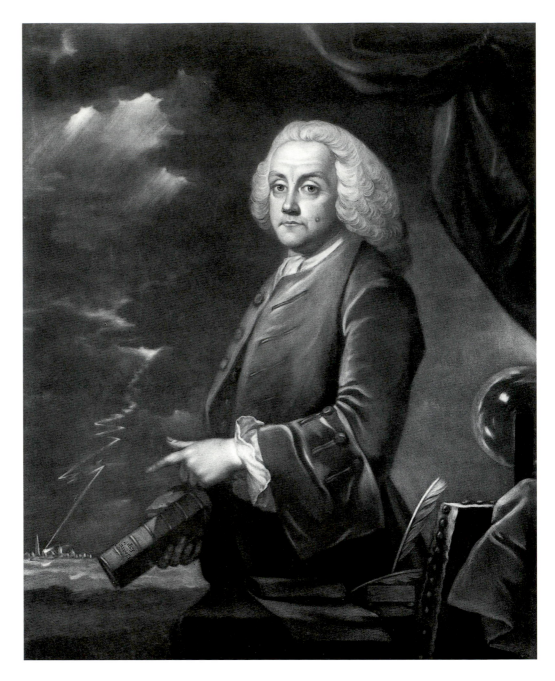

What was so appealing to Franklin about this portrait? How did the artist, who must have consulted at length with Franklin on the electrical apparatus depicted, present him? The still air in Franklin's study is literally electric. If the background is read as a city view rather than a setting for electrical experiments, we see that jagged bolts of lightning are striking buildings portrayed through the window, exploding a house and ripping the steeple top from a church. Franklin observed lightning during thunderstorms; they "inflam'd my Curiosity."[18] The scene is surely Philadelphia, where summer thunder-storms occurred with regularity. As Franklin noted later, in 1772:

> Pointed Conductors to secure Buildings from Lightning have now been in use near 20 Years in America, and are there become so common, that Numbers of them appear on private Houses in every Street of the principal Towns, . . . Thunder Storms are much more frequent there than in Europe, and hitherto there has been no Instance of a House so Guarded being damaged by Lightning. . . . Here in England the Practice has made a slower Progress,

Damage by Lightning being less frequent, and People of course less apprehensive of Danger from it.[19]

It is evening in this portrait, and Franklin observes the electrical phenomena from the safety of his book-lined study, protected from the violent storm by the very lightning rod that brings the charge into his chamber. Franklin is portrayed with the decorum and easy grace allowed to a gentleman, but his clothing, physical wig, and unidealized countenance mark him as one of the professional class. He is the image of controlled energy, calm and observant in the face of a great storm. His amazing discoveries and inventions are summarized visually, while his rational genius is paralleled not by the wild lightning but by the controlled invisible force that pushes the cork balls apart and causes the bells to ring. Such genius was widely admired by men of Franklin's generation. In a eulogy that Benjamin Rush delivered in 1790, he praised William Cullen, the great professor of medicine at the University of Edinburgh, for having a genius that was not "eccentric" but orderly: "The actions of the former may be compared to the crooked flash of distant lightning, while the latter resembles in its movements the steady revolutions of the heavenly bodies."[20]

The model houses and the electrified cork balls in Franklin's portrait were examples of equipment used by Ebenezer Kinnersley and others who spoke, for a fee, on scientific or "philosophical" topics. Isaac Greenwood had lectured publicly in Boston in 1727 and 1734, and at the Library Company of Philadelphia in 1740.[21] A "Dr. Spence" in Boston in 1746 had sparked Franklin's curiosity concerning electricity. Lecturers often carried philosophical apparatus, including orreries, air pumps, and electrostatic machines, with them. Such apparatus, when it could be afforded, was also used by instructors in schools and colleges.

Charles Peale Polk's portrait of Presbyterian minister David Wiley (circa 1768–1812), which includes an unusual cylinder electrical machine, may allude to such a use, for Wiley moved to Georgetown around 1800 to serve as principal of the Columbian Academy, where he taught natural philosophy and mathematics, geography, and Greek [Figure 5–12]. Advertisements for the academy mention apparatus owned by the school, including "Globes, Maps, an Electrical Machine, Quadrant, and other Mathematical Instruments."[22] Wiley also worked as a surveyor, served as mayor of Georgetown in 1811, and as secretary to the Columbian Agricultural Society for the Promotion of Rural and Domestic Economy, which had been organized by gentlemen of Maryland, Virginia, and the District of Columbia. Wiley founded and edited the society's journal, the *Agricultural Museum*, from its inception in 1810 until around 1812.[23]

Wiley's portraitist, Charles Peale Polk, was Charles Willson Peale's nephew. Polk, who moved to Washington around 1801, grew up in his uncle's household, where he absorbed Peale's interest in natural history and learned to paint. Polk thought of opening a museum in Washington like his uncle's in Philadelphia, but was dissuaded from this enterprise by Peale. We know nothing about the circumstances surrounding his portrait of Wiley. It probably dates from around 1802, when both men were fairly new to Washington, and when, according to newspaper advertisements, Wiley was lecturing on science at the Columbian Academy, using the above-mentioned "Electrical Machine." The machine pictured in Wiley's portrait is of English design, and is unusual in that the cushion, which generates a charge by turning against the glass, is on the bottom rather than the side of the cylinder. The metal spikes just visible at the top of the cylinder, which collect the charge (only positive in this machine), should also be on the side [Figure 5–13]. Other inconsistencies in the machine, all parts of which sit on a wooden

base atop the table, could be the result of the artist's misunderstanding of its components, but given Polk's connections to the scientific milieu of Peale's museum, the machine may be an unusual one designed by Wiley. He poses proudly beside it, holding a Leyden jar, which would have been used to store an electric charge for future use.

Of the many portraits of American merchants and mariners that include mathematical instruments, Charles Willson Peale's portrait of Captain James Josiah (1751–1820) is perhaps the finest [Figure 5–14]. The portrait is signed and dated 1787. Josiah, a master mariner, was the captain and part owner of the brig *St. Croix Packet*, which made regular voyages to the West Indies. He was in Philadelphia in March 1787 and returned in early June.[24] At this time, Josiah was persuaded to join the crew of the 290-ton ship *Asia*, whose builder was Josiah's father-in-law, Joseph Marsh. The *Asia* was the first Philadelphia vessel specifically built for the China trade. Josiah must have been enamored of the prospect of such an adventurous undertaking, for he agreed to be first mate, or second in command, in order to make the voyage to China. Josiah probably sat to Peale during the summer or fall. The *Asia* was launched on August 16, and Josiah was "put in pay" on August 29. The ship sailed from Philadelphia on December 10, 1787.

Josiah is posed as though in the cabin of a ship, with a brig that may be meant to represent the *Asia* visible in the distance. He wears the uniform of a Continental navy captain, as described in the uniform regulations issued in September 1776. Since Josiah had served as a captain during the Revolution, his use of this uniform is appropriate, especially in a portrait that highlights his competency as a ship's officer.[25] On the table is a chart of Asian waters. The inscribed images and words are to some extent illegible, but

FIGURE 5–12. *(opposite)*
David Wiley by Charles Peale Polk (1767–1822), oil on canvas, 92.1 x 65.7 cm (36 1/4 x 25 7/8 in.), circa 1800. National Portrait Gallery, Smithsonian Institution, Washington, D.C.

FIGURE 5–13
Cylinder electrical machine made by E. Palmer, London, wood, glass, brass, and silk, 38.8 x 25.8 x 49.4 cm (15 3/8 x 10 1/8 x 19 1/2 in.), after 1838. Division of Information, Technology, and Society, National Museum of American History, Smithsonian Institution, Washington, D.C.

The object in the portrait of David Wiley is a cylinder electrical machine, a form that originated in the 1740s and remained popular through the first half of the nineteenth century. When the glass cylinder is rotated and rubbed against a cushion of leather, an electrical charge is generated. The object in Wiley's hand is a Leyden jar, which would store the electrical charge generated by the machine.

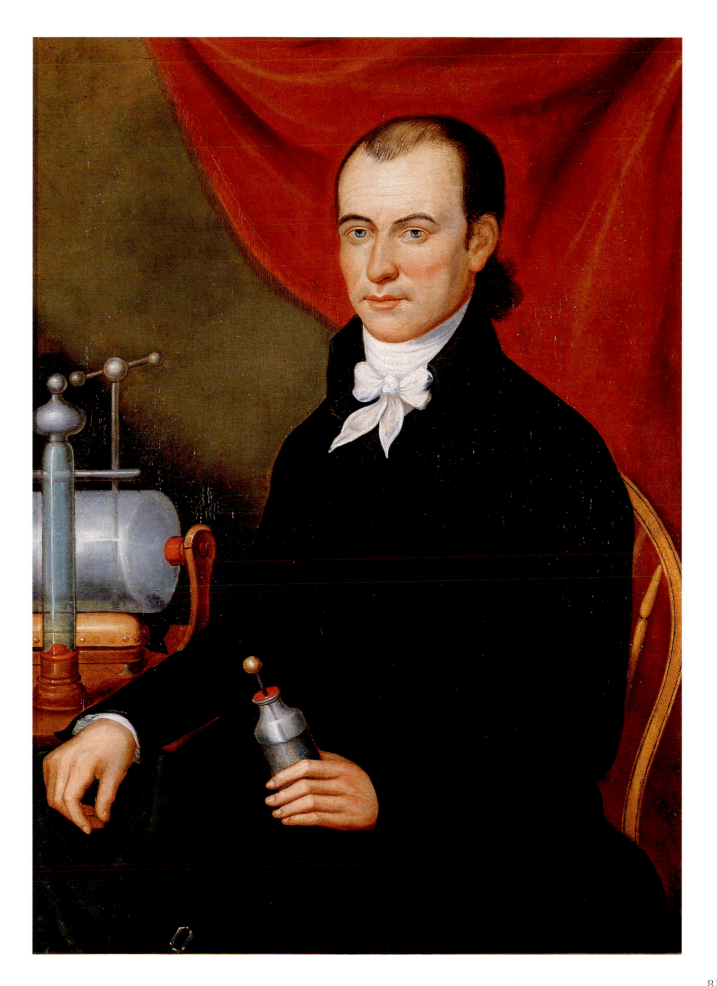

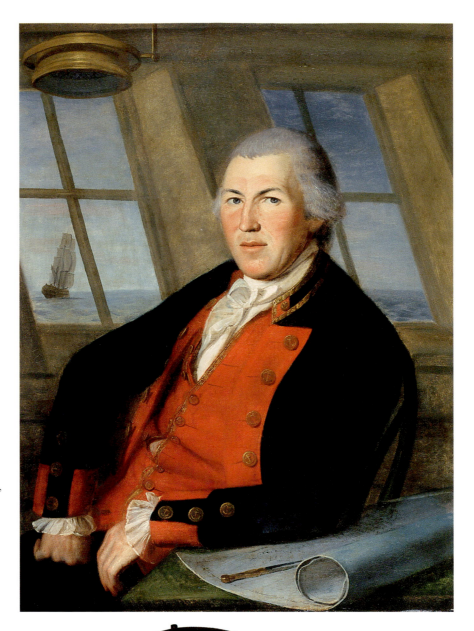

FIGURE 5–14.
James Josiah by Charles Willson
Peale (1741–1827), oil on canvas,
91.4 x 67.6 cm (36 x 26 5/8 in.),
1787. Private collection

FIGURE 5–15.
"Tell-tale" compass, marked
"Made by Jno Gilbert Tower
Hill, London," brass drum case,
glazed bottom with engraved
thirty-two-point card, case: 15.9
cm (6 1/4 in.) high; 15.9 cm
(6 1/4 in.) diameter, circa 1790.
Peabody Essex Museum, Salem,
Massachusetts

This type of compass was
designed to hang from the ceiling
of the captain's cabin so that he
could monitor the direction of
his ship even when in bed.

FIGURE 5–16.
Benjamin King by an unidentified
artist, oil on canvas, 86.4 x 71.1
cm (34 x 28 in.), circa 1785.
Peabody Essex Museum, Salem,
Massachusetts

include "BONEA BRADRANCA . . . MOTAPE . . . NONO . . . [and] JAPAN." On the
chart is a pair of dividers, and a "tell-tale" compass is secured to the ceiling above
[Figure 5–15]. Tell-tale compasses are rare today; most eighteenth-century examples
were made in England, but some were crafted in America.

Although most of the instruments that Americans used for observing or teaching
about natural phenomena were imported from England, a number of makers of mathe-
matical instruments, and makers of clocks and other timepieces, did work in America,
supplying appropriate devices for navigation and surveying. Most of these men were
from the artisan class. Given the cost of a painted portrait on canvas and its status in the
eighteenth century, it is not surprising that there are few such likenesses of instrument
makers. One example is a painting that has traditionally been identified as Benjamin
King of Salem (1740–1804), a member of a large family of mathematical and nautical
instrument makers in Salem, Massachusetts, and Newport, Rhode Island [Figure 5–16].
King's portrait is not grand, but is larger than the more standard quarter-length size.
The canvas approximates the "kit-cat" size (36 x 28 inches), which included the hands
and often an attribute referring to the sitter's profession or avocation. The painting may
be dated by his clothing to circa 1785. Although there is no signature on the portrait, it is
tempting to associate it with King's first cousin Samuel King. He painted portraits in
Newport but traveled occasionally to Salem, and worked in his father's instrument shop,
which he continued to run after his father's death in 1786. King signed and dated a por-
trait of Boston minister John Eliot in 1779. He also appears to have been in Boston
again from about 1780 to 1785, where he rented the studio that had once been John
Smibert's.[26]

King's coat and waistcoat are plain but well made. He does not wear a wig, in keeping with the fashion; after 1770 they were worn less frequently than earlier. He leans with his arm draped over the back of a chair, his right hand placed inside the front of his waistcoat, a conventional sign of gentility. François Nivelon's *Book of Genteel Behavior* (London, 1738) described this pose as signifying "manly boldness tempered with modesty."[27] The awkwardness of the pose is due to the painter's lack of experience; the attitude that he has attempted to convey was meant to be easy and graceful.

The artist has posed King holding a spyglass of the type used by mariners. Benjamin King made mathematical and navigational instruments; however, the spyglass he holds was probably made in England. Even if King had the skill to fabricate a spyglass (the lenses would still have been imported), there would have been no reason to have done so.

Another portrait that makes use of instruments and pose to transform a practical man who worked for a living into a polite man of science is John Mason Furness's portrait of John Vinall (1736–1823), which probably dates from the early 1790s [Figure 5–17].[28] Vinall spent most of his career teaching mathematics and writing in Boston and Newburyport, and he is known to have made a map of a portion of Newburyport. In 1773 he inquired if Henry Knox would sell him a pair of English globes that Knox had acquired by mistake. Vinall dedicated his textbook on practical mathematics, *The Preceptor's Assistant, or Student's Guide: Being a Systematical Treatise of Arithmetic, both Vulgar and Decimal; Calculated for the use of schools, counting houses, and private families* (Boston, 1792) to Governor John Hancock, whose son had attended Vinall's school. In 1794, Vinall sent a copy of his book to the American Philosophical Society, through David Rittenhouse, then president of the society. The letter made clear his desire to be accepted as a correspondent of the society, and of Rittenhouse. He apologized for writing without introduction to Rittenhouse, for he was "acquainted with the celebrity of your character." Vinall then detailed his various scientific interests, including mathematics, his "observations upon the variations of the magnetic needle," and his "experiments in medical electricity."[29]

Vinall did not have a degree from a colonial college or British university. In spite of assertions made in his letter to Rittenhouse, there is no evidence that he participated in the activities of Boston's American Academy of Arts and Sciences. However tenuous his links to the polite world of scientific correspondence, he clearly made the most of every opportunity. Vinall's portrait has been dated to the early 1790s, partially because the publication of his book in 1792 would have been an important event in Vinall's life, an event worthy of commemoration by a portrait. Little is known of the artist, John Mason Furness. Like Samuel King, he had also rented John Smibert's former studio in Boston, just after King had vacated the premises in 1785. The style of Vinall's portrait indicates that Furness may have attempted to emulate John Singleton Copley's work, with its strong lights and darks, and careful attention to details and the reproduction of surfaces. Furness has painted him in an easy, informal pose, as though inscribing a map with his quill pen. He wears fine attire, including an elaborately embroidered, if old-fashioned, waistcoat. Vinall's portrait is evidence for his desire to be portrayed as a man of scientific and mathematical skill, and the owner of an expensive terrestrial globe and cased drafting instruments. Such goods—clothing, furniture, and instruments—defined his identity as clearly as his fierce expression.

John Singleton Copley's masterful portrait of John Winthrop (1714–1779), the Hollis professor of mathematics and natural philosophy at Harvard, presents an American who aspired to scientific renown on an international stage [see Figure 5–1]. This portrait is usually dated to around 1773, as Winthrop paid Copley for a portrait of his wife, Hannah Fayerweather Winthrop, in June of that year.[30] Copley was Boston's

FIGURE 5–17. *(opposite)*
John Vinall by John Mason Furness (1763–1804), oil on canvas, 125.3 x 100.6 cm (49 3/8 x 39 5/8 in.), circa 1792. Brooklyn Museum of Art, New York; Dick S. Ramsay Fund, 41.878

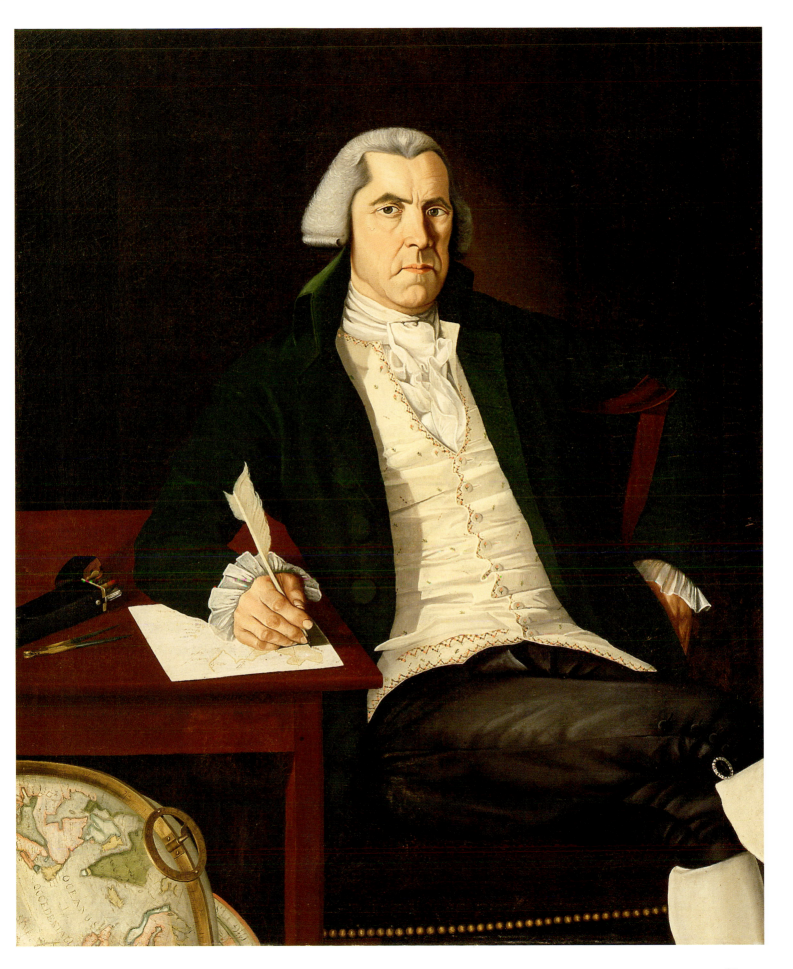

preeminent painter, and his patrons were mostly wealthy merchants and professional men, and their wives. His portrait of Winthrop is unusual in its precise focus on the sitter's scientific and academic work.

Winthrop was one of America's most learned men of science. He corresponded with Americans Benjamin Franklin, James Bowdoin, and Ezra Stiles, as well as men of science in Britain about his observations and discoveries. With assistance from Franklin, Winthrop was elected to the Royal Society of London in 1766, and to the American Philosophical Society in 1768. In 1771 he was granted an honorary doctorate of laws by the University of Edinburgh, and in 1773 the same degree was bestowed on him by Harvard—the first time the degree had been awarded there.

 Stephen Sewall, who graduated in 1761, remembered Winthrop's lectures: "His diction was refinedly pure, and exquisitely elegant; his method perfectly easy, and in the highest degree perspicuous. So compleat a master was he of every subject he handled, that each new lecture seemed a new revelation."[31] Winthrop sometimes permitted students to use the philosophical apparatus. Benjamin Wadsworth noted that "Mr. Winthrop set Spirits of wine on fire by Electricity & I with a Considerable number of my class & others were electrized."[32]

Soon after taking on his duties at Harvard, Winthrop ordered a copy of Newton's *Principia* from London, and he eventually incorporated his understanding of Newton's laws into his lectures. Ezra Stiles wrote on hearing of his death, "In Math. & nat. Phil. I believe he had not his equal in Europe: he was a perfect master of Newton's Principia—which cannot be said of many Professors of Philosophy in Europe."[33]

Winthrop was especially fascinated by astronomy, publishing papers on sunspots, comets, the transit of Mercury across the sun in 1741, and the transits of Venus of 1761 and 1769. He explained the importance of these latter events in a lecture delivered in March 1769:

> A Transit of Venus under the Sun is the most uncommon, and the most important phaenomenon, that the whole compass of astronomy affords us. . . . On account of their rarity alone, they must afford an exquisite entertainment to an astronomical taste. But this is not all. . . . They furnish the only adequate means of solving a most difficult Problem,—that of determining the true distance of the Sun from the Earth. This has always been a principal object of astronomical inquiry. Without this, we can never ascertain the true dimensions of the solar system and the several orbs of which it is composed, nor assign the magnitudes and densities of the Sun, the planets and comets; nor, of consequence, attain a just idea of the grandeur of the works of GOD.[34]

Transits of Venus are very rare, occurring at intervals of eight years and then more than one hundred years. One had been observed by two astronomers in 1639. The next would not occur until 1874 and 1882. Thus, the two eighteenth-century transits of Venus were the subject of great anticipation. In 1754, Peter Collinson wrote to a friend who had been frustrated in astronomical observations, "We will hope for Better Success, If Please God You live till Venus make her Transit."[35]

Winthrop and two of his students made the arduous journey to St. John's, Newfoundland, to observe the transit of Venus in the early morning of June 6, 1761. He was extremely proud of having been the only informed observer in North America of an event that had riveted the attention of men of science throughout Europe. In his account of the voyage, he described the location of their observation camp and the transit itself:

> The town of St. John's being bounded with high mountains toward the Sun-rising, so that no house in it would answer our end, we were obliged to seek farther; and, after a fatiguing and

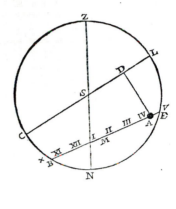

FIGURE 5–18.
Page from John Winthrop, *Relation of a Voyage from Boston to Newfoundland for the Observation of the Transit of Venus, June 6, 1761* (Boston, 1761). Rare Books and Special Collections Division, Library of Congress, Washington, D.C.

fruitless attempt or two, fix'd on an eminence at some distance, from whence we could have a view of the Sun presently after his rising. . . . We pitch'd some tents upon it for a shelter; which, together with our Apparatus, and such materials as we had occasion to make use of, we convey'd up thither, with the labor of several days. . . . The morning of the 6th of June was serene and calm. The Sun rose behind a cloud that lay along the horizon, but soon got above it; and at 4h 18m we had the high satisfaction of seeing that most agreable Sight, VENUS ON THE SUN, and of shewing it in our telescopes to the Gentlemen of the place, who had assembled very early on the hill to behold so curious a spectacle.[36]

Winthrop described his observations and calculations in much detail, and included a diagram of the planet's path across the sun [Figure 5–18]. He published his findings in Boston, but also sent them to England, so that all of the observations could be correlated. In 1769, Winthrop's asthma prevented any thought of journeying to Lake Superior, where the complete transit of that year might be viewed, and he had to content himself with observations made from Cambridge. These observations were most likely made with the telescope pictured in his portrait.

Winthrop's portrait celebrates his great achievement in Newfoundland in 1761 as well as his more localized observations of the transit of 1769. The circumstances surrounding the commission are unknown. Copley created a painting filled with references to Winthrop's love for astronomy and to his adventurous expedition.

Winthrop sits in a darkened chamber. He is dressed in a physical wig and a black academic gown (not a banyan) with starched linen bands, and is surrounded by the deep blues of the tablecloth and upholstered chair. He points to a diagram of the transit of Venus, which corresponds exactly to that published in his account of his 1761 expedition.[37] The pink dawn sky and large verdant hill visible through the columned aperture clearly make reference to the hill (named "Venus's Hill" by the "Gentlemen present")

FIGURE 5–19.
Gregorian reflecting telescope made in London by James Short (1710–1768), brass, steel, and glass, 43 x 37 x 27 cm (16 15/16 x 14 1/2 x 10 5/8 in.), circa 1758. Collection of Historical Scientific Instruments, Harvard University, Cambridge, Massachusetts

James Short, a leading optician of the eighteenth century, made more than a thousand telescopes for astronomers throughout Britain and across Europe. Winthrop seems to have been his first American customer.

Like most of Short's telescopes, this is based on the optical design introduced by James Gregory in 1663. The markings—"JAMES SHORT LONDON 163/954 = 12"—mean that it was made in London, that it has a focal length of 12 inches, that it was the 954th telescope that Short had made, and the 163rd of that focal length.

John Winthrop used this telescope to observe the transit of Venus across the face of the sun in 1769. Winthrop's grand-uncle, who was also named John Winthrop, had a telescope in the 1660s; this may have been the first astronomical telescope in America.

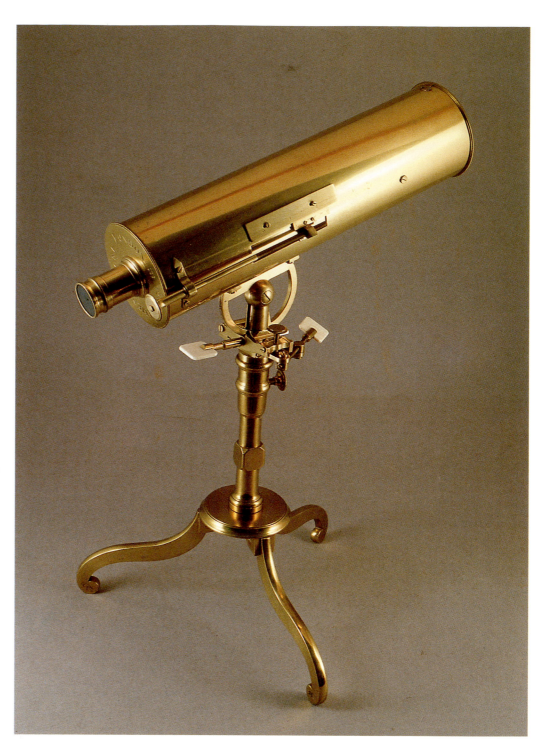

where Winthrop made his sunrise observations. Gleaming on the table, next to several books, and pointed to the softly lighted sky visible through a large aperture, is his brass reflecting telescope.

Winthrop's telescope was a Gregorian reflector made by James Short (1710–1768), an optician from Edinburgh who spent most of his working life in London. Recent research on the serial numbers devised by Short for his instruments indicates that this telescope dates from the late 1750s.[38] Franklin was in London at the time, and may have ordered it from Short, whom he characterized as "a Friend of mine, and the great Optician." The telescope was given to the college after Winthrop's death, and remains in Harvard's Collection of Historical Scientific Instruments [Figure 5–19].

Winthrop may have used his own telescope to observe the 1769 transit of Venus. For the 1761 transit, however, he used a "curious reflecting telescope," which had been made by Benjamin Martin in London and which Thomas Hancock had given to Harvard. This telescope, after having been lost for many years, now belongs to the Science Museum in London.[39]

Copley's painting may be read as a summation of Winthrop's life, referring to astronomical events that were of utmost importance to him and his international reputation. At the same time, with the telescope pointing toward the heavens, it may refer to a future journey beyond the terrestrial sphere. After Winthrop's death in 1779, Mercy Otis Warren, who was one of Mrs. Winthrop's closest friends, and a sitter to Copley herself [see Figure 2–4], published verses about him that provide a verbal parallel to the portrait:

The musick of the spheres resounds,	Treads o'er the pavement of the skies,
And hastens the delay;	And looking down, surveys
A cherub lowers his golden wings,	A thousand transits gliding through
And wafts him on his way.	The vast extended space.
He through a galaxy of light,	Venus may pass the nether sun,
By Newton's eye unseen,	And planets cross the pole;
Beyond the telescopic view,	The great astronomer beholds
Of weak-ey'd, mortal men,	The author of the whole.[40]

A telescope also appears in Charles Willson Peale's portrait of John Ewing (1732–1802), a Presbyterian minister who taught natural philosophy at the University of the State of Pennsylvania, as the College of Philadelphia was named upon restructuring in 1779 by the radical Pennsylvania government. Like Winthrop at Harvard, Ewing was especially interested in astronomy. He observed the 1769 transit of Venus from Philadelphia, and he contributed articles on astronomy to the first American edition of the *Encyclopedia Britannica*. His lectures on natural philosophy were published after his death.

Ewing and Peale had ample opportunity to know one another. Ewing's appointment as the university's provost in 1779 aligned him with the radical Whigs then in power, called a "mobocracy" by Benjamin Rush, a group that included Peale and David Rittenhouse.[41] And Ewing was serving as vice president of the American Philosophical Society in 1786 when Peale was elected to membership in that organization. Peale must have been commissioned by Ewing to paint the portrait by June 1787, when he wrote to Ewing that "being without money for my marketing tomorrow obliges me to ask your assistance in two or three pounds . . . will it be convenient to you to sett some time tomorrow."[42] The portrait was not finished until August 1788 [Figure 5–20].[43]

The painting depicts Ewing in his physical wig and elaborately ruched academic gown. He seems cool enough, but a few details betray the hot summer atmosphere. Ewing's hand holds the quill pen loosely over limp sheets of paper on which nothing is written, and his starched linen bands are not quite as stiff as decorum would require—one corner is turned up. Later in 1788, Peale painted at least one portrait, of William Smith of Baltimore, that makes direct reference to the autumn season. Perhaps he has with a few slight details indicated the heat felt in a closed, dark chamber during the course of a sultry Philadelphia day.

The telescope in the background is a Gregorian reflector of the type made by W. & S. Jones of London. Although we do not know whether this instrument belonged to Ewing

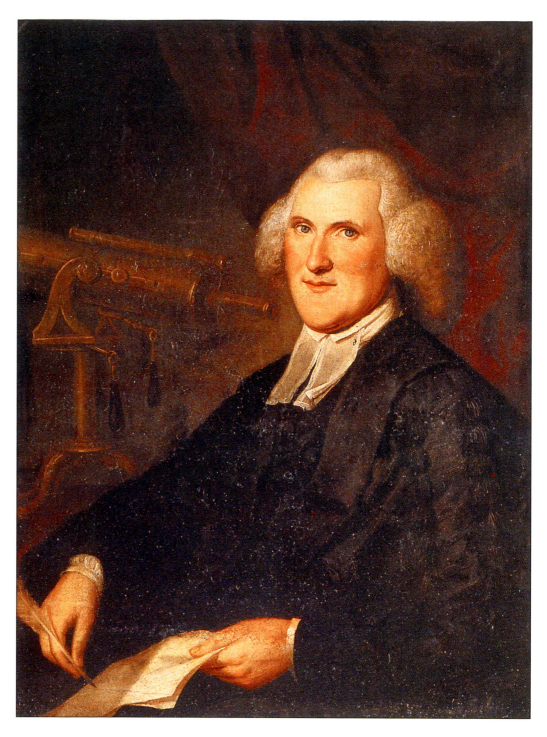

FIGURE 5–20.
John Ewing by Charles Willson Peale (1741–1827), oil on canvas, 91.5 x 68.5 cm (36 x 27 in.), 1788. Dean Emerson

or to the university, we do know that Joseph Priestley had a similar instrument at his home in Northumberland, Pennsylvania. So, too, did the Séminaire de Québec, the first Francophone institution of higher learning in North America [Figure 5–21].

Optical instruments were also treasured by botanists, including James Greenway (circa 1720–circa 1797), a wealthy landowner in Dinwiddie County, Virginia.[44] Luigi Castiglioni, an Italian count who visited Greenway in 1786, noted that he was also "an Englishman by birth, a doctor by profession, and an amateur botanist." Moreover, "Being versed in the rudiments of the Linneanus system, he gathered and named more than six hundred plants, some of which are rather rare and have not yet been written up."[45]

By 1788, Greenway was corresponding with the American Philosophical Society,

and in 1794 he was elected to membership in that organization. These links to the larger scientific community, however tenuous, were of utmost importance to Greenway, who even at the end of his life intensely felt his isolation. As he wrote to Benjamin Smith Barton in 1792, "I wish I could spend the Remainder of my Days in the Conversation and Litterary Correspondence of Men of Science, like yourself; but my remote and obscure Situation almost deprives me of those mental Enjoyments, which arise from such Society."[46]

Greenway's correspondence with Benjamin Smith Barton reveals that he hoped to publish his vast collection of Virginia plants, in an attempt to improve upon John Clayton's *Flora virginica*, published by Gronovius in 1743. Greenway's personal copy of *Flora virginica* is laboriously annotated, but his work was never brought to fruition. When he died, sometime before 1797, he left some forty volumes of dried specimens, later destroyed. In one letter to Barton, Greenway recounted the history of his botanical interests:

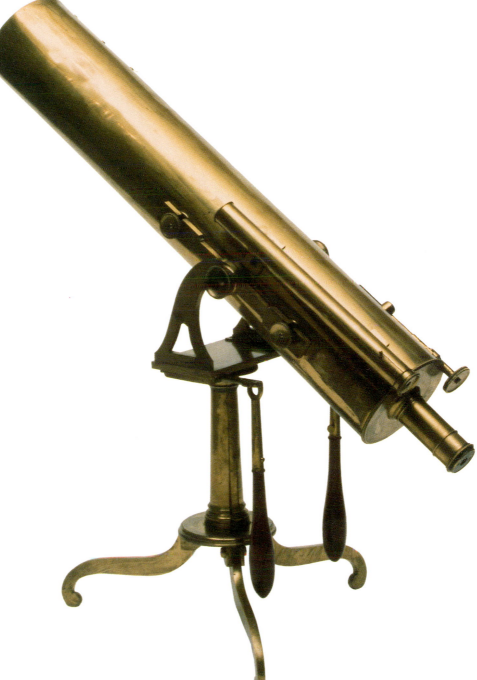

FIGURE 5–21.
Gregorian reflecting telescope signed by W. & S. Jones, London, brass, 50 x 40 x 30 cm (19 5/8 x 15 3/4 x 11 3/4 in.), circa 1800. Musée de la civilisation, dépôt du Séminaire de Québec, Canada

The reflecting telescope in John Ewing's portrait was probably purchased from George Adams Jr., the leading purveyor of scientific instruments in London in the latter decades of the eighteenth century. This particular example belonged to the Séminaire de Québec. It was sold by W. & S. Jones, the London firm that purchased Adams's stock following his death in the 1790s.

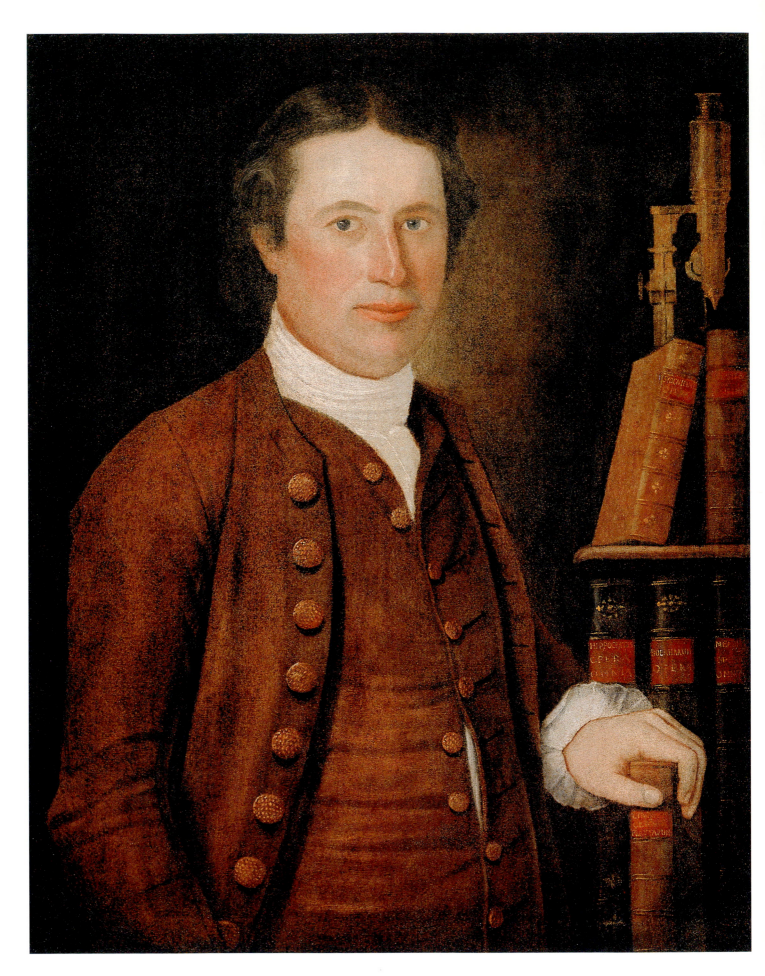

Between 20 & 30 Years ago, a Professor in one of the European Universities was introduced, by letter, to me, and requested a Collection of our American plants, which I proposed to publish in Germany. In the course of two or three years, I sent him between 400 & 500. These he carried to Linnaeus, for Assistance, as the dried plants were difficult to investigate. This brought on a further correspondence with the Founder of our System, who complimented me with a Copy of his Works, and his Picture. . . . Our Correspondence was broke off by the War commencing between Britain and America. —The War giving a different Turn to Mens Minds, our botanical Studies lay neglected.[47]

John Durand made reference to these botanical interests in his portrait of Greenway [Figure 5–22]. Although this portrait is undated, it is similar in style to Durand's 1775 portrait of Greenway's neighbor, Gray Briggs, and was probably made at that time. Durand was an itinerant artist who also painted in New York, Connecticut, and Bermuda.[48]

FIGURE 5–22.
James Greenway attributed to John Durand (active 1765–1782), oil on canvas, 75 x 60.8 cm (29 1/2 x 23 15/16 in.), circa 1775. Muscarelle Museum, College of William and Mary, Williamsburg, Virginia

Durand portrayed Greenway with a dignified bearing, in a plain but elegant suit of clothes. Several buttons of his waistcoat are undone, a pictorial convention that appears to indicate the potential for the "hand-in" gesture, a sign of polite bearing. Two shelves of medical treatises—by such great physicians as Hippocrates, Sydenham, Boerhaave, Richard Mead, and Celsus—indicate Greenway's medical competence.[49] By placing Greenway's hand on a volume of Linnaeus's *Genera plantarum*, Durand called attention to his interest in botany. This pose may reflect awareness of Linnaeus's own 1740 portrait by A. Ehrensvärd, reproduced in several contemporary engravings [Figure 5–23]. It was perhaps one of these prints that Linnaeus (1707–1778) sent to Greenway, which Greenway referred to as "his Picture," sent with a copy of Linnaeus's works. The engraving hung in a place of honor in Greenway's library for years thereafter.[50]

Another item in the portrait is a fine brass Cuff-type microscope, a form designed in the mid-1740s by London instrument maker John Cuff, and made and sold by London makers into the early nineteenth century [Figure 5–24]. Microscopes of this sort were expensive—exceedingly nice to own, but not absolutely necessary for the examination of botanical specimens. Although Greenway mentions "the help of a glass" in his 1788 "account of the beneficial effects of the CASSIA CHAMAECRISTA," this could easily have been a reference to any sort of magnifying glass.

In one instance, the inclusion of an instrument in a portrait constituted a visual joke. The Reverend William Smith (1727–1803) was an Anglican minister who taught mathematics and natural sciences at the College of Philadelphia. During the tumultuous years surrounding the American Revolution, he was twice provost, first of the college, and later, of the University of Pennsylvania. Benjamin Rush's son James called him "a man of light but lively parts—of some learning and much eccentricity."[51] Over the years, Smith's irascibility made him many enemies, including Benjamin Franklin, who had initially appointed him to head the Philadelphia Academy, the college's precursor. At Franklin's death in 1790, he received as many votes as David Rittenhouse for the honor of proclaiming a eulogy to Franklin; it was almost a year later before Smith delivered it. Afterward, according to a Smith family anecdote, his daughter remarked, "I don't think you believed more than one-tenth part of what you said of old Ben Lightning-rod."[52]

Around 1800 Smith arranged to have his portrait painted by Gilbert Stuart, the leading painter in Philadelphia [Figure 5–25]. By 1802, if not earlier, Stuart was Smith's neighbor and sometime dinner guest.[53] In a letter to Smith, Benjamin Rush described Stuart as "a man whose talents for conversation have long commanded nearly as much admiration as his pencil."[54]

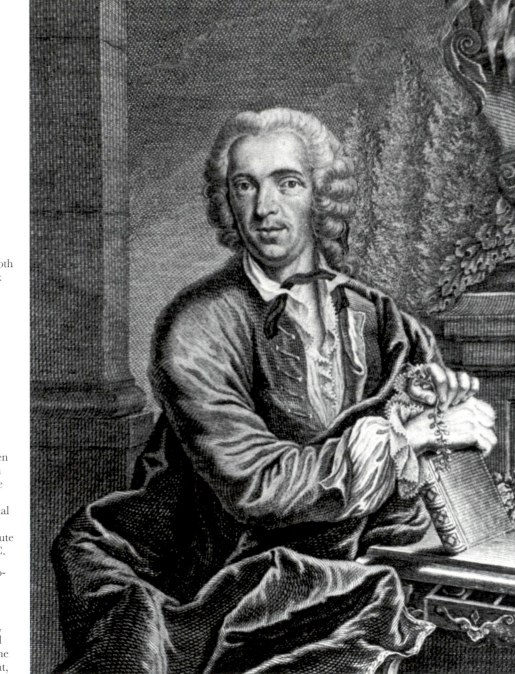

The painting is large, and unusual for Stuart in its horizontal format. Smith wears a crimson-hooded academic gown that designated a doctor of divinity from Oxford, a degree he received in 1759. He is engaged in writing, with one quill in hand and another nearby, and a handkerchief in his left hand, perhaps to blot any spills. Behind a red drape is an extensive view of the Falls of the Schuylkill, a prospect near Smith's country house. Under the papers on his table is a compass. Behind the scattered books is a magnificent brass theodolite, a surveying instrument used for measuring horizontal and vertical angles. This particular example seems to be the extremely expensive "plain" theodolite attributed to the noted London instrument maker Jesse Ramsden, and advertised in 1791.

By the late 1790s, Smith had lost his wife and retired from academic life to his coun-

try house. He became involved in land speculation in the western part of the state, and with the building of canals. In 1799, he took offense at some statements made by Benjamin Latrobe, who had been engaged to design the waterworks that would supply Philadelphia with good water from the Schuylkill, a plan that superceded an older one, supported by Smith, to contrive a system of canals and aqueducts for the same end. Smith was particularly affronted by what he perceived as Latrobe's attacks on his scientific and mathematical skill.[55] He replied in print, a lengthy rejoinder full of sarcasm, and Latrobe made the mistake of also replying in print. This drove Smith into a vitriolic outburst, which concluded, in answer to an example Latrobe had given concerning the velocity and path of running water, with Smith's verbal image of pouring an entire bowl of "Toddy" down poor Latrobe's throat![56] Latrobe published nothing more on the subject, but noted in his diary:

> Dr. Smith, so well known for his talents, by his abuse of them,—for his famous political sermon at the beginning of the revolution, & his Canal exertions since the war,—is now an old decrepid Man, worn down by age & hard drinking. He rides a miserable broken-winded, & potbellied mare, whose figure is as grotesque as that of the Doctor.[57]

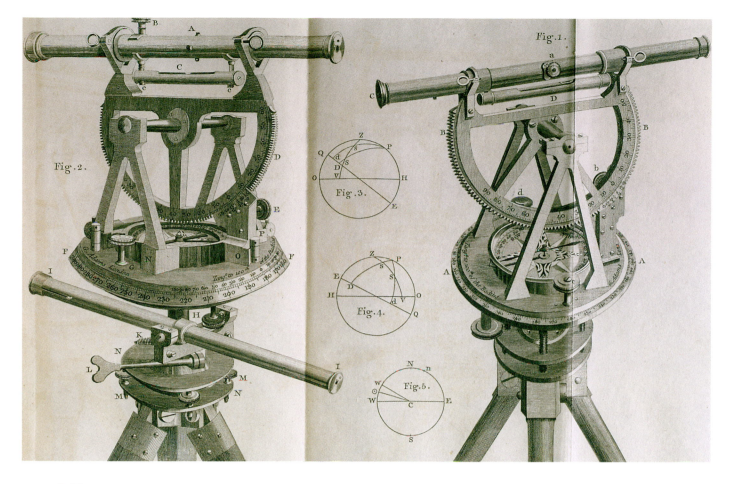

FIGURE 5–26.
"Plain" theodolite (left), made in London, probably by Jesse Ramsden (1735–1800) and illustrated in George Adams, *Geometrical and Graphical Essays* (London, 1791). Smithsonian Institution Libraries, Washington, D.C.

A theodolite is a surveying instrument with a telescope, which is designed to measure horizontal and vertical angles. The first theodolites date from the 1720s, and the form underwent repeated revision over the course of the next one hundred years. The instrument shown in William Smith's portrait was devised by Jesse Ramsden, the leading mathematical instrument maker in London in the latter decades of the eighteenth century. This particular instrument was very expensive, and very few of them seem to have been made. Because Smith's instrument appears larger than life-size, and because of the angle from which it was shown, it is likely that the artist worked from the advertisement shown here rather than the actual instrument.

Was Stuart's portrait designed to be Smith's final word concerning his own reputation as a knowledgeable man of science, a reputation he thought had been sullied so recently by the young upstart Latrobe? The vehicle for the portrait's immediate message may have been the theodolite. We have no evidence that Smith actually owned such a fine object. The theodolite is not listed in Smith's will or inventory. And Smith's children and descendants seemed not to care for the scientific still life, or they were not willing to pay for it, for it is omitted from all of the copies of Stuart's painting made by Jacob Eichholtz after Smith's death. Stuart and Smith may have fabricated it, and the portrait, as a visual retort to Latrobe. By including the most pretentious surveying instrument possible, the artist and sitter suggested that Smith's mathematical and scientific skills and professional position were equal to, or exceeded, those of Latrobe. The theodolite stands on a tripod, and appears to be larger than life. Since the image in the painting closely resembles the illustration of this instrument in George Adams's *Geometrical and Graphical Essays* (London, 1791), it may be that Stuart copied the engraving at Smith's request [Figure 5–26]. Men of science were often portrayed with specific and carefully delineated instruments. In this case, however, the instrument was probably a visual hyperbole, meant to emphasize Smith's own, perhaps inflated, view of his scientific sophistication.

Mathematical, optical, and philosophical instruments were tools that enhanced and expanded men's physical and intellectual abilities. They were crucial for measuring and investigating the natural world. The possession of expensive instruments was usually the most important marker of one's status as a man of science. It is clear that their inclusion in portraits constructs an unmistakable identity for the sitter.

97

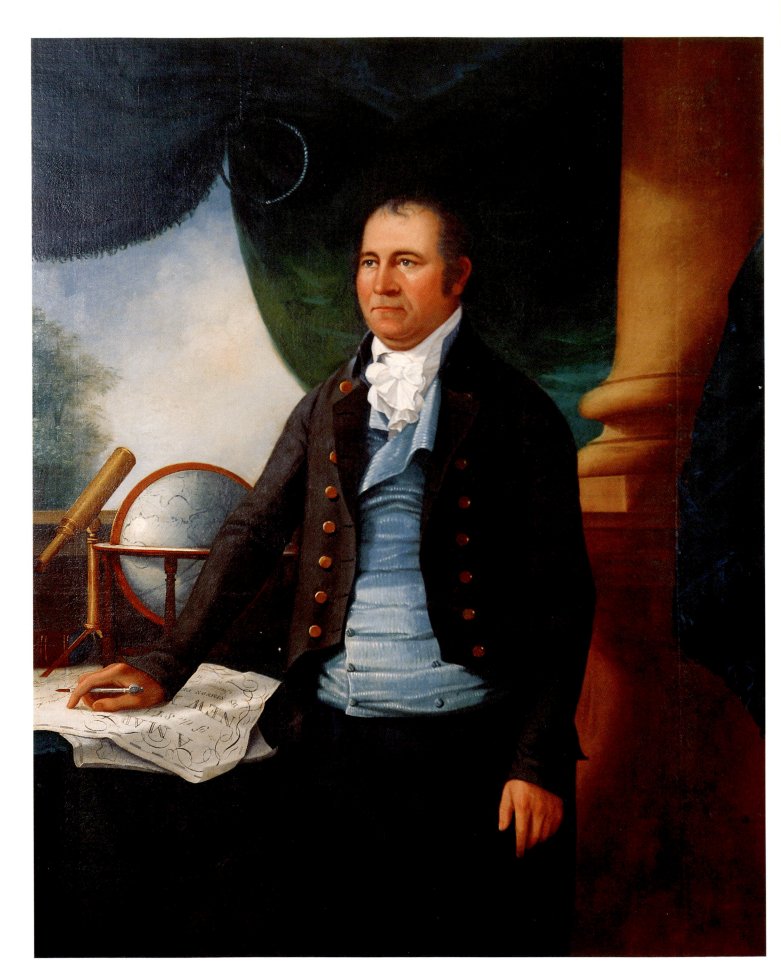

Chapter 6

Mapping Nature

Diagrams, Maps, and Botanical Specimens in Portraits

Men with a fascination for studying, mapping, and measuring the natural world often had a propensity for drawing. That art was linked to science was noted by writers on painting, who commented on the importance of accurate drawings and diagrams for scientific texts. Charles Lamotte wrote in 1730:

> There are Abundance of curious Things in Arts and Sciences, in which all the Oratory of *Tully*, and the Poetry of *Virgil* can afford no Manner of Help; nay, which Words would only serve to puzzle and darken, that are made plain and clear by a few Strokes of the Pencil. In Geography, for instance, which is so useful a Knowledge, and one of the Eyes of History, what Notion can the most eloquent Description give of a Country, its Situation, Figure, Bounds, and Extent, which shall be equal to a good Chart or Map, that represents all clearly and distinctly to the Eye. The same may be said of Mathematicks. Though you were to read a Proposition of *Euclid* a thousand times over to a Scholar, he will be as much at a loss as he was before: But show him a Figure, and delineate a Plan, then all Difficulties vanish, and every thing is clear and plain.[1]

And Jonathan Richardson summarized:

> [Painting is] subservient to many other useful Sciences; it gives the Architect his Models; to Physicians and Surgeons the Texture, and Forms of all the Parts of Human Bodies, and of all the *Phaenomena* of Nature. All Mechanicks stand in need of it. But 'tis not necessary to enlarge here, the many Explanatory Prints in Books, and without which those Books would in a great measure be unintelligible, [to] sufficiently shew the Usefulness of this Art to Mankind.[2]

Certainly, many naturalists were skilled draftsmen, as were surveyors and cartographers. To include a careful diagram or map, or botanical drawing or specimen in their portraits was an endeavor that involved both artist and subject in a mutually creative construct. Accuracy was of overwhelming importance, and gave the entire portrait an aura of truth.

John "Tulip" Custis IV (1678–1749) was a wealthy Virginia planter who took great delight in his garden. He was knowledgeable about plants, but unlike James Greenway, whose avocation was the identification and systematic study of native flora, Custis was a collector, best known for his imported specimens. He greatly enjoyed his all-too-infrequent meetings with others who shared his interests. One such friend was the Philadelphia botanist John Bartram. Custis was introduced to Bartram through a letter from Peter Collinson in London, written in preparation for Bartram's visit to Virginia in 1738. In it, Collinson noted that Bartram was "a down right plain Country Man" in

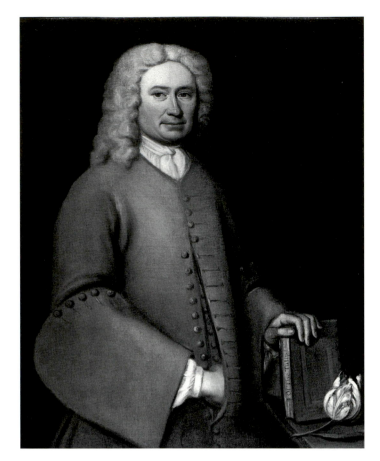

FIGURE 6–2.
John Custis IV by an unidentified artist, oil on canvas, 92.4 x 70.8 cm (36 3/8 x 27 7/8 in.), circa 1725. Washington-Custis-Lee Collection, Washington and Lee University, Lexington, Virginia

FIGURE 6–3. *(opposite)*
John Custis IV by an unidentified artist, oil on canvas, 86.4 x 65.4 cm (34 x 25 3/4 in.), circa 1725. Tudor Place Foundation, Inc., Washington, D.C.

whose conversation Custis would "find compensate for his appearance." Bartram was enchanted with Custis, and wrote to Collinson that he "entertained mee all ye while with him with extraordinary Civility & respect beyond what ever I met with in all my travels before from a stranger." Custis, too, was delighted by Bartram's visit, and also reported to Collinson, "he is the most takeing faceitious man I have ever met with and never was so much delighted with A stranger in all my life."[3]

Custis was particularly enthralled by exotic double tulips imported from Europe. He admitted "being an admirer of all the tribe striped gilded and variegated plants; . . . I am told those things are out of fashion; but I do not mind that I allways make my fancy my fashion."[4] In a 1725 letter to his London agent, Robert Cary, Custis described his garden and detailed his frustration with the vagaries of obtaining rare plants and bulbs from England:

> I have a pretty little garden in which I take more satisfaction than in anything in this world and have a collection of tolerable good flowers and greens from England; but have had great losses by their coming in partly by the carelessness and ignorance of the masters of the ships that [?] brought them. . . . I had 100 roots of fine double Dutch tulips sent me from one [?] a gardiner at Battersy, but the ship came in so late that most of them split themselves; 2 or 3 came up which are now fine flowers; . . . if it layes in your way without to much trouble I should be glad of a few double tulip roots which may be kept dry in the cabbin.[5]

Two portraits of Custis make reference to this enthusiasm. One, dated 1725 [Figure 6–2], shows Custis with a white double tulip with pink gilding or striping, and holding a book entitled *Of the Tulip*. The other, undated [Figure 6–3], shows Custis with a tulip painted in reds and oranges, and holding a book entitled *The Tulip*. Neither painting is signed. It is not known if the portraits were done in Virginia or in England.[6]

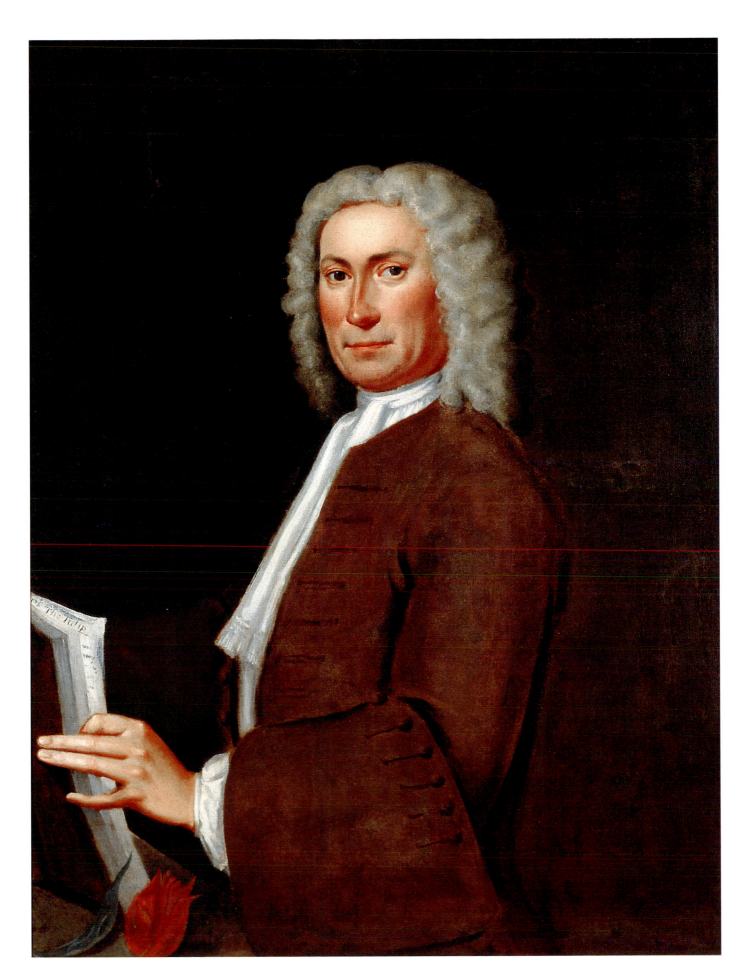

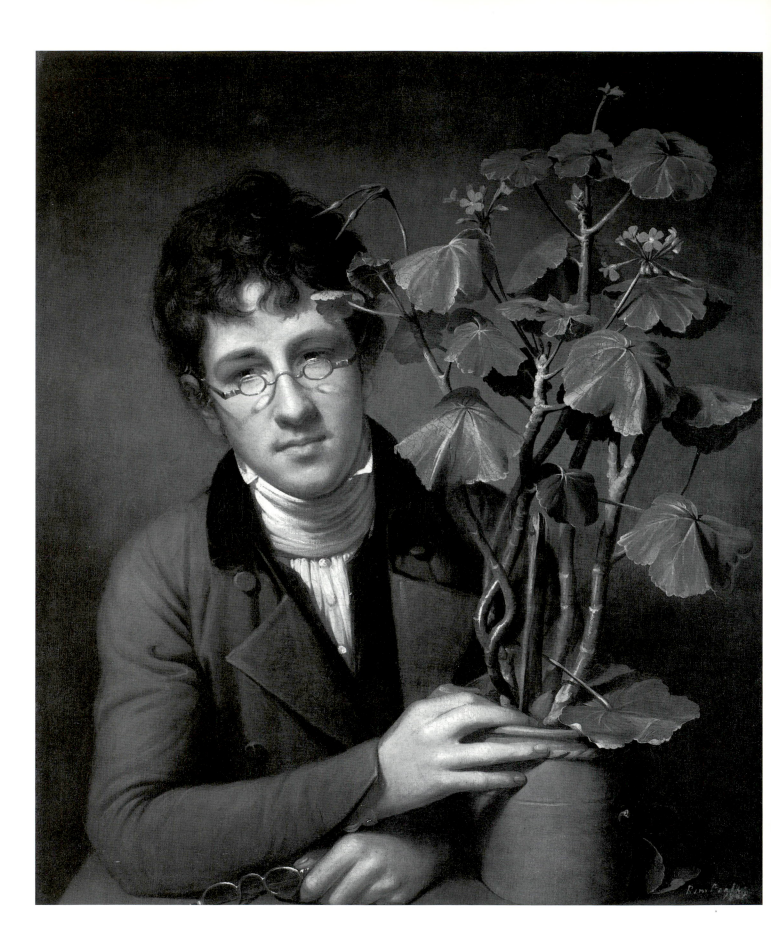

In both portraits, the artists made use of nuances of pose and bearing, costume and gesture to indicate the sitter's dignity and grace. In the Tudor Place portrait, Custis holds his left hand delicately, just touching a few of the pages of the volume dedicated to tulips. The flower is carefully delineated, and attracts attention. While women were often painted with floral attributes, men were not. When we read Custis's surviving correspondence concerning his fine garden in Williamsburg, however, we understand the delight he experienced in his imported Dutch bulbs when they arrived intact and bloomed in Virginia soil. The portraits document his pride in his collection of expensive tulips, as well as the efforts of friendly correspondents, plantsmen, ship's captains, and his own gardeners—a network of persons working to produce the coveted blooms.

Rembrandt Peale created a number of portraits of American and European men of science. Some were painted for his father's museum, but others were made for friends or family members. One of the most engaging is his portrait of his younger brother, Rubens Peale (1784–1865), probably painted in the early months of 1801 [Figure 6–4].[7] The portrait makes clear reference to Rubens's interest in plants—in this case a particular variety of scarlet-flowered geranium, *Pelargonium inquinans*. Rubens's daughter Mary Jane Peale received the portrait in 1854 from Rembrandt Peale's friend James Claypoole Copper, to whom he had given the portrait a few years after its completion. She recorded the gift in her diary, an important source for our understanding of the painting's imagery:

FIGURE 6–4.
Rubens Peale with a Geranium by Rembrandt Peale (1778–1860), oil on canvas, 71.4 x 61 cm (28 1/8 x 24 in.), 1801. National Gallery of Art, Washington, D.C.; Patrons' Permanent Fund

> I called at Mr Coppers—he presented me with a very beautiful portrait of Father when about [age left blank] he is represented with a flower-pot in his hand containing a Waterloo geranium—when it was first introduced & considered very wonderful—a very fine specimen. It was first painted without spectacles & then to make it more perfect it was painted with spectacles on the eyes as he always wore them & then the others were left in order not to mar the picture.[8]

Ellen Miles has researched both the portrait and the geranium and has concluded that while it was not the first geranium imported to America, it may have been the first of this species. Its name may refer to the Battle of Waterloo.

Rubens Peale's right hand rests on the rim of the terra-cotta pot, and two fingers touch the soil, checking for moisture. This gentle gesture betrays Rubens's fondness for plants, an affection that developed during his childhood, along with a fascination with animals. As a small child, he had very poor eyesight and was thought to be delicate. Later, his situation changed, as he recounted:

> One day when I returned from school I was informed that our family Phycian [*sic*] was dead, at this inteligence I was so much pleased that I danced about the room with joy. . . . I then went into the garden and took the watering pot and watered my flowers which I was forbid to do, and after that time I gradually increased in strength & health.[9]

Among the talented Peale family, Rubens distinguished himself as a naturalist, and worked with his father at the museum. He later managed the Peale museums in Philadelphia, Baltimore, and New York.

Benjamin Smith Barton (1766–1815), a well-known Philadelphia physician and botanist, was active from his earliest years in promoting scientific publications. He published a number of his own treatises, including several works on *materia medica*, ethnology, and natural history, and his major work, the *Elements of Botany* (1803), the first American botanical textbook. He edited the *Philadelphia Medical and Physical Journal* (1805–1809) and published a number of articles in the *Transactions* of the American Philosophical

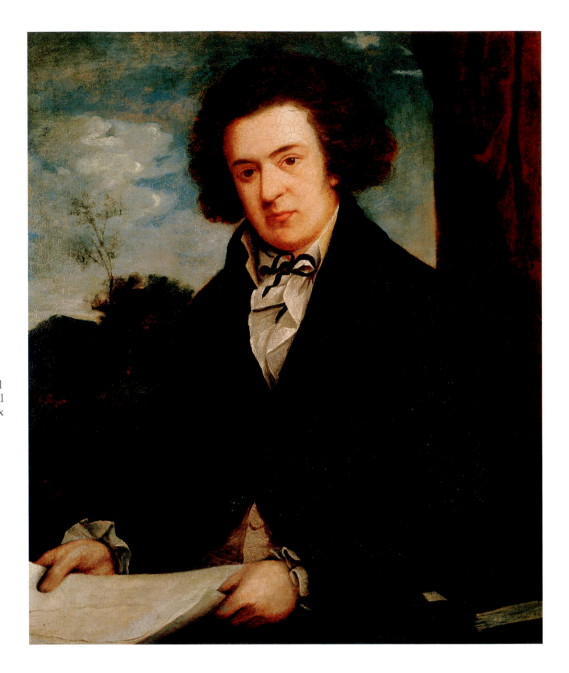

FIGURE 6–5.
Benjamin Smith Barton by Samuel
Jennings (active 1787–1834), oil
on canvas, 76.2 x 63.5 cm (30 x
25 in.), 1789. American
Philosophical Society,
Philadelphia, Pennsylvania

Society. Barton was also a self-promoter: he used his own publications, may have pilfered
others' work, and in one instance used portraiture to establish his reputation as a man of
science. This portrait, painted by Samuel Jennings, presented the twenty-three-year-old
Barton as a naturalist, and established his knowledge in a manner that bypassed institu-
tional education in favor of wilderness observation tempered by personal reading and
reflection [Figure 6–5].

Jennings had been active as an artist in Philadelphia in 1787; by January 1790 he
was in London. The portrait of Barton is signed and dated on the reverse of the canvas;
the date is August 1789, when Barton was aboard the ship bringing him to Philadelphia
from London.[10] It is possible that Jennings was already in London that summer, and
began the portrait there before Barton set sail, dating it when it was finished.[11]

The portrait underscores an important publication by the young Barton. He had
gone to Edinburgh to study medicine in 1786 following his studies at the College of
Philadelphia. Although Barton did well in Edinburgh, serving as president of the Royal
Medical Society, he evidently misused some of the society's funds and left without a

degree. After further study in London and in Göttingen, he departed for Philadelphia in July 1789, still without a degree. He began to practice medicine and teach natural history and botany at the College of Philadelphia.[12]

While abroad, Barton wrote a treatise entitled *Observations on some parts of Natural History: to which is prefixed an account of Several Remarkable Vestiges of an Ancient Date*. This was privately published in London around 1787. Although the treatise recounted observations made by other travelers, of tumuli and other ruins found in Mexico and the American West, the focus was on a site that had "lately been discovered near the banks of the MUSKINGUM" near its junction with the Ohio River. Barton had visited this site in the summer of 1785 while working with David Rittenhouse, who was his uncle, and others to survey the western boundary of Pennsylvania.[13] The most remarkable aspect of these ruins, which seemed to include the outlines of a town, was a great "PYRAMID," fifty-eight feet high, and covered "with GRASSES and other kinds of vegetables." Although Barton could draw, he credited the diagram appended to his treatise to William Tilton of Philadelphia; the engraving was done in London. This diagram is precisely delineated in Barton's portrait; he holds it as though he were looking at it [Figure 6–6].[14] The pyramid itself may be represented within the landscape background, in front of a mountain and trees, and with a small tree growing atop it.

Barton made two great claims in his treatise. First, he noted that the remains he described and had diagrammed were "the most remarkable of the kind, that have hitherto been discovered in any of the higher latitudes of North America: on this account, I . . . have had them accurately and elegantly engraved from the original plan, which was

FIGURE 6–6.
Diagram of a site near the banks of the Muskingum River, in Benjamin Smith Barton, *Observations on some parts of Natural History: to which is prefixed an account of Several Remarkable Vestiges of an Ancient Date* (London, [1787?]). Rare Books and Special Collections Division, Library of Congress, Washington, D.C.

105

done from an actual survey." Then, after summarizing information available to him on the various ruins found in North and Central America, and comparing them to similar vestiges reported in Ireland and Wales, he proposed "that the DANES have contributed to the peopling of America" and may have first explored the continent.[15] Barton concluded his essay by noting that it was "the first effort of a very young man." We do not know whether Barton knew that Captain Jonathan Heart had published a similar diagram and a more carefully documented description of the same ruins in the *Columbian Magazine* for May 1787.[16] Despite his interpretative errors, his descriptions and diagram were meant to be contributions to the contemporary discourse concerning the origins of Native American peoples. The portrait includes references to his first publication, but may also have coincided with a Philadelphia broadside published by Barton in 1789 for a book that was never published—"an historical and philosophical inquiry into the original nature and design of various remains of antiquity, which have been discovered in America."

Jennings painted a very young man dressed in fashionable attire. He is posed with a book—his first—and with the diagram, claiming it visually as his own, in spite of evidence to the contrary. Barton is ready to conquer the scientific community of Philadelphia as a naturalist and ethnographer *avant la lettre*. One vehicle for the creation of his public persona was his portrait.

Surveying, geography, and cartography were important for the mapping and acquisition of American land, and skilled practitioners were valued. Often their mathematical talents were augmented by the ability to draw, providing an easy link between surveyors and artists. These shared interests often informed portraits of surveyors. In America, surveying was a respected skill, and to be granted a public appointment as a surveyor was to gain both power and profit.

Andrew Ellicott (1754–1820), best known for his surveys and map of the District of Columbia, also helped to establish the boundaries between Virginia and Pennsylvania, and later, in 1786, was part of the team chosen to establish the boundary between Pennsylvania and New York. For both projects, he worked with David Rittenhouse. In 1785, he journeyed to Philadelphia, where he attended meetings of the American Philosophical Society, to which he was elected a year later. On December 4, Ellicott went "by perticular Invitation to spend the Day with Doctr Franklin," who would later write to recommend Ellicott's skill as a surveyor: "I found him in his little Room Among his Papers—he received me very politely and immediately entered into conversation about the Western Country—his Room makes a Singular Appearance, being filled with old philosophical Instruments, Papers, Boxes, Tables, and Stools."

In 1785, while surveying in Virginia, Ellicott wrote to his wife, Sarah, requesting that she "Give my respects to Young Mr. West, I intend him to draw our Pictures on my Return,—he will make a Capital figure as a Limner." About six weeks later, he asked Sarah to sit to "young West" for a miniature; he added a postscript to the letter: "Do not forget the Picture—I know you would not, if you could be sensible of the Pleasure it would give me."[17] A miniature of Andrew Ellicott that may date from the 1780s has survived, and may be the work of George William West. Another portrait is a profile drawing on paper, probably done in the 1790s [Figure 6–7]. This type of profile drawing inscribed within a circle was introduced to America by an artist with the surname Bouché, who was probably a French émigré, and who arrived in Maryland in the early 1790s.[18] Rembrandt Peale made similar drawings around 1799. Ellicott's profile image, with its reference to the antique, is conceived in the newly fashionable neoclassical style. Profiles were also thought to be extremely accurate portraits and were preferred by

Johann Caspar Lavater, the leading contemporary exponent of the science of physiognomy—the reading of a person's character through the facial features. Bouché's drawings might have been made with a physiognotrace—a device used by other artists working in America by the mid-1790s to trace exactly a person's profile—or with a camera obscura. Ellicott made surveying instruments and used them; he may well have been drawn to the precision of this sort of likeness. The artist usually included a sketchy landscape background in his drawings; in this case, he has delineated two tiny figures. The figure on the left is meant to be a surveyor with a telescope (too large to be an actual surveyor's instrument) on a tripod; another figure in the right background appears to be his assistant. Ellicott must have been pleased with the profile drawing, for he had Jacob Eichholtz paint a profile portrait on panel much later, in 1809, when he was living in Lancaster, Pennsylvania [Figure 6–8].

Ezra Ames portrayed Simeon De Witt (1756–1834) in as formal a manner as the artist could muster, with a standing figure, swagged draperies, prominent column, and vague landscape in the background [see Figure 6–1]. This format had been made famous in America by Gilbert Stuart in 1796 with his full-length "Lansdowne" portrait of George Washington (1732–1799) [Figure 6–9].[19] De Witt's son appreciated the reference, noting that he was

> a tall, large man, 5 ft. 11^1/$_2$ in. high, with a noble, serious face, resembling in some respects that of Genl. Washington, of grave but cheerful conversation, dignified deportment, affable to all, with that real polish of manner required by the society of the first gentlemen of the time in civil and military life, with whom his official position brought him in constant contact.[20]

De Witt had attended Queen's College (later Rutgers), and served as geographer of the United States during the Revolution. He was appointed surveyor general of the state of New York in 1784, a powerful position that he held until his death.[21] In 1786 and 1787, he served as a commissioner for the survey that established the boundary line between Pennsylvania and New York. He spent weeks in the woods and mountains with Andrew Ellicott, David Rittenhouse, his uncle James Clinton, and the rest of their crew. De Witt's skills included drawing; both Rittenhouse and Ellicott reported that he had drawn a portrait of a young Native American girl, a daughter of the "Head Sachem."[22] He also made watercolor sketches, and published a treatise entitled *The Elements of Perspective* (1813).

De Witt's portrait is not dated, but his costume is almost identical to that of the male figures in *The Fondey Family* that Ames signed and dated in 1803. Unfortunately, Ames's account books are missing for the period of October 1802 to May 4, 1804. De Witt's son, Richard Varick De Witt, gave 1804 as the portrait's date in a manuscript "Memoir of Pictures."[23] Further evidence for the date comes from the map spread across the table. This is clearly the map of New York State that De Witt had been working on since 1786 and that was finally published in 1802. A smaller version was published in 1804 [Figure 6–10]. Other objects in the portrait are a telescope, a terrestrial globe, and De Witt's cased drafting instruments, which lie in the shadows under his arm [Figure 6–11]; only his silver *porte crayon* is held lightly in his hand. By portraying De Witt in this way, Ames privileged his mathematical and cartographic skills, and gave dignity to a profession fraught with danger.

While De Witt was in the process of gathering information for the map, more than 1.5 million acres of land were obtained, through a series of treaties, from Native American tribes east of Seneca Lake. This land was designated as a military tract, and

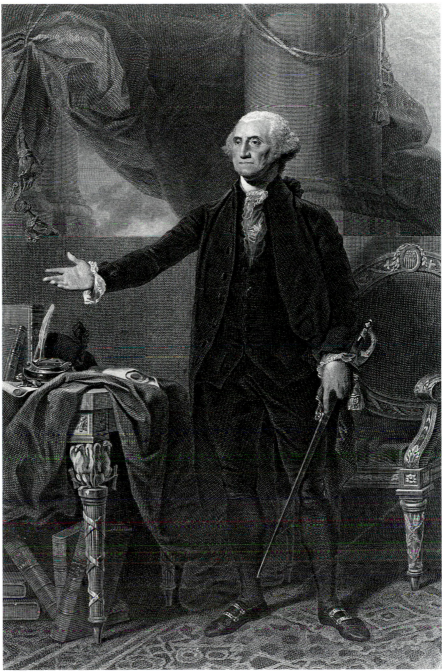

FIGURE 6–9.
George Washington by James Heath
(1757–1834), after Gilbert Stuart,
engraving, 50.6 x 33.3 cm
(19 7/8 x 13 1/16 in.), 1800.
National Portrait Gallery,
Smithsonian Institution,
Washington, D.C.

was to be portioned out to Revolutionary War veterans from New York. On De Witt's map this area is more geometrically divided than other regions within the state, and each of the townships bore a name taken from ancient history or the British Common-wealthmen, seventeenth-century defenders of liberty and heroes for American revolu-tionaries. De Witt was lampooned for these names, although the commissioners of the Land Office actually created the nomenclature in 1791.[24] In 1802, the painter John Vanderlyn wrote, "Simeon De Witt, the State Surveyor General, had already passed over the country with his Lempriere [a dictionary of classical names] in hand, erasing the Indian nomenclature, and giving to townships and villages names ludicrous in their mis-application." By 1819, two New York City newspapers printed similar complaints in the form of "An Ode To Simeon DeWitt, Esquire, Surveyor-General . . . Godfather of the Christen'd West:"

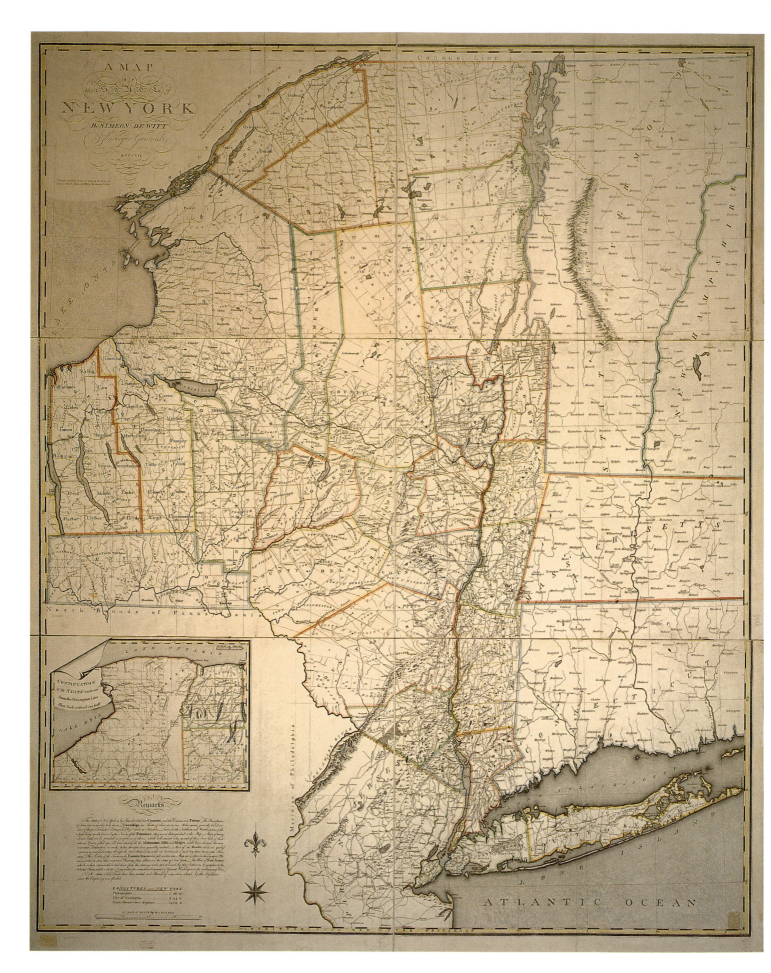

The children of each classic town,
Shall emulate their sire's renown
In science, wisdom, or in war. . . .
Historians are in Livy found
Ulysses, from her teeming ground
Pours politicians, ready made;
Fresh orators in Tully rise, . . .
And Milton, finds us pamphleteers,
As well as poets, by the gross.
Surveyor of the western plains:

The sapient work is thine—
Full-fledged, it sprung from out thy brains;
One added touch, alone, remains
To consummate the grand design,
Select a town—and christen it,
With thy unrival'd name, DeWitt!
Soon shall the glorious bantling bless us
With a fair progeny of fools,
To fill our colleges and schools,
With tutors, regents, and professors.[25]

De Witt and Ames both lived in Albany, and they shared many interests. The two may have met as early as 1794, when the artist created miniature portraits for De Witt's cousin, Governor George Clinton. A dozen years later, De Witt asked Ames to paint a view of the solar eclipse of June 1806. De Witt mentioned this painting in a letter to Benjamin Rush, noting that Ames was "an eminent portrait painter of this place."[26] De Witt's letter was read to the American Philosophical Society, to which De Witt had been elected in 1790, and was later published in the *Transactions* of that organization. The painting is now unlocated.

Freemasonry offered another point of contact. We know that Ames was seriously involved with Freemasonry, as was De Witt Clinton, another cousin. Given his interest in surveying and science, Simeon De Witt may also have been a Mason. In 1823, when a portion of the Erie Canal was opened, Ezra Ames, as grand high priest of the Grand Chapter of the State of New York, "dressed in his official robes," led the ceremonies, a ritual complete with processions and consecration of the capstone of the canal lock. De Witt was present as a member of the Canal commission.[27]

Delineating a plant, drawing a map, or diagramming ancient ruins were activities that linked scientific and artistic skills. It is not surprising, then, to find portraits such as Benjamin Smith Barton's or Simeon De Witt's to be complex documents of the relationship between sitter and artist, enhanced by shared interests and skills.

FIGURE 6–11.
Simeon De Witt's cased drafting instruments, silver-mounted green snakeskin case containing two dividers, scale, key, bow pen, and comb/pen/pencil; case, approximately 15.2 cm (6 in.) long, circa 1790–1830. Albany Institute of History and Art, New York; gift of Sarah Walsh De Witt

Cased sets of instruments—containing pens, dividers, and a scale—have been widely used by engineers, architects, and cartographers since the sixteenth century. This case, which was probably imported from England, is signed "S. DeWitt, Surv'r. Gen."

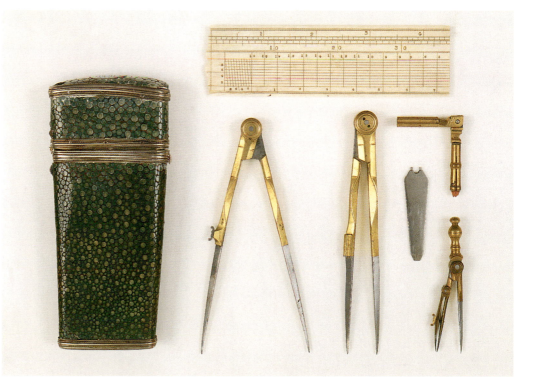

JOHN JEFFRIES M.D.

*We appear'd at this time to be about three quarters of the distance towards the French shore; and, we had fallen so low as to be beneath the plane of the French cliffs. ——— We were then preparing to get up into our Slings, when I found the Mercury in the Barometer again falling, & looking around, soon observ'd that we were rising, & that the pleasing View of France was enlarging & opening to us every moment, as we ascended so as to overlook the high grounds.

*Dr JEFFRIES NARRATIVE, ——— SECOND VOYAGE.

Publish'd according to Act of Parliament, April 3d 1786, by James Robson, Bond Street.

112

Chapter 7

Portrait Prints and Scientific Exchange

It was with great Surprize and Pleasure, that I received your Picture, from Philadelphia

—Mather Byles to Benjamin Franklin, circa 1765–1766

T he eighteenth century saw a proliferation of portrait prints of those from many ranks of the social scale. Some prints were published as frontispieces in books; an engraving of John Vanderbank's portrait of the aged Isaac Newton appeared in the 1726 edition of his *Principia*. Others were sold separately, and were often displayed in homes and public institutions [Figure 7–2]. For portraitists, engravings served as resources for poses and gestures.[1]

FIGURE 7–1.
John Jeffries by Caroline Watson (circa 1760–1814), after John Russell, engraved frontispiece to his *Narrative*, 18.4 x 16.5 cm (7 1/4 x 6 1/2 in.) image, 1786. National Portrait Gallery, Smithsonian Institution, Washington, D.C.

The earliest likenesses published in America were portraits of ministers. Typical in this regard is Peter Pelham's 1728 print of Cotton Mather (1663–1728), the Boston minister who is known today for his views on the importance of inoculation against small-pox, for which he was reviled during his lifetime. He wrote a number of scientific treatises, was an early member of the Royal Society, and published a comprehensive book on science, *The Christian Philosopher* (London, 1721), which drew on the work of a number of contemporary British and European authors, including Newton.

For lack of a portraitist in Boston, Pelham based his mezzotint on a portrait that he had painted himself [Figure 7–3]. Pelham had recently emigrated from London, where he had produced a mezzotint of John Theophilus Desaguliers (1683–1744), one of Newton's prominent disciples, shown with the prism he used to demonstrate the properties of light [Figure 7–4]. Like Desaguliers, Mather is depicted in clerical dress, but there are no references to his scientific work.

There is scant evidence about the availability in America of portrait engravings of famous European men of science—engravings that might have served as models for portraits of Americans with scientific interests. A painting of English natural philosopher Robert Boyle (1627–1691)—a copy after the circa 1689 portrait of Boyle by Johann Kerseboom—was presented to the College of William and Mary in 1732. Boyle's estate provided support to the Indian school at the college. At least one engraved portrait of Boyle crossed the Atlantic [Figure 7–5]. It belonged either to Oliver Wolcott Sr. or to his son, Oliver Wolcott Jr.[2]

Edward Bromfield, whose portrait attributed to John Greenwood has also been discussed here [see Figure 4–11], is said to have owned "a glorification of Sir Isaac Newton, by G. Bicknell, 1733 (the first engraver of his day, according to Walpole)."[3] This was probably an engraving by George Bickham Sr., published in London in 1732 [Figure

113

FIGURE 7–2.
Isaac Newton by John Faber
(1684–1756), after John
Vanderbank, mezzotint, 33.7 x
24.8 cm (13 5/16 x 9 3/4 in.),
1726–1727. Winterthur
Museum, Winterthur, Delaware

FIGURE 7–3.
Cotton Mather by Peter Pelham
(1697–1751), mezzotint, 30.6 x
25 cm (12 x 9 3/16 in.) image,
1728. National Portrait Gallery,
Smithsonian Institution,
Washington, D.C.

FIGURE 7–4.
John Theophilus Desaguliers by Peter
Pelham (1697–1751), after Hans
Hysing, mezzotint, 26 x 36.1 cm
(10 1/4 x 14 1/4 in.), circa 1725.
Museum of Fine Arts, Boston;
gift of C. P. Curtis

FIGURE 7–5.
Robert Boyle by F. Diodati
(1647–1690), after W. Faithorne,
line engraving, 20 x 15 cm
(7 3/4 x 5 15/16 in.), not dated.
Personal Miscellaneous, Oliver
Wolcott Sr. Papers, Manuscripts
and Archives Division, the New
York Public Library, New York
City, Astor, Lenox and Tilden
Foundations

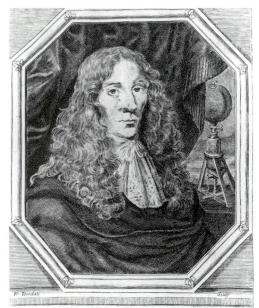

7–6]. George Vertue's engraving after Vanderbank's portrait would have been known through its inclusion as the frontispiece to Newton's *Principia*. Engraver Henry Dawkins included another engraved likeness of Newton after a well-known portrait by Godfrey Kneller in his circa 1754 handbill for New York instrument maker Anthony Lamb [Figure 7–7]. In 1789, Thomas Jefferson requested that John Trumbull obtain a copy of a portrait of Newton without delay. He wanted "Bacon, Locke and Newton . . . as I consider them as the three greatest men that ever have lived, without any exception." Jefferson had asked Trumbull to have all three likenesses included on one canvas, "that they may not be confounded at all with the herd of other great men," but this proved to be impossible, and the portrait of Newton was copied separately.[4]

Portrait engravings of men of science also served as gifts. They were material evidence of the value of correspondence and exchange within the growing transatlantic sci-

entific community. Carl Linnaeus, for example, sent to James Greenway—a man he would never meet, but from whom he desired information about plants in Virginia—not only a copy of one of his books, but his portrait. In 1784 Benjamin Rush gratefully received from a British correspondent a portrait engraving of his medical school professor and mentor, William Cullen [Figure 7–8]: "Accept of my thanks for your kind letter enclosing a print of my honoured master Dr. Cullen. I shall enclose it in a gilded frame & give it a place in my parlour. I think the resemblance of him is very striking."[5] Benjamin Thompson sent portrait prints of himself to friends and allies. In 1787, Manasseh Cutler noticed that Benjamin Franklin had "a prodigious number of medals, busts, and casts in wax or plaster of Paris, which are the effigies of the most noted characters in Europe,"

Anthony Lamb
Mathematical Instrument-maker.
at S.r Isaac Newton's Head New York
Makes and sells all sorts of Mathematical Instruments,
for Sea and Land, in Silver, Brass, Ivory, or Wood, with a great
variety of other curious Work, in the neatest and best manner,
wholesale or retail, at reasonable rates, Viz M.r Godfrey,
new Sea Quadrants, Davis's d.o Crosstaff, Nocturnals,
Rectifyers, Universal, Gunter, Sliding d.o & Surveying
Scales, plain Dividers, d.o with Points, Surveying
Chairs, Cases of Instruments, Horizontal & Ring
Dials, Amplitude, Meridian, Hanging & Poc-
ket, Compasses, all sorts of Surveying Compas-
ses, with Agate, capt Needles, all sorts of In-
struments, for Gunnery & Fortification, Sec-
tors, Protractors, Sockets & Balls, three legga
Staffs, Water Levels, Callipers, Sliding, Rules
& Rods for gauging, Back-gamon-tables,
Rulers for cutting of Parchment, Treble d.o for
ruling Blank Books, Shipwrights Draught -
Bows, Trunk Tellescopes, Walking Stick d.o Ivory
leav'd Table Books, German Flutes, Seal Handles, Wal-
king Sticks, Billiard d.o & Balls, Hydrometers for trying of
Rum, Quicksilvering of Looking Glasses & Sconces, &c, &c, &c,
Likewise Copper plate Blanks, as Bills of Lading
Bonds Indentures, Bills of Sale, Acts of Parliament, Powers of
Attorney, Wills and Powers, Parchment & Paper Blanks for the
Law, with a variety of Prints. also
Artificial Teeth

1755

FIGURE 7–7. *(opposite)*
Tradebill used by Anthony
Lamb, by Henry Dawkins (active
1754–1780), engraving, 27.9 x
18.9 cm (11 x 7 7/16 in.), circa
1754. The New-York Historical
Society, New York City

FIGURE 7–8.
William Cullen by Valentine
Green (1739–1813), after
William Cochrane, mezzotint,
37.9 x 27.5 cm (14 15/16 x
10 7/8 in.), 1772. History of
Medicine Division, National
Library of Medicine, National
Institutes of Health, Bethesda,
Maryland

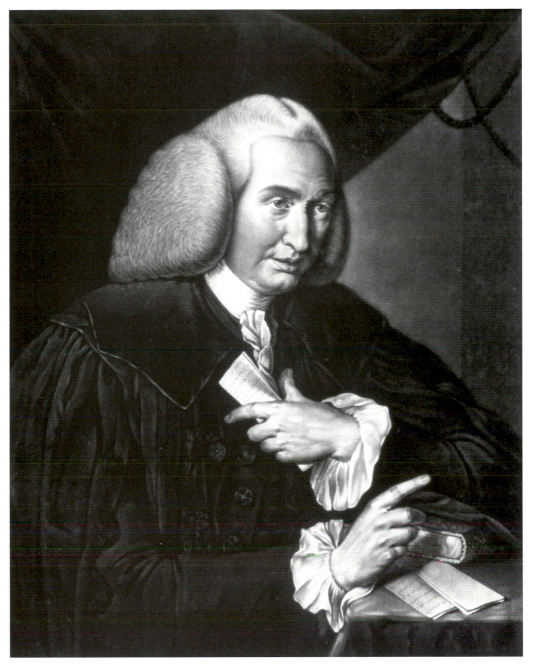

on the mantelpiece in his Philadelphia library.[6] Franklin probably had a collection of prints of his illustrious contemporaries as well, given the prints that we know he received and sent to others.

Benjamin Franklin's correspondence reveals the extent to which he made use of portraits to cement relationships and further his reputation. In 1784 he wrote to Benjamin Vaughan, "if there is a good print of [Captain] Cook, I should be glad to have it, being personally acquainted with him."[7] Franklin sent an engraved portrait of British merchant and botanist Peter Collinson (1693/94–1768) to their friend John Bartram in 1770 [Figure 7–9]. Collinson had supported Bartram's botanical work for years, introducing him to British patrons who would buy his specimens for their gardens and arranging in 1765 for his stipend as the King's botanist. When Bartram wrote to thank Franklin for the print, he expressed his pleasure in having it, along with portraits of Franklin (probably Edward Fisher's engraving after the portrait by Mason Chamberlin), British natural-

ist George Edwards (1694–1773) [Figure 7–10], and Carl Linnaeus [see Figure 5–23], all sent to him by Franklin. Bartram then announced his desire for an engraved portrait of John Fothergill (1712–1780), an English physician and Bartram's friend and correspondent. The figures illustrate engravings that would have been available to Franklin, although there were variants. Bartram displayed his collected portraits in what he called his "new stove and lodging room," where he gazed upon them: "alltho I am no picture Enthusiast, yet I love to looke at ye representation of men of inocency integrity ingenuity & Humanity." Earlier, in 1768, he already had Franklin's image in his bedchamber: "Alltho I have been long deprived of thy agreeable conversation yet for several years I have had thy pretty exact picture hanging by my bed which gives a dayly fresh membrance of intimate friendship to thy sincear friend."[8]

Collinson was painted twice, late in life: a 1765 miniature by Nathaniel Hone and a painting attributed to Benjamin Wilson from about 1767. The painted portrait was the basis for several engraved likenesses. Fothergill, on the other hand, may not have had a portrait made during his lifetime. A painting traditionally identified as of Fothergill, dated to the 1740s, is in the collections of the Royal College of Physicians of London. Contemporary accounts, however, imply that no portrait of Fothergill was reproduced for the public during his lifetime, because his Quaker beliefs made him disinclined to publish any images of his person.[9] Gilbert Stuart, who painted Fothergill posthumously in 1781, had known his subject since 1776, when Stuart's American friend and Fothergill's kinsman, Benjamin Waterhouse, brought Stuart under Fothergill's protection. The portrait [Figure 7–11] portrays Fothergill with great dignity, wearing a conservative suit and physical wig, fingering the pages of an open book. As one reviewer noted when the portrait was exhibited at London's Royal Academy in 1781, "He who has rescued so many from the grave is now restored to life by an admirable pencil. Death, which generally terminates all friendly recollections, has not prevented Mr. Stuart from doing what Dr. Fothergill would not permit when he was alive."[10] A large mezzotint after Stuart's portrait was published in 1781 by Valentine Green [Figure 7–12]. Other artists and engravers also published likenesses of Fothergill after his death. Many of these images were illustrations for magazines or books, such as John Coakley Lettsom's *The*

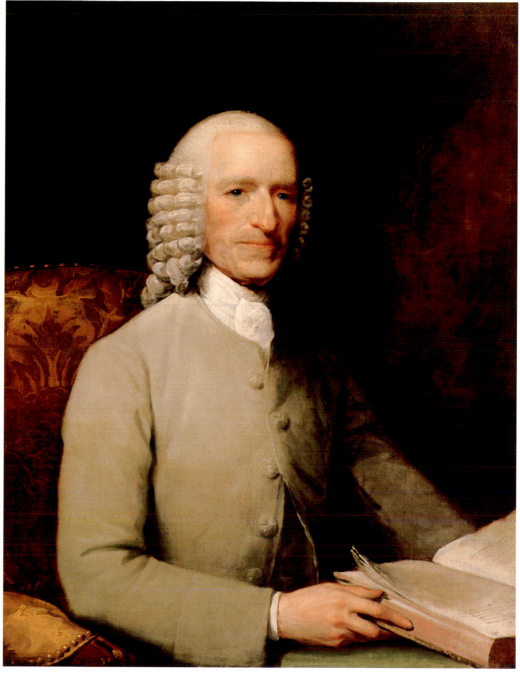

Works of John Fothergill, and were based on an unlocated wax portrait of Fothergill made by Patience Wright (1725–1786) that belonged to Lettsom.

Franklin distributed many images of himself. By 1779, when he was representing the colonies in France, he admitted that he was "universally popular." "This popularity has occasioned so many Paintings, Busto's, Medals & Prints to be made of me, and distributed throughout the Kingdom, that my Face is now almost as well known as that of the Moon."[11] But earlier, during the 1760s and early 1770s, Franklin relied on the 1763 mezzotint by Edward Fisher, done after his portrait by Mason Chamberlin, which emphasized his scientific achievements [Figure 7–13]. He may have preferred it to the slightly earlier mezzotint made after Benjamin Wilson's 1759 painting, or Wilson may have limited the number that were made. As Franklin wrote from Philadelphia in 1763 to Ezra Stiles, who had requested a portrait, "I should however send you one if I had it;

but the Painter [Wilson] thinking the Plate ill-done, it was suppress'd. A few only came here, and none are to be had."[12]

The print after Chamberlin's portrait was Franklin's favorite during this time. He wrote again to Ezra Stiles a year later:

> My Brother . . . tells me you would like to have one of the new Prints of your Friend. As there are a few others in your Government, who do me that Honour to have some regard for me, and who perhaps I may never again have the Pleasure of visiting in any other Manner, I have taken the Liberty to trouble you with the Care of six of those Prints to be distributed agreable to the enclos'd List, as you have convenient Opportunity. They are said, in Point of Execution, to be extreamly well done. As to Likeness, there are different Opinions, as usual in such Cases. I send them roll'd in a Tin Case, as folding might damage them.[13]

This was the engraving Franklin sent to numerous friends and colleagues; other copies were forwarded to William Franklin and sold. By 1769, William Franklin wanted more:

> I am often ask'd for your Prints by your old Friends and Acquaintance, and I have given among them all I had except one. All that Hall had to sell were sold immediately. If the Plate is good I should be glad you would have a 100 of them work'd off and sent to me. Coz. Davenport says, he could sell any Number.[14]

Of course, Franklin was among the best-known Americans of his day. It makes sense that his portrait would be sought after. And yet, the practice of sending prints to persons who shared one's interest was part of the culture of correspondence and professional identification that bound together men with shared scientific interests, and helped to keep "the chain of friendship bright."

Portrait engravings could also serve more public, political purposes. During the years surrounding the American Revolution, images of America's leading men of science were viewed as marketable objects. In March 1775, painter John Singleton Copley's half-brother Henry Pelham wrote to the engravers Charles Reak and Samuel Okey with a proposal to engrave Copley's circa 1773 portrait of John Winthrop to "be a match" for the earlier engraving of Franklin after the Chamberlin portrait. Pelham described Winthrop as "a Politician and a Philosopher." They were also working on a print after Copley's portrait of Samuel Adams, wanted to do one of John Hancock, and were pleased at the idea of engraving Winthrop's portrait "as A Companion to the Ingenious and Learned Dr. Franklin."[15] The engraving after Winthrop's portrait, however, was never made; by June 22, Winthrop wrote to John Adams in Philadelphia, "Boston [is] almost deserted by the inhabitants—Charlestown burnt down. Cambridge, Medford, Salem, Danvers, and Marblehead almost deserted. Tis impossible at your distance to conceive of the distress."[16]

After the Revolution, other men of science took advantage of the power of printed portraits and published books to further their careers and reputations. John Jeffries (1744–1819) was one of these. Jeffries was born in Boston, educated at Harvard, served medical apprenticeships in Boston and London, and received his M.D. from Marischal College in Aberdeen, Scotland, in 1769. He then returned to Boston and established a successful practice. Although his father, David, was a founder of the Sons of Liberty, and Joseph Warren, the physician and hero of the Revolution, was a close friend, Jeffries's Loyalist sympathies divided the family in 1775. He served in the British army, and when the British retreated from Boston in 1776, he and his wife, Sarah Rhoads, and children relocated to Nova Scotia. In 1779 they moved to England. Jeffries then received several appointments, including that of surgeon major of the forces in America, and he returned

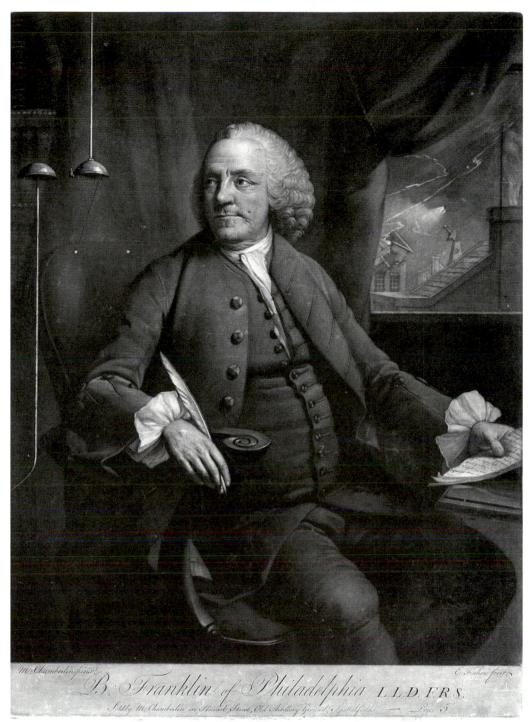

FIGURE 7–13.
Benjamin Franklin by Edward Fisher (1722–1785), after Mason Chamberlin, mezzotint, 34.9 x 27.7 cm (13 3/4 x 10 7/8 in.), 1763. National Portrait Gallery, Smithsonian Institution, Washington, D.C.

alone to America, leaving his wife and children under the protection of Benjamin Thompson. In 1780, he received news of Sarah's sudden death. Frantic, he sold his commission and returned to London, where he developed a lucrative practice as an obstetrician and gynecologist, while continuing to serve as general physician to the Loyalist community there.[17]

On November 25, 1783, Jeffries viewed a balloon flight launched by Count Francesco Zambeccari in the London suburb of Moorfields. Ballooning soon became a fashionable craze in London, Paris, and even in Philadelphia. For Jeffries, it became, in his own words, "my ruling passion."[18] By 1784, Jeffries had agreed to provide financial backing for Jean Pierre Blanchard—a French aeronaut who had made several balloon

ascents in England that year—in return for a place on the voyages. Jeffries was excited by the prospects of studying the atmosphere from such a height, and gathered a number of scientific and meteorological instruments for their first flight, which, after a day's delay, took place on November 30, 1784. Blanchard hired the Swiss chemist Aimé Argand to oversee the complicated production of hydrogen for the inflation of the balloon. Members of the highest society in England, including the Prince of Wales, watched the ascent. Jeffries was elated, and pleased that Joseph Banks, president of the Royal Society, "complimented me so much and did me the honours to say I had done very well and done more in my attention, etc., to observations in my aerial voyage than had been done by anyone before."[19]

On January 7, 1785, Jeffries accompanied Blanchard on a balloon flight across the English Channel into France. The flight took two hours and forty-five minutes. Once again, Jeffries took a mariner's compass and a barometer that had been made for his first flight "by Mr. Jones, Optician, in Holborn, and graduated down to *eighteen inches*" [Figure 7–14].[20] Jeffries made more "philosophical observations" on the first voyage; this time his chief object "was, the novelty and enterprize of being one of the first who passed across the sea from England into France, *by the rout of the Air*."[21] The flight provided all the adventure Jeffries could have imagined. There was difficulty in keeping the balloon aloft; at one point, when the shores of France were in view, Jeffries and Blanchard were so desperate to lighten their load that they pitched overboard everything they could, including some of their clothing. It was bitterly cold. At this moment, Jeffries noticed that the mercury was falling in his barometer, and soon they were ascending again, on their way to a triumphant landing in the Forest of Guînes. Fortunately, Jeffries had not thrown overboard a letter from William Franklin (Benjamin's Loyalist son who was then living in London) to his father in Passy, near Paris. Jeffries delivered this, the first "airmail" letter, upon his arrival, and was entertained by Franklin repeatedly during his visit. Jeffries and Blanchard were celebrities in Paris and London, and made the most of the public exposure. One popular verse noted:

> They cried as they came over,
> Here comes the English rover.
> Those heroes dined at Dover
> And went to France for tea.[22]

Ballooning was later seen as a milestone in the history of manned flight. At the time, however, it was received with skepticism by many men of science. The flight across the channel was a great adventure, and a wonderfully newsworthy "first," but Jeffries became determined to present both flights (with little credit to Blanchard, with whom he was feuding) as scientific endeavors. He wrote his account of them upon his return to London, and mounted a campaign in the spring of 1785 to have it read before the Royal Society. He also planned to publish the narratives, and probably intended to include a printed portrait in his book from the outset. The use of a portrait as a frontispiece for a scientific publication was hardly new, but Jeffries and his portraitist, John Russell, gave the staid frontispiece a notable freshness and immediacy [Figure 7–15]. Jeffries sat twice in June 1785 to Russell, who shared his scientific interests and was known for his drawings of the lunar surface. Jeffries noted in his diary, "had much conversation with him on various subjects—I find him & Mrs. R. very agreeable."[23] Jeffries had to wait until the next year to publish his narrative; he was having trouble persuading Joseph Banks to have his work read before the Royal Society. Since Banks had informed him that the work could not be read before the society if it were already in print, Jeffries circulated

FIGURE 7–14. *(opposite)*
Barometer signed by Jones and
Son, London, wood, brass, glass,
mercury within glass, and
leather, 88.9 x 10.2 x 7.6 cm
(35 x 4 x 3 in.), circa 1785.
National Air and Space
Museum, Smithsonian
Institution, Washington, D.C.;
gift of Dr. James H. Means

John Jeffries, the first American
to make an aerial voyage, carried
this barometer and other scientif-
ic instruments when he ascended
in a balloon from the Rhedarium
Yard in London on November
30, 1784. He also carried it on
his balloon voyage across the
English Channel in January
1785. This barometer is now
celebrated as being the world's
oldest surviving flight instrument.

FIGURE 7–15.
John Jeffries by John Russell
(1745–1806), pastel on paper,
60 x 45 cm (23 5/8 x 17 3/4 in.)
sight, 1785. National Maritime
Museum, Greenwich, London

manuscript copies, and had one sent to Franklin. Franklin in turn sent his copy to James
Bowdoin, and revealed his own skepticism about the value of balloon flight:

> In his [Jeffries's] Letter, that came with it, he requests I would not suffer it to be printed,
> because a copy of it had been put into the Hands of Sir Joseph Banks for the Royal Society,
> and was to be read there in November. If they should not think fit to publish it, as I appre-
> hend may be the Case, they having hitherto avoided meddling with the Subject of Balloons,
> I shall be glad to have the Manust return'd to me. In the mean time, I thought it might afford
> some Amusement to you and to your Society.[24]

While he waited, Jeffries had Russell's pastel portrait engraved by Caroline Watson
[see Figure 7–1], and text added to the plate. His paper was read before the Royal

Society in January 1786. By late April, the printed *Narrative* was ready. The timing was perfect, for Russell was exhibiting Jeffries's glorious pastel portrait that spring at the Royal Academy. Jeffries sent copies of the *Narrative* to numerous patrons, friends in the world of science, and relatives over the following years, including a copy to Franklin.[25] He kept careful records of these gifts, and often added a separate copy of the print, which he called a "French proof," to the package. To Franklin he wrote in June 1786: "Dr. Jeffries likewise takes the liberty to accompany it with a proof impression, of the historical Portrait of himself, alluding to a critical period of his Aerial Voyage from England into France."[26]

The portrait and resulting print present Jeffries as an adventurous man of science—far removed from the static image of the philosopher in his study. Jeffries is posed as though inside the airborne balloon, holding one fur-gloved hand on his barometer, a prized instrument that remained in Jeffries's family for years and is now in the collection of the National Air and Space Museum. Jeffries's clothing was produced to his specifications, and was designed for warmth and a snug fit.[27] The caption on the print describes the precise moment that the portrait commemorates—worthy of a late-twentieth-century action movie, but very rare for 1786:

> We appear'd at this time to be about three quarters of the distance towards the French shore; and we had fallen so low as to be beneath the plane of the French Cliffs.—We were then preparing to get up into our Slings, when I found the Mercury in the Barometer again falling, & looking around, soon obsrv'd that we were rising, & that the pleasing View of France was enlarging & opening to us every moment, as we ascended so as to overlook the high grounds.

Jeffries capitalized on his celebrity as a balloonist in order to gain a reputation as a serious man of science. He may or may not have succeeded, but the fact that his business as a fashionable physician increased was a pleasant by-product. Jeffries returned to Boston after the death of his father, in 1787, and was a respected physician there, becoming a naturalized American citizen in 1817, the year of his death.

Another instance of a portrait used to further the reputation of a man of science is the woodcut of Benjamin Banneker affixed to the 1795 edition of *Benjamin Bannaker's* [*sic*] *Pennsylvania, Delaware, Maryland, and Virginia Almanac* . . . [Figure 7–16]. Banneker (1731–1806) was a self-taught free black man who lived near Baltimore. He began to learn mathematics and astronomy at the age of fifty-seven, often with books and instruments borrowed from George Ellicott, Andrew Ellicott's cousin. Banneker began to calculate the ephemerides (astronomical data presented in calendrical form) for the year 1791. He sent it to a Baltimore printer, who forwarded the calculations to Andrew Ellicott for review. Banneker wrote to Ellicott,

> I beg that you will not be too Severe upon me but favourable in giving your approbation . . . knowing well the difficulty that attends long Calculations and especially with young beginners in Astronomy. . . . I suppose it to be the first attempt of the kind that ever was made in America by a person of my Complection—.

That year's ephemeris was not published, but Banneker continued his calculation for 1792. Meanwhile, Andrew Ellicott asked Banneker to serve as his "scientific assistant" for the survey of the Federal Territory (the District of Columbia). By 1792, Banneker had found printers in Georgetown, Baltimore, and Philadelphia for his almanac. Banneker and his backers (several abolitionist groups) were determined to disprove Thomas Jefferson's statements disparaging the intellectual capabilities of African Americans. George Ellicott's brother Elias wrote in favor of the publication to James Pemberton, a Quaker abolitionist in Philadelphia:

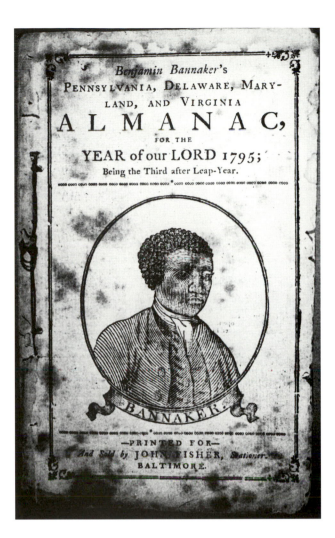

FIGURE 7–16.
Benjamin Banneker by an unidentified artist, cover image for *Benjamin Bannaker's* [*sic*] *Pennsylvania, Delaware, Maryland, and Virginia Almanac, for the Year of our Lord 1795* (Baltimore, 1794). Reference Department, Maryland Historical Society, Baltimore

he is a Poor man & Would be Pleased With having something for the Copy but if the Printer is not Willing to give any thing He would rather let him have it for nothing than not to have it Published. He thinks as it is the first performance of the kind ever done by one of his complection that it might be a means of Promoting the Cause of Humanity as many are of the Opinion that the Blacks are Void of Mental Endowments.

Banneker did not always allow others to speak for him, however, for in August 1791 he had written directly to Jefferson. In this lengthy, now famous letter, he set out his grievances against the institution of slavery, reprimanded Jefferson for his slurs, and sent him a copy of the almanac for 1792. The letter was reprinted in the almanac for 1793; each edition differed from other almanacs in its inclusion of material about African Americans, including biographical accounts of Banneker. The almanac continued to be published, in twenty-eight editions, through 1797. The popularity of the abolitionist cause gave Banneker's almanac a boost in sales. By 1795, an image by an unidentified woodcut engraver was attached to the cover of some editions of the almanac, a visual adjunct to the political agenda of the text. Banneker was sixty-four; the portrait seems to depict a much younger man, but captures his plain and neat dress and dignity of bearing. He was described in these terms by Thomas Ellicott: "he was quite a black man, of medium stature, of uncommonlly soft and gentlemanly manners" and by Martha Ellicott (Tyson), George's daughter: "His ample forehead, white hair, and reverent deportment, gave him a very venerable appearance. . . . [His] countenance . . . had a most benign and thoughtful expression."[28]

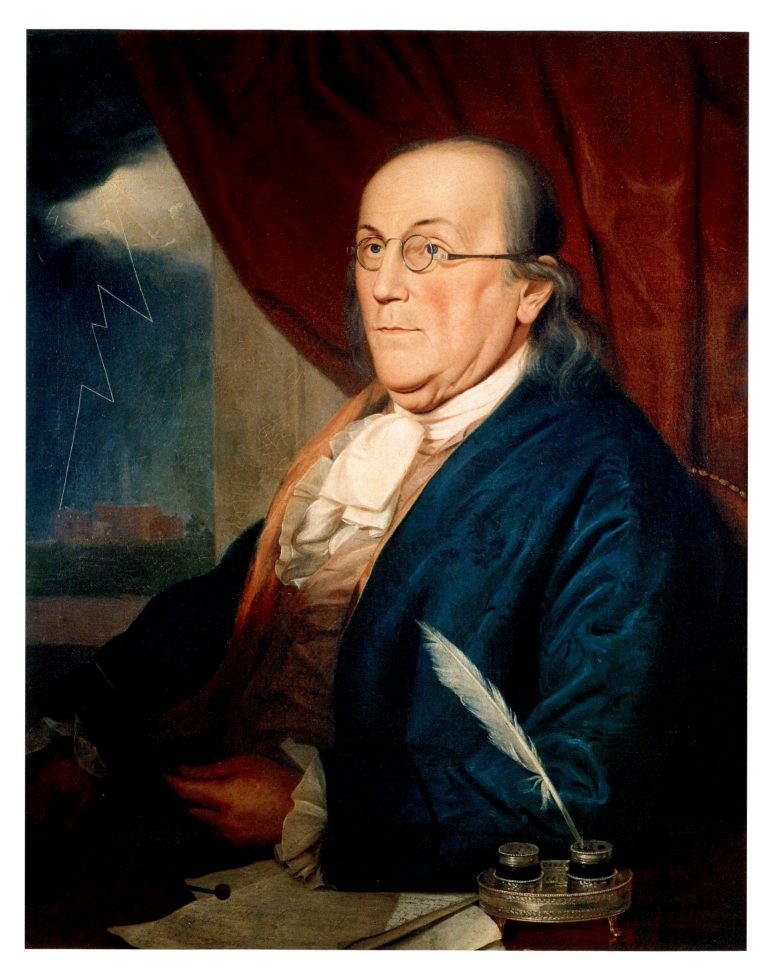

Chapter 8

Liberty, Revolution, and the Portrait around 1800

Few portraits of American men of science were painted during the years of the Revolution, when correspondence with European colleagues was interrupted and leisure for scientific investigation was lost. As one of Benjamin Rush's eulogists put it, the "tumult of political life ill agrees with the silent pursuits of science."[1] The American Revolution and the acquisition of national independence, however, created a desire to demonstrate uniquely American achievements, giving rise to a new, public image of the ideal man of science. Giuseppe Ceracchi was an Italian sculptor who visited the United States to make portraits of Revolutionary worthies and sought to make monuments for the new republic. A ideal man of science was described as part of his 1795 plan for one such monument: "In the second [compartment], *Philosophy*, without whose assistance *Liberty* would soon be obscured by Ignorance, is represented as presiding at this memorable epoch. He appears in the character of a venerable sage, with a grave and majestic aspect. He is seated, dressed in the consular habit, and leans upon the altar of Justice."[2] Such a venerable sage was to be a seeker of truth whose "retired," disinterested status paralleled the Whig ideal of a virtuous citizen. The idea of retirement from the public or urban world of business or politics included the notion of a natural philosopher, retired to his books, experiments and observations, and writing. After the Revolution, the idea of retirement was pervasive among the educated classes; not only did this arcadian ideal appeal to a desire to return to a normal life after the war, but it was a defining one for men who wished to present themselves as virtuous republicans—working only for the good of the country, not for their own interests. Men of science could be easily assimilated into this model, since scientific inquiry was ideally viewed as being above politics or faction. As Benjamin Rush wrote to his mentor in Edinburgh, Dr. William Cullen, at the close of the Revolution: "The members of the republic of science all belong to the same family. What has physic to do with taxation or independence?"[3] Joseph Banks wrote tellingly to Franklin in 1783, making reference to George Washington, whose retirement to Mount Vernon was calculated to bring forth comparisons to Cincinnatus, the Roman general who disdained public honors in favor of life on his farm:

> General Washington has we are told Cincinnatus like return'd to cultivate his garden now the emancipated States have no farther occasion for his sword. How much more pleasant would it be for you to return to your more interesting more elevated and I will say more useful pursuit of Philosophy.[4]

Few could live up to such a view of the man of science as an ideal citizen, but they were the product of new attitudes toward education, individual rights, and the acquisition of knowledge. Newtonian science had provided a breeding ground for the radical

political views that led to the Revolution. As Thomas Paine noted in *The Age of Reason*, when he arrived in London in 1757, he plunged into the study of science. "As soon as I was able, I purchased a pair of globes, and attended the philosophical lectures of [Benjamin] Martin and [James] Ferguson."[5] Most scientific lectures were not overtly political; they opened this field of knowledge to large numbers of people eager for information but barred by economics, religion, or class from academic education. Paine (1737–1809) achieved his fame and infamy, not through formal education and social connections, but through his wits and his writings, which were filled with discussions of astronomy and the universe. His career paralleled that of Charles Willson Peale, his friend and fellow radical, who painted his portrait in 1782. The portrait was commissioned by Henry Laurens, who was in London during these years. Although lost, the image survives through a mislabeled British mezzotint published in 1783 [Figure 8–2]. Paine, like Benjamin Thompson, is portrayed with his hand holding his head, and his forefinger pointing to his cranium—indicating the source of his ideas.

In spite of the relative lack of support for scientific and intellectual endeavors in the new republic, various scientific and/or inventive Americans were celebrated in sermons, pamphlets, newspapers, and epideictic poetry—and in portrait prints. They were joined in these rhetorical rosters of worthies by political or military heroes, or the names of American artists—John Singleton Copley or Benjamin West.

Some of these demonstrations of American genius were meant to persuade viewers that European culture, true to the ancient notion of *translatio studii*, was indeed moving westward. Others defended the new republic against European accusations, based on theories of degeneracy and climate, that Americans could not equal, much less surpass, European achievements.[6] The elevation of the man of science to the role of national exemplar was also a product of the importance given to Enlightenment science and the connection some men found between liberty, civic virtue, and the fostering of scientific "truth."[7]

Benjamin Franklin and David Rittenhouse, the first two presidents of the American Philosophical Society, were the main focuses of late eighteenth-century efforts to celebrate American scientific accomplishment. Franklin was frequently the subject of effusive praise, as in Philip Freneau and Hugh Henry Brackenridge's much-quoted poem "The Rising Glory of America" (1771):

> . . . even now we boast
> A *Franklin*, prince of all philosophy,
> A genius piercing as the electric fire,
> Bright as the lightning's flash, explain'd so well
> By him, the rival of Britannia's sage.—
> This is the land of every joyous sound,
> Of liberty and life, sweet liberty!
> Without whose aid the noblest genius fails,
> And Science irretrievably must die.[8]

Later, after years of public service, Franklin looked forward to a return to private life. As he wrote in 1783 to Joseph Banks, a friend above and beyond political loyalties: "I hope soon to have more Leisure, and to spend a part of it in those Studies, that are much more agreeable to me than political Operations." He longed to return to Philadelphia, where as he told another correspondent, "I have Instruments if the Enemy did not destroy them all, and we will make Plenty of Experiments together."[9]

Franklin arrived in Philadelphia in September 1785 but was immediately pressed back into public service—as president of the Supreme Executive Council of

FIGURE 8–2.
Thomas Paine by James Watson (circa 1740–1790), after a lost original by Charles Willson Peale, mezzotint, 27.7 x 22.6 cm (10 7/8 x 8 15/16 in.), 1783. National Portrait Gallery, Smithsonian Institution, Washington, D.C.

C.W. Pele Pinx. Philadelphia *James Watson Fecit*

EDWARD PAYNE ESQ.^R

FROM AN ORIGINAL PORTRAIT IN THE POSSESION OF

HENRY LAURENS ESQ.^R

Publish'd according to Act of Parliament Jan.^r 1.^st 1785.

Pennsylvania and as a delegate to the Constitutional Convention of 1787. He was an old man—very old by the standards of his time. Manasseh Cutler met Franklin in Philadelphia in 1787: "I saw a short, fat, trunched old man, in a plain Quaker dress, bald pate, and short white locks, sitting without his hat under the tree." After visiting with Franklin for the evening and admiring his books and the plethora of small portraits arranged on his mantelpiece, Cutler pronounced himself "highly delighted with the extensive knowledge he appeared to have of every subject, the brightness of his memory, and clearness and vivacity of all his mental faculties. . . . He has an incessant vein of

humor, accompanied with an uncommon vivacity, which seems as natural and involuntary as his breathing."[10] Rubens Peale also remembered seeing Franklin in banyan and cap, puttering around what Ellicott had called his "little Room": "The last time I saw him, was in his Laboratory, my father took me with him, this was just before his death, he wore a loose wrapper and a red flannel cap."[11]

By 1789 Franklin was ill. In between other projects, he continued to add to his manuscript autobiography, but as he told Samuel Vaughan in June, pain and the effects of opium left him "but little time in which I can write anything."[12] On July 17, 1789, the American Philosophical Society voted to commission from Charles Willson Peale a portrait of their president, to "as speedily as is convenient, be executed, in the best manner,—to be perpetually kept in one of their apartments" [see Figure 8–1]. A member of the society since 1786, Peale was the obvious choice for the commission. He found Franklin too weak to pose, however. He wrote in his diary that Franklin was "confined to his bed, and he requested [me] to coppy my Portrait of him and that he would try to give me an opportunity to finished [*sic*] it by his setting again—." When Peale returned, "his pain was so great that he could sit only 1/4 hour. . . . This being his situation, I am compelled to decline giving the Doctr further trouble."[13]

Peale's likeness of Franklin was based on the life portrait he had taken in 1785 for his museum collection [Figure 8–3], which included Franklin's bifocal spectacles. As a copy, the features are somewhat labored, but the painting presents Franklin, for the first time in years, specifically as a man of science, and thus it was an appropriate image for the Philosophical Society. He wears a blue damask banyan with pink silk lining. His writing materials are at hand, but not actually in use. The painting focuses on Franklin's earlier experiments with lightning and his invention of the lightning rod. The nocturnal view in the background includes a vivid lightning bolt striking one of several brick structures in the middle distance. He holds the tip of a pointed lightning rod in his hand [Figure 8–4], while a rod terminating with a round knob lies on the table before him. Peale has laboriously copied onto the paper beside the inkwell a passage from *Experiments and Observations*, which explains Franklin's ideas on the conduction of electricity and the path taken by lightning, and points out the efficacy of lightning rods. By 1789 a controversy that dated from the early 1770s had made Franklin's promotion of pointed lightning rods—the type he holds in his hand—into a political and nationalistic statement.[14]

FIGURE 8–4.
Section of a lightning rod erected by Benjamin Franklin, iron, 31.7 x 3.8 x 3.2 cm (12 1/2 x 1 1/2 x 1 1/4 in.), circa 1756. The Franklin Institute, Philadelphia, Pennsylvania

Benjamin Franklin's reputation as a man of science rested on his understanding of the nature of electricity, his suggestion of experiments to prove that lightning was electrical, and his invention of the lightning rod. In September 1752, Franklin erected a lightning rod on his house in Philadelphia. This rod protected the building from harm, and it captured electricity to be used for experimental purposes. Franklin published directions for constructing a lightning rod in *Poor Richard's Almanack* for 1753. The rod shown here was attached to John Wister's house in Philadelphia, in about 1756.

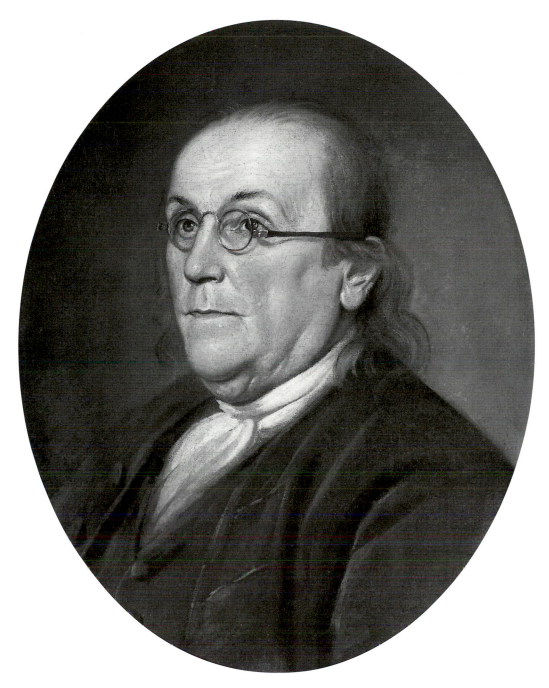

In 1772, the Royal Society of London was asked to make recommendations to protect a powder magazine from lightning. A committee of four, including Franklin and Benjamin Wilson, Franklin's portraitist and fellow "electrician," was appointed. The committee recommended pointed conductors, and the report was published in the society's *Philosophical Transactions*, but Wilson refused to sign it, for he objected to pointed rods as needlessly inviting strokes of lightning. Wilson promoted rods that terminated in a rounded knob. Franklin disagreed: "some electricians . . . recommend knobs on the upper ends of the rods, from a supposition that the points invite the stroke. It is true that points draw electricity at greater distances in the gradual, silent way; but knobs will draw at greater distances a stroke." Thus, knobs were dangerous.[15] Wilson attacked Franklin for years thereafter; by the mid-1770s, the controversy was entirely political, and King George had entered the fray, ordering conductors with knobs installed on his palace. Franklin was disgusted:

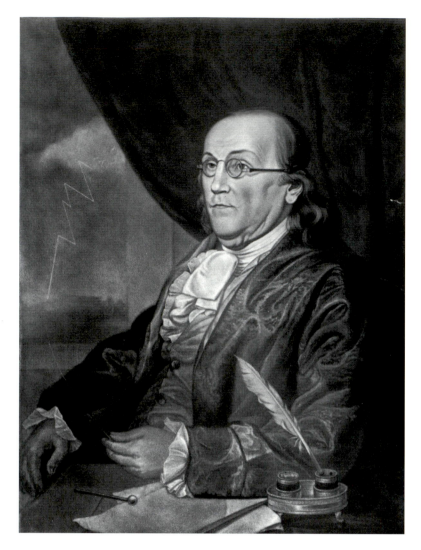

The King's changing his *pointed* conductors for *blunt* ones is . . . a matter of small importance to me. If I had a wish about it, it would be that he had rejected them altogether as ineffectual. For it is only since he thought himself and family safe from the thunder of Heaven, that he dared to use his own thunder in destroying his innocent subjects.[16]

Peale's painting of Franklin celebrates his scientific achievements and his position as an American man of science. Both honorific and nationalistic, the portrait would have been a perfect addition to the American Philosophical Society's new quarters. But there is scanty documentation for its fate. The Philosophical Society commissioned Peale to paint a portrait of Rittenhouse, Franklin's successor as president, on December 2, 1791. At the same meeting it was voted to have Peale frame a portrait of Franklin that he had presented "some time ago"—this has always been presumed to be the copy of David Martin's portrait made in 1772. Nothing was ever said about the 1789 portrait, although the 1791 likeness of Rittenhouse, in canvas size, and in its duplication of the blue and pink banyan, appears to be a pendant. We do not know if the Philosophical Society ever took possession of the portrait, or how long the painting remained in Peale's possession. The provenance of the Franklin portrait is unknown until it was presented to the Historical Society of Pennsylvania in 1852. A contemporary proof mezzotint after the portrait has come to light recently, but the engraver is unidentified [Figure 8–5].

Next to Franklin, David Rittenhouse received the most public attention given to a practicing man of science after the Revolution. Thomas Jefferson wrote about both of

them in a famous passage from his *Notes on the State of Virginia*, countering French aspersions on the ability of America to produce men of accomplishment in the arts and sciences:

> In physics we have produced a Franklin, than whom no one of the present age has made more important discoveries. . . . We have supposed Mr. Rittenhouse second to no astronomer living: that in genius he must be the first, because he is self taught. As an artist he has exhibited as great a proof of mechanical genius as the world has ever produced. He has not indeed made a world; but he has by imitation approached nearer its Maker than any man who has lived from creation to this day.[17]

Jefferson was referring to Rittenhouse's orreries, mechanical models of the solar system that he designed and built around 1770. In 1783 Jefferson had proposed that Rittenhouse make another orrery to be presented to the King of France—an idea that did not reach fruition, but which indicates the political uses to which American science might be put.

Another and far grander portrait, also by Peale, presents Rittenhouse as a worthy successor to Franklin, again wearing the blue banyan with the pink silk lining [Figure 8–6]. The reflecting telescope at Rittenhouse's right may be the one that he had recently inherited from Franklin.[18] The diagram on the table may depict the path of the comet that he had discovered in January 1793. The diagram partially rolled up on the left may depict the inner solar system.[19] This later portrait is not, however, a copy of the 1791 painting—there are too many distinctive details. The artist may have based the features on the earlier portrait, rather than asking for another sitting. The execution of the telescope and diagrams is much less precise than in other portraits by Peale. It is possible that the painting may have been completed posthumously, as the source for an engraving published by Edward Savage [Figure 8–7].

Rittenhouse was heaped with honors in his later years. He had been awarded an honorary LL.D. in September 1789 by the College of New Jersey, and had been elected to the Royal Society of London in June 1795, still an honor for an American even after the Revolution. And yet, when he died in June 1796, the funeral was small and quiet: a short evening service in his garden. He was buried beneath the floor of his observatory.

Savage's engraving after Peale's portrait was published on December 10, 1796. A week later, in a eulogy before the American Philosophical Society, Benjamin Rush created a persona for Rittenhouse that, while adhering to known facts, molded him into an American Newton. Rittenhouse, he noted, had first read Newton's *Principia* (in English) while still a boy, and mastered the calculus, "the science of Fluxions" without knowing that Newton or Leibnitz had preceded him. "What a mind was here! —Without literary friends or society, and with but two or three books, he became, before he had reached his four and twentieth year, the rival of the two greatest mathematicians in Europe!"[20] Rush also noted Rittenhouse's overwhelming love of astronomy, and his passionate defense of attempts "to depreciate this branch of natural philosophy, by denying its utility, and application to human affairs." Rush mentioned Rittenhouse's service, late in life, to the United States Mint, which paralleled Newton's own appointment as master of the Mint.[21] Even though Rush had opposed Rittenhouse's support of the radical Whigs, in the eulogy he highlighted his efforts on behalf of the Revolution, again drawing a parallel to Newton's support of the Glorious Revolution in England:

> Let it not be said, that he departed from the duties of a Philosopher, by devoting a part of his time and talents to the safety and happiness of his country. It belongs to monarchies, to limit the business of government to a priviledged order of men, and it is from the remains of a

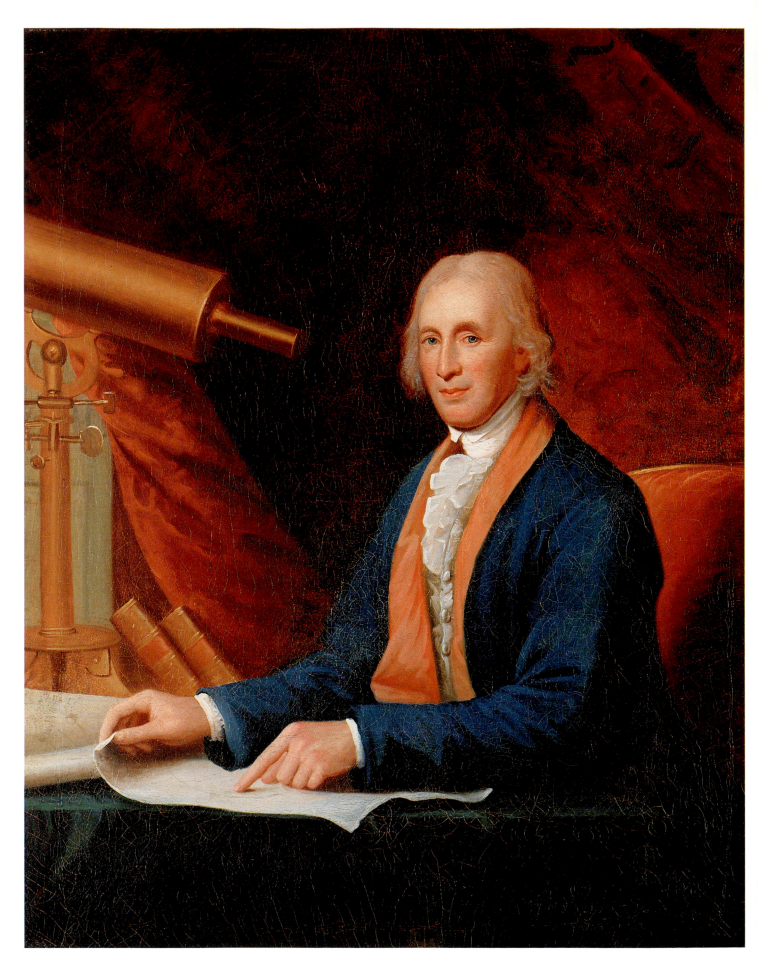

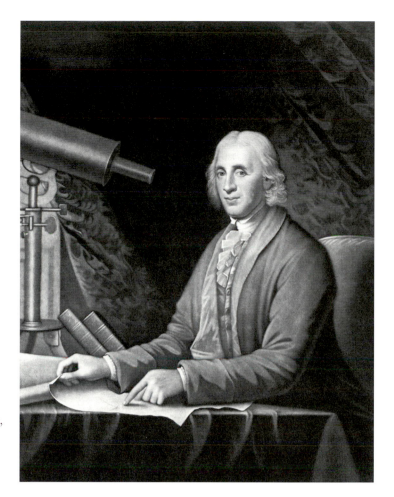

monarchical spirit in our country, that we complain when clergymen, physicians, philosophers and mechanics, take an active part in civil affairs.[22]

Rush concluded his speech by asking the society to withdraw to Rittenhouse's small observatory near his house, where his body was interred. "It was natural for him in the near prospect of appearing in the presence of his Maker, to feel an attachment to that spot in which he had cultivated a knowledge of his perfections, and held communion with him through the medium of his works." Rush continued, imagining "that awful spot.—In entering it—we behold the telescope, dear instrument of his discoveries, turned upon its axis, and pointed to the earth, which has closed its master's eyes."[23] In the Peale portrait and the Savage engraving, Rittenhouse still lives, the telescope poised in its proper position and the astronomer pausing between observations. It was an image of an American Newton, and a Philadelphia patriot and man of science.

Prints of American worthies had a market after the Revolution; some portraits served as illustrations for books or magazines, while others were published separately, like the *Rittenhouse*. In one of Savage's advertisements for the *Rittenhouse* print, he suggested that "Subscribers may have their prints put into elegant and burnished frames, finished every way."[24] Savage had already produced an engraving after a copy of David Martin's portrait of Franklin in 1793 [Figure 8–8], to be a companion piece to his print of George Washington, which was loosely based on a portrait Savage had painted for the Philosophy Chamber at Harvard. When Washington was asked to sit for this portrait in 1789, he wrote to Joseph Willard: "I am induced, Sir, to comply with this request from a wish that I have to gratify, so far as with propriety may be done, every reasonable desire

of the Patrons and promoters of Science."[25] As discussed above, Samuel Okey had hoped to reissue an engraved portrait of Franklin after the Chamberlin image as a companion to a print of John Winthrop's portrait by Copley. This plan, like others announced in contemporary newspapers, answered a general curiosity to see the faces of such well-known and admired figures. Such curiosity also led the public to exhibitions of portraits of men of science, particularly Franklin and Rittenhouse, along with heroes of the Revolution, in museums such as Peale's in Philadelphia and collections exhibited by other artists and entrepreneurs in New York, Boston, Hartford, and elsewhere.

American nature was also a source of national pride and the focus for much debate during the years after the Revolution. One of the most important books on American nature from this period was Thomas Jefferson's *Notes on the State of Virginia*, first published in 1785 and often reprinted. Since his days as a student at the College of William and Mary, Jefferson (1743–1826) had been interested in natural history—including botany, geology, and paleontology—mathematics and astronomy, surveying, cartography, and mechanical invention. He owned a large number of scientific instruments, and encouraged other men of science, such as Charles Willson Peale and Alexander Wilson, in their endeavors. Jefferson succeeded David Rittenhouse as president of the American Philosophical Society in 1796, and retained the office during his presidency. His involvement in making scientific observation and collecting a major goal of the Lewis and Clark expedition is well known.[26]

Although his political enemies ridiculed his fascination with prehistoric bones and theories about the formation of the earth, two portraits meant for public consumption indicate a more benign association of Jefferson with science—an association lauded by his supporters.[27] In 1805, at the beginning of Jefferson's second term, Alexander Wilson wrote to William Bartram:

> The enlightened philosopher—the distinguished naturalist—the first statesman on earth, the friend, the ornament of science, is the father of our Country, the faithful guardian of our liberties. . . . I am at present engaged in drawing the two Birds I brought from the Mohock; which, if I can finish to your approbation, I intend to transmit to our excellent President, as the child of an amiable parent presents some little flower to its affectionate father as a token of its esteem.[28]

A stipple engraving by Cornelius Tiebout, published on July 4, 1801, by Augustus Day, is filled with references to Jefferson's role as natural philosopher [Figure 8–9]. Jefferson's likeness is derived from a life portrait made by Rembrandt Peale, which had been previously engraved. This print was meant to be the same size as a recent full-length engraving of George Washington after Gilbert Stuart's "Lansdowne" portrait, but instead of the attributes included by Stuart, Tiebout has included a copy of the Declaration of Independence, a bust of Franklin, a globe, and a single-disc electrostatic generator [Figure 8–10].[29] These objects associate Jefferson with the American Revolution, with Franklin, and with both the natural and physical sciences.

Another image makes more particular reference to Jefferson's fascination with geology and natural wonders while linking him to his home state of Virginia, the ostensible subject of the *Notes*. This enormous painting, executed by Caleb Boyle in about 1801 [Figure 8–11], was exhibited with a pendant portrait of John Jay at the Shakespeare Gallery in New York City in April 1802.[30] Boyle advertised as a portrait painter in New York in 1800 and again in 1803; little else is known of his career.[31] His large paintings were meant to draw crowds to the Shakespeare Gallery, one of several venues for paintings open in New York at that time. Jefferson did not pose for the painting. It was based

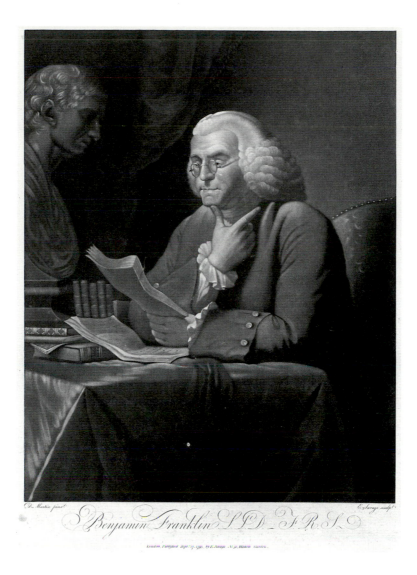

FIGURE 8–8.
Benjamin Franklin by Edward Savage (1761–1817), after Benjamin West, after David Martin, mezzotint, 45.7 x 35.5 cm (18 x 14 in.), 1793. National Portrait Gallery, Smithsonian Institution, Washington, D.C.

on portrait engravings after Rembrandt Peale and on a popular image of the "Rock Bridge" (Natural Bridge) in Virginia, published by Isaac Weld in his *Travels through the States of North America, and the Provinces of Upper and Lower Canada, during the Years 1795, 1796, and 1797.*[32] Weld's book went through four editions around 1800; in his text he described the scene in terms that expressed the awe experienced by eighteenth-century visitors: "Here the stupendous arch appears in all its glory, and seems to touch the very skies. To behold it without rapture . . . is impossible; and the more critically it is examined, the more beautiful and the more surprising does it appear."[33]

Jefferson, who purchased Natural Bridge and adjoining land in 1774, had recorded visiting it as early as 1767; he published further observations in the *Notes on the State of Virginia.* Calling the bridge "the most sublime of nature's works," he associated his experience of it with contemporary theories of the sublime, an aesthetic category that emphasized the physical and emotional:

few men have the resolution to . . . look over into the abyss. You involuntarily fall on your hands and feet, creep to the parapet and peep over it. Looking down from this height about a minute, gave me a violent head ach. If the view from the top be painful and intolerable, that from below is delightful in an equal extreme. It is impossible for the emotions arising from the sublime, to be felt beyond what they are here; so beautiful an arch, so elevated, so light: and springing as it were up to heaven, the rapture of the spectator is really indescribable![34]

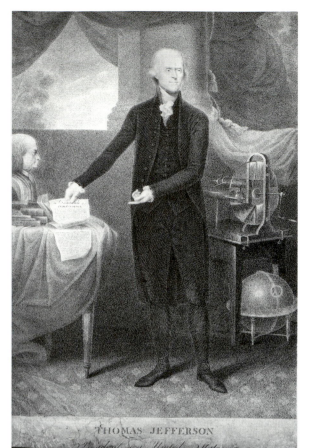

FIGURE 8–9.
Thomas Jefferson by Cornelius
Tiebout (circa 1773–1832),
stipple engraving, 55.2 x 34.3 cm
(21 3/4 x 13 1/2 in.), 1801.
American Philosophical Society,
Philadelphia, Pennsylvania

FIGURE 8–11. *(opposite)*
Thomas Jefferson by Caleb Boyle
(active 1795–1804), oil on can-
vas, 233.6 x 154.3 cm (92 x
60 3/4 in.), circa 1801. Kirby
Collection of Historical
Paintings, Lafayette College,
Easton, Pennsylvania

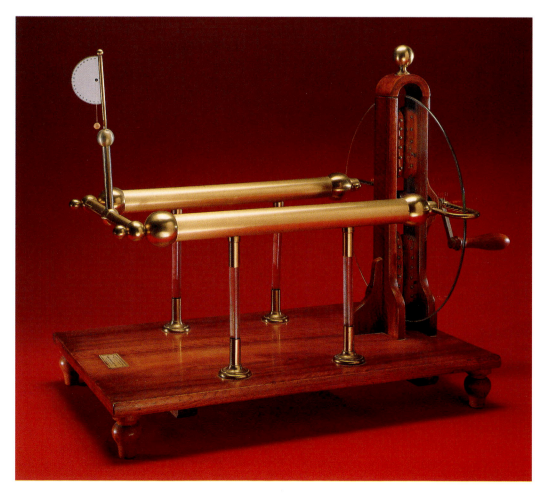

FIGURE 8–10.
Single-disc Ramsden electrostatic
generator, signed by E. Rousseau
et ses fils, Paris, 60 x 79.6 x 44.5
cm (23 1/2 x 31 1/4 x 17 1/2 in.),
mid-nineteenth century, after
an eighteenth-century design.
Division of Information,
Technology, and Society,
National Museum of American
History, Smithsonian Institution,
Washington, D.C.

In the 1740s, after hearing rumors
about recent discoveries made
by European savants, many
Americans became eager to know
about and experiment with elec-
tricity. Electrical lectures attracted
large, enthusiastic audiences.
Colleges purchased electrical
apparatus and used them in their
courses. And numerous individuals
bought or built electrical machines
for their own use.

Thomas Jefferson purchased an
electrical machine in London in
1786. His was a plate machine,
which generates an electrical
charge when the glass plate is
rotated and rubbed against a
cushion of leather. This form
originated in the 1750s and
remained popular through the
nineteenth century.

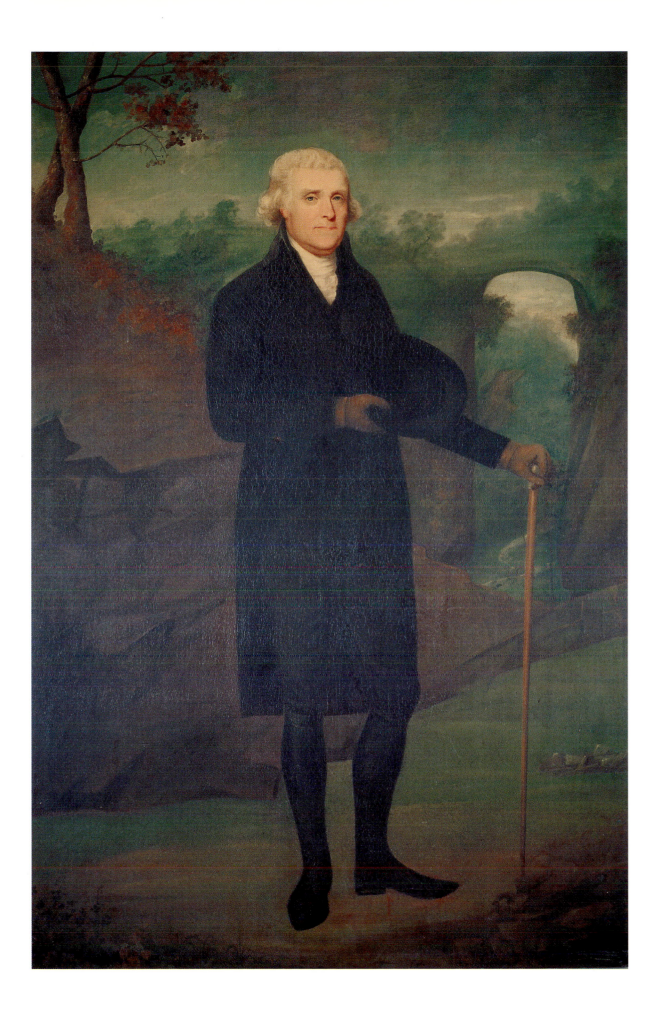

FIGURE 8–12.
The Natural Bridge by John Constantine Stadler (active early nineteenth century), after William Roberts, colored aquatint, 81.9 x 62.2 cm (32 1/4 x 24 1/2 in.), 1808. Museum of Early Southern Decorative Arts, Winston-Salem, North Carolina

Jefferson experienced the "Rock Bridge" in highly visual terms; he asked several artists, including Maria Cosway and John Trumbull, to paint it. During his presidency, another artist, William Roberts, presented Jefferson with a view of the bridge and in 1808 published an aquatint after the painting, two copies of which were also sent to Jefferson [Figure 8–12]. The painting hung in the dining room at Monticello.[35]

Boyle gave his public a grand image of a well-known place—the Rock Bridge—as well as its owner—the President of the United States. Curious viewers would see a natural wonder, a spectacle of American nature, and a famous face. As far as we know, Jefferson knew nothing of Boyle's painting. In that it was meant to draw crowds and make money for the artist, it probably expressed a public image of Jefferson that happened also to encompass the natural marvel most directly linked to him.

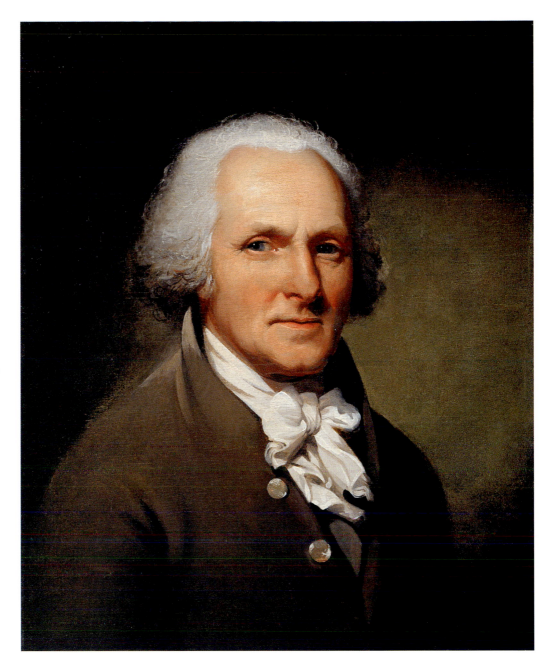

FIGURE 8–13.
Charles Willson Peale, self-portrait,
oil on canvas, 65 x 51.7 cm
(25 9/16 x 20 3/8 in.), circa
1791. National Portrait Gallery,
Smithsonian Institution,
Washington, D.C.

Jefferson's portraits had great popular appeal; life portraits and fabrications such as Boyle's were found in every entrepreneur's museum or gallery during his presidency. One of the most prominent of these museum-keepers was Charles Willson Peale (1741–1827), who had painted Jefferson's portrait in about 1791 for his collection of eminent worthies [Figure 8–13]. Peale was a true eighteenth-century polymath—artisan, portrait painter, naturalist, and taxidermist, inventor, writer, museum-keeper, and entrepreneur. His interest in science intensified after the Revolution, and, like his career as an artist, served as an opportunity for social advancement through the use of his intellect and talents. His scientific endeavors may have created opportunities for portrait commissions; he also painted numerous portraits of men of science for his Philadelphia museum.

Jefferson was one of Peale's most loyal supporters and friends. Among their many shared interests were the enormous bones of what were thought to be prehistoric mammoths. Peale could also see the popular appeal that the display of such relics of an earlier age could generate in his Philadelphia museum and abroad. In the summer of 1801,

Peale led an expedition to a marl pit on a local farm in Shawangunk, New York, where he excavated the fragmentary remains of three skeletons of an enormous extinct quadruped, an animal that Georges Cuvier named the mastodon for the breast-like bumps on its huge teeth. Jefferson and the American Philosophical Society funded the expedition. Peale brought the bones back to Philadelphia and put together two nearly complete skeletons. He fabricated missing parts from wood or papier-mâché with help from sculptor William Rush. By Christmas Eve, Peale placed the mammoth (as he continued to call it) on view in his museum [Figure 8–14]. He began his painting of the excavation, *The Exhumation of the Mastodon*, in 1806 and completed it in 1808, when he hung it in the exhibit [Figure 8–15].[36] Peale described it in a letter to his daughter Angelica in 1806:

> I have on hand a picture which requires all my attention, and greater exertions than any undertaking I have ever done. How I shall acquit myself on the finishing is yet doubtful in a great number of figures in a busy scene of taking up the Mammoth Bones in a Deep Pit with numbers of spectators as was actually the case during that great labour. I hope to make it a very interesting picture, the subject being grand, nay awful, by the appearance of [a] tremendous gust coming on.[37]

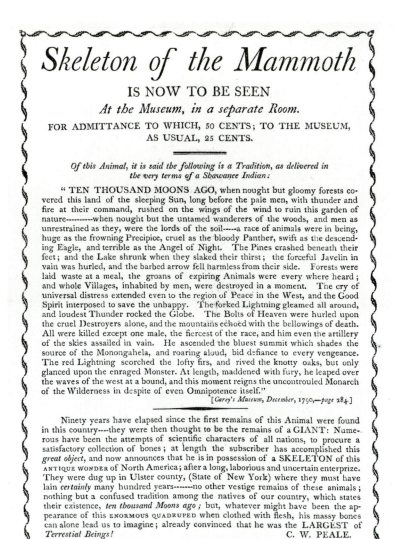

FIGURE 8–14.
"The Skeleton of the Mammoth is now to be seen . . . ," broadside, 29.9 x 22.5 cm (11 13/16 x 8 7/8 in.), Philadelphia, circa 1801. American Philosophical Society, Philadelphia, Pennsylvania

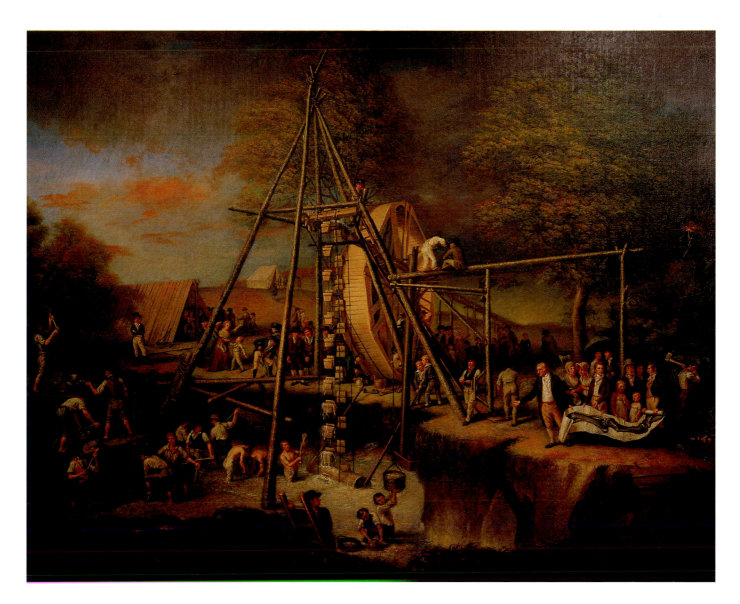

The painting is busy—it is full of figures, many of whom are draining the pit and revealing bone. The large pump devised by Peale to remove the water dominates the scene, although its repetitive, mechanical function is offset by the sublimity of the darkness and threatening thundercloud. The storm did appear and was chronicled by Rembrandt Peale in his account of the excavation. Its pictorial function seems to have been to indicate the awesome and frightening prospect of revealing to human eyes the remains of such an enormous creature, believed to have been violent and destructive. *The Exhumation of the Mastodon* is not just a pictorial account of a scientific expedition: The painting is also concerned with the foundation and reputation of Peale's Museum, and Peale's dual career as artist (maker of the painting) and naturalist (its subject). As a summation of his vision of himself and the role of the man of science in American culture, the *Exhumation of the Mastodon* is as much a portrait as a history painting, and may be compared to Peale's great self-portrait of 1822, *The Artist in His Museum* [Figure 8–16]. If, as Laura Rigal proposes, we reintegrate the painting imaginatively into the space of Peale's mammoth exhibit, with the enormous ancient skeleton and the framed pages of Rembrandt Peale's dissertation on its history, we may view it as more than a narrative image. Peale has included portraits of many members of his family, including two of his wives, Elizabeth DePeyster Peale, who died in childbirth in 1804, and his new wife,

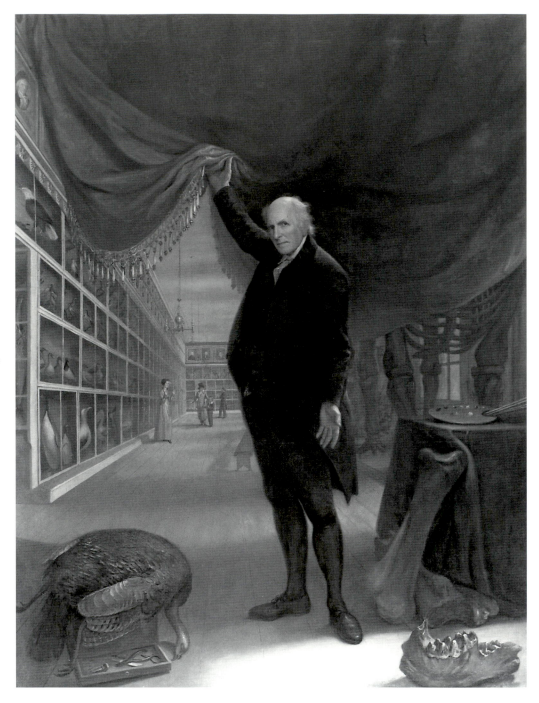

FIGURE 8–16.
The Artist in His Museum by
Charles Willson Peale
(1741–1827), oil on canvas, 262.9
x 203.2 cm (103 1/2 x 80 in.),
1822. Pennsylvania Academy of
the Fine Arts, Philadelphia; gift
of Mrs. Sarah Harrison (the
Joseph Harrison Jr. Collection)

FIGURE 8–17. *(opposite)*
Nehemiah Strong by Ralph Earl
(1751–1801), oil on canvas, 172.1
x 96.5 cm (67 3/4 x 38 1/4 in.),
1790. Yale University Art
Gallery, New Haven,
Connecticut; gift of the artist

Hannah Moore Peale, whom he married in 1806. His sons Rembrandt and Rubens, who
aided him in the excavation and later took one of the skeletons to Europe, as well as
Raphaelle, are also pictured, along with eight other children. Another figure, standing in
a pose of contemplation at the far end of the pit, is said to represent the ornithologist
Alexander Wilson, who made many paintings of birds from specimens in Peale's
Museum. Wilson, like Peale, represented a self-made and educated man of science, who,
through knowledge and artistic ability, was able to create rational order from the raw
materials of nature.

Other portraits of men of science painted around 1800 have less to do with public
presentation, but are more responsive to personal idiosyncrasies, often related to the
vicissitudes of the scientific life in the new nation. For instance, Reverend Nehemiah

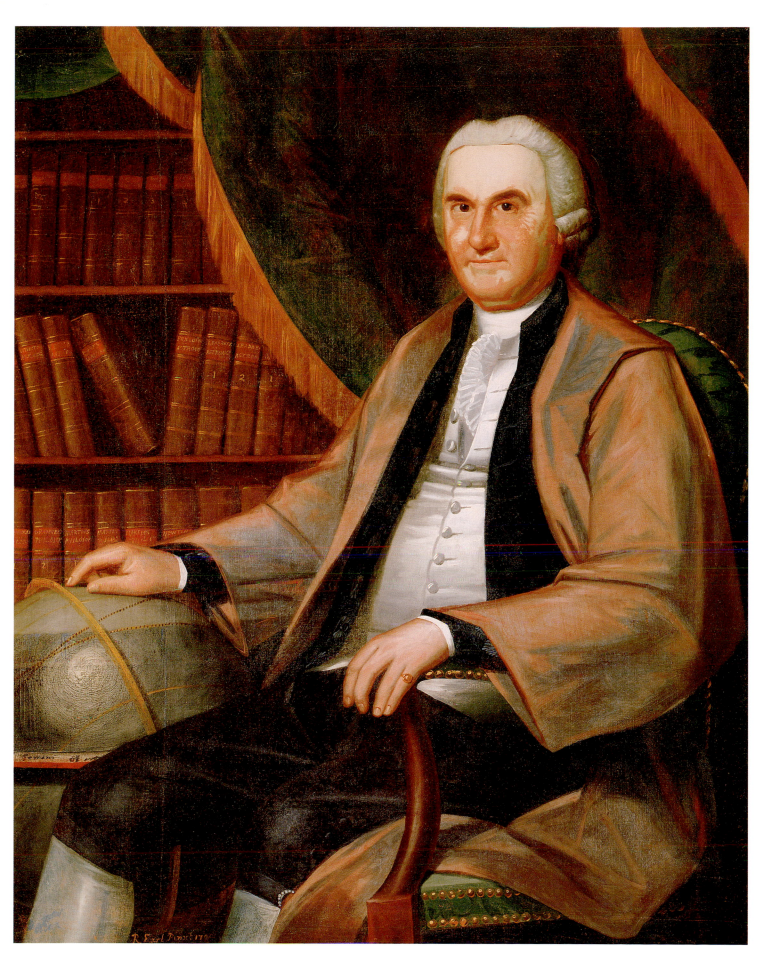

FIGURES 8–18A AND B.
Terrestrial and celestial globes signed by J. & W. Cary, London, 30 cm (11 13/16 in.) diameter, with mahogany stands, circa 1798/1816. Geography and Maps Division, Library of Congress, Washington, D.C.

These globes show English efforts to gain intellectual and physical control of the world. The terrestrial globe incorporates information obtained from Captain Cook and other English navigators, while the celestial globe incorporates information obtained by the Astronomer Royal and other notable English astronomers. Together they might have been used for scientific educational purposes and as indications of wealth and prestige.

Since globes were expensive to produce, they often remained in print for many years. The maps that cover these globes were drawn and engraved by John Cary, while the globes were marketed by the firm of J[ohn] and W[illiam] Cary. They are essentially the same globes as the ones that Cary first advertised in 1798.

Strong (1728–1807) served as the professor of mathematics and natural philosophy at Yale College from 1770 to 1781, and provided calculations for several almanacs. A combination of the college's lack of funds during the Revolution and Strong's reputation as a Tory provoked his resignation from Yale in 1781, while Ezra Stiles was president. Ralph Earl, whose Loyalist leanings were one reason for his spending the war years in England, had painted Strong's portrait (unlocated) while he was in New Haven in the mid-1770s.[38] In 1783, Strong, although no longer associated with the college, presented that portrait to Yale for its library. Stiles reported this in a passage from his "Literary Diary" for September 19:

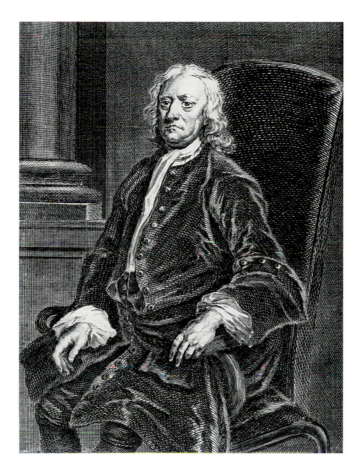

> The day before Commenct the Rev. James Pierponts Portrait on Canvass dated 1711 aet. 51, was deposited in the College Library, for the present. And this day the late Professor Strong deposited his Picture there also for the present. undetermined as to both whether they are to continue there. . . . We have now Portraits in oyl colors in the Liby K. George I, Gov. Saltonstall, Rev. Jno Davenpt first Minr. of New Haven, Revd Mr Pierpont one of the Founders of this College, Rev. Prof. Strong, Rabbi Karigal: besides Mezzotints of Gov. Yale & Bp Berkley.[39]

Stiles was clearly ambivalent about accepting Strong's portrait for a collection that though small, clearly represented the founders of the college and of New Haven. The painting did remain in the library, however, for in 1790, Earl (perhaps to attract more sitters in New Haven after his return from England) painted another portrait of Strong, at no cost to the sitter, to be given to the college in exchange for the earlier painting [Figure 8–17].[40] Strong must have been pleased with this large, imposing canvas, for he contacted Stiles himself to effect the exchange. At the end of his letter he noted that the canvas should be carefully placed, "that its situation may be favorable in respect of Light and Shade; as otherwise the performance may suffer in abatement from its Genuine Likeness. / For this purpose mr. Earl recomends the west end of the Library appartment, where, formerly, the portrait of K. George was placed."[41] Strong's audacity in suggesting that his portrait take the place of a king's image, even a British one, did not go unnoticed by Stiles. In a second letter, Strong made a witty apology:

> When I mentioned it as mr. Earl's choice, that it might be set where K. George formerly stood, Neither he nor I had any conception of composing any Design of *Dithroning his Majesty*; But only ascending that former throne, which of late (tho perhaps before the President came to preside) he had abdicated.[42]

Strong's portrait emphasizes his bulky frame and a skin disorder that caused discoloration or depigmentation in his face. Earl's startling naturalism extends to a careful representation of Strong's books, volumes on natural philosophy and astronomy, a celestial globe, and a banyan of lilac shot silk.[43] He is presented as an astronomer. A pair of globes and three of the books pictured in the portrait were listed in Strong's will and inventory of 1807. The globes, terrestrial and celestial, were most likely acquired at the same time, for globes were often sold together [Figures 8–18a and b].[44]

While the pose chosen by Earl is a traditional one, often used for men of learning, Strong's position also parallels that used in an engraved portrait of Isaac Newton inserted in copies of one of the books that may be depicted in the painting—Benjamin Martin's *Biographia Philosophica* (1764), a biographical dictionary of famous men of science [Figure 8–19]. Newton's image was the only one included in the book, and may have been the only image of Newton that Strong knew, for it was a copy, reversed, after the well-known print by John Faber after John Vanderbank. Strong and Earl created an image that in its size and pretensions offered an audacious "replacement" for the king—a curmudgeonly former professor and astronomer, presented as a learned heir to Newton himself.

Samuel F. B. Morse's portrait of his father, Jedidiah Morse (1761–1826) [Figure 8–20], is another example of how a banyan, globe, and books were used to define a scientific and scholarly identity. Morse, although remembered largely for his invention of the telegraph, was originally an artist. Around 1810, after graduating from Yale but before traveling to Europe to study painting, Morse painted his first portrait of his father. The elder Morse was a graduate of Yale, a Congregational minister in Charlestown, Massachusetts, and the foremost American geographer. He had published his *Geography*

Made Easy in 1784, and continued to publish various books on the subject for more than thirty years. Many of these volumes are depicted in his portrait—large leather-bound, gold-tooled tomes, including his *Universal Geography*, *American Gazeteer*, *History of New England*, and *Elements of Geography*, while a slim volume of sermons lies above, as though set aside. A globe is visible in the background of this cramped space reminiscent of sixteenth-century Northern European portraits. Morse wears a golden damask banyan, lined in green, with a scarlet collar. This flattering portrayal of a scholar surrounded by his own books presents an ideal image of quiet study and reflection in the face of the activity and even turmoil present in Jedidiah's life during these years. Jedidiah Morse looked to the sale of his books for income necessary to supplement his minister's stipend. He actively marketed, revised, and reprinted his books and was criticized as a minister for his overt capitalism. By 1808, bad investments and misplaced trust were creating financial difficulties for Morse.[45] It would seem inevitable that he would want to be portrayed as far removed from the world and engaged in scholarly pursuits. This is also the image projected in Samuel Morse's watercolor of around the same time, which depicts Jedidiah at the center of his family, lecturing on geography with a prominently displayed terrestrial globe, and a copy of one of his books, diagram extended, on the Chippendale table [Figure 8–21]. Sidney and Richard Morse stand to the right, while Samuel Morse leans forward, intent on his father's words and gestures. Elizabeth Breese Morse also listens closely, her sewing scissors discarded—tiny implements overshadowed by the bulk and visual authority of the globe.

FIGURE 8–21.
The Morse Family by Samuel F. B. Morse (1791–1872), watercolor on paper, 30.5 x 38 cm (12 x 15 in.), circa 1810. National Museum of American History, Smithsonian Institution, Washington, D.C.

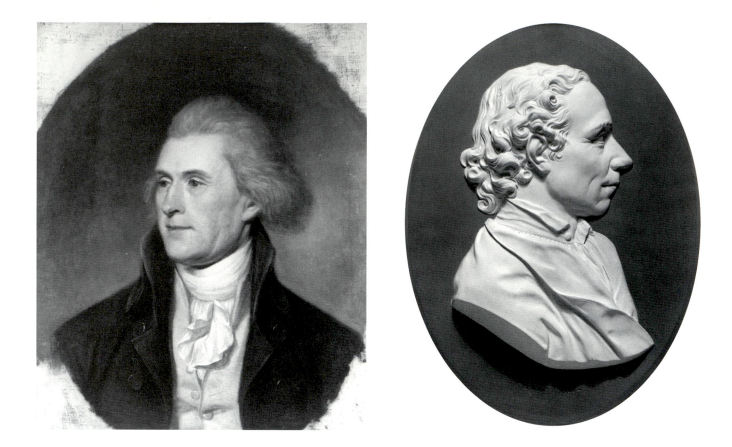

The conventions of portraiture were changing at the turn of the century. Although numerous portraits survive of men of science posed with attributes that denote their interests, others indicate scientific genius and the life of the mind through an emphasis on the head as the seat of intelligence and facial expression as the carrier of sensibility. Lord Byron, for instance, banished books and writing materials, those conventional attributes of "studious men," from his portraits as being too like "trade" and not "spontaneous."[46] Such romantic portraits emphasize imagination and genius as much as likeness, and rarely include any other objects or attributes. While it is difficult verbally to distinguish them from earlier quarter-length portraits, there is a visual distinction. Many of Charles Willson Peale's bust portraits painted for his museum give an overwhelming emphasis to "character"—the appearance of verisimilitude with an apparently artless attention to features meant to reveal qualities of mind. In a few of these paintings Peale has given a sense of animation to the sitter in order to indicate genius. His 1791 portrait of Thomas Jefferson is a prime example [Figure 8–22]. Some of Rembrandt Peale's portraits of men of science from just after 1800 also have this quality, including his portrait of Joseph Priestley.

Priestley (1733–1804), a Unitarian minister, an important chemist, and a political and religious radical, emigrated from England to the United States in 1794, hoping to find a more congenial political climate. On receiving a formal welcoming address from members of the American Philosophical Society, of which he had been a foreign member since 1785, Priestley indicated his pleasure at joining "a Society of philosophers who will have no objections to a person on account of his political or religious sentiments," and praised his adopted country, "in which every obstruction is removed to the exertions of all kinds of talents, [which] will be far more favourable to Science, and the arts, than any monarchical government has ever been."[47] Priestley had known Franklin in England, and admired his work in electricity. In America, he became friendly with

Benjamin Rush and Thomas Jefferson, among others, and in his reputation as a "republican," he drew barbed comments from Federalists after Jefferson's election as President. He settled in Northumberland, Pennsylvania, and while he was for the most part reclusive, he did participate in the scientific community of Philadelphia.

Several portraits of Priestley had been made in England. He managed to bring with him to America a profile portrait in blue and white jasper made by Wedgwood and Bentley in the late 1770s [Figure 8–23]. Wedgwood wrote to his partner about this image, "Dr. Priestley is arriv'd & we are with great reverence taking off his presbyterian parson's wig & preparing a Sr. I. Newton as a companion to him."[48]

Charles Willson Peale sent Priestley tickets to his museum very shortly after his arrival in Philadelphia in June 1794, and mentioned him in several subsequent letters. Rembrandt Peale took Priestley's portrait for his father's museum collection in 1801 [Figure 8–24]. It is a beautifully executed likeness, depicting Priestley wigless and in a

plain black suit with white linen. The portrait gives the appearance of verisimilitude; details of the countenance are rendered with great care. Like other bust portraits made by Rembrandt Peale and Charles Willson Peale for the museum, it sends its message through this lifelike image.[49] We know from Rembrandt Peale's recollections that he and Priestley discussed contemporary ideas on physiognomy and phrenology, the legibility of the features and the skull—that is, whether character was discernible in the face and shape of the head. Peale recalled:

> In 1801, whilst painting the portrait of Doctor Priestley, I gave him some of my notions, which amused him, from their novelty, and he asked me what I supposed was indicated by a peculiar elevation on the summit of his head? Never having seen anything like it, I could form no idea of its meaning, if it had any—but, it is singular, that when I became acquainted with Doctor Gall [a famous phrenologist], in 1812, I found it was marked by him as the organ of veneration.[50]

Similar concentration on the head as the seat of the intellect and likeness as a carrier of character and sensibility is present in a portrait of Alexander Wilson, attributed to Thomas Sully and presented to the American Philosophical Society in 1822 [Figure 8–25]. Wilson (1766–1813) was a Scottish schoolmaster and poet who had immigrated to America in 1794. He shortly became interested in ornithology, and with help from William Bartram and the Peales, whose numerous mounted specimens served as models for many of his watercolors, he prepared a multivolume *American Ornithology* [Figure 8–26]. The first volume was published in 1808; in seeking subscribers and doing all the

1. *Turdus Melodus*, Wood Thrush. 2. *Turdus Migratorius*, Red-breasted Thrush, or Robin.

3. *Sitta Carolinensis*, White breasted black-capped Nuthatch. 4. *Sitta Varia*, Red-bellied-black-capped Nuthatch.

Drawn from Nature by A. Wilson.

2

Engraved by A. Lawson.

153

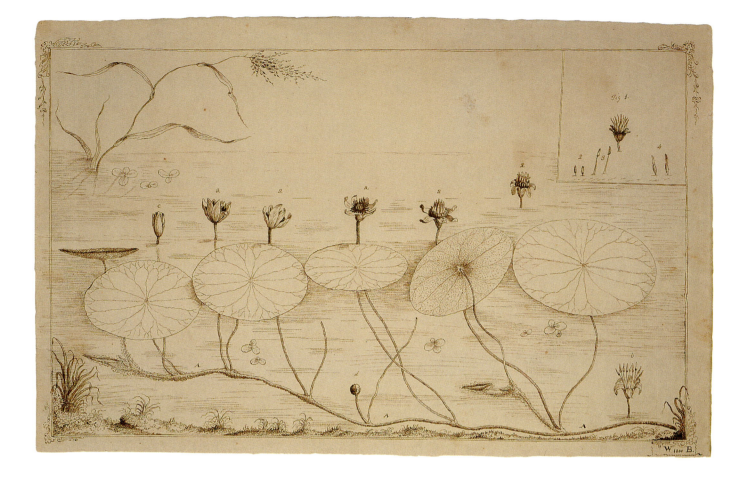

FIGURE 8–27.
William Bartram, "An Aquatic
Plant" (*Brasenia schreberi* Gmel.),
ink on paper, 24.8 x 38.7 cm
(9 3/4 x 15 1/4 in.), 1800.
American Philosophical Society,
Philadelphia, Pennsylvania

work for the succeeding eight volumes, Wilson ruined his health. The remaining four volumes were completed after his death and published by Charles-Lucien Bonaparte. Like William Bartram, whose romantic sensibilities have been well documented, Wilson, who was a poet, was acutely aware of his environment. Wilson's letters to Bartram are full of playful affection. The following excerpt concerns a bee sting suffered by Bartram:

> I truly sympathize, tho' not without a smile, at the undeserv'd treatment you have experienced from your busy Colony. Recollection of the horrible fate of their fathers smotherd with Sulphur or perhaps a presentiment of what awaits themselves might have urg'd them to this outrage but had they known you, my dear friend, as well as I do, they would have distill'd their honey into your lips instead of poison and circl'd around you humming gratefull acknowledgements to their benevolent benefactor who spreads such a luxuriance of blossoms for their benefit.[51]

William Bartram (1739–1823) and his father John Bartram were the leading eighteenth-century American botanists and horticulturalists. William was not, however, a public man. A Quaker, Bartram refused appointments to teach botany or to serve as the botanist for the Lewis and Clark expedition, preferring a quiet life of observation and study in the woods and in his father's garden. John Bartram knew that "Botany and drawing are his darling delight," but tried for years to persuade him to follow a more lucrative path as a physician, engraver, or merchant. William managed, over the years, to follow his own wishes, and pursue his love of plants and drawing [Figures 8–27, 8–28, 8–29, and 8–30]. His lasting fame is based on his account of an adventure begun in 1773—a solitary journey he made through the southern colonies, which took almost four years. John Fothergill, his father's friend and correspondent, funded the trip, and

required that Bartram keep an account of his findings and make drawings of plants he discovered, as well as gather specimens. His *Travels Through North & South Carolina, Georgia, East & West Florida* . . . was finally published in 1791, and subsequently fired the imagination of Wordsworth and Coleridge, James Fenimore Cooper, Emerson, and Thoreau. Bartram wrote of nature's unspoiled beauty, and believed that all nature was suffused with the spirit of its creator. His account of sunrise in Florida is richly descriptive:

> Behold how gracious and beneficent shines the roseate morn! Now the sun arises and fills the plains with light; his glories appear on the forests, encompassing the meadows, and gild the top of the terebinthine Pine and exalted Palms, now gently rustling by the pressure of the waking breezes: the music of the seraphic cranes resounds in the skies; in separate squadrons they sail, encircling their precincts, slowly descend beating the dense air, and alight on the green dewy verge of the expansive lake; its surface yet smoking with the gray ascending mists, which, condensed aloft in clouds of vapour, are born away by the morning breezes, and at last gradually vanish on the distant horizon. All nature awakes to life and activity.[52]

Most of the *Travels* was written years after Bartram's return to Pennsylvania, where he often worked under a tree in his family garden. He grew infirm and his vision dimmed, but the growing fame of his book drew visitors such as William Dunlap, who described him as an old man working in his garden, clothed in leather and coarse linen,

FIGURE 8–28.
William Bartram, "The Great Alachua-Savana in East Florida," ink on paper, 32.4 x 40.6 cm (12 3/4 x 16 in.), circa 1774. American Philosophical Society, Philadelphia, Pennsylvania

The Great Alachua-Savana in East Florida, above 60 miles in circumference.
Near 100 miles W. from S. Augustin & 45 miles W. from the River S. Juan.

FIGURE 8–29.
William Bartram, "Arethusa divaricata" (*Cleistes* divaricata [L.] Ames and Isotria verticilata Raf.), ink on paper, 37.5 x 22.3 cm (14 3/4 x 8 3/4 in.), 1796. American Philosophical Society, Philadelphia, Pennsylvania

FIGURE 8–30.
William Bartram, "Passiflora incarnata. Gynandria pentandria" (*Passiflora incarnata* L.) ink on paper, 25.4 x 12.7 cm (10 x 5 in.), not dated. American Philosophical Society, Philadelphia, Pennsylvania

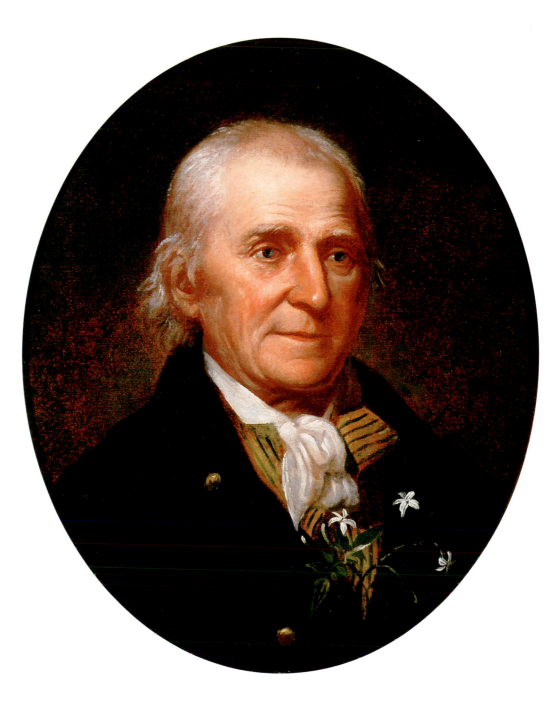

who "entered into conversation with the ease and politeness of nature's noblemen. His countenance was expressive of benignity and happiness."[53] Around 1800, Bartram drew twenty-four plates for Benjamin Smith Barton's *Elements of Botany*.

Bartram had known Charles Willson Peale for years, but it was only in June 1808 that Peale made Bartram's portrait for his museum collection [Figure 8–31]. Peale wrote of this addition to Rembrandt, who was painting portraits in Paris. In the same letter he teased his son that his recent portraits were so good that "if you do not improve very fast I shall overtake you."[54] Bartram's portrait is one of Peale's most sympathetic likenesses, and in its lines it reveals much of the subject's kindly and gentle disposition.

Peale and Bartram were almost exact contemporaries: in 1808 both were in their late sixties. Peale had been interested in health and longevity for a few years. He noted in 1807 that he was determined to "shew more talents at 65 than when at the age of 40 years."[55] Peale first documented his interest in longevity in 1792, when he created a por-

John Rovin in the 172, & Sarah his Wife
In the 164ᵗʰ Year of their respective Ages.
from a Picture formerly belonging to the Percys Earl of
Northumberland : and now in the possession of
William Boswille Esqʳ of Welbeck Street, London.

FIGURE 8–32.
John and Sara Rovin, illustrated in
John Sinclair, *The Code of Health
and Longevity* (1807). Rare Books
and Special Collections Division,
Library of Congress,
Washington, D.C.

trait of John Strangeways Hutton, aged 109 years, and hung it in his museum. In 1809 he copied several portraits of superannuated persons from a book he admired greatly, John Sinclair's *The Code of Health and Longevity* of 1807, including images of John and Sarah Rovin (lifedates unknown) [Figure 8–32]. Bartram's portrait may be not only a likeness of Philadelphia's best-known botanist, but an image that expressed Peale's interest in the achievements of old age, as well—both Bartram's and his own.[56]

The flowering plant emerging from Bartram's green-and-yellow-striped waistcoat is a curious one. Peale may have been making a reference to a 1774 portrait of Carl Linnaeus by Alexander Roslin, which had been engraved several times since its creation [Figure 8–33]. Linnaeus's portrait includes the fragrant flowering plant he had discovered and which was named for him—*Linnea borealis.* Bartram would have appreciated the reference to the founder of modern botanical nomenclature. We do not know, however, why Peale chose the specific flower included in Bartram's portrait. It has been identified as *Jasminum officinale,* a plant with fragrant white flowers which grew originally in Persia, but had been naturalized in Europe for several centuries. It was not a native American

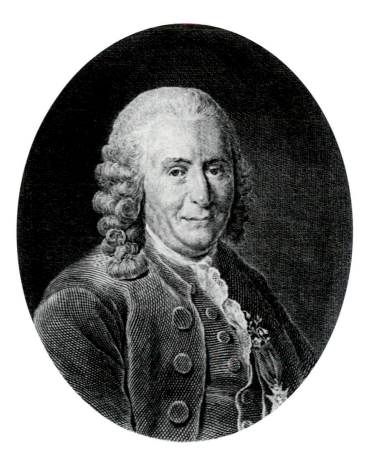

FIGURE 8–33.
Charles Linné [Carl Linnaeus] by C. Boily (lifedates unknown), after Alexander Roslin, engraving, 12 x 10 cm (4 3/4 x 4 in.) oval, 1804. Burndy Library, Dibner Institute for the History of Science and Technology, Cambridge, Massachusetts

plant, but was imported by plantsmen during the eighteenth century, and often called "jessamine" or "Persian jessamine."[57] Its associations were exotic and oriental. A writer for Curtis's *Botanical Magazine* noted in 1787, "There is an elegance in the Jasmine, which added to its fragrance, renders it an object of universal admiration."[58]

Peale's likeness of Bartram was meant for the public space of Peale's Museum, where it would join nearly one hundred other images of celebrated worthies. And yet, Peale emphasized Bartram's inner life and contemplative musings far more than his public successes. Most of the portraits discussed here announce the subject's prominence in the serious, masculine world of science. The images are often crammed with references to knowledge gained, books written, apparatus owned, and social position secured through scientific study. It is fitting to terminate this book with a discussion of the kindly countenance of a man whom the Indians called "Puc-puggy," the Flower Hunter, whose life was spent avoiding the world of public reputation, and who would have been pleased to know that one of his visitors described him in 1818 as "one of the most unambitious lovers of nature I have ever seen."[59]

Each portrait presented here shows one person within a particular context; collectively they emphasize the role of individuals in making history. This is not necessarily a history of great men, but a reminder of the power of individual lives to enrich our understanding of the past. The assertiveness of Ezra Ames's grand portrait of Simeon De Witt as surveyor general of New York speaks to the power of the surveyor in early American culture as eloquently as it touts Ames's abilities as a portraitist.[60] And James Greenway's small portrait with his botanical and medical volumes, and his precious microscope, attest to the importance of science in his life in rural Virginia, so far removed from the centers of European and even American science.

When gathered together, portraits of American men of science reveal patterns in their imagery. Even without textual confirmation, the portraits themselves indicate that the sitters were related, however loosely, by shared interests. They reveal far more than just likeness—they represent the social and cultural identity of the sitters. American men of science, for all their varied interests, were part of the middling classes, striving for a place in society. Other portraits of their contemporaries position their subjects similarly, with different, appropriate poses, settings, and attributes. Pictures of women highlight their virtues or fertility. Portraits of men who went to sea often include telescopes. Merchants and men of business are often portrayed with business correspondence or ledgers, and sometimes with portraits of their ships in the background. Portraits of men of science are also meant to situate the subject within this general world of American polite society, but they move beyond that in their specificity of detail. Franklin could have had portraits that presented him as a well-to-do businessman and man of the world. But he or his patrons almost always went further. Those portraits of Franklin discussed here picture him most emphatically as an ingenious man of science. In his 1762 portrait by Mason Chamberlin, he sits in a room crackling with electrified air, while lightning causes demonstration models to explode in the background. The imagery would have been utterly compelling for those who viewed the painting, or any engravings after it.

Portraits that clearly mark the sitter as a man of science were not unique to America. There were many similar portraits of Europeans, particularly British subjects, that shared this imagery, just as they shared scientific interests and correspondence. Most portraits of these men, American and European, were addressed not only to their families and neighbors, but to the larger republic of science. Portrait prints were not only sold to those curious to know the faces of public figures such as Newton or Franklin, but were exchanged and distributed as part of the cultural practice of disseminating scientific knowledge—singly, as tokens of esteem, or as frontispieces to scientific treatises. Exploring the imagery used to define eighteenth-century men of science and the relationship that such imagery may have had to their lives can bring the cultural ambiance of early American science to life.

It is clear that for many men of science, it was important to be associated visually, by means of pose and attributes, with pictures of intellectuals—men of learning. The head-in-hand pose was used frequently by artists, as was the practice of situating such men in interiors furnished with desks, books, and writing materials. Men of science were also linked visually with creative thinkers by means of costume—the loose, flowing morning gown, or banyan. It is striking to see how many eighteenth-century portraits portray dignified male sitters wearing this informal attire. The banyan's connotations of dignity, retirement, the life of the mind, and creative use of the faculties were stronger than any connection with less-than-proper costume or deportment in society. In portraits of "ingenious" men wearing clerical bands, academic robes, or formal dress (appropriate for moving in the external world), there are often other markers of scientific interests—specific objects linked to their work.

These highly specific objects—often more carefully delineated and described than objects in other contemporary portraits—contribute to the uniqueness and dramatic visual presence of the portraits. And, as we have seen, the objects pictured in portraits of men of science usually have some basis in reality—they were owned or used by the sitter. One telling exception is William Smith's theodolite. Though most likely not owned by him, it was copied in every detail from a contemporary engraving. This example can help us to understand the usefulness of portraiture as visual evidence not only of personal appearance and possessions, but of the aspect of biography that is most difficult to

document—ambition and desire. Portraits that emphasize a man's devotion to science often tell us more about his public affiliations and perceived social or cultural role than about what we would call personal character.

In 1776, Oliver Wolcott wrote to his wife Laura about David Rittenhouse and his orrery: "I saw Mr Rittenhouse and Viewed him with great Curiosity, but I saw no other Mark of Genius Stamped upon him than what is discoverable in an ordinary man. He appeared extremely Modest and rather what We call Shamefaced—but he has erected a Monument which will be admired while learning lasts, or Man is capable of adoring the Creator."[61] Wolcott was clearly looking for a visual marker of exceptional genius, similar, perhaps, to the calm, poised countenance created by Peale in his painted portraits. That portraits are mediated depictions of faces does not diminish their value. For an educated person of the late eighteenth century, looking for signs of character or genius in the face was a culturally constructed practice based on knowledge of physiognomy. Painters might play on that notion in creating painted faces that did carry markers of dignity, composure, or genius. It is difficult to recover just what those visual signs might have been. Wolcott gives us one Rittenhouse, Peale several others, painted over a twenty-five-year period. And yet Peale's visual Rittenhouse tells us more about the sitter's social identity as an astronomer and American genius than Wolcott's verbal description does.

The desire to assert a connection with the republic of learning, to participate in the project of the Enlightenment, and to create images that emphasized the scientific life were strong among men of science during the years surrounding the American Revolution. The resulting portraits form a great resource for the study of American art history, but they also enrich our knowledge of the many individuals who contributed to the history of early American science.

Notes

INTRODUCTION

1. For recent examples of essays from both fields that address the complexity of portraiture's expressive language, see Patricia Fara, "The Royal Society's Portrait of Joseph Banks," *Notes and Records of the Royal Society of London* 51 (1997): 199–210; Ludmilla Jordanova, "Medical Men, 1780–1820," in Joanna Woodall, ed., *Portraiture Facing the Subject* (Manchester, Eng.: Manchester University Press, 1997), pp. 101–15; Ellen G. Miles and Leslie Reinhardt, "'Art conceal'd': Peale's Double Portrait of Benjamin and Eleanor Ridgely Laming," *Art Bulletin* 78 (March 1996): 56–74; and David Steinberg, "The Characters of Charles Willson Peale: Portraiture and Social Identity, 1769–1776" (Ph.D. diss., University of Pennsylvania, 1993).

2. See Margaret C. Jacob, *The Cultural Meaning of the Scientific Revolution* (Philadelphia: Temple University Press, 1988), p. 33.

3. See Alan Morton and Jane Wess, *Public and Private Science: The King George III Collection* (Oxford: Oxford University Press, 1993).

4. Roy Porter, "The Economic Context," in *Science and Profit in Eighteenth-Century London* (Cambridge: Whipple Museum of the History of Science, 1985), p. 3.

5. Thomas Collinson to Benjamin Franklin, [May 2, 1767?], in Leonard W. Labaree et al., eds., *The Papers of Benjamin Franklin* (New Haven: Yale University Press, 1959–), vol. 14, pp. 144–45 (hereafter cited as *Franklin Papers*).

6. Ezra Stiles to Elizabeth Hubbard, January 18, 1755, and Benjamin Franklin to Ezra Stiles, June 2, 1757, in Isabell M. Calder, ed., *Letters & Papers of Ezra Stiles, President of Yale College, 1778–1795* (New Haven: Yale University Library, 1933), pp. 1–4.

7. John Bartram to Cadwallader Colden, November 2, 1744, in Edmund Berkeley and Dorothy Smith Berkeley, eds., *The Correspondence of John Bartram, 1734–1777* (Gainesville: University Press of Florida, 1992), p. 247.

8. The fullest account of Franklin's portraits is Charles Coleman Sellers, *Benjamin Franklin in Portraiture* (New Haven: Yale University Press, 1962). Other useful studies are Ellen G. Miles, "The French Portraits of Benjamin Franklin," in J. A. Leo Lemay, ed., *Reappraising Benjamin Franklin: A Bicentennial Perspective* (Newark: University of Delaware Press, 1993), pp. 272–89, and Wayne Craven, "The American and British Portraits of Benjamin Franklin," in ibid., pp. 247–71.

9. Benjamin Franklin to James Bowdoin II, May 31, 1788, in Albert Henry Smyth, ed., *The Writings of Benjamin Franklin* (New York: Macmillan, 1905–1907), vol. 9, p. 652.

10. The phrase "keep the chain of friendship bright" and its variations are found repeatedly in letters exchanged between American men of science and some of their British correspondents. The phrase is of Native American origin and refers to a covenant chain of peace and friendship. Dr. John Fothergill gave Franklin a silver teapot in 1765, inscribed "Keep bright the chain," which Franklin bequeathed to Henry Hill, a Philadelphia wine merchant. For an illuminating view of how men of science presented themselves as members of this "chain" through the writing and exchange of personal letters, see Konstantin Dierks, "Letter Writing, Masculinity, and American Men of Science, 1750-1800," *Pennsylvania History* 65 (October 1998): 165–96.

11. Cadwallader Colden to Dr. John Mitchell, November 7, [1745], in *The Letters and Papers of Cadwallader Colden*, vol. 8: *Additional Letters and Papers, 1715–1748, Collections of the New-York Historical Society for the Year 1934* (New York: New-York Historical Society, 1937), p. 337.

12. Samuel F. B. Morse to Jedidiah Morse, August 17, 1811, in Edward Lind Morse, ed., *Samuel F. B. Morse: His Letters and Journals* (New York: Kennedy Galleries, Inc., Da Capo Press, 1973), vol. 1, p. 40.

13. For an incisive discussion of the broad world of eighteenth-century correspondence and social discourse, but with particular emphasis on French cultural practices, see Dena Goodman, *The Republic of Letters: A Cultural History of the French Enlightenment* (Ithaca, N.Y.: Cornell University Press, 1994).

CHAPTER 1

1. Eliza Lucas Pinckney to Miss B[artlett], [circa March–April 1742], in Elise Pinckney, ed., *The Letterbook of Eliza Lucas Pinckney, 1739–1762* (Columbia: University of South Carolina Press, 1997), p. 31.

2. Alexander Garden to Cadwallader Colden, May 23, 1755, in *The Letters and Papers of Cadwallader Colden*, vol. 5: *1755–1760, Collections of the New-York Historical Society for 1921* (New York: New-York Historical Society, 1923), p. 5.

3. Quoted in Edward C. Carter II, *"One Grand Pursuit": A Brief History of the American Philosophical Society's First 250 Years, 1743–1993* (Philadelphia: American Philosophical Society, 1993), pp. 12–13.

4. Quoted in Whitfield J. Bell Jr., "Science and Humanity in Philadelphia, 1775–1790" (Ph.D. diss., University of Pennsylvania, 1947), p. 145.

5. Joseph Priestley, *The History and Present State of Electricity* (3d ed., 1775; reprint, New York: Johnson Reprint Corporation, 1966), pp. xxiii–xxv.

6. Benjamin Franklin to Joseph Huey, June 6, 1753, quoted in J. L. Heilbron, "Franklin as an Enlightened Natural Philosopher," in J. A. Leo Lemay, ed., *Reappraising Benjamin Franklin: A Bicentennial Perspective* (Newark: University of Delaware Press, 1993), p. 205.

7. John Winthrop, *Relation of a Voyage from Boston to Newfoundland, for the Observation of the Transit of Venus, June 6, 1761* (Boston, 1761), pp. 5–6, 23, reprinted in Michael N. Shute, ed., *The Scientific Work of John Winthrop* (New York: Arno Press, 1980).

8. Benjamin Franklin to Cadwallader Colden, October 11, 1750, in *The Letters and Papers of Cadwallader Colden*, vol. 4: *1748–1754, Collections of the New-York Historical Society for the Year 1920* (New York: New-York Historical Society, 1921), p. 227.

9. For a discussion of the identification of the culture of science with men, see David F. Noble, *A World Without Women: The Christian Clerical Culture of Western Science* (New York: Alfred A. Knopf, 1992).

10. See Ruth Perry, "Radical Doubt and the Liberation of Women," *Eighteenth-Century Studies* 18 (1984–1985): 472–93. I want to thank Konstantin Dierks for this reference.

11. See William Darlington, *Memorials of John Bartram and Humphry Marshall* (Philadelphia: Lindsay & Blakiston, 1849), pp. 535–36.

12. For a fully researched account of Jane Colden's life and botanical career, see the chapter "What Jane Knew: Botany in British Colonial New York," in Sara Gronim, "Ambiguous Empire: The Knowledge of the Natural World in British Colonial New York" (Ph.D. diss., Rutgers University, 1999).

13. This has been partially reproduced in H. W. Rickett and Elizabeth C. Hall, eds., *Botanic Manuscript of Jane Colden, 1724–1766* (N.p.: Garden Club of Orange and Dutchess Counties, N.Y., 1963).

14. Cadwallader Colden to [Dr. Whytt?], February 15, 1758, in *Letters and Papers of Colden*, vol. 5, p. 217.

15. Peter Collinson to Cadwallader Colden, April 6, 1757, in ibid., p. 139.

16. See "The Description of a New Plant; by Dr. Alex. Garden, Physician at Charles-town in South Carolina," *Essays and Observations, Physical and Literary*, vol. 2 (Edinburgh: G. Hamilton and J. Balfour, 1756), pp. 1–7.

17. See Alexander Garden to Cadwallader Colden, May 23, 1755: "It gives me great pleasure that you give me leave to send Miss Colden's Description of that new plant to any of my Correspondents as I had before sent it to Dr. Whytt at Edinburgh—," *Letters and Papers of Colden*, vol. 5, p. 11.

18. Collinson to Colden, April 6, 1757, ibid., p. 139.

19. See Gronim, "Ambiguous Empire," p. 46, for Jane Colden's correct death date of March 10, 1760.

CHAPTER 2

1. See Richard H. Saunders and Ellen G. Miles, *American Colonial Portraits, 1700–1776* (Washington, D.C.: Smithsonian Institution Press for the National Portrait Gallery, 1987), pp. 43–49; see also Richard L. Bushman, *The Refinement of America: Persons, Houses, Cities* (New York: Alfred A. Knopf, 1992), especially pp. 30–99; and the useful essays in Ellen G. Miles, ed., *The Portrait in Eighteenth-Century America* (Newark: University of Delaware Press, 1993).

2. On the relationship between the culture of politeness and changing conventions for male portraiture among the upper classes in Britain, see David Solkin, "Great Pictures or Great Men? Reynolds, Male Portraiture, and the Power of Art," *Oxford Art Journal* 9 (1986): 42–49. See also Lawrence E. Klein, *Shaftesbury and the Culture of Politeness: Moral Discourse and Cultural Politics in Early Eighteenth-Century England* (Cambridge: Cambridge University Press, 1994).

3. Letter written on November, 12, 1776. See Philip Dormer, fourth Earl of Chesterfield, *Letters . . . to His Godson and Successor*, ed. the Earl of Carnarvon (Oxford: Clarendon Press, 1890), p. 226, cited in David Mannings, "Studies in British Portrait Painting in the 18th Century, with Special Reference to the Early Work of Sir Joshua Reynolds" (Ph.D. diss., University of London, 1977), p. 81.

4. Roger de Piles, *The Principles of Painting* (London, 1743), pp. 161–69.

5. Jonathan Richardson, *An Essay on the Theory of Painting* (2d ed., 1725; reprint, Manston, Eng., 1971), pp. 13–14.

6. Jonathan Richardson, *The Works of Jonathan Richardson* (London, 1792), pp. 80–81.

7. Ibid., p. 44.

8. Ibid., p. 35.

9. Ibid., p. 13.

10. See John Hayes, *British Paintings of the Sixteenth through Nineteenth Centuries: The Collections of the National Gallery of Art Systematic Catalogue* (Washington, D.C.: Cambridge University Press for the National Gallery of Art, 1992), pp. 215–17.

11. See Ellen G. Miles et al., *American Paintings of the Eighteenth Century: The Collections of the National Gallery of Art Systematic Catalogue* (Washington, D.C.: Cambridge University Press for the National Gallery of Art, 1995), pp. 118–20.

12. See Carol Troyen's entry on this portrait in Carrie Rebora et al., *John Singleton Copley in America* (New York: Harry N. Abrams for the Metropolitan Museum of Art, 1995), pp. 193–94.

13. See Elizabeth Mankin Kornhauser et al., *Ralph Earl: The Face of the Young Republic* (New Haven: Yale University Press, 1991), p. 134, for a discussion of this portrait.

CHAPTER 3

1. For a recent exploration of the humanist scholar that focuses on the study and its furnishings, see Dora Thornton, *The Scholar in His Study: Ownership and Experience in Renaissance Italy* (New Haven: Yale University Press, 1997).

2. See John Peacock, "The 'Wizard Earl' Portrayed by Hilliard and Van Dyck," *Art History* 8 (June 1985): 139–57.

3. John Aubrey, *Aubrey's Brief Lives*, ed. Oliver L. Dick (London: Secker and Warburg, 1950), p. xliii, quoted in *Chain of Friendship: Selected Letters of Dr. John Fothergill of London, 1735–1780*, with introduction and notes by Betsy C. Corner and Christopher C. Booth (Cambridge, Mass.: Harvard University Press, Belknap Press, 1971), p. 81, n. 1.

4. John Evelyn, *Publick employment and an active life prefer'd to solitude, and all its appanages* (London, 1667), p. 83, cited in Steven Shapin, " 'A Scholar and a Gentleman': The Problematic Identity of the Scientific Practitioner in Early Modern England," *History of Science* 29, pt. 3, no. 85 (September 1991): 291.

5. Joseph Addison, in *The Spectator*, no. 287, Tuesday, January 29, 1712. I would like to thank Lee Vedder for this reference. For an informed discussion of the impact of developing notions of gentility, civility, and polite social discourse on various ranks of persons in eighteenth-century Britain and America, see David S. Shields, *Civil Tongues & Polite Letters in British America* (Chapel Hill: University of North Carolina Press for the Institute of Early American History and Culture, 1997).

6. For a lengthy discussion of these ideas, see Steven Shapin, *A Social History of Truth: Civility and Science in Seventeenth-Century England* (Chicago: University of Chicago Press, 1994), esp. pp. 126–92.

7. Stephen E. Patrick, " 'I Have at Length Determined to Have My Picture Taken': An Eighteenth-Century Young Man's Thoughts about His Portrait by Henry Benbridge," *American Art Journal* 22, no. 4 (1990): 80.

8. See Raymond Klibansky, Erwin Panofsky, and Fritz Saxl, *Saturn and Melancholy* (London: Thomas Nelson and Sons, 1964), and more recently, Zirka Z. Filipczak, *Hot Dry Men/Cold Wet Women: The Theory of Humors in Western European Art, 1575–1700* (New York: American Federation of Arts, 1997), esp. pp. 56, 69–70, 131.

9. See David Piper, *Catalogue of Seventeenth-Century Portraits in the National Portrait Gallery, 1625–1714* (Cambridge: Cambridge University Press, 1963), p. 249.

10. For Franklin's Scottish connections, see Richard B. Sher, "An 'Agreable and Instructive Society': Benjamin Franklin and Scotland," in John Dwyer and Richard B. Sher, eds., *Sociability and*

Society in Eighteenth-Century Scotland (Edinburgh: Mercat Press, 1993), pp. 181–93.

11. Robert Alexander helped finance Martin's art studies, including three years in Italy. See the typescript copy of an unlocated original memoir of Martin's life, "Account of His Life by His Brother," Scottish National Portrait Gallery, Edinburgh.

12. For a full discussion of all the versions and replicas of the Martin portrait, see Sellers, *Franklin in Portraiture*, pp. 74–80, 328–40.

13. See George Richardson, *Iconology; or, a Collection of Emblematical Figures*, 2 vols. (London, 1779), vol. 1, pp. 79–80, and Figure 146.

14. Joseph Moser, [reminiscences of Allan Ramsay, in whose studio Martin worked for a time], *European Magazine and London Review* 64 (1813): 516; quoted in Sellers, *Franklin in Portraiture*, p. 78.

15. Quoted by John Platt, *Franklin's House Historic Structures Report, Independence N.H.P. Pennsylvania* (Washington, D.C.: Office of Archeology and Historic Preservation, 1969), frontispiece.

16. On the history of this imagery, so important for representations of men of science, see Julius S. Held, "Rembrandt's Aristotle," in *Rembrandt Studies* (Princeton: Princeton University Press, 1991), pp. 17–58.

17. See excerpts from *Poor Richard's Almanac* for 1748 and 1749 in *Franklin Papers*, vol. 3, pp. 250–51, 348–49.

18. Ibid., p. 348.

19. The most recent discussion of Gullager's portraits is Linda J. Docherty, "Preserving Our Ancestors: The Bowdoin Portrait Collection," in Katharine J. Watson et al., *The Legacy of James Bowdoin III* (Brunswick, Maine: Bowdoin College Museum of Art, 1994), pp. 67–68, 74–75.

20. See Gordon E. Kershaw, *James Bowdoin: Patriot and Man of the Enlightenment* (Brunswick, Maine: Bowdoin College Museum of Art, 1976), p. 17 and cat. nos. 50 and 51.

21. Quoted from the Boston *Columbian Centinel* for November 16, 1791, in Marvin S. Sadik, *Colonial and Federal Portraits at Bowdoin College* (Brunswick, Maine: Bowdoin College Museum of Art, 1966), p. 96.

22. Ezra Stiles, Diary, August 1, 1771, in Franklin Bowditch Dexter, ed., *The Literary Diary of Ezra Stiles, D.D., LL.D.* (New York: Charles Scribner's Sons, 1901), vol. 1, p. 13.

23. See Edmund S. Morgan, *The Gentle Puritan: A Life of Ezra Stiles, 1727–1795* (New Haven: Yale University Press for the Institute of Early American History and Culture, 1962), pp. 160–62.

24. Journal entry for July 3, 1787, in William Parker Cutler and Julia Perkins Cutler, *Life Journals and Correspondence of Rev. Manasseh Cutler, LL.D.* (Cincinnati: Robert Clarke & Co., 1888), vol. 1, p. 220.

25. On Franklin's portrait, see Dexter, *Literary Diary of Ezra Stiles*, vol. 2, pp. 386–87; on other portraits in the library at Yale, see p. 94. After Franklin's death, Stiles noted (pp. 390–91) that he had first met Franklin in 1755, although he had known him since 1743.

26. See ibid., vol. 1, pp. 131–32. For a discussion of this portrait as it relates to contemporary attitudes towards physiognomy, see David Steinberg, "Facing Paintings and Painting Faces before Lavater," in Peter Benes, ed., *Painting and Portrait Making in the American Northeast*, Dublin Seminar for New England Folklife, Annual Proceedings, vol. 19 (Boston: Boston University, 1995), pp. 201–16.

27. For Morgan's life and career, see Whitfield J. Bell Jr., *John Morgan, Continental Doctor* (Philadelphia: University of Pennsylvania Press, 1965).

28. Quoted in ibid., p. 75.

29. John Morgan to William Smith, November 16, 1764, quoted in ibid., p. 99.

30. For a full discussion of Kauffman's American sitters and the circumstances concerning Morgan's portrait, see Arthur S. Marks, "Angelica Kauffmann and Some Americans on the Grand Tour," *American Art Journal* 12 (spring 1980): 4–24.

31. Ibid., p. 12.

32. Ibid., p. 15; [Julia Morgan Harding, ed.], *The Journal of Dr. John Morgan of Philadelphia 1764* (Philadelphia: J. B. Lippincott, 1907), pp. 106–8.

33. For the above discussion, see Marks, "Angelica Kauffmann," pp. 12–16, and Bell, *John Morgan*, pp. 86–91, 98.

34. See John Singleton Copley to Henry Pelham, November 6, 1771, cited in Rebora et al., *Copley in America*, pp. 291–92.

35. See William Sawitzky, *Matthew Pratt, 1734–1805* (New York: New-York Historical Society, 1942), p. 45 and *passim*. Pratt's travel to Williamsburg, Virginia, and other points in eastern Virginia is documented in two advertisements in the *Virginia Gazette* (March 4 and 18, 1773) found in the Museum of Early Southern Decorative Arts, Research Files, Winston-Salem, N.C.

36. This diagram is difficult to interpret; it may depict the earth and the moon in eclipse. This is a graciously offered educated guess communicated in a letter to the author from Owen Gingerich, Harvard-Smithsonian Center for Astrophysics, February 3, 1997.

37. Cadwallader Colden, *An Explication of the First Causes of Action in Matter. . .* (London, 1746), pp. v, 75.

38. Benjamin Franklin to Cadwallader Colden, October 16, 1746, in *Franklin Papers*, vol. 3, p. 90.

39. Cadwallader Colden, "An Introduction to the Study of Phylosophy wrote in America for the use of a young gentleman" [circa 1760], p. 20, Cadwallader Colden Papers, Box 1, Scientific Letters, Papers, and Notes, New-York Historical Society, New York City.

40. "An Introduction to the Study of Phylosophy wrote in America for the use of a young Gentleman," attached to a letter from Cadwallader Colden to "my son Alexander," July 10, 1760, Colden Papers, NYHS.

41. John Adams, diary entry for September 28, 1775, in L. H. Butterfield, ed., *Diary and Autobiography of John Adams* (Cambridge, Mass.: Harvard University Press, Belknap Press, 1962), vol. 2, p. 187; Thomas Jefferson, *Notes on the State of Virginia*, in Merrill D. Peterson, ed., *The Portable Thomas Jefferson* (New York: Penguin, 1975), pp. 101–3.

42. See Charles Coleman Sellers, *Portraits and Miniatures . . . by Charles Willson Peale*, *Transactions of the American Philosophical Society*, n.s., vol. 42, pt. 1 (Philadelphia: American Philosophical Society, 1952), p. 182.

43. I am grateful to Owen Gingerich of the Harvard-Smithsonian Center for Astrophysics for this information.

44. For a thorough discussion and interpretation of the history of cometary science and comet lore, see Sara Schechner Genuth, *Comets, Popular Culture, and the Birth of Modern Cosmology* (Princeton: Princeton University Press, 1997).

45. Mather Byles, *The Comet: A Poem. . .* (Boston, 1744), p. 4.

46. David Rittenhouse, *An Oration, Delivered February 24, 1775, before the American Philosophical Society . . .* (Philadelphia, 1775), pp. 19–22.

47. See Brandon Brame Fortune, "Charles Willson Peale's Portrait Gallery: Persuasion and the Plain Style," *Word & Image* 6 (October–December 1990): 308–24 and n. 6.

48. See Edmond Halley, "De Constructione Problematum Solidorum, sive Æquationum tertiae vel quartae Potestatis, unica data Parabola ac Circulo efficienda, differtatiancula," *Philosophical Transactions of the Royal Society of London* 16 (July–August 1687):

335–43; diagram, p. 341. This information, as well as handwritten notes from Alan Cook identifying the diagram, and other notes on Halley's portrait from David W. Hughes (1984) and E. F. MacPike (1932), are to be found in files maintained by the Library of the Royal Society. See also Alan Cook, *Edmond Halley: Charting the Heavens and the Seas* (Oxford: Clarendon Press, 1998), p. xvi.

49. See Royal Society of London, *Journal Books of Scientific Meetings, 1660–1800* [microform] (Frederick, Md.: University Publications of America, 1985).

50. William Barton, *Memoirs of the Life of David Rittenhouse, LL.D. F.R.S. . .* (Philadelphia: E. Parker, 1813), p. 453.

51. Benjamin Rush, *An Eulogium, Intended to Perpetuate the Memory of David Rittenhouse. . .* (Philadelphia, 1796), p. 40.

52. Walter Robertson to Benjamin Rush, February 4, 1795, Benjamin Rush Papers, The Library Company of Philadelphia (hereafter LCP). On Peale's interest in physiognomy and character, see Fortune, "Peale's Portrait Gallery," pp. 308–24; and David Steinberg, "Charles Willson Peale Portrays the Body Politic," in Lillian B. Miller et al., *The Peale Family: Creation of a Legacy, 1770–1870* (New York: Abbeville Press for the Trust for Museum Exhibitions and the National Portrait Gallery, 1996), pp. 118–33.

53. See Sanborn C. Brown, *Benjamin Thompson, Count Rumford* (Cambridge, Mass.: MIT Press, 1979).

54. See ibid., p. 184.

55. See ibid., pp. 251–52.

56. Quoted from a letter of July 19, 1802, in ibid., p. 237.

57. Curatorial records, New Hampshire Historical Society, Concord.

58. Interestingly, David Steinberg has noted that in Charles Willson Peale's *oeuvre*, there are only two instances of this pose—head in hand, with a forefinger pointing to the head: portraits of Thomas Paine (see below) and Timothy Matlack (private collection), both men who gained prominent positions through their wits, not by wealth or social connections. See Steinberg, "Peale Portrays the Body Politic," p. 125.

CHAPTER 4

1. We are indebted to Arthur S. Marks for introducing the problem of banyans in portraiture, particularly in portraits of artists and John Singleton Copley's portraits of merchants in his fascinating, but unpublished, lectures on this subject. Banyans and other robes worn informally by men are discussed in most books on British and American costume. Among the most important sources are Patricia A. Cunningham, "Eighteenth-Century Nightgowns: The Gentleman's Robe in Art and Fashion," *Dress* 10 (1984): 2–11; Margaret H. Swain, "Nightgown into Dressing Gown: A Study of Mens' Nightgowns: Eighteenth Century," *Costume* 6 (1972): 10–21; Margaret H. Swain, "The Nightgown of Governor Jonathan Trumbull," *Bulletin of the Wadsworth Atheneum* 6th ser., vol. 6 (winter 1970): 28–38; and Aileen Ribeiro, *Dress in Eighteenth-Century Europe, 1715–1789* (London: B. T. Batsford Ltd., 1985), pp. 26–27. For informative conversations about nightgowns and banyans, and a careful reading of this chapter, we would like to thank Claudia Kidwell of the National Museum of American History. Leslie Reinhardt of the National Portrait Gallery also offered helpful advice.

2. The term "banyan" will be used for the rest of this essay.

3. See Jonathan Belcher to "Captain Franklyn," Boston, September 11, 1734, in *Jonathan Belcher Letterbooks*, vol. 2, reprinted in the *Collections of the Massachusetts Historical Society* 6th ser., vol. 7

(Boston: Massachusetts Historical Society, 1894): 118–19. I am grateful to Ellen Miles for this reference.

4. See "The Burning of Harvard Hall, 1764, and Its Consequences," in *Transactions of the Colonial Society of Massachusetts* 14 (1911–1914): 33. I want to thank Sandra Grindlay for this reference.

5. Quoted in Alice Morse Earle, *Two Centuries of Costume in America* (Williamstown, Mass.: Corner House Publishers, 1974), vol. 2, p. 427.

6. Quoted in C. Willett Cunnington and Phillis Cunnington, *Handbook of English Costume in the Eighteenth Century* (Boston: Plays, Inc., 1972), p. 220.

7. Swain, "Nightgown into Dressing Gown," pp. 10–21. For more information on these loose gowns, often made of rich materials, see Linda Baumgarten, *Eighteenth-Century Clothing at Williamsburg* (Williamsburg, Va.: Colonial Williamsburg Foundation, 1986), pp. 49–51.

8. See Filipczak, *Hot Dry Men, Cold Wet Women*, pp. 56 and 88. Filipczak also cites an informative essay on robes in portraiture by Marieke de Winkel, " 'Eene der deftigsten dragten': The Iconography of the *Tabbaard* and the Sense of Tradition in Dutch Seventeenth-Century Portraiture," in Reindert Falkenburg et al., eds., *Image and Self-Image in Netherlandish Art, 1550–1750* (Zwolle: Waanders Uitgevers, 1995), pp. 145–67.

9. See, for example, the emblem of melancholy in Henry Peacham's *Minerva Britanna, or a Garden of Heroical Devises* of 1612, where the male figure is accompanied by a cat and an owl. See Huston Diehl, *An Index of Icons in English Emblem Books, 1500–1700* (Norman: University of Oklahoma Press, 1986), p. 146.

10. For Boswell's diary entries and letters from this period, see Frederick Albert Pottle and Frank Brady, eds., *Boswell on the Grand Tour: Italy, Corsica, and France 1765–1766* (New York: McGraw Hill, 1955), pp. 74–76. Copies are located in the curatorial file, Scottish National Portrait Gallery.

11. John Bartram to Peter Collinson, June 11, 1743, in Berkeley and Berkeley, *Correspondence of Bartram*, p. 215. On Witt, see Herbert Leventhal, *In the Shadow of the Enlightenment: Occultism and Renaissance Science in Eighteenth-Century America* (New York: New York University Press, 1976), pp. 107–8; U. P. Hedrick, *A History of Horticulture in America to 1860* (New York: Oxford University Press, 1950), pp. 84–85. On Kelpius and Witt, see Julius F. Sachse, *The German Pietists of Provincial Pennsylvania* (Philadelphia, 1895).

12. See Swain, "The Nightgown of Trumbull," p. 28.

13. See Alan Burroughs, *John Greenwood in America, 1745–1752* (Andover, Mass.: Addison Gallery of American Art, Phillips Academy, 1943).

14. Reverend Thomas Prince, "Late Mr. Edward Bromfield jun's Microscope-Discoveries," *American Magazine* 3 (December 1746): 548–49.

15. This was Yale's first microscope, a compound microscope acquired from a Mr. Scarlett of London in 1734. It is described in *A Catalogue of Surviving Early Scientific Instruments of Yale College* (New Haven: Yale University, 1947), no. 1.

16. The *Boston Weekly Gazette* is quoted in Cunningham, "Eighteenth-Century Nightgowns," p. 3.

17. On the Highmore portrait and Pelham mezzotint, see Saunders and Miles, *American Colonial Portraits*, pp. 142–43.

18. On Smibert and his use of this costume, and for Nathaniel Smibert's portrait of Ezra Stiles, see Richard H. Saunders, *John Smibert: Colonial America's First Portrait Painter* (New Haven: Yale University Press, 1995), pp. 70, 124, and cat. nos. 51 and 59.

19. The connotations of the banyan in defining the persona of a gentleman in Copley's work, particularly his self-portrait of 1769, have been addressed by Susan Rather in "Carpenter, Tailor, Shoemaker, Artist: Copley and Portrait Painting around 1770," *Art Bulletin* 79 (June 1997): 269–90.

20. Quoted in *Paul Revere's Boston, 1735–1818* (Boston: Museum of Fine Arts, 1975), p. 75.

21. Prince, "Bromfield jun's Microscope-Discoveries," p. 551.

22. Diary entry for September 24, 1775, Butterfield, *John Adams*, vol. 2, p. 182.

23. Benjamin Rush, "On the Influence of Physical Causes in Promoting an Increase of the Strength and Activity of the Intellectual Faculties of Man," in *Two Essays on the Mind* (New York: Brunner/Mazel, 1972), p. 96. Rush was writing about the beneficial effects of loose gowns in "Manuscript Lectures of the Theory and Practice of Physick, 1790–1791," p. 336, Benjamin Rush Papers, HSP: "Studious People should always have their Clothes loose—for Ligatures are unfriendly to the active Exercise of the intellectual Powers.—hence we see all Studious men in Gowns and Slippers and frequently with open Collars."

24. The Library Company of Philadelphia owns many volumes from Rush's library, or books that may have been owned by Rush, and thereafter by his son, James. Among these titles are many of the books included in his portrait, or other titles by the same authors.

25. Rush commented in his notes from 1790–1791 on Hamilton's account of the attitudes in which the dead were found (Rush, "Manuscript Lectures," p. 331, HSP). Rush is referring to Sir William Hamilton's "An Account of the Earthquakes which happened in Italy, from February to May 1783," *Philosophical Transactions of the Royal Society of London* LXXII (1783): 181–82.

26. See Rush, "Syllabus of a Course of Lectures, upon Physiology, Pathology, Hygiene, and the Practice of Medicine," in *Sixteen Introductory Lectures, to Courses of Lectures Upon the Institutes and Practice of Medicine* (Philadelphia, 1811), p. 25.

27. Moyes's lectures in February 1786 are discussed by Whitfield J. Bell Jr. in "Science and Humanity in Philadelphia," p. 184; he may have been in Philadelphia the previous year, for in a letter of February 23, 1785 (an error in transcription?), from Mary Norris to the arborist Humphry Marshall, she writes about his appearance in Philadelphia. See William Darlington, *Memorials of John Bartram and Humphry Marshall* (Philadelphia: Lindsay and Blakiston, 1849), pp. 535–36. Moyes, who was blind, was an itinerant lecturer in England and a lecturer in chemistry at the University of Edinburgh. See F. W. Gibbs, "Itinerant Lecturers in Natural Philosophy," *Ambix* 6 (1960): 111–17.

28. Benjamin Rush, *An Oration delivered before the American Philosophical Society. . . containing an Enquiry into the Influence of Physical Causes upon the Moral Faculty* (Philadelphia, 1786), p. 24.

29. Charles Willson Peale to Benjamin Rush, Philadelphia, July 31, 1786, in Lillian B. Miller et al., eds., *The Selected Papers of Charles Willson Peale and His Family* (New Haven: Yale University Press for the National Portrait Gallery, 1983–), vol. 1, p. 450.

30. Benjamin Rush to James McHenry, June 2, 1779, in L. H. Butterfield, ed., *Letters of Benjamin Rush* (Princeton: Princeton University Press for the American Philosophical Society, 1951), vol. 1, pp. 223–24.

31. Benjamin Rush to William Cullen, Philadelphia, September 16, 1783, in ibid., p. 310.

32. William Nicholson, *An Introduction to Natural Philosophy* (London, 1787), p. x.

33. [William Livingston], *Philosophic Solitude; or, The Choice of a Rural Life: A Poem* (1747; New York, [1769]), pp. 23, 35.

34. On retirement as a cultural and literary construct, see Maren Sofie Rostvig, *The Happy Man: Studies in the Metamorphoses of a Classical Ideal* (Oslo: Norwegian Universities Press, 1962); Michael O'Loughlin, *The Garlands of Repose: The Literary Celebration of Civic and Retired Leisure* (Chicago: University of Chicago Press, 1978), pp. 53–79; Raymond Williams, *The Country and the City* (New York: Oxford University Press, 1973); and Tamara Plakins Thornton, *Cultivating Gentlemen: The Meaning of Country Life among the Boston Elite, 1785–1860* (New Haven: Yale University Press, 1989).

CHAPTER 5

1. See Alice N. Walters, "Conversation Pieces: Science and Politeness in Eighteenth-Century England," *History of Science* 35 (1997): 121–54.

2. For William Robertson's *The Family of Sir Archibald Grant of Monymusk*, see James Holloway, *Patrons and Painters: Art in Scotland, 1650–1760* (Edinburgh: Scottish National Portrait Gallery, 1989), pp. 78–80 and figs. 57 and 58.

3. See James Welu, "Vermeer's *Astronomer*: Observations on an Open Book," *Art Bulletin* 67 (June 1986): 263–67.

4. For a concise statement of the links between the culture of science and Freemasonry, see Betty Jo Teeter Dobbs and Margaret C. Jacob, *Newton and the Culture of Newtonianism* (Atlantic Highlands, N.J.: Humanities Press International, 1995), pp. 101–4.

5. On Franklin's Masonic affiliations see Julius Friedrich Sachse, *Benjamin Franklin as a Free Mason* (Philadelphia, 1906).

6. For a recent discussion of Masonic imagery and cultural artifacts, see John D. Hamilton, *Material Culture of the American Freemasons* (Lexington, Mass.: Museum of Our National Heritage, 1994). On Masonic symbolism, see W. L. Wilmhurst, *The Meaning of Masonry* (1927; reprint, New York: Bell Publishing Co., 1980), esp. pp. 87–137.

7. See Hamilton, *American Freemasons*, pp. 29–30.

8. Quoted in Louise Todd Ambler, *Benjamin Franklin. A Perspective* (Cambridge, Mass.: Fogg Art Museum, 1975), p. 63.

9. Francis Hopkinson to Benjamin Franklin, September 5, 1779, in *Franklin Papers*, vol. 30, pp. 298–99.

10. Inventory of Franklin's Estate, Franklin Papers, American Philosophical Society, Philadelphia, Pennsylvania. The telescope was valued at $43.15. We wish to thank Ellen R. Cohn of the Papers of Benjamin Franklin for this information.

11. Quoted in Richard Wendorf, *Sir Joshua Reynolds: The Painter in Society* (Cambridge, Mass.: Harvard University Press, 1996), p. 133. I want to thank Ellen Miles for this reference.

12. The painting has been thoroughly discussed, and the experiments indicated by the bells, cork balls, and miniature buildings painted in the background described, in Richard Dorment, *British Painting in the Philadelphia Museum of Art from the Seventeenth through the Nineteenth Century* (Philadelphia: Philadelphia Museum of Art, 1986), pp. 38–44. See also Sellers, *Franklin in Portraiture*, pp. 57–59, 218–22. On Edward Fisher's engraving after the portrait, see Richard Saunders's entry in Saunders and Miles, *American Colonial Portraits*, pp. 258–59.

13. See J. A. Leo Lemay, *Ebenezer Kinnersley: Franklin's Friend* (Philadelphia: University of Pennsylvania Press, 1964).

14. Richard Dorment has proposed that the structures seen through Franklin's painted window were models of this sort; his explanation is followed here. See Dorment, *British Painting*, pp. 42–43.

15. Benjamin Franklin to Jonathan Mayhew, Philadelphia, February 24, 1764, in *Franklin Papers*, vol. 11, p. 89.

16. Quoted in Miles and Saunders, *American Colonial Portraits*, p. 258.

17. Quoted in Sellers, *Franklin in Portraiture*, p. 222.

18. Benjamin Franklin to Peter Collinson, September 1753, in *Franklin Papers*, vol. 5, pp. 69–70.

19. Benjamin Franklin to Horace-Bénédict de Saussure, October 8, 1772, ibid., vol. 19, p. 325.

20. Benjamin Rush, *An Eulogium in honor of the late Dr. William Cullen. . . deliver'd before the College of Physicians of Philadelphia* (Philadelphia, 1790), pp. 18–19.

21. See David C. Leonard, "Harvard's First Science Professor: A Sketch of Isaac Greenwood's Life and Work," *Harvard Library Bulletin* 29 (April 1981): 135–68.

22. Georgetown *Olio*, December 16, 1802, p. 199.

23. See *Dictionary of American Biography* and Linda Simmons, "David Wiley and His Electrostatic Machine," *Rittenhouse* 1 (May 1987): 78–81.

24. The best source for information on Josiah is William Bell Clark, "James Josiah, Master Mariner," *Pennsylvania Magazine of History and Biography* 79 (October 1955): 452–84. See also Margaret C. S. Christman, *Adventurous Pursuits: Americans and the China Trade, 1784–1844* (Washington, D.C.: Smithsonian Institution Press for the National Portrait Gallery, 1984), pp. 70–78.

25. Information on Josiah's uniform was provided by Marko Zlatich, volunteer in the History of Technology division of the National Museum of American History, in a memorandum of February 17, 1998. The 1776 regulations read: "Captains. Blue Cloth with Red Lappels, Slash Cuff, Stand up Collar, flat Yellow Buttons, Blue Britches, Red Waistcoat with Narrow Lace."

26. Very little has been published on Samuel King. That he spent at least the winter of 1771/72 in Salem is documented in Dexter, *Literary Diary of Ezra Stiles* for April 27, 1772, vol. 1, p. 229. See also *D.A.B.* and William B. Stevens, "Samuel King of Newport," *Antiques* 96 (November 1969): 729–33. For King's rental of Smibert's former studio, see Saunders, *John Smibert*, p. 125.

27. See Arline Meyer, "Re-dressing Classical Statuary: The Eighteenth-Century 'Hand-in-Waistcoat' Portrait," *Art Bulletin* 77 (March 1995): 45–64.

28. With the exception of information gleaned from Vinall's book and a letter from Vinall to David Rittenhouse in the collection of the American Philosophical Society (see n. 29), all of the material cited here has been generously provided by Teresa A. Carbone, associate curator for research at the Brooklyn Museum of Art, and is taken from her entry on Vinall's portrait that will be published in *American Paintings in the Brooklyn Museum of Art: Artists Born by 1876* (forthcoming, 1999).

29. John Vinall to David Rittenhouse, August 23, 1794, APS.

30. See the entry on Mrs. Winthrop's portrait in John Caldwell and Oswaldo Rodriguez Roque et al., *American Paintings in the Metropolitan Museum of Art*, vol. 1 (Princeton: Princeton University Press, 1994), pp. 97–99. This portrait is smaller than John Winthrop's portrait; they do not, therefore, appear to have been planned as pendants.

31. Cited in Clifford K. Shipton, "John Winthrop," in *Sibley's Harvard Graduates* (Boston: Massachusetts Historical Society, 1937–1965), vol. 9, p. 245. For a summary of Winthrop's teaching methods and study of Newton, based in part on original research in the Harvard Archives, see Michael Carter Mathieu, "John Winthrop and Colonial Science Education at Harvard" (Masters thesis, Harvard University, 1989), pp. 43–44 and *passim*, courtesy Harvard University, Archives.

32. Mathieu, "John Winthrop," p. 95.

33. Dexter, *Literary Diary of Ezra Stiles*, vol. 2, p. 334.

34. John Winthrop, *Two Lectures on the Parallax and Distance of the Sun, As Deducible from the Transit of Venus* (Boston, 1769), pp. 5, 14, reprinted in Shute, *Scientific Work of John Winthrop*.

35. Peter Collinson to James Alexander, March 6, 1754, in *Letters and Papers of Colden*, vol. 4, p. 433.

36. John Winthrop, *Relation of a Voyage*, pp. 10–11, reprinted in Shute, *Scientific Work of John Winthrop*.

37. I am grateful to Owen Gingerich of the Harvard-Smithsonian Center for Astrophysics for identifying the diagram. It is illustrated on p. 13 of Winthrop's *Relation of a Voyage*.

38. See D. J. Bryden, *James Short and His Telescopes*, ed. the Royal Scottish Museum, bicentenary exhibition, July 26–September 7 (Glasgow: Bell and Bain, 1968).

39. For Franklin's comment on Short, see his letter to Isaac Norris, September 16, 1758, in *Franklin Papers*, vol. 8, p. 158. On Winthrop's telescope see David P. Wheatland, *The Apparatus of Science at Harvard, 1765–1800* (Harvard University: Collection of Historical Scientific Instruments, 1965), pp. 13–14; on the instruments taken to Newfoundland see I. Bernard Cohen, *Some Early Tools of American Science* (Cambridge, Mass.: Harvard University Press, 1950), pp. 37–39.

40. *Independent Chronicle*, October 21, 1779, p. 1.

41. See Benjamin Rush to Charles Lee, October 24, 1779, in Butterfield, *Letters of Rush*, vol. 1, p. 244; and Edward Potts Cheyney, *History of the University of Pennsylvania, 1740–1940* (Philadelphia: University of Pennsylvania Press, 1940), pp. 124–33.

42. Charles Willson Peale to John Ewing, June 14, 1787, in Lillian B. Miller, ed., *The Collected Papers of Charles Willson Peale and His Family*, microfiche edition (Millwood, N.Y.: Kraus-Thompson, 1980), fiche IIA 15 E2.

43. Charles Willson Peale's Diary entries for July 19 and August 19, 1788, in Miller et al., *Selected Papers of Peale*, vol. 1, pp. 515, 523.

44. The best published source for information on Greenway is Edward A. Wyatt IV, "Dr. James Greenway, Eighteenth Century Botanist, of Dinwiddie County, with an Account of Two Generations of His Descendants," *Tyler's Quarterly and Genealogical Magazine* 17 (April 1936): 210–23. Although no evidence has been found to indicate that Greenway taught at the College of William and Mary, in 1770 the college did appoint Greenway surveyor of Dinwiddie County in return for a portion of his profits. See "Appointment by the President and Masters of the College of William and Mary of James Greenway to be Surveyor of Dinwiddie County, 1770," University Archives, Swem Library, College of William and Mary, Williamsburg, Virginia, Subject File: Surveying—Individuals: James Greenway. I would like to thank Ann C. Madonia and Melinda McPeek for this reference.

45. Quoted in Richard L. Jones, *Dinwiddie County: Carrefour of the Commonwealth* (N.p.: Board of Supervisors of Dinwiddie County, 1976), p. 236.

46. James Greenway to Benjamin Smith Barton, September 14, 1792, Barton Delafield Papers, APS. I would like to thank Whitfield J. Bell Jr. for this and subsequent references to Greenway letters in the Barton Delafield Papers, as well as for access to his research notes on Greenway.

47. James Greenway to Benjamin Smith Barton, October 17, 1791, ibid.

48. The portrait of Gray Briggs and its pendant of Dorothy Pleasants Briggs, his wife, are in a private collection; see Franklin W. Kelly, "The Portraits of John Durand," *Antiques* 122 (November 1982): 1087. Greenway's portrait is also one of a pair with that of his wife, Martha Dixon Greenway, owned by the Muscarelle

Museum at the College of William and Mary. Greenway mentions Briggs as his neighbor in a letter to Barton, September 14, 1792, Barton Delafield Papers, APS.

49. The painting has recently been conserved, so that the inscriptions on the books are fairly easy to discern. They are, from top to bottom, right to left: "SYDENHAM / OPERA; —SUS / —ICINE; HIPPOCRATES /OPERA / OMNIA; BOERHAAV- / OPERA; MEAD- / OPERA / OMNIA; LINNE— /GENERA /PLANTARUM." In a letter to Benjamin Smith Barton of March 3, 1794, he calls himself "an old fashioned follower of Sydenham." Barton Delafield Papers, APS.

50. The placement of the portrait in Greenway's library in his home, the Grove, is noted in Wyatt, "Dr. James Greenway," p. 214, and is taken from the memoirs of Winfield Scott, a distant relation who knew Greenway in his last years.

51. Note written on a letter from Smith to Benjamin Rush, August 5, 1802, Rush Papers, LCP.

52. Horace Wemyss Smith, *Life and Correspondence of the Rev. William Smith, D.D.* (Philadelphia: Ferguson Bros. and Co., 1880), vol. 2, p. 344.

53. Ibid., vol. 1, p. 413, states that the portrait was done in 1800, after Smith had settled in his house at the Falls of Schuylkill in early February. Stuart is mentioned as being a dinner guest at Smith's country house in a letter from Smith to Benjamin Rush, August 5, 1802, Rush Papers, LCP.

54. Draft letter from Benjamin Rush to William Smith, August 10, 1802, Rush Papers, LCP.

55. See Albert Frank Gegenheimer, *William Smith, Educator and Churchman, 1727–1803* (Philadelphia: University of Pennsylvania Press, 1943), pp. 218–19; and Talbot Hamlin, *Benjamin Henry Latrobe* (New York: Oxford University Press, 1955), pp. 159–60.

56. See [William Smith], *Remarks on a Second Publication of B. Henry Latrobe, Engineer* (Philadelphia, 1799), pp. 6–7.

57. Benjamin Henry Latrobe, Diary, March 15, 1800, in Edward C. Carter II et al., eds., *The Papers of Benjamin Henry Latrobe*, microtext edition (Clifton, N.J.: James T. White & Company for the Maryland Historical Society, 1976), fiche 12/D5.

CHAPTER 6

1. Charles Lamotte, *An Essay upon Poetry and Painting* (1730; reprint, New York: Garland Publishing, 1970), pp. 39–40.

2. Richardson, *Essay on the Theory of Painting*, pp. 8–9.

3. Peter Collinson to John Custis, December 24, 1737, quoted in Earl Gregg Swem, ed., "Brothers of the Spade: The Correspondence of Peter Collinson, of London, and of John Custis, of Williamsburg, Virginia, 1734–1746," *Proceedings of the American Antiquarian Society* 58 (1949): 66; John Bartram, "Journal of a Trip to Maryland and Virginia" [autumn 1738], enclosed in a letter to Collinson, quoted in Berkeley and Berkeley, *Correspondence of Bartram*, p. 102; John Custis to Peter Collinson, [August 12], 1739, quoted in Swem, "Brothers of the Spade," p. 77. A full discussion of Custis's plant collecting and his garden may be found in Peter Martin, *The Pleasure Gardens of Virginia from Jamestown to Jefferson* (Princeton: Princeton University Press, 1991), pp. 54–64.

4. John Custis to Peter Collinson, [July 29], 1736, in Swem, "Brothers of the Spade," p. 49. Although the wild speculation in tulips of the seventeenth century was long past, "broken" or variegated tulips did retain their popularity into the early nineteenth century.

5. John Custis to Robert Cary, 1725, quoted in Swem, "Brothers of the Spade," p. 37.

6. See Jo Zuppan, "John Custis of Williamsburg, 1678–1749," *Virginia Magazine of History and Biography* 90 (April 1982): 177–97. Although the Tudor Place portrait has been tentatively attributed to Charles Bridges, who worked in Virginia from 1735 until 1743 or 1744, there is no documentation for the attribution. There is no evidence for an itinerant artist in Williamsburg at this time; nor is there evidence that Custis traveled to England after his youthful education was completed.

7. The discussion of Rubens's portrait is based on intensive research carried out by Ellen G. Miles, published as the entry on *Rubens Peale with a Geranium* in Franklin Kelly et al., *American Paintings of the Nineteenth Century, Part II: The Collections of the National Gallery of Art Systematic Catalogue* (Washington, D.C.: Oxford University Press for the National Gallery of Art, 1998). I would like to thank Dr. Miles for allowing me prepublication access to her entry.

8. Ibid.

9. Ibid.

10. The duration of the voyage was July 22 to September 23, 1789. See Barton's Commonplace Book for 1789, transcripts at APS; original at HSP.

11. The portrait is inscribed on the original canvas, verso: "Saml. Jennings / pinx August 1789" in an eighteenth-century script. On the lining canvas is inscribed, in a later hand: "Portrait / of Benjamin Smith Barton / given to J. R. B. by his son's widow Mrs. Cora Livingston Barton in New York, / Nov. 1869." The features of the sitter bear a close resemblance to other portraits of Barton, including an aquatint by Bass Otis of circa 1812, and a profile engraving done by Saint-Mémin in 1802. See the curatorial file, APS.

12. See Whitfield J. Bell Jr., "Benjamin Smith Barton, M.D. (Kiel)," *Journal of the History of Medicine and Allied Sciences* 36 (April 1971): 197–203.

13. See Benjamin Smith Barton, "Journal of the Western Boundary Survey 1785," HSP; photocopies at APS. The journals were amended by Barton for at least fourteen years.

14. Benjamin Smith Barton, *Observations on some parts of Natural History...* (London, [1787?]), pp. 30–33. That Barton holds this diagram was noted first by Whitfield J. Bell Jr.

15. Ibid., pp. 35, 65.

16. Later, he indicated his knowledge of Heart's work by noting in an addition to his "Journal of the Western Boundary Survey" that Heart had published a letter concerning the site in the *Transactions of the American Philosophical Society* for 1793. See Barton, "Journal of the Western Boundary," p. 35.

17. For Ellicott's visit to Franklin, see Catharine van Cortlandt Mathews, *Andrew Ellicott: His Life and Letters* (New York: Grafton Press, 1908), p. 50. See also Andrew Ellicott to Sarah Ellicott, May 25 and July 6, 1785, in ibid., pp. 37, 44. The artist Ellicott calls "Billy West" in a 1786 letter may be George William West (1770–1795), whose death notice in the *Maryland Journal* (Baltimore) for August 5, 1795, included the information that he had been studying painting in London when he was taken ill, and that he was (like Ellicott's "Billy West") the son of a minister. See Alfred Coxe Prime, *The Arts and Crafts in Philadelphia, Maryland, and South Carolina, 1786–1800* ([Topsfield, Mass.]: Walpole Society, 1932), p. 38. For an account of George William West's short career, see J. Hall Pleasants, "George William West: A Baltimore Student of Benjamin West," *Art in America* 37 (January 1949): 6–47.

18. I am grateful to Ellen G. Miles for this attribution. For Bouché, and similar drawings by the young Rembrandt Peale, see Ellen G. Miles, *Saint-Mémin and the Neoclassical Profile Portrait in America*, ed. Dru Dowdy (Washington, D.C.: National Portrait Gallery and Smithsonian Institution Press, 1994), pp. 62–63, 116.

19. Ames would have known Stuart's work by the first decade of the century; he had visited New York while Stuart was there, and by 1813 had been commissioned to make a full-length copy of the "Lansdowne" image, probably based on an engraving. Theodore Bolton and Irwin F. Cortelyou, *Ezra Ames of Albany: Portrait Painter, Craftsman, Royal Arch Mason, Banker, 1768–1836* (New York: New-York Historical Society, 1955), pp. 306–7. Ames's portrait of Henry Jones (signed and dated 1810) is similar to the De Witt painting in scale and elaborateness.

20. Quoted in William Heidt Jr., *Simeon DeWitt: Founder of Ithaca* (Ithaca, N.Y.: De Witt Historical Society of Tompkins County, 1968), p. 36.

21. On De Witt, see Walter W. Ristow, "Simeon De Witt, Pioneer Cartographer," in *American Maps and Mapmakers: Commercial Cartography in the Nineteenth Century* (Detroit: Wayne State University Press, 1985), pp. 73–85; Silvio A. Bedini, "Simeon De Witt (1756–1834), Surveyor, Cartographer and Land Developer," pt. 1, *Professional Surveyor* (January/February 1993): 43–44 and pt. 2 (March–April 1993): 51–52; Silvio A. Bedini, *Thinkers and Tinkers: Early American Men of Science* (New York: Charles Scribner's and Sons, 1975), pp. 252–56, 305–7; T. Romeyn Beck, *Eulogium on Simeon De Witt Delivered before the Albany Institute April 23, 1835* (Albany, N.Y., 1835), bound with a manuscript addendum by John Kintzing Kane, "Simeon De Witt, May 19, 1835," APS; and Heidt, *Simeon DeWitt*.

22. Andrew Ellicott to Sarah Ellicott, August 6, 1786, in Mathews, *Andrew Ellicott*, p. 59; Brooke Hindle, *David Rittenhouse* (Princeton: Princeton University Press, 1964), p. 282.

23. See Richard Varick De Witt, "Memoir of Pictures," Manuscript Collection 316, Albany Institute for History and Art: "Portrait of my Father three quarter length 1804 (In Rutgers College)/ by Ezra Ames of Albany."

24. See Ristow, *American Maps*, p. 78.

25. Vanderlyn was referring to John Lempriere's (?1765–1824) *Bibliotheca classica; or, A Classical Dictionary*, which went through many editions. *New York Evening Post* for July 1819; both are quoted in Heidt, *Simeon DeWitt*, pp. 12–13. See also Ristow, *American Maps*, pp. 78–80.

26. Simeon De Witt to Benjamin Rush, April 25, 1807, APS. On Ames, see Bolton and Cortelyou, *Ezra Ames*, particularly pp. 36 and 151.

27. See Bolton and Cortelyou, *Ezra Ames*, pp. 102–4.

CHAPTER 7

1. For information on portrait prints in colonial America see Saunders and Miles, *American Colonial Portraits*, pp. 22–25, 56–57, and 66–67.

2. I want to thank Ellen Miles for bringing this engraving to my attention.

3. Justin Winsor, ed., *The Memorial History of Boston*, 4 vols. (Boston, 1880–1881), vol. 4, p. 510.

4. Thomas Jefferson to John Trumbull, February 15, 1788, in Julian P. Boyd et al., eds., *The Papers of Thomas Jefferson* (Princeton: Princeton University Press, 1950–), vol. 14, p. 561; on Jefferson's art collection, see Seymour Howard, "Thomas Jefferson's Art Gallery for Monticello," *Art Bulletin* 59 (December 1977): 583–600.

5. Benjamin Rush to Thomas Hogg, Philadelphia, April 22, 1784, Miscellaneous MSS, LCP.

6. Cutler and Cutler, *Manasseh Cutler*, vol. 2, p. 269.

7. Benjamin Franklin to Benjamin Vaughan, July 26, 1784, quoted in Verner W. Crane, "The Club of Honest Whigs: Friends of Science and Liberty," *William and Mary Quarterly*, 3rd ser., 23 (April 1966): 216, n. 20.

8. John Bartram to Benjamin Franklin, November 24, 1770, and on the portrait by his bed, John Bartram to Benjamin Franklin, November 5, 1768, in Berkeley and Berkeley, *Correspondence of Bartram*, pp. 708, 735.

9. For a brief discussion of engraved portraits of Fothergill within the context of Quaker visual culture, see Marcia Pointon, "Quakerism and Visual Culture 1650–1800," *Art History* 20 (September 1997): 410–13.

10. Quoted in *Gilbert Stuart: Portraitist of the Young Republic 1755–1828* (Providence, R.I.: Museum of Art, Rhode Island School of Design, 1967), pp. 14–15, 48.

11. Benjamin Franklin to Jane Mecom, October 25, 1779, in *Franklin Papers*, vol. 30, p. 583.

12. Benjamin Franklin to Ezra Stiles, May 29, 1763, in ibid., vol. 10, p. 266.

13. Benjamin Franklin to Ezra Stiles, June 19, 1764, in ibid., vol. 11, p. 230.

14. William Franklin to Benjamin Franklin, [circa January 2, 1769], in ibid., vol. 16, p. 4.

15. Henry Pelham to [Charles Reak and Samuel Okey], March 10, 1775, and Reak and Okey to Pelham, March 16, 1775, in *Letters and Papers of John Singleton Copley and Henry Pelham, 1739–1776* (1914; reprint, New York: Kennedy Graphics, Inc., Da Capo Press, 1970), pp. 293–94, 308–9.

16. John Winthrop to John Adams, June 21 and 22, 1775, in Robert J. Taylor et al., *Papers of John Adams* (Cambridge, Mass.: Harvard University Press, Belknap Press, 1977), vol. 3, p. 46.

17. On Jeffries, see Tom D. Crouch, "Jeffries and the Channel," in his *The Eagle Aloft: Two Centuries of the Balloon in America* (Washington, D.C.: Smithsonian Institution Press, 1983), pp. 71–96; see also "John Jeffries," in Shipton, *Sibley's Harvard Graduates*, vol. 15, pp. 419–27.

18. Quoted in Crouch, *Eagle Aloft*, pp. 78–79. On the craze for ballooning in America, see Michael E. Connaughton, "'Ballomania': The American Philosophical Society and Eighteenth-Century Science," *Journal of American Culture* 7 (1984): 71–74.

19. Quoted in Crouch, *Eagle Aloft*, p. 83.

20. John Jeffries, *A Narrative of the Two Aerial Voyages of Doctor Jeffries with Mons. Blanchard; with meteorological observations and Remarks…* (London, 1786), pp. 13–14.

21. Ibid., pp. 49–50.

22. Quoted in Shipton, *Sibley's Harvard Graduates*, vol. 15, p. 425.

23. John Jeffries Diary, 1778–1819, June 7, 1785, Jeffries Family Papers, Massachusetts Historical Society, Boston.

24. Benjamin Franklin to James Bowdoin, January 1, 1786, in Smyth, *Writings of Franklin*, vol. 9, p. 479.

25. For Jeffries's sittings to Russell, his frustrations with the Royal Society, and his meticulous records of his expenses relating to the pastel portrait, engraving, and publication of his *Narrative*, see Jeffries Diary, MHS, especially entries for January 1785 through April 1786, and Jeffries Letters, Accounts, Etc., 1785–1835, which include his expense accounts, "Publication of my Aerial Narrative [1786–1788]" and "Books & Prints presented, to whom & when, [1786–1795]," MHS. I am grateful to Tom Crouch for telling me about these records, for copies, and for access to microfilmed records at NASM.

26. John Jeffries to Benjamin Franklin, June 1, 1786, APS.

27. For a detailed discussion of Jeffries's clothing, which also survives in the collections of Houghton Library, Harvard University, see Claudia Kidwell, "Apparel for Ballooning with

Speculations on More Commonplace Garb," *Costume* 11 (1977): 73–87.

28. The quotations used here were all taken from the chapter on Banneker included in Sidney Kaplan, *The Black Presence in the Era of the American Revolution, 1770–1800* (Greenwich, Conn: New York Graphic Society, 1973), pp. 111–28. See also Silvio Bedini, *The Life of Benjamin Banneker* (New York: Charles Scribner's Sons, 1971) for more detailed information on Banneker and the production of his almanacs; on Banneker's portrait see p. 193.

CHAPTER 8

1. William Staughton, *An Eulogium in Memory of the late Dr. Benjamin Rush. . . July 8, 1813* (Philadelphia, 1813), p. 19.

2. See "A Description of a Monument Designed to Perpetuate the Memory of American Liberty" (1795), in *Giuseppe Ceracchi Scultore Giacobino, 1751–1801* (Rome: Palazzo dei conservatori, 1989), p. 94. I would like to thank Ellen Miles for this reference.

3. Benjamin Rush to William Cullen, Philadelphia, September 16, 1783, in Butterfield, *Letters of Rush*, vol. 1, p. 310.

4. Joseph Banks to Benjamin Franklin, London, August 25, 1783, quoted in I. Bernard Cohen, *Benjamin Franklin's Experiments: A New Edition of Franklin's Experiments and Observations on Electricity* (Cambridge, Mass.: Harvard University Press, 1941), p. 8.

5. Quoted in John Keane, *Tom Paine: A Political Life* (Boston: Little, Brown, 1995), p. 42, as part of a useful discussion of Paine's links to Newtonian science.

6. For a discussion of American portrait collections formed during and after the Revolution and their relationship to contemporary ideas on virtue, American genius, and the rhetorical plain style, see Brandon Brame Fortune, "Portraits of Virtue and Genius: Pantheons of Worthies and Public Portraiture in the Early American Republic, 1780–1820" (Ph.D. diss., University of North Carolina at Chapel Hill, 1987); for a summary of American discussions of the notion of *translatio studii*, see Joseph J. Ellis, *After the Revolution: Profiles of Early American Culture* (New York: W. W. Norton, 1979), pp. 3–21; on the contemporary debate concerning American degeneracy, see Antonello Gerbi, *The Dispute of the New World: The History of a Polemic*, trans. Jeremy Moyle (1955; rev. ed., Pittsburgh: University of Pittsburgh Press, 1973).

7. See Joyce Appleby et al., *Telling the Truth about History* (New York: W. W. Norton, 1994), pp. 15–19, and Keane, *Tom Paine*, pp. 40–45; see also Caroline Robbins, *The Eighteenth-Century Commonwealthman* (Cambridge, Mass.: Harvard University Press, 1959); and Brooke Hindle, *The Pursuit of Science in Revolutionary America, 1735–1789* (Chapel Hill: University of North Carolina Press for the Institute of Early American History and Culture, 1956), pp. 248–79.

8. Philip Freneau and Hugh H. Brackenridge, "The Rising Glory of America," in Philip Freneau, *Poems Relating to the American Revolution* (New York: W. J. Widdleton, 1865), p. 14.

9. Franklin to Joseph Banks, Passy, July 27, 1783, and Franklin to Jan Ingenhousz, April 29, 1785, quoted in Cohen, *Franklin's Experiments*, pp. 8–9.

10. Cutler and Cutler, *Manasseh Cutler*, vol. 1, pp. 267–70.

11. Rubens Peale, "Memorandum of Rubens Peale," p. 5, Peale-Sellers Papers, APS. I am grateful to Ellen G. Miles for this reference.

12. Quoted in J. A. Leo Lemay and Paul M. Zall, eds., *The Autobiography of Benjamin Franklin: A Genetic Text* (Knoxville: University of Tennessee Press, 1981), p. xliv.

13. Sellers, *Portraits and Miniatures*, p. 82; Miller et al., *Selected Papers of Peale*, vol. 1, p. 564.

14 For a thorough discussion of the cultural context of this controversy, see Trent A. Mitchell, "The Politics of Experiment in the Eighteenth Century: The Pursuit of Audience and the Manipulation of Consensus in the Debate over Lightning Rods," *Eighteenth-Century Studies* 31 (spring 1998): 307–32.

15. Quoted in Cohen, *Franklin's Experiments*, pp. 135–36.

16. Ibid., p. 138.

17. Thomas Jefferson, *Notes on the State of Virginia*, pp. 101–3.

18. Franklin's will states: "My reflecting telescope, made by Short, which was formerly Mr. Canton's, I give to my friend, *Mr. David Rittenhouse*, for the use of his observatory." See Smyth, *Writings of Franklin*, vol. 10, p. 509.

19. Letter to the author from Owen Gingerich, Harvard-Smithsonian Center for Astrophysics, February 3, 1997.

20. Rush, *Eulogium to Rittenhouse*, p. 9.

21. Paul Theerman has studied the parallels between Newton and Rittenhouse, but does not speculate, as we do, that Rittenhouse's life, as constructed by his contemporaries and eulogist, may have been consciously modeled on that of Newton. See Theerman, "National Images of Science: British and American Views of Scientific Heroes in the Early Nineteenth Century," in Joseph W. Slade and Judith Yaross Lee, *Beyond the Two Cultures: Essays on Science, Technology, and Literature* (Ames: Iowa State University Press, 1990), pp. 259–74.

22. Rush, *Eulogium to Rittenhouse*, pp. 35–36.

23. Ibid., p. 44.

24. Advertisement in *Gazette of the United States*, December 29, 1796, quoted in Prime, *Arts and Crafts*, p. 72.

25. George Washington to Joseph Willard, December 23, 1789, in John C. Fitzpatrick, ed., *The Writings of George Washington. . .* (1931; reprint, Westport, Conn.: Greenwood Press, 1970), vol. 30, p. 483. I am grateful to Ellen G. Miles for this reference.

26. For a discussion of Jefferson's varied scientific interests, see Silvio A. Bedini, *Thomas Jefferson: Statesman of Science* (New York: Macmillan, 1990).

27. See Linda K. Kerber, *Federalists in Dissent: Imagery and Ideology in Jeffersonian America* (Ithaca, N.Y.: Cornell University Press, 1970), pp. 67–94.

28. Alexander Wilson to William Bartram, March 4, 1805, in Clark Hunter, ed., *The Life and Letters of Alexander Wilson* (Philadelphia: American Philosophical Society, 1983), p. 232.

29. We know that Jefferson acquired an electrical machine and a pair of globes; but in Philadelphia, where the print was published, similar instruments were owned by the American Philosophical Society. A manuscript list of "Mathematical Apparatus" owned by Jefferson after 1786 is reproduced in Bedini, *Thomas Jefferson*, pp. 500–501. For instruments owned by the American Philosophical Society, see Robert P. Multhauf, *A Catalogue of Instruments and Models in the Possession of the American Philosophical Society* (Philadelphia: American Philosophical Society, 1961).

30. See Rita Susswein Gottesman, *The Arts and Crafts in New York, 1800–1804* (New York: New-York Historical Society, 1965), p. 19; and James L. Yarnall and William H. Gerdts, *The National Museum of American Art's Index to American Art Exhibition Catalogues from the Beginning through the 1876 Centennial Year* (Boston: G. K. Hall & Co., 1986), vol. 1, p. 403.

31. See Gottesman, *Arts and Crafts*, pp. 3–4; and John Jay Ide, "A Discovery in Early American Portraiture," *Antiques* 25 (March 1934): 99–100.

32. See Noble E. Cunningham Jr., *The Image of Thomas Jefferson in the Public Eye: Portraits for the People, 1800–1809* (Charlottesville: University Press of Virginia, 1981), pp. 131–33.

33. Isaac Weld Jr., *Travels through the States of North America, and the Provinces of Upper and Lower Canada during the Years 1795, 1796, and 1797* (4th ed., London, 1800), p. 164.

34. Jefferson, *Notes on the State of Virginia*, p. 54.

35. On Roberts, see Barbara C. Batson, "Virginia Landscapes by William Roberts," *Journal of Early Southern Decorative Arts* 10 (November 1984): 35–48. For Jefferson's paintings and prints by Roberts, see also Susan R. Stein, *The Worlds of Thomas Jefferson at Monticello* (New York: Harry N. Abrams, Inc., in association with the Thomas Jefferson Memorial Foundation), pp. 190–91. On views of the Natural Bridge, see Pamela H. Simpson, *So Beautiful an Arch: Images of the Natural Bridge, 1787–1890* (Lexington, Va.: Washington and Lee University, 1982).

36. Peale's *Exhumation* has been the focus of many scholarly analyses. The most recent is Laura Rigal, "Peale's Mammoth," in David C. Miller, ed., *American Iconology: New Approaches to Nineteenth-Century Art and Literature* (New Haven: Yale University Press, 1993), pp. 18–38.

37. Charles Willson Peale to Angelica Peale Robinson, September 13, 1806; quoted in Rigal, "Peale's Mammoth," p. 31.

38. On Earl's portraits of Nehemiah Strong, see Kornhauser et al., *Ralph Earl*, pp. 169–71.

39. Dexter, *Literary Diary of Ezra Stiles*, vol. 3, p. 94.

40. Kornhauser et al., *Ralph Earl*, p. 169, makes the suggestion that Earl may have been seeking sitters in New Haven.

41. Nehemiah Strong to Ezra Stiles, August 30, 1790, quoted in ibid., p. 169.

42. Nehemiah Strong to Ezra Stiles, September 8, 1790, quoted in ibid., p. 169.

43. See ibid. for a list of Strong's books represented by Earl. On Strong's costume, see Aileen Ribeiro's costume notes on the painting, p. 171.

44. See Strong's manuscript will and the inventory of his possessions, Stratford, Connecticut, 1807, Connecticut State Library, Hartford. See also the entry on this portrait in Christine Skeeles Schloss, *The Beardsley Limner and Some Contemporaries: Postrevolutionary Portraiture in New England, 1785–1805* (Williamsburg, Va.: Abby Aldrich Rockefeller Folk Art Collection, 1972), pp. 36–37. I wish to thank Elizabeth Mankin Kornhauser for sharing copies of Strong's probate documents with me.

45. See Richard J. Moss, *The Life of Jedidiah Morse: A Station of Peculiar Exposure* (Knoxville: University of Tennessee Press, 1995), pp. 81–115. See also Paul J. Staiti, *Samuel F. B. Morse* (Cambridge: Cambridge University Press, 1989), pp. 1–11.

46. Richard Holmes, "The Romantic Circle," *New York Review of Books*, April 10, 1997, p. 34.

47. "Early Proceedings of the American Philosophical Society for the Promotion of Useful Knowledge, Compiled by One of the Secretaries from the Manuscript Minutes of its Meetings from 1744 to 1838," *Proceedings of the American Philosophical Society*, vol. 22, pt. 3 (July 1885): 224 (minutes for July 18, 1794).

48. Quoted in Ambler, *Benjamin Franklin*, p. 128.

49. Fortune, "Peale's Portrait Gallery," pp. 308–24.

50. Rembrandt Peale, "Reminiscences. Characteristics," *The Crayon* 1 (June 13, 1855): 370. On Priestley's portraits, see Valerie A. Livingston, "Joseph Priestley in the Public Eye: Reconstructing the Man Through Portraits and Caricatures," in *Joseph Priestley in America 1794–1804* (Carlisle, Pa.: Trout Gallery, Dickinson College, 1994), pp. 30–35.

51. Alexander Wilson to William Bartram, May 22, 1804, in Hunter, *Life and Letters*, p. 215.

52. William Bartram, *Travels and Other Writings*, ed. Thomas P. Slaughter (New York: Library of America, 1996), p. 209.

53. William Dunlap, diary entry for May 9, 1797, quoted in Thomas P. Slaughter, *The Natures of John and William Bartram* (New York: Alfred A. Knopf, 1996), p. 246.

54. Charles Willson Peale to Rembrandt Peale, Philadelphia, June 26 and July 3, 1808, in Miller et al., *Selected Papers of Peale*, vol. 2, pt. 2, p. 1093.

55. Charles Willson Peale to John Hawkins, March 28 and April 3, 1807, in ibid., p. 1010.

56. Brandon Brame Fortune, "Charles Willson Peale's Late Self-Portraits and the Authority of Old Age" (paper delivered at the annual meeting of the College Art Association, New York City, February 17, 1994).

57. See Hedrick, *A History of Horticulture*, pp. 164–74.

58. Curtis's *Botanical Magazine* 1 (1787): 31. I would like to thank Dan H. Nicolson for this reference.

59. William Baldwin to William Darlington, August 14, 1818, quoted in Slaughter, *John and William Bartram*, p. 256.

60. For a careful discussion of the layering of identities and the roles of sitter and artist in portraiture, see Joel Weinsheimer, "Mrs. Siddons, the Tragic Muse, and the Problem of *As*," *Journal of Aesthetics and Art Criticism* 36 (spring 1978): 317–28.

61. Oliver Wolcott to Laura Wolcott, March [8], 1776, in Paul H. Smith et al., eds., *Letters of Delegates to Congress, 1774–1789*, 24 vols. (Washington, D.C.: Library of Congress, 1976–1983), vol. 3, p. 360. I would like to thank Konstantin Dierks for this reference.

Selected Bibliography

Ambler, Louise Todd. *Benjamin Franklin: A Perspective*. Cambridge, Mass.: Fogg Art Museum, 1975.

Appleby, Joyce, et al. "The Heroic Model of Science." In *Telling the Truth about History*. New York: W. W. Norton, 1994.

Bartram, John. *The Correspondence of John Bartram, 1734–1777*. Edited by Edmund Berkeley and Dorothy Smith Berkeley. Gainesville: University Press of Florida, 1992.

Bartram, William. *Travels and Other Writings*. Edited by Thomas P. Slaughter. New York: Library of America, 1996.

Baumgarten, Linda. *Eighteenth-Century Clothing at Williamsburg*. Williamsburg, Va.: Colonial Williamsburg Foundation, 1986.

Bedini, Silvio A. *Thinkers and Tinkers: Early American Men of Science*. New York: Charles Scribner's Sons, 1975.

____. *Thomas Jefferson: Statesman of Science*. New York: Macmillan, 1990.

Bell, Whitfield J., Jr. *The Art of Philadelphia Medicine*. Philadelphia: Philadelphia Museum of Art, 1965.

____. *Patriot-Improvers: Members of the American Philosophical Society*. Vol. 1. Philadelphia: American Philosophical Society, 1997.

____. "Science and Humanity in Philadelphia, 1775–1790." Ph.D. diss., University of Pennsylvania, 1947.

Bryden, D. J. *James Short and His Telescopes*. Edited by the Royal Scottish Museum. Bicentenary exhibition, July 26–September 7. Glasgow: Bell and Bain, 1968.

Bumgardner, Georgia B. "American Almanac Illustration in the Eighteenth Century." In *Eighteenth-Century Prints in Colonial America, to Educate and Decorate*, edited by Joan D. Dolmetsch. Williamsburg, Va.: Colonial Williamsburg Foundation, 1979.

Burgess, Renate. *Portraits of Doctors and Scientists in the Wellcome Institute of the History of Medicine*. London: Wellcome Institute of the History of Medicine, 1973.

Bushman, Richard L. *The Refinement of America: Persons, Houses, Cities*. New York: Alfred A. Knopf, 1992.

Carter, Edward Clark, II. *"One Grand Pursuit": A Brief History of the American Philosophical Society's First 250 Years, 1743–1993*. Philadelphia: American Philosophical Society, 1993.

Cohen, I. Bernard. *Benjamin Franklin's Experiments: A New Edition of Franklin's Experiments and Observations on Electricity*. Cambridge, Mass.: Harvard University Press, 1941.

____. *Benjamin Franklin's Science*. Cambridge, Mass.: Harvard University Press, 1990.

____. *Some Early Tools of American Science*. Cambridge, Mass.: Harvard University Press, 1950.

Colden, Cadwallader. *The Letters and Papers of Cadwallader Colden*. Vol. 4, *1748–1754*. In *Collections of the New-York Historical Society for the Year 1920*. New York: New-York Historical Society, 1921.

____. *The Letters and Papers of Cadwallader Colden*. Vol. 5, *1755–1760*. In *Collections of the New-York Historical Society for 1921*. New York: New-York Historical Society, 1923.

____. *The Letters and Papers of Cadwallader Colden*. Vol. 8, *Additional Letters and Papers, 1715–1748*. In *Collections of the New-York Historical Society for the Year 1934*. New York: New-York Historical Society, 1937.

Collinson, Peter. "Brothers of the Spade: Correspondence of Peter Collinson, of London, and of John Custis, of Williamsburg, Virginia, 1734–1746." Edited by Earl Gregg Swem. *Proceedings of the American Antiquarian Society* 58 (1949): 17–190.

Craven, Wayne. "The American and British Portraits of Benjamin Franklin." In *Reappraising Benjamin Franklin: A Bicentennial Perspective*, edited by J. A. Leo Lemay. Newark: University of Delaware Press, 1993.

Cunningham, Noble E., Jr. *The Image of Thomas Jefferson in the Public Eye: Portraits for the People, 1800–1809*. Charlottesville: University Press of Virginia, 1981.

Cunningham, Patricia A. "Eighteenth-Century Nightgowns: The Gentleman's Robe in Art and Fashion." *Dress* 10 (1984): 2–11.

Datson, Lorraine. "The Ideal and Reality of the Republic of Letters." *Science in Context* 4 (1991): 367–86.

Dierks, Konstantin. "Letter Writing, Masculinity, and American Men of Science, 1750–1800." *Pennsylvania History* 65 (October 1998): 165–96.

Dobbs, Betty Jo Teeter, and Margaret C. Jacob. *Newton and the Culture of Newtonianism*. Atlantic Highlands, N. J.: Humanities Press International, 1995.

Docherty, Linda J. "Preserving Our Ancestors: The Bowdoin Portrait Collection." In *The Legacy of James Bowdoin III*, edited by Katharine J. Watson et al. Brunswick, Maine: Bowdoin College Museum of Art, 1994.

Dorment, Richard. Catalogue entry for Mason Chamberlin's portrait of Benjamin Franklin. In *British Painting in the Philadelphia Museum of Art from the Seventeenth through the Nineteenth Century*. Philadelphia: Philadelphia Museum of Art, 1986.

Fara, Patricia. "The Royal Society's Portrait of Joseph Banks." *Notes and Records of the Royal Society of London* 51 (1997): 199–210.

Filipczak, Zirka. *Hot Dry Men / Cold Wet Women: The Theory of Humors in Western European Art, 1575–1700*. New York: American Federation of Arts, 1997.

Fothergill, John. *Chain of Friendship: Selected Letters of Dr. John Fothergill of London, 1735–1780*. Introduction and notes by Betsy C. Corner and Christopher C. Booth. Cambridge, Mass.: Harvard University Press, Belknap Press, 1971.

Franklin, Benjamin. *The Autobiography of Benjamin Franklin: A Genetic Text*. Edited by J. A. Leo Lemay and Paul M. Zall. Knoxville: University of Tennessee Press, 1981.

____. *The Papers of Benjamin Franklin*. Edited by Leonard W. Labaree et al. New Haven: Yale University Press, 1959– .

____. *The Writings of Benjamin Franklin*. Edited by Albert Henry Smyth. New York: Macmillan, 1905–1907.

Fraser, David. "Joseph Wright of Derby and the Lunar Society." In *Wright of Derby* by Judy Egerton et al. New York: Metropolitan Museum of Art, 1990.

Gerbi, Antonello. *The Dispute of the New World: The History of a Polemic, 1750–1900*. Translated by Jeremy Moyle. Rev. ed. Pittsburgh: University of Pittsburgh Press, 1973.

Goodman, Dena. *The Republic of Letters: A Cultural History of the French Enlightenment*. Ithaca, N.Y.: Cornell University Press, 1994.

Greene, John C. *American Science in the Age of Jefferson*. Ames: Iowa State University Press, 1984.

Gronim, Sara. "Ambiguous Empire: The Knowledge of the Natural World in British Colonial New York." Ph.D. diss., Rutgers, the State University of New Jersey, 1999.

Hackman, Willem D. *Apples to Atoms: Portraits of Scientists from Newton to Rutherford*. London: National Portrait Gallery, 1986.

____. *Electricity from Glass: The Development of the Frictional Electrical Machine, 1600–1850*. Alphen aan den Rijn: Sijthoff and Noordhoff, 1978.

Hamilton, John D. *Material Culture of the American Freemasons*. Lexington, Mass.: Museum of Our National Heritage, 1994.

Hargreaves-Maudsley, W. N. *A History of Academical Dress in Europe until the End of the Eighteenth-Century*. Oxford: Clarendon Press, 1963.

Hindle, Brooke. *The Pursuit of Science in Revolutionary America, 1735–1789*. Chapel Hill: University of North Carolina Press for the Institute of Early American History and Culture, 1956.

Jacob, Margaret C. *The Cultural Meaning of the Scientific Revolution*. Philadelphia: Temple University Press, 1988.

Jordanova, Ludmilla. "Medical Men, 1780–1820." In *Portraiture: Facing the Subject*, edited by Joanna Woodall. Manchester, Eng.: Manchester University Press, 1997.

Kanz, Roland. *Dichter und Denker im Porträt. Spurengänge zur deutschen Porträtkultur des 18. Jahrhunderts*. Munich: Deutscher Kunstverlag, 1993.

Kerber, Linda K. "The Objects of Scientific Inquiry." In *Federalists in Dissent: Imagery and Ideology in Jeffersonian America*. Ithaca, N.Y.: Cornell University Press, 1980.

Kettering, Alison McNeil. "Gentlemen in Satin: Masculine Ideals in Later Seventeenth-Century Dutch Portraiture." *Art Journal* 56 (summer 1997): 41–47.

Klein, Lawrence E. *Shaftesbury and the Culture of Politeness: Moral Discourse and Cultural Politics in Early Eighteenth-Century England*. Cambridge: Cambridge University Press, 1994.

Klibansky, Raymond, Erwin Panofsky, and Fritz Saxl. *Saturn and Melancholy*. London: Thomas Nelson and Sons, Ltd., 1964.

LeFanu, William. *A Catalogue of the Portraits and Other Paintings, Drawings and Sculpture in the Royal College of Surgeons of England*. Edinburgh and London: E. & S. Livingston Ltd., 1960.

Lemay, J. A. Leo, ed. *Reappraising Benjamin Franklin: A Bicentennial Perspective*. Newark: University of Delaware Press, 1993.

Leventhal, Herbert. *In the Shadow of the Enlightenment: Occultism and Renaissance Science in Eighteenth-Century America*. New York: New York University Press, 1976.

Livingston, Valerie A. "Joseph Priestley in the Public Eye: Reconstructing the Man through Portraits and Caricatures." In *Joseph Priestley in America, 1794–1804: 14 September–12 November, 1994*, edited by Peter M. Lukehart. Carlisle, Pa.: Trout Gallery, Dickinson College, 1994.

Mannings, David. "Sir John Medina's Portraits of the Surgeons of Edinburgh." *Medical History* 23 (1979): 176–90.

Marks, Arthur S. "Angelica Kauffmann and Some Americans on the Grand Tour." *American Art Journal* 12 (spring 1980): 4–24.

Mathieu, Michael Carter. "John Winthrop and Colonial Science Education at Harvard." Masters thesis, Harvard University, 1989.

Meyer, Arline. "Re-dressing Classical Statuary: The Eighteenth-Century 'Hand-in-Waistcoat' Portrait." *Art Bulletin* 72 (March 1995): 45–64.

Miles, Ellen G. "The French Portraits of Benjamin Franklin." In *Reappraising Benjamin Franklin: A Bicentennial Perspective*, edited by J. A. Leo Lemay. Newark: University of Delaware Press, 1993.

____, ed. *The Portrait in Eighteenth-Century America*. Newark: University of Delaware Press, 1993.

Miles, Ellen G., and Richard Saunders. *American Colonial Portraits, 1700–1776*. Washington, D.C.: Smithsonian Institution Press for the National Portrait Gallery, 1987.

Mitchell, Trent A. "The Politics of Experiment in the Eighteenth Century: The Pursuit of Audience and the Manipulation of Consensus in the Debate over Lightning Rods." *Eighteenth-Century Studies* 31 (spring 1998): 307–32.

Morton, Alan, and Jane Wess. *Public and Private Science: The King George III Collection*. Oxford: Oxford University Press, 1993.

Multhauf, Robert P. *A Catalogue of Instruments and Models in the Possession of the American Philosophical Society*. Philadelphia: American Philosophical Society, 1961.

Noble, David F. *A World without Women: The Christian Clerical Culture of Western Science*. New York: Alfred A. Knopf, 1992.

O'Loughlin, Michael. *The Garlands of Repose: The Literary Celebration of Civic and Retired Leisure*. Chicago: University of Chicago Press, 1978.

Patrick, Stephen E. " 'I Have at Length Determined to Have My Picture Taken': An Eighteenth-Century Young Man's Thoughts about His Portrait by Henry Benbridge." *American Art Journal* 22, no. 4 (1990): 80.

Peacock, John. "The 'Wizard Earl' Portrayed by Hilliard and Van Dyck." *Art History* 8 (June 1985): 139–57.

Peale, Charles Willson. *Charles Willson Peale: The Artist in Revolutionary America, 1735–1791*. Vol. 1 of *The Selected Papers of Charles Willson Peale and His Family*. Edited by Lillian B. Miller et al. New Haven: Yale University Press for the National Portrait Gallery, 1983.

Peale, Charles Willson. *Charles Willson Peale: The Artist as Museum Keeper, 1791–1810*. Vol. 2 of *The Selected Papers of Charles Willson Peale and His Family*. Edited by Lillian B. Miller et al. New Haven: Yale University Press for the National Portrait Gallery, 1988.

Perry, Ruth. "Radical Doubt and the Liberation of Women." *Eighteenth-Century Studies* 18 (1984–85): 472–93.

Porter, Roy. "The Economic Context." In *Science and Profit in Eighteenth-Century London*. Vol. 3. Cambridge: Whipple Museum of the History of Science, 1985.

Rather, Susan. "Carpenter, Tailor, Shoemaker, Artist: Copley and Portrait Painting around 1770." *Art Bulletin* 79 (June 1997): 269–90.

Ribeiro, Aileen. *The Art of Dress: Fashion in England and France, 1750 to 1820*. New Haven: Yale University Press, 1995.

Rice, D. Talbot. *The University Portraits*. Edinburgh: The University Press, 1957.

Richardson, Edgar P., et al. *Charles Willson Peale and His World*. New York: Harry N. Abrams, 1983.

Rigal, Laura. "Peale's Mammoth." In *American Iconology: New Approaches to Nineteenth-Century Art and Literature*, edited by David C. Miller. New Haven: Yale University Press, 1993.

Robinson, Norman H. *The Royal Society Catalogue of Portraits*. London: The Royal Society, 1980.

Rostvig, Maren-Sofie. *The Happy Man: Studies in the Metamorphoses of a Classical Ideal*. 2 vols. 2nd ed. New York: Humanities Press, 1962–1971.

Rush, Benjamin. *Letters of Benjamin Rush.* Edited by L. H. Butterfield. 2 vols. Princeton: Princeton University Press for the American Philosophical Society, 1951.

Rutledge, Anna Wells. *A Catalogue of Portraits and Other Works of Art in the Possession of the American Philosophical Society.* Philadelphia: American Philosophical Society, 1961.

Sellers, Charles Coleman. *Benjamin Franklin in Portraiture.* New Haven: Yale University Press, 1962.

Shapin, Steven. " 'A Scholar and a Gentleman': The Problematic Identity of the Scientific Practitioner in Early Modern England." *History of Science* 29, pt. 3, no. 85 (September 1991): 291.

_____. *A Social History of Truth: Civility and Science in Seventeenth-Century England.* Chicago: University of Chicago Press, 1994.

Simmons, Linda. "David Wiley and His Electrostatic Machine." *Rittenhouse* 1 (May 1987): 78–81.

Smith, David R. " 'I Janus:' Privacy and the Gentlemanly Ideal in Rembrandt's Portraits of Jan Six." *Art History* 11 (March 1988): 42–63.

Steinberg, David. "Charles Willson Peale Portrays the Body Politic." In *The Peale Family: Creation of a Legacy, 1770–1870,* edited by Lillian B. Miller et al. New York: Abbeville Press for the Trust for Museum Exhibitions and the National Portrait Gallery, 1996.

_____. "Facing Paintings and Painting Faces before Lavater." In *Painting and Portrait Making in the American Northeast,* edited by Peter Benes. Dublin Seminar for New England Folklife, Annual Proceedings, vol. 19. Boston: Boston University, 1995.

Stiles, Ezra. *The Literary Diary of Ezra Stiles, D.D., LL.D.* Edited by Franklin Bowditch Dexter. 3 vols. New York: Charles Scribner's Sons, 1901.

Swain, Margaret H. "Nightgown into Dressing Gown: A Study of Mens' Nightgowns: Eighteenth Century." *Costume* 6 (1972): 10–21.

Theerman, Paul. "National Images of Science: British and American Views of Scientific Heroes in the Early Nineteenth Century." In *Beyond the Two Cultures: Essays on Science, Technology, and Literature,* edited by Joseph W. Slade and Judith Yaross Lee. Ames: Iowa State University Press, 1990.

Thornton, Dora. *The Scholar in His Study: Ownership and Experience in Renaissance Italy.* New Haven: Yale University Press, 1997.

Thornton, Tamara Plakins. *Cultivating Gentlemen: The Meaning of Country Life among the Boston Elite, 1785–1860.* New Haven: Yale University Press, 1989.

Walters, Alice N. "Conversation Pieces: Science and Politeness in Eighteenth-Century England." *History of Science* 35 (1997): 121–54.

Welu, James. "Vermeer's *Astronomer*: Observations on an Open Book." *Art Bulletin* 67 (June 1986): 263–67.

Wheatland, David P. *The Apparatus of Science at Harvard, 1765–1800.* Cambridge, Mass.: Harvard University Press, 1965.

Winkel, Marieke de. " 'Eene der deftigsten dragten': The Iconography of the *Tabbaard* and the Sense of Tradition in Dutch Seventeenth-Century Portraiture." In *Image and Self-Image in Netherlandish Art, 1550–1750,* edited by Reindert Falkenburg et al. Zwolle: Waanders Uitgevers, 1995.

Wolstenholme, G. E. W., and David Piper. *The Royal College of Physicians of London: Portraits.* London: J. & A. Churchill Ltd., 1964.

Wolstenholme, G. E. W., John F. Kerslake et al. *The Royal College of Physicians of London: Portraits, Catalogue II.* New York: American Elsevier, 1977.

Index

PHOTOGRAPHY CREDITS AND COPYRIGHTS

Designed by Gerard A. Valerio, Bookmark Studio, Annapolis

Composed in Baskerville by Sherri Ferritto, Typeline

Printed and bound by Friesens Corp., Altona, Manitoba, Canada